Domestic Space in Britain, 1750–1840

Material Culture of Art and Design

Material Culture of Art and Design is devoted to scholarship that brings art history into dialogue with interdisciplinary material culture studies. The material components of an object – its medium and physicality – are key to understanding its cultural significance. Material culture has stretched the boundaries of art history and emphasized new points of contact with other disciplines, including anthropology, archaeology, consumer and mass culture studies, the literary movement called 'Thing Theory', and materialist philosophy. **Material Culture of Art and Design** seeks to publish studies that explore the relationship between art and material culture in all of its complexity. The series is a venue for scholars to explore specific object histories (or object biographies, as the term has developed), studies of medium and the procedures for making works of art, and investigations of art's relationship to the broader material world that comprises society. It seeks to be the premiere venue for publishing scholarship about works of art as exemplifications of material culture.

The series encompasses material culture in its broadest dimensions, including the decorative arts (furniture, ceramics, metalwork, textiles), everyday objects of all kinds (toys, machines, musical instruments), and studies of the familiar high arts of painting and sculpture. The series welcomes proposals for monographs, thematic studies, and edited collections.

Series Editor:
Michael Yonan

Advisory Board:
Wendy Bellion, University of Delaware, USA
Claire Jones, University of Birmingham, UK
Stephen McDowall, University of Edinburgh, UK
Amanda Phillips, University of Virginia, USA
John Potvin, Concordia University, Canada
Olaya Sanfuentes, Pontificia Universidad Católica de Chile, Chile
Stacey Sloboda, University of Massachusetts Boston, USA
Kristel Smentek, Massachusetts Institute of Technology, USA
Robert Wellington, Australian National University, Australia

Volumes in the Series

British Women and Cultural Practices of Empire, 1775–1930
Edited by Rosie Dias and Kate Smith

Jewellery in the Age of Modernism, 1918–1940: Adornment and Beyond
Simon Bliss

Childhood by Design: Toys and the Material Culture of Childhood, 1700–Present
Edited by Megan Brandow-Faller

Material Literacy in Eighteenth-Century Britain: A Nation of Makers
Edited by Serena Dyer and Chloe Wigston Smith

Sculpture and the Decorative in Britain and Europe, Seventeenth Century to Contemporary
Edited by Imogen Hart and Claire Jones

Georges Rouault and Material Imagining
Jennifer Johnson

The Versailles Effect: Objects, Lives and Afterlives of the Domain
Edited by Mark Ledbury and Robert Wellington

Domestic Space in Britain, 1750–1840: Materiality, Sociability and Emotion
Freya Gowrley

Domestic Space in France and Belgium: Art, Literature and Design, 1850–1920
Edited by Claire Moran

Enlightened Animals in Eighteenth-Century Art: Sensation, Matter, and Knowledge
Sarah R. Cohen

Lead in Modern and Contemporary Art
Edited by Sharon Hecker and Silvia Bottinelli

Material Cultures of the Global Eighteenth Century
Edited by Wendy Bellion and Kristel Smentek

Transformative Jars
Edited by Anna Grasskamp and Anne Gerritsen

The Material Landscapes of Scotland's Jewellery Craft, 1780-1914
Sarah Laurenson

Intimate Interiors: Sex, Politics, and Material Culture in the Eighteenth-Century Bedroom and Boudoir
Edited by Tara Zanardi and Christopher M. S. Johns

Ceramics in the Victorian Era: Meanings and Metaphors in Painting and Literature
Rachel Gotlieb

The Art of Mary Linwood: Embroidery and Cultural Agency in Late Georgian Britain
Heidi A. Strobel

The Gallery at Cleveland House: Displaying Art and Society in Late Georgian London
Anne Nellis Richter

Material Selves: Object Biographies and Identities in Motion
Edited by Alex Burchmore

Domestic Space in Britain, 1750–1840

Materiality, Sociability and Emotion

Freya Gowrley

BLOOMSBURY VISUAL ARTS
LONDON • NEW YORK • OXFORD • NEW DELHI • SYDNEY

BLOOMSBURY VISUAL ARTS
Bloomsbury Publishing Plc
50 Bedford Square, London, WC1B 3DP, UK
1385 Broadway, New York, NY 10018, USA
29 Earlsfort Terrace, Dublin 2, Ireland

BLOOMSBURY, BLOOMSBURY VISUAL ARTS and the Diana logo are trademarks of Bloomsbury Publishing Plc

First published in Great Britain 2022
Paperback edition published in 2024

Copyright © Freya Gowrley, 2022

Freya Gowrley has asserted her right under the Copyright, Designs and Patents Act, 1988, to be identified as Author of this work.

For legal purposes the Acknowledgements on p. xiii constitute an extension of this copyright page.

Cover image: Plas Newydd C1850 (© Chronicle/Alamy Stock Photo)

All rights reserved. No part of this publication may be reproduced or transmitted in any form or by any means, electronic or mechanical, including photocopying, recording, or any information storage or retrieval system, without prior permission in writing from the publishers.

Bloomsbury Publishing Plc does not have any control over, or responsibility for, any third-party websites referred to or in this book. All internet addresses given in this book were correct at the time of going to press. The author and publisher regret any inconvenience caused if addresses have changed or sites have ceased to exist, but can accept no responsibility for any such changes.

A catalogue record for this book is available from the British Library.

Library of Congress Cataloging-in-Publication Data
Names: Gowrley, Freya, author.
Title: Domestic space in Britain, 1750–1840 : Materiality, Sociability and Emotion / Freya Gowrley.
Description: [New York] : Bloomsbury Academic, [2022] | Includes bibliographical references and index. | Summary: "Between 1750 and 1840, the home took on unprecedented social and emotional significance. Focusing on the design, decoration, and reception of a range of elite and middling class homes from this period, Domestic Space in Britain, 1750–1840 demonstrates that the material culture of domestic life was central to how this function of the home was experienced, expressed, and understood at this time. Examining craft production and collection, gift exchange and written description, inheritance and loss, it carefully unpacks the material processes that made the home a focus for contemporaries' social and emotional lives. The first book on its subject, Domestic Space in Britain, 1750–1840 employs methodologies from both art history and material culture studies to examine previously unpublished interiors, spaces, texts, images, and objects. Utilising extensive archival research; visual, material, and textual analysis; and histories of emotion, sociability, and materiality, it sheds light on the decoration and reception of a broad array of domestic spaces. In so doing, it writes a new history of late eighteenth- and early nineteenth-century domestic space, establishing the materiality of the home as a crucial site for identity formation, social interaction, and emotional expression"— Provided by publisher.
Identifiers: LCCN 2021037174 (print) | LCCN 2021037175 (ebook) | ISBN 978-1-5013-4336-0 (hardback) | ISBN 978-1-5013-4335-3 (epub) | ISBN 978-1-5013-4334-6 (pdf) | ISBN 978-1-5013-4333-9
Subjects: LCSH: Interior decoration—Great Britain—History—18th century. | Interior decoration—Great Britain—History—19th century. | Domestic space—Great Britain—History—18th century. | Domestic space—Great Britain—History—19th century. | Material culture—Great Britain—History—18th century. | Material culture—Great Britain—History—19th century. | Great Britain—Social life and customs—18th century. | Great Britain—Social life and customs—19th century.
Classification: LCC NK2043 .G69 2022 (print) | LCC NK2043 (ebook) | DDC 747.0941/09033—dc23
LC record available at https://lccn.loc.gov/2021037174
LC ebook record available at https://lccn.loc.gov/2021037175

ISBN:	HB:	978-1-5013-4336-0
	PB:	9781350437364
	ePDF:	978-1-5013-4334-6
	eBook:	978-1-5013-4335-3

Series: Material Culture of Art and Design

Typeset by RefineCatch Limited, Bungay, Suffolk
Printed and bound in Great Britain

To find out more about our authors and books visit www.bloomsbury.com and sign up for our newsletters.

For my family

Contents

List of Plates	x
List of Figures	xi
Acknowledgements	xiii
Introduction: Home Ties	1

Part One Representation

1. 'My anecdotes of this social neighbourhood': The Thick Description of Caroline Lybbe Powys — 27
2. Publishing John Wilkes's 'Villakin': Reception and Reputation at Sandham Cottage — 63

Part Two Movement

3. Material Translations, Biographical Objects: Craft(ing) Narratives at A la Ronde — 101
4. 'A little temple, consecrate to Friendship and the Muses': Romantic Friendship and Gift-exchange at Plas Newydd, Llangollen — 139

Part Three Ownership

5. 'I love her as my own child': Inheritance, Extra-Illustration and Queer Familial Intimacies at Strawberry Hill — 177

Conclusion: Materializing Loss — 223

Bibliography — 235
Index — 257

Plates

1. Cottage pastille burner, Staffordshire, mid-nineteenth century.
2. *Mr Wilkes's Villakin, in Sandown Bay, Gentleman's Magazine*, January 1804, 95:17. Engraving.
3. Jane and Mary Parminter, specimen table, Exmouth, Devon, 1790s. Glass, mineral, shell, paint, paper and wood. National Trust Collections, A la Ronde, Exmouth, Devon.
4.1 Shellwork picture, Isola Bella, Italy, *c.* 1780–90. Paper, shell, and wood. National Trust Collections, A la Ronde, Exmouth, Devon.
4.2 Shellwork picture, Isola Bella, Italy, *c.* 1780–90. Paper, shell, and wood. National Trust Collections, A la Ronde, Exmouth, Devon.
5. Stained glass windows, Plas Newydd, Llangollen, *c.* 1795.
6. Anne Damer, extra-illustrated 1784 edition of *A Description of the villa of Mr. Horace Walpole* (*c.* 1784–1803). Quarto 33 30 Copy 25. The Lewis Walpole Library, Yale University.
7. Anne Damer, extra-illustrated 1784 edition of *A Description of the villa of Mr. Horace Walpole* (*c.* 1784–1803). Quarto 33 30 Copy 25. The Lewis Walpole Library, Yale University.
8. Fremington Pottery, ceramic harvest jug, North Devon, 1828–9. Slip coated earthenware. National Trust Collections, A la Ronde, Exmouth, Devon.

Figures

0.1	Cottage pastille burner, Staffordshire, mid-nineteenth century.	2
2.1	'Wilkes's Cottage', *The Mirror of Literature, Amusement, and Instruction*, 13 October 1832. Wood engraving. Royal Collection Trust.	65
2.2	Harriet Wilkes, *A North-East View from Sandham Cottage, Isle of Wight*. Date Unknown. Etching. National Gallery of Art, Washington.	73
2.3	Carved beechwood armchair, *c.* 1780–1800. Victoria and Albert Museum, London.	80
2.4	Derby Porcelain Factory, figurine of John Wilkes, *c.* 1775. Soft-paste porcelain, painted in enamels and gilded. Victoria and Albert Museum, London.	85
2.5	William Hogarth, *John Wilkes Esq*. Published by Longman, Hurst, Rees and Orme, 1 July 1807. Engraving. The Lewis Walpole Library, Yale University.	88
2.6	Johan Zoffany, *Mary and John Wilkes*. Exh.1782. Oil on canvas. National Portrait Gallery, London.	89
3.1	Jane and Mary Parminter, specimen table, Exmouth, Devon, 1790s. Glass, mineral, shell, paint, paper and wood. National Trust Collections, A la Ronde, Exmouth, Devon.	102
3.2	A la Ronde, Exmouth, Devon. *c.* 1796.	103
3.3	Gold bezel mounted with a micromosaic urn, Rome, 1790s. The Rosalinde and Arthur Gilbert Collection. Victoria and Albert Museum, London.	111
3.4	Giovanni Battista Piranesi, *Veduta dell' Arco di Costantino*, from *Vedute di Roma*, *c.* 1750–1778. Tomo II, tav. 25.	112
3.5	Detail, breakfront bookcase, 1795–1800. Glass, brass, and mahogany. National Trust Collections, A la Ronde, Exmouth, Devon.	116
3.6	Jane and Mary Parminter, shell gallery (detail), *c.* 1796–1811. Shells, feathers, lichen, mica, spar, animal bones, mirrored glass, paint, cut paper and pottery. A la Ronde, Exmouth, Devon.	117

xii *Figures*

3.7	Jane and Mary Parminter, drawing room fireplace, A la Ronde Exmouth, Devon, *c.* 1796. Feathers, shells, paper, paint and wood.	121
4.1	W.L. Walton, after E.W. Jacques, *Plas Newydd*, Chester: T. Catherall, 1847. National Library of Wales.	140
4.2	Sarah Ponsonby, frontispiece for Anna Seward, *Llangollen Vale, with Other Poems*, published by G. Sael, London, 1796.	146
4.3	Mary Leighton (née Parker). Watercolour on paper. DD/LL, 7. Letters from Sarah Ponsonby to Mrs Parker, Sweeney Hall, Oswestry, 1 vol. Denbighshire Record Office and Archive, Ruthin.	149
4.4	Stained glass windows, Plas Newydd, Llangollen, *c.* 1795.	150
4.5	John Raphael Smith, after George Romney, *Serena*, London, 1782. Mezzotint on paper. Victoria & Albert Museum, London.	155
5.1	*The Damerian Apollo*, 1789. Published by William Holland, London. Etching on laid paper, hand-coloured. The Lewis Walpole Library, Yale University.	192
5.2	Anne Damer, extra-illustrated 1784 edition of *A Description of the villa of Mr. Horace Walpole* (*c.* 1784–1803). Quarto 33 30 Copy 25. The Lewis Walpole Library, Yale University.	193
5.3	Anne Damer, extra-illustrated 1784 edition of *A Description of the villa of Mr. Horace Walpole* (*c.* 1784–1803). Quarto 33 30 Copy 25. The Lewis Walpole Library, Yale University.	195
5.4	Anne Damer, extra-illustrated 1784 edition of *A Description of the villa of Mr. Horace Walpole* (*c.* 1784–1803). Quarto 33 30 Copy 25. The Lewis Walpole Library, Yale University.	197
5.5	Anne Damer, extra-illustrated 1784 edition of *A Description of the villa of Mr. Horace Walpole* (*c.* 1784–1803). Quarto 33 30 Copy 25. The Lewis Walpole Library, Yale University.	199
5.6	Anne Damer, extra-illustrated 1784 edition of *A Description of the villa of Mr. Horace Walpole* (*c.* 1784–1803). Quarto 33 30 Copy 25. The Lewis Walpole Library, Yale University.	207
5.7	Anne Damer, extra-illustrated 1784 edition of *A Description of the villa of Mr. Horace Walpole* (*c.*1784–1803). Quarto 33 30 Copy 25. The Lewis Walpole Library, Yale University.	208
5.8	Anne Damer, extra-illustrated 1784 edition of *A Description of the villa of Mr. Horace Walpole* (*c.* 1784–1803). Quarto 33 30 Copy 25. The Lewis Walpole Library, Yale University.	215

Acknowledgements

Echoing the stories of those upon whom this book focuses, its writing has been as much a social and emotional process as an intellectual one. The book took shape as a PhD thesis completed at the University of Edinburgh, and it developed there under the careful stewardship of Viccy Coltman. Viccy's unwavering support and constant belief in this project have been matched only by her perceptive critiques, which have served to improve it in immeasurable ways. As with everything I ever write, I hope this book lives up to her high expectations.

This book has been shaped through productive conversation with many scholars, including Chris Breward, Adam Budd, Luisa Calè, Carolyn Day, Elizabeth Eger, Laura Engel, Cath Feely, Sally Holloway, Julie Park, Zoë Thomas, Stephen Watkins, Emily West, Michael Yonan and Eugenia Zuroski, who have variously provided mentorship, encouragement and friendship throughout the difficult early career period. Viccy, Joanne Begiato, Anthony Delaney, Caroline Gonda, Karen Lipsedge, Lucie Matthews-Jones, Kathy Lubey, Matthew Reeve and Kate Smith all read and commented upon drafts of its constituent chapters, for which I am immensely grateful.

I am lucky to have completed this book at the University of Derby while in the role of Post-Doctoral Fellow in History, where I benefitted enormously from being part of its community of talented eighteenth centuryists, including Paul Elliott, Joe Harley, Erin Lafford and Paul Whickman. Ruth Larsen, in particular, has generously supported my development as a scholar, a colleague and a teacher, and has listened to me fret about this book on more than one occasion. Perhaps my biggest academic debt, however, is to the members of our online writing group, and particularly to Serena Dyer, Elisabeth Gernerd, Caroline McCaffrey-Howarth, Madeleine Pelling and Rebecca Senior. Without the empathetic and emphatic support of this inspiring group of brilliant art historians and material culture specialists, this book would have undoubtedly been much harder to write.

I am also grateful to the University of Edinburgh for funding the doctoral research upon which this book is based, and to its Institute of Advanced Studies in the Humanities, where I spent a blissful ten months revising this text. I am also indebted to the Paul Mellon Centre for Studies in British Art, the Birmingham

Eighteenth-Century Centre, the British Society for Eighteenth-Century Studies and the Design History Society, who all generously funded archival research. Particular thanks are due to Sue Walker, Cindy Roman, and Kristen McDonald at the Lewis Walpole Library, whose fellowship scheme provided both a grant and the necessary intellectual space to flesh out the book project during the teaching-heavy year that followed the completion of my PhD. I must also thank archival staff, librarians and other personnel at the various institutions at which I conducted my research, including the National Library of Scotland, the National Library of Wales, the British Library, Denbighshire Record Office, Shropshire Records and Archive Centre, Cheshire Archives, the Library of Birmingham, the John Rylands Library, the University of Edinburgh Special Collections and the Cadbury Research Library.

I wish to thank my family for the support and love they have shown me throughout my academic career. If it were not for their steadfast belief in my potential, I would have undoubtedly ended up outside of academia. Particular thanks must go to my father, who has read the chapters of this book almost as many times as I have. This book is dedicated to him. Finally, my ultimate thanks go to Kevin, with whom I have talked about some of these houses for a very long time.

Introduction: Home Ties

In the first half of the nineteenth century, several potteries (including Staffordshire and Coalport) began to produce an array of miniature ceramic houses (fig. 1, pl. 1). Attractively painted in pastel tones, examples ranged in scale from about the size of a large teapot to those that could fit comfortably in the palm of one's hand. Popular throughout the nineteenth century, a plethora of these ceramic representations of domestic spaces can be found in museum collections and for sale in antique shops and in online auctions, often for a low sum commensurate with their current level of popularity. Although characterized by visual variety – with variously shaped doors, windows, roofs, turrets and all manner of coloured ornamentation – they are united in their display of prototypical domesticity. Not simply miniaturized houses, these are tiny homes. According with the idealization of the cottage that characterized this period, their ceramic forms conjure associated ideas of fashionable retreat, the pleasant rusticity of the *cottage orné* and comfortable homeliness, recognizable to us still today.[1] These objects had both aesthetic and practical functions. While some are purely decorative, others took the form of pastille burners, and were designed to hold incense composed of aromatic gums, powders and essential oils, which would waft gently through the house.[2] As displayed in late Georgian and early Victorian residences, their presence introduced aspirational narratives of bucolic, sentimental and agreeable domesticity into an individual's home, while they simultaneously perfumed the air, transforming a house's sensory experience by creating enjoyable and comfortable atmospheres. The cottages are accordingly domestic wares that themselves perpetuated and reinforced standard notions of contemporary homeliness through a sensorily evocative, and repetitively iconic, reproduction of the same. Like a child's drawing of a house, with two lines representing four walls, crowned with a pitched roof, these objects were symbolic of the very idea of the home, emerging at a time when it had taken on a new significance.

Made and sold during the period that John Tosh has designated as the beginning of the 'climax of domesticity', it is unsurprising that such idealized

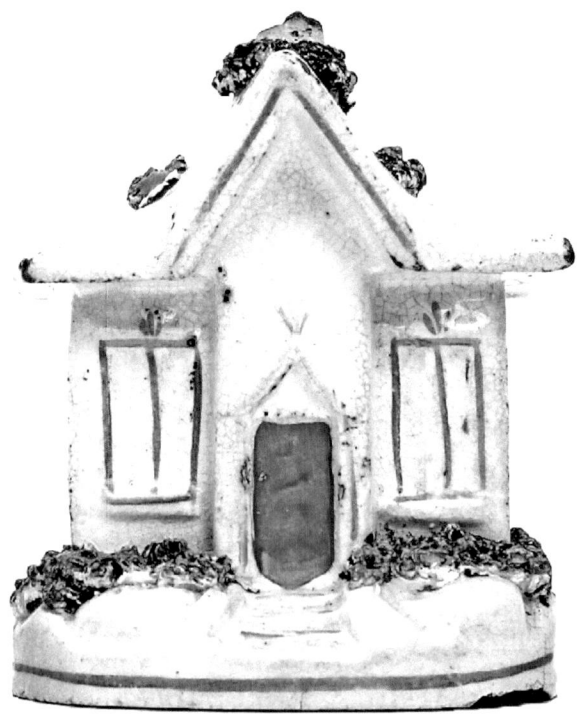

Figure 0.1 Cottage pastille burner, Staffordshire, mid-nineteenth century. Photograph: author.

presentations of quaint homeliness reached the height of their popularity in the 1830s and 1840s.[3] The century prior was characterized by huge shifts in buying habits, approaches to emotional expression and the rituals of polite sociability and leisure, all of which resulted in a radical transformation of both the physical fabric and ideological construction of the home. This was the time of the 'consumer', 'industrial' and 'print' revolutions, the rise of sentimentalism, the development of visiting culture and the emergence of the nascent British empire, all of which had profound influence on the construction of the home during this period, both literal and metaphorical.[4] At the same time, studies of eighteenth-century Britain have long shown this to have been a time of intense change in consumer behaviour, with more forms of material, textual and visual culture available to purchase by an ever-wider range of purchasers, at a new proliferation of shopping destinations.[5] Between these emerging commercial environments, and the shifts in emotional styles wrought by sentimentalism, love and loss came to have increasingly recognizable and material languages thanks to the commercialization of affection that occurred as the century progressed.[6]

This was also a period that saw widespread interest in, and engagement with, both real homes and their representations. Prints of famous country houses sold exceptionally well, and homes and their evocative decorative schemes provided scenic texture for novels and plays, and formed the backgrounds for the semi-public intimacy on display in the conversation piece.[7] Although the traditional narrative of the separation of the spheres has firmly related the private with the domestic, the rituals that characterized elite sociability, such as visiting and domestic tourism, ensured that the eighteenth- and early nineteenth-century home developed a particularly complex relationship with privacy.[8] Visited by constant rounds of friends, acquaintances and tourists, the home was rendered permeable and its tasteful presentation was judged accordingly. These shifting cultural and social contexts therefore ensured that between 1750 and 1840, the home took on a new social and emotional significance, one that was firmly rooted in the material culture of domestic space.

Domestic Space in Britain, 1750–1840: Materiality, Sociability and Emotion is concerned with tracing the development of this idea of the home throughout the second half of the eighteenth and first half of nineteenth century. It argues that through the representation and circulation of visual and material objects associated with the home during this period, a concept of domestic materiality arose that related it to, and imbued it with, the affects of human attachment, through which notions of the home as a social and emotional space powerfully materialized. In so doing, the book seeks to provide a material prehistory to Tosh's argument that:

> when the Victorians sang 'Home Sweet Home', when they sagely repeated 'Home is where the heart is', and when they warmly commended the home life of their own dear Queen, it is clear that they were expressing more than their appreciation of food, shelter and rest; they were giving voice to their deep commitment to the *idea* of home.[9]

Although the word 'home' did not have the same significance for individuals in the eighteenth and early nineteenth centuries as it does now, this book uses material culture to explore how, by the mid nineteenth century, 'the house' had undergone a sentimental transformation through which the idea of the modern home – that is, the emotionally and socially inflected space that we know today – began to emerge.[10] Examining the cultural processes by which these changing frameworks for the home and its materialities were understood, it argues that this is a key period for identifying its development by unpicking the ways in which the visual and material cultures of the home became important sites for

identity formation, social interaction and emotional expression. Focusing on the design, decoration and reception of a range of elite homes from this period, it demonstrates that the material culture of domestic life was central to how the home was experienced, expressed and perceived at this time.

Yet by no means does the book uphold the singular domestic ideal suggested by the ceramic cottages discussed at the opening of this introduction. By exploring the development of the home and its material cultures as coactive emotional landscapes, and shining a light on comparatively overlooked spaces, narratives and historical actors in the process, the book also refutes the overwhelming and enduring heteronormativity of the idea of the home. As such, it seeks to destabilize and rethink notions of the eighteenth- and early nineteenth-century home as much as it explores them.

Examining craft production and collection, gift exchange and written description, acquisition and loss, the book's chapters elucidate the material processes that made the home a focus for contemporaries' social and emotional lives. In so doing, it establishes a framework for understanding the connections between individual domestic material objects and those who interacted with them, conceiving of 'broad processes as the products of dynamic practices to which ordinary people contributed'.[11] The book explores these issues through five detailed case studies, each of which pays close attention to its subject, whether focused on a specific house, the actions of a small group of individuals or a singular and unique object. It therefore relates broad cultural processes to close attention to historical actors, or, to adapt Clifford Geertz's words, it links the 'local truths' of individual experience to the 'general visions' of eighteenth- and early nineteenth-century cultural history.[12]

By charting this narrative, the book builds on a wealth of studies examining the home and its history. Within art history much of this research has been preoccupied with the country house and London town house as artistic, architectural and social spaces.[13] This body of research developed in response to the tandem issues of architectural survival and loss that have unarguably characterized how eighteenth-century domestic space has been studied and understood since the nineteenth century onwards; with the spaces that have survived intact, more often than not those that have been discussed. These accounts have often presented country houses in particular as sites of greatness; structures where the histories of famous architects, artists, designers and craftsmen, alongside 'great' noble families, compellingly intersected; ultimately resulting in a relatively narrow canon of important domestic residences from this period.[14]

More recently, work by scholars such as Amanda Vickery, Jane Hamlett and others has firmly cemented a wider array of eighteenth- and nineteenth-century homes as spaces worthy of sustained enquiry.[15] Vickery's *Behind Closed Doors: At Home in Georgian England*, for example, provides a comprehensive overview of many of the key issues at stake in the home during this period, including gender, craft production, consumption and taste, which the author reads against a broad spectrum of eighteenth-century domestic residences. Likewise, Hamlett's *Material Relations: Domestic Interiors and Middle-Class Families in England, 1850–1910*, gives an account of the material culture of the home as intimately tied to the emotions of its inhabitants; variously discussing love, marriage, sex, childhood and death in relation to the domestic space of the later nineteenth century, thereby establishing the Victorian home as a locus for a complex network of familial intimacies. This book follows but hopes to expand upon these texts, going beyond the broader overviews provided by *Behind Closed Doors* and *Material Relations* to offer detailed analysis of specific homes and their associated visual and material culture, while maintaining their broad commitment to thinking about what the home 'meant' around this time.

Despite this historiographical richness, there is currently no study that specifically examines the complex relationship between sociability, emotion and domestic material culture in the eighteenth and early nineteenth centuries. While it seems self-evident to us that the home is a space of intimacy, identity expression and feeling, the present study unpacks exactly how, through material culture and its representations, the home became enmeshed with the social and emotional lives of its inhabitants, visitors and viewers. It follows a body of scholarship emerging from the history of the emotions that charts how objects have embodied social relations throughout history, and which has sought to demonstrate their fundamental role in 'eliciting and concretizing' emotion.[16] This work has focused on two key categories of material object that materialize familial sentiment, affection between friends, romantic love and everything in between. The first is the commercially produced emotional object, created as a direct material response to the discourses of sentimentality that were so prevalent as both philosophical models for feeling and within literary texts this time. This is exemplified by what Sally Holloway has described as the development of a 'marketplace of love', which saw couples purchase trinkets such as heart-shaped inkwells, decorative boxes, perfume bottles and other kinds of 'toys' as markers and expressions of romantic affection.[17] Deidre Lynch has directly connected the eighteenth century's increasingly commercialized consumer society with sentimentalism as a philosophical and literary movement, identifying this as a

period typified by 'sentimental animism' in which 'personal effects became key to the organization of an individual's affection'.[18] According to Lynch, that the late eighteenth century can be read as a culture of sentimentalizing objects is made clear by the fact that the term 'keepsake' dates to 1790, as well as the emergence of the 'it-narrative' as a discrete genre of literature around this time. Notably, it-narratives focus not only on self-conscious objects, but more explicitly on things that feel, think, sentimentalize and ultimately empathize through narratives of material interconnectedness.[19] As such, their emergence at this particular moment constitutes a historically specific reflection on the relationship between material culture and emotion, highlighting the capacity of inanimate objects to provoke feelings of pleasure, comfort and pain for contemporaries.

Beyond commercially made sentimental objects, the emotional potential of material culture is evident through the significance of the 'superadded' object at this time. A superadded object is one that has come to be imbued with emotive associations and functions at some point during its biography, becoming sentimental through the cultural processes through which it was engaged at different stages of its life cycle.[20] In this model, keepsakes, souvenirs, heirlooms, knick-knacks, trifles and small objects of all kinds could assume emotional significance beyond the object's initial intended function. Of this body of material wares, the 'token' in its various formulations has emerged as a particularly lucrative field of enquiry. From portrait and eye portrait miniatures, to locks of hair, small metal objects and pieces of textile, tokens were easily exchanged, handled and carried around. Accordingly, the token could be a potent signifier of familial and romantic affection, whose material and semantic qualities were equally redolent to their possessors as they are to historians today. For example, John Styles' work on the Foundling Museum's collection of textile tokens left with abandoned babies at the London Foundling Hospital from 1741 onwards has highlighted the potential of objects to recall broken familial histories, while both Marcia Pointon and Hanneke Grootenboer have stressed the physical properties of small visual objects, revealing the tactility, portability and wearability of the miniature portraiture, and thereby, its propensity to evoke the affections of its viewer/owner.[21] Thanks to longstanding aesthetic and gendered hierarchies that have privileged forms of high art over the 'knick-knack', the 'trifle' and the 'bauble' – whose very nomenclature suggests not only their diminutive size but also their unserious repute – such objects had previously been neglected by the majority of art historians, only to be championed by scholars of historical material culture as able to powerfully reveal the identities and social relations of those who interacted with them.[22]

The emotional functions of the visual and material culture of the home are a central concern of this book, which explores their role in creating and representing social and familial ties of all kinds throughout its chapters. In each of these accounts, the materiality of the home emerges as a key means by which contemporaries expressed and conveyed emotion, engaged in sociable interaction and through which they processed their most keenly felt losses. While examining a number of examples of commercially produced material wares commissioned to express sentiment and affection, the book is primarily concerned with how paying attention to superadded objects allows us to unpack the emotional connections between people and things at this time. Using examples of books, printed images, painted portraits, shells, micromosaics, botanical illustrations, stained glass, carved wood, plants and even food and drink, it asks how the various cultural and material processes that objects were subjected to by their viewers, owners and makers, saw them transformed into deeply emotional objects, that in turn worked to construct the sentimental space of the home itself.

As a field, eighteenth-century studies is notably preoccupied with things. Research by Serena Dyer, Madeleine Pelling, Viccy Coltman, Maureen Daly Goggin, Beth Fowkes Tobin, Stacey Sloboda and Susan M. Stabile, to name just a few, has reaped the rewards borne from paying deep attention to objects.[23] In these studies, material wares emerge as compelling bundles of meaning, identity and sentiment, and are revealed as reflecting and constructing some of the period's foundational ideologies. *Domestic Space in Britain* borrows its approaches from these works, alongside extensive scholarship from the field of eighteenth-century literature, which itself has become increasingly concerned with how the small things of eighteenth-century life populated its literary cultures, firmly demonstrating that the material cannot be properly understood without reference to the textual, and vice versa.[24] These texts offer a method for reading eighteenth-century visual and material culture in which space, images, objects and literary representation work collectively as a means by which to better comprehend the many meanings of the home at this time.

This scholarly recognition of the significance of the material culture of everyday life is one that was shared by those living in the eighteenth and early nineteenth centuries, who, as Cynthia Wall suggests, were increasingly aware of the presence of 'things on the market, in the house, in daily life'.[25] Read against the rise of descriptive lists of domestic objects, and their constant appearances within auction catalogues, travel writing and journals, the period's new emphasis on material wares reflects how individual things came to be treated seriously

through their being described, made note of, discussed and recorded. While many of the domestic artefacts described in these texts do not form the body of objects examined by canonical art history today, their ekphrastic transformation into text nevertheless demarks the significance of this material culture at the time of writing.

Although description most clearly forms the thematic emphasis of its first two chapters, objects described in texts are at the forefront of the conceptual and practical apparatus of the book as a whole. Understanding that the cultural work performed by objects in the space of the home is as much about physical stuff as its ideological construction, this book traces how this domestic material culture appeared in text and image, following Kate Smith in viewing material culture and its representations as 'intrinsically intertwined entities'.[26] The present study is accordingly deeply concerned with the symbiotic relationship between domestic material culture and its representations. Seeking subjective experience as 'embodied in the surviving cultural record', it deploys a broad array of source materials including visual images, letters, diaries, travel literature, newspaper reports, poetry and novels to access how contemporaries conceived of the material objects that they produced and consumed.[27] This approach is central to each of the book's chapters, which all deal to a greater or lesser extent with how such spaces and their complex materialities were presented by those who owned, visited and viewed them in written texts. However, it is careful to discuss literary representations of objects as more than passive, historical documentation, instead viewing them in relation to the active processes of description, narrativization, publication and the literary communication of affection, all of which characterized the textual employment and deployment of visual images and material objects associated with the home.

The relationship between text and object as unpicked within the book's chapters therefore represents a clear manifestation of the slippage between the consumption and production of domestic space and its associated material culture. This interconnectivity reinforces the fact that material culture exists on several levels of temporal experience: the immediate, in which objects were handled, used and seen; a secondary level, in which contemporaries experienced material culture through visual and literary renderings of objects and spaces; and a third, in which representational materials such as images and texts can be used by historians to understand objects' multifarious meanings in the present.

The complex boundary between text and object does not therefore merely reflect the collapsibility between material objects and the forms of mediation that characterized eighteenth- and early nineteenth-century art and literature,

but is also representative of some of the practical and methodological concerns at stake in this study; namely the question of how we as art and cultural historians might access the material culture of the past. Using evidence uncovered in epistolary correspondence, or found nestled in diaries, notebooks and other forms of diurnal writing, methodologically this material provokes a number of issues, most notably the gap between the performatively written self and the lived experience of historical actors, as well as the distinctive methodologies that must be employed when dealing with visual and material objects on the one hand, and literary ones on the other.

Most crucially for the purposes of this book, this anecdotal, often highly narrative, textual material depends heavily on the description of objects which may or may not continue to exist, a paradigm of absence and presence that will be further explored in the book's final chapter. Within the present study, objects might be lone survivors to be read in relation to an absent material record, or when lost themselves, the textual record might teem with references to their prior existence. This binary once again highlights the complex temporalities of material culture, evoking its potential to recall memories, experiences and the passage of time, something as palpable to its contemporaries as to historians seeking to understand it today.

In eighteenth- and early nineteenth-century texts concerned with objects we can see an alignment between the aims of art historian and the authorial subject: a shared commitment to the close reading of, and engagement with, material culture. As Jocelyn Anderson argues, such an approach is fundamentally an art historical one.[28] Rooted in the practices of close engagement with visual and material culture, this kind of careful looking and thinking about images and objects has been identified by scholars such as Coltman, Michael Yonan and Sam Rose as fundamental tools within the art historian's methodological toolkit.[29] As Wall writes of the eighteenth-century object-narrator, 'rather than some simple absorption of status quo or reification of imposed ideologies', 'descriptions of other people's spaces, other people's things, constituted analysis and self-construction'.[30] Read in this way, lists of things are not merely descriptive, but deeply interpretative; demonstrating a visual, material and cultural literacy on the part of those who interacted with eighteenth-century material culture, and crucially, one that existed beyond the dispassionate judgement of the aristocratic art collector or connoisseur. The engagements with objects examined in this book move past this figure to focus on a more diverse, yet no less sophisticated, array of material relationships that occurred in eighteenth- and early nineteenth-century domestic space. Within this context, an individual's writing about an

object can be read as highly revealing, with the choice to describe, that is, to tell material histories, as meaningful as their encounter with the original thing itself.

Wall's evocation of Bill Brown's 'thing theory' is useful here. Though Brown argues that an object's 'thingness' is at its highest when it is suddenly broken or otherwise removed from 'their flow within the circuits of production and distribution, consumption and exhibition', Wall suggests that eighteenth-century things are those encountered 'in catalogs, inventories, letters, guidebooks', 'acquired by shopping, collecting, bidding', 'arranged and rearranged in private spaces, both in the world and in texts'.[31] For Wall, the eighteenth-century thing is as much noticed when it appears, starts working, or when it starts 'filling and then differentiating houses' as when it breaks. As she writes, 'the market for and arrangement of things in the world created the space for the description of things in texts, interiors produced interiors, surfaces produced meanings'.[32]

While highlighting the importance of small things decidedly not forgotten, the appearance of objects within texts of all kinds also demonstrates one of the modes in which domestic materiality was made to matter during this period: its ekphrastic transformation into text.[33] By being singled out and written about, individual objects were located within the epistolary structures and socio-textual networks of connection that characterized eighteenth- and early nineteenth-century social life. Selected, noticed, discussed, they were objects subjected to all kinds of transformative encounters, whether recorded and described in manuscripts, published in texts, translated into the space of the collection, given as a gift, inherited from a family member or friend or lost forever. These transactions were the material engagements through which eighteenth- and early nineteenth-century objects could be rendered prescient; those that were instrumental in turning objects into noticed things, and from houses into homes. It is upon these five 'material processes' – description, publication, translation, exchange, inheritance and loss – that this book focuses, and it pays deep attention to how they each shaped particular objects and domestic spaces, as well as the lived experience of individual historical actors. In so doing, the book relates the specificity of its examples to the broader historiographical and contemporary cultural processes that characterized people's deeply meaningful interactions with the home and its associated material culture during this period.

The close reading of individual lives, acts and objects is one of the foundational methodological approaches of microhistory, which seeks to 'ask large questions in small places'.[34] Microhistory offers an array of specific methods by which to read particular details against grander narratives and, as such, the book exploits its strength in actively articulating and problematizing the tension between the

grand narrative and individual experience that characterizes all forms of historical inquiry.[35] The framework provided by microhistory's concept of the 'exceptional typical' is particularly useful for conceptualizing these distinct contexts. As Jill Lepore has argued in her discussion of the relationship between biographical writing and microhistory, the latter is deeply concerned with the representativeness of its subjects:

> if biography is largely founded on a belief in the singularity and significance of an individual's life and his contribution to history, microhistory is founded upon almost the opposite assumption: however singular a person's life may be, the value of examining it lies not in its uniqueness, but in its exemplariness, in how that individual's life serves as an allegory for broader issues affecting the culture as a whole.[36]

This dynamic between exceptionalism and typicality is accordingly a valuable tool for negotiating some of the methodological issues at the heart of this book; namely, how to make broad assumptions from tightly focused case studies centring on highly individualistic lives. Allowing for a flexible relationship not only between the 'normal' and the atypical, but also, between the specific actions and behaviours of its subjects, and their wider relation to the systems which characterized the production, organization and dissemination of eighteenth- and early nineteenth-century culture, this approach usefully addresses 'the vexed question of how to integrate micro-level data into macro-level explanations'.[37]

By adopting a microhistorical approach to lives and spaces often previously overlooked, the book follows what Elizabeth Freeman has called a 'commitment to overcloseness', a deliberate, ideological undertaking of close reading through which the alternative or 'lost moments of official history' emerge.[38] Not simply completing a close reading for close reading's sake, the book provides detailed narratives of people's affective engagements with the materiality of the eighteenth- and early nineteenth-century home that function as repositories for histories that stretch beyond the (hetero)normative and the canonical. While ultimately focusing on elite houses, the book nevertheless seeks to go beyond the conventional foci of the history of the home during this period, examining provincial homes, under-discussed examples of country houses, and the lives of those overlooked by traditional histories of the family. The kinds of domestic material culture that the book discusses also represent a break with art historical tradition. Addressing the enduring lacuna that exists between art history and material culture studies head on, the book explores the 'in-between objectscape'

between the two, examining everything from high art objects such as sculpture and paintings, alongside examples of extra-illustrated texts, women's craft production and found objects such as discarded fragments from local buildings, and spoils collected from beach shores.[39] Beyond established accounts of grand country estates and impeccably finished town-house interiors, the materiality privileged in this book reflects the snatched manifestations of a wide variety of things in the rhythms of daily life, in which objects and spaces were, in the first instance, momentarily encountered, noticed, moved, purchased, donated, received, and lost, and in the second, published, drawn and otherwise mediated.

Somewhere between fleeting historical experiences, surviving material and visual objects, and the everyday literary forms in which they were recorded by contemporaries, emerges a productive space in which the textures of domestic materiality and its many meanings can be fully investigated, wherein what Freeman calls the 'lost power that dwell[s] within silly details' can compellingly emerge.[40] A commitment to the overcloseness engendered by a microhistorical approach thereby creates a more encompassing history of eighteenth- and early nineteenth-century domestic space, revealing the overlooked narratives and lost histories uncovered when attention is paid to places and objects that lie outside of traditional areas of art or architectural historical enquiry.

By approaching its material in this manner, the book makes room to explore the potential 'queernesses' of the home at this time, a topic that has often been overlooked within the extant literature on the eighteenth-century home.[41] While this book by no means provides an exhaustive account of the role of visual and material culture in the emotional and social lives of the queer home during the second half of the eighteenth and the first half of the nineteenth centuries, four of the case studies examined in its pages can be queered in the sense that they represent deviations from heteronormative familial domestic life. To use Jack Halberstam's phrasing, these homes reflect 'practices and structures' that oppose 'conventional forms of association, belonging, and identification', whether through their domestic set up, eventual inheritance along lines of queer kinship, or through their prominence in queerly-inflected and shaped representations.[42]

Two chapters examine explicitly female homosocial utopias whose inhabitants deliberately avoided the confines of marriage so that they might instead live together. These include discussions of Plas Newydd, home to the so-called 'Ladies of Llangollen', Lady Eleanor Butler (1739–1829) and Sarah Ponsonby (1755–1831), who eloped to Wales from rural Ireland in order to live together, and A la Ronde, home to Jane and Mary Parminter (1750–1811 and 1767–1849), cousins whose financial independence allowed them to eschew the expectations

of femininity that were typical of the period. While homosocial living in and of itself does not necessarily constitute queer domesticity, the Parminter's self-conscious and highly deliberate rejection of a patriarchal future for their home means that it can be read in this manner. Plas Newydd, as the home to a pair of women who enjoyed a relationship of unquestionable intimacy and whose closeness transcended contemporary conventions of friendship, can be regarded as a more explicitly queer space. Discussions of these homes appear alongside the analysis of two interrelated domestic spaces. The first, Strawberry Hill, was home to Horace Walpole (1717–97) and later the sculptor, Anne Seymour Damer (1748–1828), to whom Walpole left the house in what I argue to be a gesture of queer heirlooming. Finally, the book examines Park Place, Damer's familial seat, whose eventual vacation forms an important part of Damer's correspondence with Mary Berry, with whom she had a particularly intimate relationship.

Beyond their shared queernesses, these spaces are also united by the non-canonical nature of their decorative and architectural schemes. Whether through their Gothicizing architecture, bricolaged surfaces, impermanent architectural features or even the lack of survival of these spaces and their associated objects (a strong indicator of how they have been valued, or not, throughout history), many of the homes discussed in this book have either been side-lined from established histories of the home in lieu of magnificent country estates, or have been treated as exceptional curiosities to be read alongside or against stylistic trends, their attendant queernesses accordingly overlooked.[43]

This is a model that can be applied to a range of objects, artistic practices, decorative styles and architectural and interior features, all of which have been deemed to be unserious visual and material forms. Dismissed as possessing merely a kind of trifling or insignificant materiality, associated with women and homoerotically inclined men, such material cultures have often been excluded from traditional art and architectural historical enquiry. The book is accordingly concerned with the productive intersections of these overlapping othernesses: whether gendered, sexual, canonical or aesthetic; it creates space for deep attention to objects, homes and lives that have previously been neglected within major art historical scholarship. Here, I follow scholars like Matthew M. Reeve, who analyses Strawberry Hill's architectural features and material cultures through a detailed approach that allows him to unpick the narratives told by both single objects and more encompassing architectural schemes that 'reflect and articulate an alternative social order'.[44] Using a model of close reading in order to trace the intricacies of individuals' interactions with material culture,

and to ask at length how they shaped their social engagements and emotional lives, this book provides a queerer history of the eighteenth- and early nineteenth-century home and its objects; one that centres the experiences of those who complicate traditional histories of domestic life.

Connecting narratives of identity, materiality, emotion and sociability, this book is about how the home performed its interlinked cultural and affective work, exploring the mechanisms through which it communicated its social and emotional functions. By examining the ownership and consumption of the home across reality and representation, and by interrogating the production and ornamentation of the home as a central means by which individuals expressed their affections and identities, it emphasizes the inherently emotional nature of domestic space through a close examination of its decoration and its furnishings. In so doing, it considers the houses of this period as dynamic assemblages of people, spaces and objects, paying deep attention to their materiality and representations in order to draw out the complexity and range of relationships that historical actors established between homes, material cultures and each other. At the same time, however, the book also grapples with some of the big questions that characterize studies of eighteenth- and early nineteenth-century culture by analysing the various states of consumption and (re)production in which people encountered houses at this time, through which the home came to function as an increasingly important repository for sentimental engagement. Each chapter of the text comprises a self-contained case study that identifies a specific cultural process as key to this transaction. Examining description, publication, translation, exchange, inheritance and loss in turn, collectively these chapters sketch an overarching model for understanding the relationship between emotion and sociability within domestic space and its visual and material cultures at this time.

Chapter breakdown

Domestic Space in Britain is divided into three parts, each featuring a pair of chapters. Part I, 'Representation', focuses on the consumption and (re)production of domestic space by its viewers and visitors, asking how its representation within both literary productions and contemporary visual culture created and perpetuated the social relations and reputations of its owners. This section includes chapters on the sociable descriptions of interiors in the letters and journals of the travel writer Caroline Lybbe Powys (1738–1817), and the

relationship between sociability and visual and material culture in published accounts and images of John Wilkes's (1725–97) cottage on the Isle of Wight.

Chapter 1 interrogates representations of material culture, focusing on a specific literary genre, that of the travel narrative, and the role of description within such literature. This chapter centres on the numerous descriptions of domestic interiors in the letters and manuscript journals of the prolific travel writer Lybbe Powys, whose writings have been mined for the historical evidence they provide, but have yet to be discussed in and on their own terms. The chapter argues that the 'thick description' that characterizes Lybbe Powys's accounts locates both the homes of her hosts and her own epistolary practices within an interpretative framework of hospitality, sociability and materiality in which the process of description was central. As well as investigating the material and spatial contents of Lybbe Powys's writings, the chapter also applies those considerations to the journals' and letters' own physicality, identifying them as material and sentimental objects written for, and shared between, various members of the author's family and friends. As material culture which (re)produced narratives of experienced materiality, Lybbe Powys's letters and journals highlight the intimate connectedness between literary content and the physical characteristics of the manuscript, or the circularity between form and function.

Building on description's significance as a cultural mode as established by the previous chapter, Chapter 2 investigates how the publication of such descriptive writing could shape attitudes towards homes and their owners by aligning an individual's character with positive representations of the domestic material cultures of their home. In so doing, it provides an unprecedented examination of John Wilkes's summer residence Sandham Cottage (which Wilkes called his 'Villakin'), on the Isle of Wight, where he lived on and off between 1788 and his death in 1797. Focusing on the role of the visual and material culture of Wilkes's home in written accounts of Sandham Cottage, the chapter explores how its famous schemes of interior decoration and exterior space functioned as a form of reputation management, neutralizing Wilkes's radical politics and instead facilitating his self-presentation as a consummately refined host, tasteful art collector and highly sociable gentleman. The chapter seeks to place such publications within a range of images, texts and objects that were a direct response to the sentimental investment in Wilkes's celebrity and changing public persona, which together constitute a defined body of material, visual and literary culture that rendered Wilkes himself a consumable.

Part II, 'Movement', focuses more straightforwardly on physical (as opposed to representational) forms of material culture, and considers the movement of

objects in and out of domestic space by its owners and inhabitants, concentrating on the close relationship between the reciprocal processes of material consumption and production and the expression of social and familial bonds. This section comprises chapters on the use of souvenirs in the creation of familial craft objects by Jane and Mary Parminter at A la Ronde in Devon, as well as the role of creative gift exchange in the interior decoration and grounds of Plas Newydd in North Wales, home to Lady Eleanor Butler and Sarah Ponsonby.

Chapter 3 centres on the role of translation in the interior decoration of A la Ronde. The house is ornamented with an array of material objects purchased during the Parminters' tour of Continental Europe, found objects from their Devonshire surroundings, and mourning devices employed to commemorate the death of Jane's sister and their travelling companion, Elizabeth Parminter. Translated into the space of the Parminters' home, such objects not only underwent a physical but also a semantic transformation, allowing the Parminters to use an array of apparently disparate objects in the creation of personal and sentimental narratives. Within the chapter, translation is presented as both a constituent event in an object's biography and a process that itself constructed a biography fabricated from material objects. It was thereby crucial to how the Parminters' collections functioned as expressions of self, family and femininity. While the Parminters' employment of 'feminine' crafts such as shell-, feather- and paperwork has been viewed as representative of their homosocial situation and attempt at creating an explicitly gendered identity, the chapter contends that this emphasis has overshadowed the complexity of the cultural project enacted in A la Ronde's decoration, attention to which reveals how the cousins used the material objects translated into their home to create domestic, familial and touristic narratives.

Chapter 4 centres on the culture of gift exchange cultivated by Butler and Ponsonby at their residence in Llangollen. The chapter examines how the women used gifts that they received to decorate the walls and windows of their home, before turning to how they themselves gifted fragments of Plas Newydd to their friends. The chapter is concerned with how the processes of exchange encouraged the cultivation of 'gift relationships'. These relationships operated on several levels. Primarily, the term highlights the propensity of exchange to convey sentiments and experiences shared between Butler and Ponsonby and their myriad friends and visitors to Plas Newydd, many of whom subsequently swapped material, literary and epistolary objects with the pair. The chapter argues that through this process of exchange, such objects became agents of affection, functioning to buttress social relationships as well as demonstrating

the taste and talents of their donors. Correspondingly, the exchange of objects from and into Plas Newydd helped to establish an intellectual and social, material and literary community of 'Romantic friendship' that operated between various provincial locales. As such, exchange offers an important framework for understanding various forms of social and cultural interaction at Plas Newydd. Beyond highlighting the significance of Butler and Ponsonby's social bonds outside of their own intimate relationship, it also allows us to think in more dynamic ways about the relationships between cultural forms during this period and beyond.

Part III, 'Ownership', explores the acquisition of domestic space, presenting the inheritance and loss of material property as an inherently emotional transaction. It comprises a final chapter, focusing on Damer's inheritance of Walpole's famous house Strawberry Hill in 1797, which is analysed through her production of manuscript texts and as a form of queer heirlooming. This chapter works in tandem with the book's final chapter-cum-conclusion, which explores the emotional significance and metaphorical potential of the lost material cultures of the empty home, while summarising the book's intellectual framework.

Chapter 5 explores Damer's inheritance of Strawberry Hill following Walpole's death in 1797. Scholarship on the house to date has almost exclusively focused on the design and decoration of Walpole's Gothic-Revival edifice; the homosocial and homoerotically-inclined cultures of the house; and the infamous sale of 1842 that saw the dispersal of the house's contents. Contrastingly, little research has been conducted on either the significance of Damer's acquisition of the property, or her relationship with the house more broadly. Using one of Damer's few surviving ego-documents, her extra-illustrated copy of Walpole's published catalogue of his home, *A Description of the Villa of Horace Walpole* (1784), this chapter delineates her inheritance not only of the property, but of the practice of extra-illustration, both of which were firmly associated with, and inherited from, Walpole. Establishing the adapted text as a space that both reflected and constructed Damer's relationship with Strawberry Hill, the volume is analysed as an object that could reveal the emotional and social lives of those involved in its production. In so doing, the chapter explores Damer's relationship with her friends and her mother as well as her self-fashioning as a sculptor at a time when such pursuits drew the ire of the satirists' pen. Finally, the chapter posits Damer's inheritance of Strawberry Hill as Walpole's attempt at creating a queer familial legacy for his home, thereby situating this transaction in relation to the interconnected contexts of familial ownership and loss, emotion and materiality.

The book's conclusion explores the semantic potential of the empty house and its lost and absent material cultures by detailing responses to the vacant Park Place in Berkshire, former residence of Damer's parents, Henry Seymour Conway (1721–95) and his wife, Caroline Campbell, Countess of Ailesbury (1721–1803). In this conclusion, loss emerges as central to the relationship between materiality, sociability and emotion, both to contemporaries' conceptions of the eighteenth- and early nineteenth-century home, and to us as (art) historians today. The chapter accordingly uses loss to explore the book's key methodological concerns and historiographical contributions through a discussion of overlooked and queer histories, microhistorical approaches, emotional objects and the history of the emotions, as well as lost things, their representations and the complicated temporalities that they create. As such, it encapsulates how the processes explored in each of the book's chapters function as something akin to a historiographical reflection; with each material process identified as both a key means by which contemporaries in the eighteenth and early nineteenth centuries understood the home, and a central theoretical framework for our understanding of objects, spaces and domesticity today.

The material objects discussed within each of these chapters recall the question posed by Edward Muir in his 1991 discussion of microhistory, in which he asked 'how can historians concerned with trifles avoid producing trivial history?'[45] Though the objects examined throughout the course of this book could easily be dismissed as knick-knacks, trinkets and fripperies, as they often were by both contemporary critics and later art historians, its constituent chapters demonstrate that while marginal phenomena, produced and consumed by perhaps only a small number of historical actors, they were not of marginal importance. On 5 April 1814, Ponsonby wrote to her friend, Sarah Parker of Sweeney Hall, in Oswestry, expressing that for her and her cohabitant, 'the choosing of a new pair of Wafer tongs [is] as important to us as the restoration of the Bourbons'.[46] Exemplifying the pair's profound concern with the material world, this was a notable pronouncement. Politically, Butler and Ponsonby were deeply conservative and strong supporters of the Bourbon monarchy. Ponsonby's statement accordingly seems to contravene the traditional divisions between 'big' histories, focusing on the political, and microhistories, histories of the everyday, the quotidian and thereby, the trivial. For Butler and Ponsonby however, their political engagements were indivisible from their material preoccupations. When in September 1823, for example, an unnamed correspondent offered Butler a lock of Napoleon Bonaparte's hair, the gift was refused on account of Butler's 'Allegiance to the Bourbon family', while Butler

herself was famously decorated with a jewelled Order of Saint Louis, 'presents of the Bourbon family'.[47] Accordingly, while a pair of wafer tongs might have been as important as the restoration of the monarchy to which Butler and Ponsonby performatively professed allegiance, these concerns were by no means mutually exclusive – their interrelation instead reflecting the centrality of 'trivial' domestic things to late eighteenth- and early nineteenth-century life. Following Ponsonby's assertion as to the importance of trifles at this time, this book offers an account in which a series of eloquent material processes – description, publication, translation, exchange, inheritance and loss – profoundly demonstrate the wider significance of trivial things and individual material acts. These acts not only characterized how people engaged with material culture, but also how they conceived of themselves, related to their contemporaries, expressed affection to loved ones and shaped the very places in which they, lived ultimately transforming houses into homes.

Notes

1 Daniel Maudlin, *The Idea of the Cottage in English Architecture, 1760–1860* (Abingdon: Routledge, 2017).
2 *Chambers Encyclopaedia: A Dictionary of Universal Knowledge for the People* (London: W. & R. Chambers, 1865), 314.
3 John Tosh, *A Man's Place: Masculinity and the Middle-Class Home in Victorian England* (New Haven & London: Yale University Press, 2007), 51.
4 On these issues, see: Deidre Lynch, 'Personal Effects and Sentimental Fictions', in Mark Blackwell (ed.), *The Secret Life of Things: Animals, Objects, and It-Narratives in Eighteenth-Century England* (Lewisburg, PA: Bucknell University Press, 2007), 64. Stephen Clarke, 'A Fine House Richly Furnished: Pemberley and the Visiting of Country Houses', *Persuasions*, 22 (2000): 199–217. Viccy Coltman, 'Sojourning Scots and the Portrait Miniature in Colonial India, 1770s–1780s', *Journal for Eighteenth-Century Studies*, 40, no. 3 (2017): 421–41. Catherine Hall and Sonya O. Rose (eds), *At Home with the Empire: Metropolitan Culture and the Imperial World* (Cambridge: Cambridge University Press, 2011).
5 Neil McKendrick, John Brewer and J.H. Plumb, *The Birth of a Consumer Society: The Commercialization of Eighteenth-Century England* (Bloomington: Indiana University Press, 1982). John Brewer and Roy Porter (eds), *Consumption and the World of Goods* (London: Routledge, 1993). Susan Staves and John Brewer (eds), *Early Modern Conceptions of Property* (Abingdon & New York: Routledge, 1995). Ann Bermingham and John Brewer (eds), *The Consumption of Culture, 1600–1800:*

Image, Object, Text (London: Routledge, 1995). Woodruff Smith, *Consumption and the Making of Respectability, 1600–1800* (New York & London: Routledge, 2002). Maxine Berg and Helen Clifford (eds), *Consumers and Luxury: Consumer Culture in Europe 1650–1850* (Manchester: Manchester University Press, 1999). Maxine Berg, *Luxury and Pleasure in Eighteenth-Century Britain* (Oxford: Oxford University Press, 2007). Kate Smith, *Material Goods, Moving Hands: Perceiving Production in England, 1700–1830* (Manchester: Manchester University Press, 2014).

6 Sally Holloway, *The Game of Love in Georgian England: Courtship, Emotion and Material Culture* (Oxford: Oxford University Press, 2019). Marcia Pointon, *Brilliant Effects: A Cultural History of Gem Stones and Jewellery* (New Haven & London: Yale University Press, 2009), 293–314.

7 Jocelyn Anderson, *Touring and Publicizing England's Country Houses in the Long Eighteenth Century* (London: Bloomsbury Academic, 2018), 64. For a new history of the conversation piece genre, see Kate Retford, *The Conversation Piece: Making Modern Art in Eighteenth-Century Britain* (New Haven & London: Yale University Press, 2017).

8 For the 'separation of spheres' model and its consequent rejection see: Lawrence E. Klein, 'Gender and the Public/Private Distinction in the Eighteenth Century: Some Questions about Evidence and Analytic Procedure', *Eighteenth-Century Studies*, 29, no. 1 (1995): 93–4; Amanda Vickery, 'Golden Age to Separate Spheres? A Review of the Categories and Chronology of English Women's History', *The Historical Journal*, 36, no. 2 (1993): 383–414; Elizabeth Eger, Charlotte Grant, Clíona Ó Gallchoir and Penny Warburton (eds), *Women, Writing and the Public Sphere, 1700–1830* (Cambridge: Cambridge University Press, 2001).

9 Tosh, *A Man's Place*, 27.

10 Indeed, a number of scholars have posited that modern domesticity emerged at this time. For example, Abigail Williams has noted that 'the idea of home and the wholesome domesticity within it acquired an increasingly privileged status in the ethical vocabulary of the later eighteenth century'. Williams, *The Social Life of Books: Reading Together in the Eighteenth-Century Home* (New Haven & London: Yale University Press, 2017), 11.

11 Brad S. Gregory, 'Is small beautiful? Microhistory and the history of everyday life', *History and Theory*, 38, no. 1 (1999): 101.

12 Clifford Geertz, 'Thick Description: Towards an Interpretive Theory of Culture', in *The Interpretation of Cultures* (London: Hutchinson & Co. Ltd. 1973), 19.

13 On country houses, see: Mark Girouard, *Life in the English Country House* (New Haven & London: Yale University Press, 1978); Dana Arnold, *The Georgian Country House: Architecture, Landscape and Society* (London: The History Press, 1998); Jon Stobart, 'Status, gender and life cycle in the consumption practices of the English elite. The case of Mary Leigh, 1736–1806', *Social History*, 40, no. 1 (2015): 82–103.

On town houses, see: Rachel Stewart, *The Town House in Georgian London* (New Haven & London: Yale University Press, 2009); Susanna Avery-Quash and Kate Retford (eds), *The Georgian London Town House: Building, Collecting and Display* (New York & London: Bloomsbury Visual Arts, 2019). Foundational work on the Georgian interior has followed this emphasis thanks to quality of surviving furnishings and decoration found within these houses. See: John Cornforth, *Early Georgian Interiors* (New Haven & London: Yale University Press, 2004); Charles Saumarez Smith, *Eighteenth-Century Decoration: Design and the Domestic Interior in England* (London: Weidenfeld and Nicolson, 1993); Hannah Greig and Giorgio Riello, 'Eighteenth-Century Interiors – Redesigning the Georgian: Introduction', *Journal of Design History*, 20, no. 4 (2007): 273–89.

14 Anderson, *Touring and Publicizing*, 13.

15 Amanda Vickery, *Behind Closed Doors: At Home in Georgian England* (New Haven & London: Yale University Press, 2009). Deborah Cohen, *Household Gods: The British and their Possessions* (New Haven & London: Yale University Press, 2006). Jane Hamlett, *Material Relations: Domestic Interiors and Middle-class Families in England, 1850–1910* (Manchester: Manchester University Press, 2016). Nicole Reynolds, *Building Romanticism: Literature and Architecture in Nineteenth-Century Britain* (Michigan: The University of Michigan Press, 2010).

16 Holloway, *The Game of Love*, 15.

17 See Chapter 4 of Holloway, *The Game of Love*.

18 Lynch, 'Personal Effects and Sentimental Fictions', 64.

19 Sandra Landreth, 'The Vehicle of the Soul: Motion and Emotion in Vehicular It-Narratives', *Eighteenth-Century Fiction* 26, no. 1 (2013): 94.

20 For object biographies, see: Arjun Appadurai (ed.), *The Social Life of Things: Commodities in Cultural Perspective* (London & New York: Cambridge University Press, 1986); Janet Hoskins, *Biographical Objects: How things tell the stories of people's lives* (Abingdon: Routledge, 2010).

21 John Styles, *Threads of Feeling: The London Foundling Hospital's Textile Tokens, 1740–1770* (London: The Foundling Museum, 2010). Marcia Pointon, '"Surrounded with Brilliants": Miniature Portraits in Eighteenth-Century England', *The Art Bulletin*, 83, no. 1 (2001): 48–71. Hanneke Grootenboer, *Treasuring the Gaze: Intimate Vision in Late Eighteenth-Century Eye Miniatures* (Chicago: University of Chicago Press, 2012).

22 For a discussion of the 'knick-knack' see Chapter 3 of this book.

23 Serena Dyer, *Material Lives: Women Makers and Consumer Culture in the 18th Century* (London: Bloomsbury Visual Arts, 2021). Viccy Coltman, *Fabricating the Antique: Neoclassicism in Britain 1760–1800* (Chicago: University of Chicago Press, 2006). Madeleine Pelling, 'Collecting the World: Female Friendship and Domestic Craft at Bulstrode Park', *Journal for Eighteenth-Century Studies,* 41, no. 1 (2018):

101–20. Maureen Daly Goggin and Beth Fowkes Tobin (eds), *Material Women, 1750–1950: Consuming Desires and Collecting Practices* (Burlington: Ashgate 2009). Stacey Sloboda, *Chinoiserie: Commerce and Critical Ornament in Eighteenth-Century Britain* (Manchester: Manchester University Press, 2014). Susan M. Stabile, *Memory's Daughters: The Material Culture of Remembrance in Eighteenth-Century America* (Ithaca: Cornell University Press, 2004).

24 See Chloe Wigston Smith, *Women, Work, and Clothes in the Eighteenth-Century Novel* (Cambridge: Cambridge University Press, 2013). Jennie Batchelor, *Dress, Distress and Desire: Clothing and the Female Body in Eighteenth-Century Literature* (London: Palgrave Macmillan, 2005). Tita Chico, *Designing Women: The Dressing Room in Eighteenth-Century English Literature and Culture* (Lewisburg, PA: Bucknell University Press, 2005). Julie Park, *The Self and It: Novel Objects and Mimetic Subjects in Eighteenth-Century England* (Redwood City, CA: Stanford University Press, 2009). Karen Lipsedge, *Domestic Space in Eighteenth-Century British Novels* (Basingstoke & New York, Palgrave Macmillan, 2012).

25 Cynthia Wall, *The Prose of Things: Transformations of Description in the Eighteenth Century* (Chicago & London: Chicago University Press, 2006), 2.

26 Smith, *Material Goods, Moving Hands*, 6.

27 Colin Campbell, 'Understanding traditional and modern patterns of consumption in eighteenth-century England: a character-action approach', in J. Brewer and R. Porter (eds), *Consumption and the World of Goods* (London: Routledge, 1993), 44.

28 Anderson, *Touring and Publicizing*, 114.

29 Michael Yonan, 'Toward a Fusion of Art History and Material Culture Studies', *West 86th: A Journal of Decorative Arts, Design History, and Material Culture*, 18, no. 2 (2011): 243. Viccy Coltman, 'Im-material Culture and History of Art(efacts)', in Anne Gerritsen and Giorgio Riello (eds), *Writing Material Culture History* (London: Bloomsbury Academic, 2014):19. Sam Rose, 'Close Looking and Conviction', *Art History*, 40, no. 1 (2017): 156–77.

30 Wall, *The Prose of Things*, 153.

31 Bill Brown, 'Thing Theory', *Critical Inquiry*, 28:1, 'Things' (Autumn, 2001): 5. Wall, *The Prose of Things*, 150.

32 Ibid., 200.

33 James Deetz, *In Small Things Forgotten: An Archaeology of Early American Life* (New York: Anchor Books, 2010).

34 Charles W. Joyner, *Shared Traditions: Southern History and Folk Culture* (Urbana & Chicago: University of Illinois Press), 1.

35 See Hayden White, *Tropics of Discourse: Essays in Cultural Criticism* (Baltimore: John Hopkins University Press, 1978), Chapter 2.

36 Jill Lepore, 'Historians Who Love Too Much: Reflections on Microhistory and Biography', *The Journal of American History*, 88, no. 1 (2001): 133.

37 Rebecca J. Scott, 'Small-Scale Dynamics of Large-Scale Processes', *The American Historical Review*, 105, no. 2 (2000): 477.
38 Elizabeth Freeman, *Time Binds: Queer Temporalities, Queer Histories* (Durham: Duke University Press, 2010), xix, xi.
39 Coltman, 'Im-material Culture and History of Art(efacts)', 22. On the relationship between the two disciplines, see: Yonan, 'Towards a Fusion'.
40 Freeman, *Time Binds*, xvii.
41 George Haggerty, 'Horace Walpole: 'Queernesses' in the Epistolary Mode', keynote paper, *Text Artefact Identity: Horace Walpole and the Queer Eighteenth Century*, Strawberry Hill, 15 February 2019. On queerness and domesticity in other periods, see: John Potvin, *Bachelors of a Different Sort: Queer Aesthetics, Material Culture and the Modern Interior in Britain* (Manchester: Manchester University Press, 2014); Matt Cook, *Queer Domesticities: Homosexuality and Home Life in Twentieth Century London* (London: Palgrave Macmillan, 2014); Michael Hatt, 'Space, Surface, Self: Homosexuality and the Aesthetic Interior', *Visual Culture in Britain*, 8, no. 1 (2007): 105–28. Carla Barrett, 'Queering the Home: The domestic labor of lesbian and gay couples in contemporary England', *Home Cultures*, 12, no. 2 (2015): 193–211.
42 Jack Halberstam (see also Judith Halberstam), *In a Queer Time and Place: Transgender Bodies, Subcultural Lives* (New York & London: New York University Press, 2005), 4.
43 On the 'shared historical trajectory' of sexuality and aesthetics, see Matthew M. Reeve, *Gothic Architecture and Sexuality in the Circle of Horace Walpole* (Philadelphia: Penn State University Press, 2020).
44 Reeve, *Gothic Architecture and Sexuality*, 13.
45 Edward Muir, 'Introduction: Observing Trifles', in Edward. Muir and Guido Ruggiero (eds), *Microhistory and the Lost Peoples of Europe: Selections from Quaderni Storici*, trans. E. Branch (Baltimore & London: John Hopkins University Press, 1991), xiv.
46 Elizabeth Mavor (ed.), *A Year with the Ladies of Llangollen* (Harmondsworth: Penguin Books Ltd, 1986), 86.
47 Ibid., 179.

Part One

Representation

1

'My anecdotes of this social neighbourhood': The Thick Description of Caroline Lybbe Powys

In a letter dated 13 January 1777, the journalist Caroline Lybbe Powys (née Girle) described a ball held at Sambrooke and Sarah Freeman's residence of Fawley Court, near Henley-on-Thames, in abundant detail.[1] Transcribed within a published copy of her journals as an 'Account of a Gala Week in the Neighbourhood of Henley-upon-Thames, Oxfordshire', the ball was merely one aspect of a week-long round of celebrations, social gatherings and entertainments, centring around the Christmas performance of 'The Provoked Husband', hosted by the family of George Mason-Villiers, 2nd Earl Grandison.[2] The play was performed in Villiers' barn and coach house, which held 300 audience members and was decorated with scenery borrowed from a theatre company, and illuminated with candles.[3] During the week, there were three performances of the play, a post-performance supper given by Villiers at the local Bell Inn, and a ball hosted by Lybbe Powys's friends, the Freemans, to which all attendees of the play had been invited.[4]

In language typical of her enthusiastically written journals and broader correspondence, Lybbe Powys described how, for the purpose of the ball, Fawley Court was transformed into a spectacle of gastronomic, ludic and visual delights:

> Their usual eating-room not being large enough, the supper was in the hall, so that we did not come in thro' that, but a window was taken out of the library, and a temporary flight of steps made into that, from which we passed into the green breakfast-room (that night the tea-room), thro' the pink-paper billiard room, along the saloon, into the red damask drawing-room. Though none set down, this room was soon so crowded as to make us return to the saloon. This was likewise very soon fill'd, and as the tea was carrying round, one heard from every one, 'Fine assembly', 'Magnificent house', 'Sure we are in London' [...] Two card-rooms, the drawing-room and eating-room. The latter looked so elegant lighted up [...] The orgeat, lemonade, capillaire, and red and white negus, with cakes, were carried round the whole evening. At half an hour after twelve the supper

was announced, and the hall doors thrown open, on entering which nothing could be more striking, as you know 'tis so fine a one, and was then illuminated by three hundred colour'd lamps round the six doors, over the chimney, and over the statue at the other end. The tables were a long one down the room, terminated by a crescent at each end, and a crescent table against the two doors in the middle; the windows were sideboards. The tables had a most pleasing effect, ornamented with everything in the confectionary way, and festoons and wreaths of artificial flowers prettily disposed; all fruits of the season, as grapes, pines, &c; fine wines (Freeman is always famous for); everything conducted with great ease – no bustle.[5]

Conveying the sensuousness of her experience, the account carefully details the visual and sensorial titillation provided by the Freemans' impressive material display, which promised nourishment, spectacle and intoxication in equal measure. From the hot liquors that were handed out to guests throughout the evening, to the opulent decorations of the hall, Lybbe Powys's description of the Freemans' ball captures how deeply material culture was implicated within the rituals of contemporary sociability. Here, the pair are identified as consummate hosts, transforming the architectural fabric and built environment of their home, presenting a hall spectacularly decorated with flowers, foliage and coloured lamps, and providing an array of epicurean delights – from mulled wines, syrups and tea, to cakes, fruit and confectionery – for their guests.

In her description of the ball, Lybbe Powys also noted that the event had 'ninety-two [guests] sat down to supper', each of whom

seem'd surpris'd at entering the hall. The house had before been amazingly admir'd, but now there was one general exclamation of wonder. This, you may be certain, pleas'd the owners, particularly as many of the nobility there now never saw it before.[6]

In a week dominated by communally experienced performance, dining and sociability, the Freemans' ball was a fittingly festive end, and one that would have increased the couple's social standing significantly through the highly public exhibition of their home. This narrative of how the splendour and opulence of material objects, particularly when presented within a domestic context, established cultural and social capital is a well-rehearsed one.[7] However, this chapter aims to go beyond a discussion of this function of impressive display by interrogating how these objects were represented through the process of descriptive writing, and moreover, how this in turn related to sociable forms of presentation, enactment and interpretation. What did this detailed replication

of the festivities at Fawley Court convey to Lybbe Powys's correspondent, who, as her letter confirms, was already intimate with both the Freemans and the decoration of their home? For the anonymous recipient, the description would have recalled familiar spaces and faces, missed due her absence, while at the same time vividly conveying a sense of the comfort and splendour provided by the Freemans for their guests.[8]

Although her biographer Anne Pimlott Baker has suggested that Lybbe Powys's writings have been dismissed as of little autonomous interest thanks to their lack of commentary upon contemporary political events, Lybbe Powys's accounts nevertheless reveal how description conveyed and reflected emotion, sociability, hospitality and materiality not only for her contemporaries, but for readers today. The evocative descriptions of interior space that appear throughout her journals and correspondence have rendered them a crucial source for historians of the home in eighteenth-century Britain.[9] There has, however, been a relative lack of attention paid to these documents as whole, and accordingly, the role played by material culture throughout her writing has yet to be fully appreciated, particularly with regard to its interplay with the contemporary forms of sociability that Lybbe Powys details so abundantly.[10] As George Haggerty has written of the similarly pervasive use of the correspondence of Horace Walpole, such letters are often 'mined for various kinds of information', yet, 'it is shocking how rarely they have been read and studied for themselves'.[11] Advocating an approach to letters that he describes as 'on their own terms – not to explain a life outside of them, but to show how they create a life of their own', Haggerty's method of dealing with Walpole's epistolary record presents a useful paradigm for addressing Lybbe Powys's oeuvre both in and on its own terms.[12] Following Haggerty's model, this chapter sheds new light on the letters, diaries and journals of Lybbe Powys, employing them to examine the role played by description in forging the relationship between the panoply forms of material culture experienced within the eighteenth-century interior and contemporary forms of domestic sociability.

Specifically, the chapter is structured around the spaces and encounters described in Lybbe Powys's journal of her 1756 tour of Norfolk, which had become a fashionable travel route by the mid-century. This trip forms her first recorded domestic excursion, which in many ways is typical of both the travel she conducted throughout the remainder of her life, and its literary preservation in the form of her journals and correspondence.[13] Characterized by descriptive narratives of comfort, convenience and hospitality; of the material and social fruits of the estate; and finally, of her family's relationship with their hosts (the

Jacksons of Weasenham Hall), this first tour constitutes an exemplary model for her specific brand of socially and materially oriented tourism. Crucially, the chapter locates this material sociability between lived primary experience and reflective description, arguing that her journals and letters operate as an evocative unification of descriptive form and narrative function, an interplay that ultimately reveals how contemporaries used and understood the material culture that surrounded them. While the descriptive nature of travel writing has long rendered it a useful source in discussions of historical material culture, this chapter aims to unpack how the process of description actively constructed the genre's relationship with the material objects that it recorded.

Materiality

As Jo Dahn has argued, eighteenth-century domestic material culture can be usefully conceptualized as a '"landscape" of objects', a 'multi-layered environment which each individual inhabits'.[14] Within this model, the material culture of the home constituted a highly legible assemblage whose viewers recognized the material and social clues that it evoked, a thesis confirmed by Lybbe Powys's perspicacious observations. Within the rituals of domestic sociability described in her journals and correspondence, this objectscape functioned as a social code of materiality in which performances of knowledge, taste and hospitality were central. In Lybbe Powys's narratives, objects frame and stage the relationship between hosts and guests; reinforcing good behaviour, good manners and good taste, while simultaneously providing a comfortable and comforting material space in which such sociable exchanges were enacted.

However, the diverse materiality of this objectscape has often been overlooked. Lybbe Powys's rich descriptions of Fawley Court, for example, are particularly revealing when examined against the historiography of the house itself. To date, Fawley Court has primarily been discussed for its extensive programme of James Wyatt interiors, which as Viccy Coltman has established, were inspired by Josiah Wedgwood's adaptation of William Hamilton's vase publications.[15] However, Lybbe Powys's account of Fawley sheds light on a highly varied interior objectscape of material culture, documenting transient architectural adaptations and impressive gastronomic displays that should be brought into conversation with the house's long-term decorative scheme in order to gain a sense of how the property was actually used and experienced by its contemporaries.

In a passage reminiscent of the descriptive multiplicity found within Lybbe Powys's writings, George M. Woodward's light satire of travel literature, *Eccentric Excursions: or, Literary & Pictorial Sketches of Countenance* (1796), argues that the journal of the 'Characteristic Traveller' 'must be appropriated to *variety*; from the rustic peculiarities of the visitors of an hedge ale-house, to the assumed pomposity of temporary residents at an inn; and the *plain frugality* of the *honest farmer*, must be noted down in contrast with the *ostentatious display* of grandeur at the *neighbouring mansion*'.[16] Like the journal of the 'characteristic traveller', Lybbe Powys's accounts examine both the sumptuous materiality of stately homes such as Holkham Hall and Blenheim Palace, and less impressive and comparatively overlooked domestic spaces, such as Weasenham Hall. Moreover, while Lybbe Powys's diaries and journals do include descriptions of the traditional subjects of art historical analysis, that is paintings, sculpture and other fine *objets d'art*, they are simply one aspect of an exhaustive 'objectscape' of materiality to which she turns her attention, transcending traditional divisions between the fine and decorative arts, permanent and transient forms of interior decoration, and the 'country house' and the provincial home.

In addition to describing the rich furnishings of her surroundings, Lybbe Powys's observations also conjure up the sensorial dimension of the contemporary home, evoking the taste of the grand spreads of food and libations provided by her hosts, the warmth of an open and roaring fire, the perfume of freshly cut flowers, and the sound of young women singing; observations that chime with the 'sensory turn' that has been a notable feature of recent cultural history.[17] In its attention to the physical experience of objects beyond their purely visual qualities, this 'turn' provides a productive context in which to situate Lybbe Powys's writings, encouraging the treatment of her aesthetic and sensory experiences with equal import.

Lybbe Powys's descriptions therefore echo the terminology employed by Mimi Hellman when tellingly describing the eighteenth-century French interior as 'delectable'.[18] Her evocative phrasing, equally applicable to the British interior, implies not only the importance of aesthetic taste in the decoration of domestic and semi-public spaces, but also the sumptuous, sensuous and almost gastronomic nature of the surroundings that the visitor to the eighteenth-century home would have routinely encountered. As Brian M. Norton has argued, in the eighteenth century, aesthetic experience was understood as encompassing far more 'than just the newly grouped "fine arts"'.[19] This position is echoed by Elizabeth Bohls's work on women's travel literature and aesthetics,

in which she provides a 'working definition of aesthetics that can encompass women's innovative ventures', thereby broadening aesthetics beyond the 'narrow, prestigious genre of academic or theoretical writing', and instead presenting it as a discourse which 'deals with the categories and concepts of art, beauty, sublimity, taste, and judgement', and, crucially, with the 'pleasure experienced from sensuous surfaces or spectacles'.[20] Both Bohls's redefinition of the aesthetic, and Norton's desire to 'decouple the aesthetic from the artwork to ponder the nature and significance of aesthetic experience in the world at large', are therefore particularly compelling when read against Lybbe Powys's aestheticized presentations of quotidian material and immaterial culture.[21]

Far from detached aesthetic evaluation, Lybbe Powys's repeated emphasis on the multivalent sensory experience of the eighteenth-century interior aligned aesthetic and bodily taste, unifying intellectual judgement with physical experience. Her travel writings therefore provide an account of the eighteenth-century interior in which permanent decoration and temporary provision were equally crucial within an impressive objectscape of sociable hospitality, a formulation that was conveyed to her intimates through descriptive writing.

Description

In both manuscript and published form, descriptive writing accorded strongly with contemporary urges to create an 'order of things'.[22] In *The Prose of Things*, Cynthia Wall cites several fundamental cultural changes as prompting the emergence of description as a dominant rhetorical form within eighteenth-century literature, including technological innovation, the emergence of a new consumer culture, philosophical interests in the particular, and narrative emphases on domestic space.[23] Description also became a central technology of the tourist experience, both within tourists' accounts of their travels, and through the printed literature that they themselves would experience during these journeys. As Stephen Clark notes, while such writings varied greatly with 'the personality and sensitivity of their writers', description was consistent as the *modus operandi* for the articulation of their journeys.[24]

Lybbe Powys's journal of her 1756 tour of Norfolk comprises a series of highly descriptive letters written to her father, John Girle, Esq. (d. 1761) whose absence from this tour prompted her first foray into travel writing. As she recollects within the journal, 'when we went with Mr. Jackson's family into Norfolk, my father, not being of our party, desired me to write him an account of our tour,

and to be particular in my description of places or things that might give me entertainment.'[25] Her father's prompt that she take descriptive note of her natural and material surroundings while travelling was, in formal terms, entirely conventional. However, for Lybbe Powys's own literary development, it was highly significant, and the letters in which this early tour was recorded provide the standard for the detailed descriptions of domestic spaces to which she would continue to adhere in her later writings.

The letters' formal characteristics echo contemporaneous epistolary practices. For example, Sir Edward Lyttleton's unpublished account of his 1755 'Tour thro' S. Wales', took the form of a series of descriptive entries directly addressed to his friend 'Bowers,' to whom he wrote from the foot of Snowdon to provide

> an Account of my Travels thus far; as promised when I left you, and to satisfy your desire of seeing North Wales, in description at least, since you are not at leisure to accompany me thither.[26]

Beyond facilitating vicarious participation in the act of travel, such carefully articulated descriptions of places visited in the absence of a friend fostered a sense of affection between correspondents. As in Lybbe Powys's detailed letters written to her father, correspondents such as Elizabeth Carter (1717–1806) and Elizabeth Montagu (1718–1800), Hester Piozzi (1741–1821) and Penelope Pennington (c. 1752–1827) also exchanged letters in which descriptive accounts generated intimacy in the face of estrangement. In 1762 for example, Carter wrote to Montagu to thank her for thinking of her

> in the midst of such a variety of pleasing engagements, you were very good, my dear friend, to find an hour to bestow upon me, and by a very lively description to render me in some degree, a sharer in your adventures and amusements [...] I am much obliged to you for [the] account of your travels, and for the observations it was so natural for you to make upon the scene which they presented to you, and which would have been made by so few people in the world besides.[27]

Correspondingly, in a letter to her close friend Pennington, dated 28 September 1791, Piozzi suggestively commended Pennington's epistolary conduct through an invocation of its descriptive qualities: 'your letters, my lovely friend, are like the places they describe, cultivated, rich, and various: the prominent feature elegance, but always some sublimity in hope and prospect.'[28] Tellingly, Piozzi's next recorded letter to Pennington, from 15 October of the same year, begins by gently teasing her friend, noting that her recent letter had 'contain'd more

agreeable descriptions of places I love, than of people', emphasizing the consistency with which description figured in their epistolary exchanges.[29]

Beyond their relationship with the conventions and practices of private correspondence, Lybbe Powys's writings also accord with a body of contemporary published texts, such as John Sturch's *A view of the Isle of Wight, in four letters to a friend* (1793) and William Toldervy's *England and Wales described. In a series of Letters, Exhibiting whatever is worthy the Observation of the Curious Traveller* (1762), both of which exploited the fashion for epistolary literature within forms of travel writing by creating narratives intended as useful guides to specific British destinations. Francis Douglas's 1782 *A general description of the East Cost of Scotland, from Edinburgh to Cullen*, for example, takes the form of a series of letters written to a friend, whom he addresses in the first letter as follows: 'Dear Sir, when I spoke of taking a jaunt into the north, you insisted upon having some account of the country, and what seemed most remarkable in it', before listing in the most precise terms exactly what his correspondent should *not* expect from his diligent descriptions.[30] Sir Richard Joseph Sulivan's *Observations made during a Tour through Parts of England, Scotland, and Wales* also adopts this form, opening the first letter with a response to 'the orders which I received' from his anonymous correspondent, thereby making good on an earlier 'promise of writing to you'.[31]

Though other texts shunned the epistolary form in favour of directly addressing their future readers, the sense of descriptive intimacy between author and correspondent often continued between author and reader. The preface of Edward Daniel Clarke's *A Tour through the South of England, Wales, and Part of Ireland, made during the Summer of 1791* (1793), for example, dedicated the text to those readers 'who can feel interested in the rambles of an Englishman, who can survey with pleasure a simple delineation of British scenery [...] the emanations of fancy, the sportive ebullitions of inventive genius [which] beam not through the thin texture which is here interwoven from the materials of a summer excursion'.[32] Ironically, this bashful disclaimer as to the 'thin texture' of his account in fact recalls Clifford Geertz's notion of not thin, but '*thick description*', a theory in which Geertz promoted the wider semantic potential of descriptions of subjective experience; a methodology that has since become a cornerstone of microhistorical enquiry.

In his foundational essay, 'Thick Description: Towards an Interpretive Theory of Culture', Geertz notes that 'the ethnographer "inscribes" social discourse, *he writes it down*. In so doing, he turns it from a passing event, which exists only in its own moment of occurrence, into an account, which exists in its inscriptions

and can be re-consulted'.³³ To adequately capture these 'moments' the ethnographer must therefore go beyond a superficial account and employ interpretive, contextual, and thereby thick, description. In 1989, the sociologist Norman K. Denzin defined thick description as doing

> more than record what a person is doing. It goes beyond mere fact and surface appearances. It presents detail, context, and emotion, and the webs of social relationships that join persons to one another. Thick description evokes emotionality and self-feelings. It inserts history into experience. It establishes the significance of an experience, or the sequence of events, for the person or persons in question. In thick description, the voices, feelings, actions, and meanings of interacting individuals are heard.³⁴

By inserting 'history into experience', thick description also inserted experience into history. Geertz's model has been adopted by the work of micro- and cultural historians such as Natalie Zemon Davis and Robert Darnton.³⁵ As Geertz himself has conceptualized, cultural analysis hinges upon the successful resolution of 'the problem of how to get from a collection of ethnographic miniatures […] an assortment of remarks and anecdotes – to wall-sized culturescapes of the nation, the epoch, the continent, or the civilization', moving from 'local truths to general visions'.³⁶ Such a problem is perpetually relevant to the historian, particularly when attempting to interpret a corpus of pseudo-ethnographic description. In the case of Lybbe Powys, we can usefully employ thick description as a methodology by which to frame the highly personal and subjective 'local truths' of her visiting and travel journals, in relation to the 'general visions' of eighteenth-century culture.

In positing the particular in relation to the general, the historian aims to create a thickly descriptive or interpretative account of their subject of enquiry. In analysing the journals of Lybbe Powys however, this form of cultural analysis functions on several levels. Not only is the historian 'doing' thick description by providing a contextual reading of this particular form of literary expression, but Lybbe Powys herself provides a thickly descriptive analysis of her own subjective experience, one in which, through the very act of description, she functions as ethnographer, inscribing the social and material discourse of eighteenth-century life. Just as Geertz himself read cultures as texts then, an assessment of Lybbe Powys's writings encourages a reciprocal reading of texts as cultures.³⁷

In this respect, Lybbe Powys's late nineteenth-century editor was notably astute. In the opening to her edition of the correspondence, Emily Climenson wrote that the journals

present such an accurate picture of life, manners and customs of the upper class of that period, that though my work of collating, noting and linking together the many, some twenty books, lent to me by various members of the family, was chiefly undertaken on their account, I feel that they cannot fail to interest the general reader, containing as they do such interesting anecdotes of royalty; and other notable people, descriptions of country seats, places, towns, manufactures, amusements, and general habits of the people which now form history.[38]

In this early intervention within the text, Climenson identified the importance of Lybbe Powys's descriptive passages in revealing the minutiae of eighteenth-century society and its participants to the Victorian reader; a thick description that provided analysis not only of the material environment in which Lybbe Powys found herself during her tours, but its ideological, familial and social functions. In creating detailed descriptions of both the visual and material cultures of the eighteenth-century house and the emotional lives of its residents, Lybbe Powys exemplifies the argument that descriptive texts 'constitute a mode of interpretation'.[39]

Hospitality

Lybbe Powys's descriptions of Weasenham Hall, located near the small town of Swaffham, in Norfolk, exemplify the social nature of her travels. This particular account is typical of those in which she or her family had an existing social relationship with the house's owners, and as such, it presents an assessment of Weasenham Hall that is at once moral and aesthetic. Describing the Hall as having a pleasing situation, she notes that the house was 'modern and elegant, with every convenience to give it the title of a good one', and that it stood 'in a pretty park, beyond that a heath, which they have planted promiscuously with clumps of firs. Beyond that the country rises to the view. On one side lay the grove and gardens, and behind the village, than which nothing can be in a more rural taste'.[40]

This description of the geographical and domestic space inhabited by Weasenham Hall flows into a series of observations pertaining to her host's character, constituting an overwhelmingly positive assessment that praises both Jackson's rectitude, and his prowess as manager of his estate. Above and beyond her conventional descriptions of Weasenham's architectural features, vistas, and leafy grounds, Lybbe Powys's account of the house centres on its owner's management of his home and servants, as well as his provision of a particularly

material form of hospitality, unifying aesthetic and moralistic judgement.[41] Following her description of the house, she moves on to describe how, by 'annual custom', the arriving party, which comprised herself, her mother, Barbara Girle, Mr Jackson and his son and daughter, were received by a welcoming party comprised of 'the Vicar, and his wife, and near tenants' at the hall.[42] Continuing, she reminds her father that he himself knows

> the hospitable manner Mr. Jackson always lives in, and will not wonder at the joy expressed on his arrival. Never did a landlord seem more beloved, or indeed deserve to be so, for he is a most worthy man, and in however high a stile a man lives in in town, which he certainly does, real benevolence is more distinguishable in a family at their country-seat, and none do more good than that where we now are.[43]

This last statement, which directly links familial benevolence with domestic space, is the first of Lybbe Powys's conflations of the home and the character of its owner. Throughout the journals, the correlation between Lybbe Powys's descriptions of households and her moral assessments of their owners is clear to see. From the parity between the 'odd house of the still odder Mr. Spilman', to her comments upon the impressive dairy maintained by Lady Leicester at Holkham Hall, discussed further below, such aesthetic and moralistic convergences demonstrate the indivisibility in Lybbe Powys's eyes of an individual and the quality of the space which one created as their household.[44]

Such drawn equivalences between the state of one's home and the state of one's character were common by the second half of the eighteenth century, as Piozzi's description of Edmund Burke, retrospectively remembered while composing her autobiography, known as *Thraliana*, highlights:

> 'tis now Time to turn over a new Leaf for the great orator Mr. Edmund Burke, who, after I had ran from Gentleman's House to Gentleman's House all over Wales in the year 1774 was the first man I had ever seen drunk or heard talk obscenely, when I lived with him and his Lady at Beaconsfield among Dirt Cobwebs Pictures and Statues that would not have disgraced the City of Paris itself where Misery and Magnificence reign in all their splendour and in perfect Amity. That Mrs. Burke drinks as well as her Husband and that their black-a-moor carries Tea about with a cut finger wrapped in Rags must help to apologise for the severity with which I have treated so very distinguished a Character.[45]

Throughout the eighteenth century, both the tea service and enslaved men and women were conceptualized as 'culture objects' that could affirm the gentility of their owners. However, they were also consistently employed within satirical

representations of 'high life', where they signalled failed pretensions to respectability.[46] Crucially, in such satires, these devices were presented as having 'gone wrong' in some capacity; tea services are cracked, tables are upturned and enslaved children are presented as engaging in morally corrupt behaviour. In Piozzi's assessment of Burke, she plays on such formulations, describing the 'culture objects' that Burke used to demonstrate his domestic respectability, while simultaneously highlighting the manner in which they failed him. Between the enslaved boy, with his 'finger wrapped in Rags', and the dirt of Burke's home, the shoddy manner in which he kept his house and servants constituted an unforgivable lapse in genteel behaviour for Piozzi, thereby demonstrating how contemporaries read the presentation and management of domestic space as indivisible from one's character.

Contrastingly, Lybbe Powys praised Jackson for his careful management of his household, including his equipage of contented servants, describing everything at the house as 'regularity itself':

> the master's method is, I take it, now become the method of the servants by *use* as well as choice. Nothing but death ever makes a servant leave them. The old house-keeper has now been there one-and-fifty years; the butler two- or three-and-thirty; poor Mrs. Jackson's maid, now Miss Jackson's, twenty-four, having been married to one of the footmen (their daughter is grown up, and is one of the housemaids) [. . .] 'tis really a pleasure to see them all so happy.[47]

Once again demonstrating her deeply entrenched association between household and owner, this account of domestic fidelity was followed swiftly by an anecdotal meander upon the subject of the uniform of green stuff gowns bestowed by Jackson upon his servants, about which Lybbe Powys had enquired with Jackson's daughter. Telling her that 'a green camblet for a gown used for many years to be an annual present of her mother's to those servants who behaved well', Jackson's daughter explained that 'now indeed, as they all behaved well, and had lived there much longer than the limited term, this was constantly their old master's New Year gift'.[48] Lybbe Powys comments on this exchange as 'a pretty compliment to his lady's memory, as well as testimony of the domestics still deserving of his good opinion', a telling hint of aestheticization within an overarchingly moralistic recollection.[49]

Beyond highlighting the diligent, and importantly, kind management of Jackson's domestic servants, this section of the journal corresponds with Wall's assertion that the prevalence of description in eighteenth-century literature was in part thanks to the narrativization of domestic space.[50] Lybbe Powys's

description of Weasenham is emblematic of the confluence between narrative and descriptive forms of writing that typified contemporary diurnal literature, moving seamlessly between a discussion of home, to owner, to object; from hall to servant to gown; and from narrative to description and back again. Ultimately, these descriptions converge to present Jackson in the guise of benevolent landlord, rightly beloved by his tenants and servants alike – an estimable characterization that in Lybbe Powys's account is intimately linked with both the management and presentation of his familial home of Weasenham. In relating these anecdotes through the descriptive practices of epistolary writing, Lybbe Powys created an ethical emphasis that surrounded his home; a narrative that in turn sustained shared memories of his moral integrity between herself and her father.

Lybbe Powys similarly rooted her description of Jackson's hospitality within her account of the house in which it was enacted. Once again addressing her father directly, she asks him to remember how Jackson loved

> company at home [...] If twenty people came in as we were sitting down to table, his dinners are so good they would need no alteration; but the larder is really quite a sight, and different from any I ever saw. 'Tis a large good room they had built on purpose, in an open green court, by the kitchen-garden, with every possible convenience; and I believe always full of everything in season, and the old gentleman makes us walk there after breakfast that we may all, as he says, have what we like for dinner.[51]

She went on to describe the high quality of the 'venison and game now in [the larder]' which she recalled as 'astonishing', commending Jackson on his famous 'Norfolk Mutton'.[52] This emphasis upon the ritualization of material culture is typical of Lybbe Powys's descriptions, which often present the householder as proudly showing off some aspect of their homestead and subsequently involving the visitor in its presentation. In this example, Jackson encouraged his guests' daily visits to Weasenham's larder to draw attention to the magnificently stocked room, building anticipation for a forthcoming dinner, while simultaneously asserting the fecundity of the estate.

Lybbe Powys's account of Jackson performatively bringing visitors into his well-stocked larder firmly establishes its significance as a material site of impressive sociability. This was reiterated in her account of a 'Gala Week in the Neighbourhood of Henley-Upon-Thames', where she described how, during the extensive programme of festivities discussed above, Elizabeth, Countess of Grandison (wife of George Mason-Villiers), had boasted to her brother that

despite having 'thirty set down to dinner every day in the parlour', their larder would most certainly 'hold out. I've done three does, a warrant gone for a fourth, three brace of pheasants, eight hares, six brace whistling plovers, twelve couple woodcocks, ten brace partridges, a peafowl, two guinea-fowl, snipes and larks without number, and most of these sent for the occasion!'[53]

Another example of such materially oriented domestic performativity is a journal entry from October 1773, in which Lybbe Powys described a visit to Sir James Dashwood's country seat, Kirtlington Park in Oxfordshire. Though not yet completed, she described Kirtlington as 'a most noble' property, and Sir James as 'one of the finest men' she ever met.[54] The central vignette of her account was a viewing of Lady Elizabeth Dashwood's cherished china cabinet.[55] Describing the cabinet as 'the most elegant I ever saw', Lybbe Powys noted that the room, located 'under the flight of stairs going into the garden', lay behind 'a Glass door of which her Ladyship only has a key' and which was ornamented 'with the very finest pieces of old China, and the recesses and shelves, painted pea-green and white, the edges being green in a mosaic pattern with white intermittent'.[56] Having entered the room, Lady Dashwood quizzed her upon the cabinet's precious contents, asking her 'judgement in China as she ever did all the visitors of that Closet, as there was one piece much superior to the others and I thought myself fortunate that a prodigious fine old Japan dish, almost at once struck my eye'.[57] As Stacey Sloboda has argued, in the eighteenth century 'exceptional, old, and expensive porcelains signified sociable and aesthetic examples of curious materiality', an association that was clearly exploited by Lady Dashwood's exercise in sinophilia.[58]

While the contemporary semantics of porcelain, and specifically Chinese porcelain, have been well documented by a number of scholars, many of these interpretations have focused upon the metaphorical possibility of ceramics' delicate surface, namely its propensity to break, crack or shatter, and its physical capacity as a form of container.[59] As Lybbe Powys's description of Lady Dashwood's china room shows, contemporary reportage upon collections of porcelain and china similarly exploited their semiotic potential, using such items to create richly performative and object-centred narratives in which the physical properties of ceramics became a crucial device for the articulation of respectable sociability and tasteful judgement. Evoking the contemporaneous phenomenon for 'it-narratives', a discrete genre of literature in which objects or non-vocal beings such as pets, narrated the events occurring around them, Lybbe Powys's anecdotes of material display and subsequent social interaction are it-*centred* narratives, in which both the forms of material culture and the

domestic spaces that housed them, became central and narrative foci within the journals.⁶⁰

Lybbe Powys's note that this encounter occurred with *all* 'the visitors of that Closet', suggests that the visit to the china cabinet, and the subsequent 'guessing game' that followed, was a ritualized practice at Kirtlington, perhaps experienced by many of the Park's female visitors. Throughout her journals, Lybbe Powys pays particular attention to recording examples of chinoiserie and porcelain, and is careful to demonstrate her discerning taste and judgement when doing so.⁶¹ When visiting Rose Hill (a property near Fawley Court) in 1771, for example, she praised the 'exact Chinese house' for its execution in the '*true* chinese taste'.⁶² Similarly, in 1766, whilst at Shrubs Hill (part of the Duke of Cumberland's 'Lodge' in Windsor Great Park) she recorded seeing a 'Chinese Island, on which is a small house quite in the taste of that nation [...] decorated with Bells and Chinese ornaments', concluding authoritatively, that 'the whole of the little spot is well worth seeing'.⁶³

When hosts took visitors into spaces specially designated for the housing or display of the estate's material wealth, they were aware that such encounters would impress upon their guests the sumptuous materiality of their home. Reciprocally, and as Lybbe Powys's descriptions suggest, both viewing and subsequently commenting upon material objects, was also a powerful means by which to demonstrate taste, knowledge and respectability. Be it through the delicate arrangement of early porcelain at Kirtlington, or the abundantly supplied larder of Weasenham, host and guest alike were entered into a dialogue of veneration and a performative, material hospitality, of which tourism, sociability and description were constituent elements.

Lybbe Powys's account of Weasenham is also important in providing an account of male-centric, intra-familial sociability and its relationship with contemporary material culture. As noted by a number of scholars, male consumers have been comparatively overlooked within the historiography on consumption.⁶⁴ However, as Karen Harvey has asserted, 'male domestic authority was firmly embedded in the subtle but potent everyday material practices of the house'.⁶⁵ In presenting his guests with panoply meat and game, Jackson enacted a kind of hospitality that exploited the 'fruits of the estate' of Weasenham. This performance constituted a confluence of competing identities, and of patriarchy, husbandry and domesticity, conflated to become sympathetic manifestations of contemporary masculine power and authority over the familial estate. As Susan Whyman has explained, since the late seventeenth century, these 'fruits' were routinely exchanged with acquaintances as part of a process of demonstrable

sociability, particularly through gifts of food items such as venison.⁶⁶ The practice of sending friends various kinds of meat, and particularly game, continued throughout the eighteenth century, with numerous correspondents thanking their acquaintances for gifts such as hams, woodcock, partridge, and other fowl. A 1798 letter from George Chamberlayne to Sir Richard Bedingfield, for example, suggested the affective potency of such a gift. Responding to a gift of fowl, he proclaimed that his correspondent was:

> much more bountiful to me than I expect I deserve; I have no means of repaying such kindness as you have shown me, than by wishing all prosperity and happiness to the house of Oxburgh. I reflect with pleasure on the many obligations conferr'd on me and mine during three generations.⁶⁷

Whyman argues that these exchanges serve to reveal the cultural values embodied by game, which to contemporaries in both the seventeenth and eighteenth centuries denoted 'paternalism, hospitality, privilege, pride, glorification of private property, masculinity, and authority', symbolically constituting 'a passionate celebration of the land, its owner, and his power'.⁶⁸ Jackson's proffering of game raised, caught and killed on his estate, clearly aimed to advance those same genealogical and familial functions. Simultaneously, letters such as Chamberlayne's suggest that receiving and eating such produce could cultivate a sense of privileged intimacy, a sentiment that would only be amplified by the redolently circular provision of this hospitality within Jackson's own home, that is, eating the fruits of Weasenham's estate amongst friends, while on the estate itself.

Like the larder, the neatly furnished dairy had also become an important extra-domestic space for the entertainment of, and provision for, visitors.⁶⁹ When visiting the Jacksons in 1756, Lybbe Powys and her mother also visited a number of neighbouring properties, including Holkham Hall, the historic seat of the Coke family, who would become the Earls of Leicester. Within her description of Holkham, Lybbe Powys expressed particular interest in the estate management demonstrated by Lady Margaret Coke, Countess of Leicester (1700–75), which she located spatially within a discussion of the house's kitchen and attendant dairy. Her conception of both Lady Leicester and Holkham itself was clearly strongly coloured by impressions furnished upon her by Jackson, who had previously advocated for Coke's kind character and competent housewifery. With enthusiasm, Lybbe Powys recalled that Holkham possessed 'such an amazing large and good kitchen I never saw', and that Jackson had spoken to her often of 'Lady Leicester's great notability', having often stayed 'a week together' at

Holkham.⁷⁰ According to Jackson, Lady Leicester inspected the wing containing the kitchen each morning, and he remarked to Lybbe Powys that one day, he had even seen 'her ladyship in her kitchen at six o'clock, thinking all her guests safe in bed, I suppose'.⁷¹ With such affirmations of its owner's upstanding character surely in mind, Lybbe Powys described Lady Leicester's dairy as 'the neatest place you can imagine, the whole marble [...] so that it all looks so delicate, and the butter made into such pretty patts hardly larger than a sixpence'.⁷² Tellingly, while her descriptions of the interiors of Holkham Hall proper hardly vary from those of other such impressive properties located throughout the country, it is Lady Leicester's diligent supervision of her home that creates the most striking impression in Lybbe Powys's correspondence.

John Crowley has argued that dairies 'exquisitely combined fashionable naturalness with careful control over the environmental results', thereby functioning as a 'highly decorated leisure space', which 'integrated function with ornament'.⁷³ Citing their tiled surfaces, emphasis on cleanliness, displays of porcelain and other ceramics, and the fact that many garden-dairies also comprised tea rooms for the entertainment of guests, Crowley presents the dairy as a uniquely performative space, which dually emphasized both the leisured and productive aspects of the estate. In both Crowley's account and Lybbe Powys's own writings then, the dairy emerges as a crucial space for aesthetic display, in which shining surfaces, temperature control, technological developments and delicate porcelain, culminated in a visual and material scheme that embodied visitor's expectations of a home that was well-maintained, beautifully ornamented, and indeed, comfortable.

Significantly, another of Lybbe Powys's close friends, Sarah Freeman of Fawley Court, also maintained a much-praised dairy, which Lybbe Powys described in 1771 as 'a most elegant dairy in the garden, ornamented with a profusion of fine old china'.⁷⁴ However, far from simply functioning as an ornamental room that suggested its accordance with contemporary models of fashionable rusticity, Fawley's dairy was a productive, collaborative space, expertly supervised by Freeman and commented upon as such by contemporaries. In his review of early nineteenth-century agricultural practices, first published in 1815, a Mr Marshall praised both Sambrooke and Sarah Freeman's proficiency in this area, noting that 'Mrs. Freeman is extremely neat and regular in the management of the dairy. This is the only instance I met with in Bucks, where the dairy-maid *milks cows*, and where cows are constantly milked *three* times a day, by which means Mrs. Freeman is quite sure the quantity of milk is increased'.⁷⁵ Of 'raising and collecting the *Cream*' Marshall notes that unlike her contemporaries whom

employed receptacles of lead or wood, 'Mrs. Freeman uses trays made of tin' and stone, while on the subject of skimming the milk, 'Mrs. Freeman skims the milk only once, and that after twenty-four hours'.⁷⁶ Such accounts demonstrate that the dairy was perceived as an inherently feminine space, deeply associated with the acceptable demonstration of female labour. Only certain forms of domestic production, such as needlework, or in this case, the management of an estate's dairy, constituted suitable forms of employment for genteel women at this time. Like needlework, which also united ornamental and productive labour, the management of a property's dairy eschewed concerns about both aristocratic luxuriation and the labouring-class necessity to work.⁷⁷ In accordance with this paradigm, Marshall's warm assessment of Fawley Court placed Freeman firmly within the productive, yet ornamental practices employed within the dairy. Presenting a householder concerned with the quantity, quality and the sale of its produce, Marshall highlights that Freeman's dairy, whilst 'ornamented with a profusion of fine old china' was not only an aesthetic site, but also one of manufacture, in which the intervention of the homeowner was central.

Like Lady Leicester's dairy at Holkham, or Jackson's brimming larder, such external domestic spaces were particularly impressive if they demonstrated their utility, either producing 'pretty pats of butter', or providing for dinners 'so good they would need no alteration'. In short, a visit to these spaces visually signified to the viewer that the home was a well-managed one, and that their host was equally diligent. Furthermore, as discussed in Chapter 4, performatively displaying such spaces to the visitor as part of a tour of a home in which one was staying, implicated them within a material objectscape of home-grown hospitality, further impressing the productive capabilities of the estate, while demonstrating to guests that this produce would be used to attend to their needs.

A concern with how material culture was employed as part of an attendance to guests' comfort consistently recurs within Lybbe Powys's journals. When visiting Holkham as part of her 1756 tour, which as contemporaries noted contained an area 'wholly calculated to accommodate Company [...] called the Stranger's Wing', Lybbe Powys described the housekeeper's provision of a breakfast 'in the genteelest taste, with all kinds of cakes and fruit, placed undesired in an apartment we were to go through', on behalf of the Coke family, who at the time were 'from home'.⁷⁸ The family's generosity received particular approbation from Lybbe Powys, who then bemoaned how when visiting 'one is so often asked whether one *chuses* chocolate, which forbidding word puts (as intended) a negative on the question'.⁷⁹

Acquired through the mechanisms of trade and empire, the consumption of hot liquors – specifically, tea, coffee and hot chocolate – were amongst the defining social practices of the eighteenth century.[80] Whether lubricating enlightened debate within coffee houses or engendering female sociability at the tea table, hot drinks were rich with ideological and symbolic potential, while cultivating a physical and social sense of comfort. Both Lybbe Powys's objection to being asked *whether* she wanted hot chocolate, rather than it being welcomingly served to her without reservation, as well as her praise of Holkham's housekeeper, are suggestive of the discomfort that she had previously felt within someone's home, thereby reinforcing just how deeply embedded the offering of food and hot liquors were within contemporary models of sociability. These evocative transcriptions of the sensuous and sumptuous qualities of the eighteenth-century interior, in which intangible and fleeting sensorial pleasures were of equal significance to more stately decorations, here combine to provide readers with a sense that comfort, and how this was given to guests by their hosts, was a defining aspect of contemporary social interaction.

In Lybbe Powys's correspondence, there is a distinction between the accounts of those homes she visited as part of an act of hospitality and sociability in which she was engaged by its owner, and those she visits purely to view the house and its contents. However, Lybbe Powys's account of Holkham suggests that these two modes of interaction were not mutually exclusive, but that respectable sociable exchange was possible even when the home's owner was absent, thanks to the hospitable function of its interior furnishings and the provision of food and drink. That Lybbe Powys's assessment of Lady Leicester's household was so cordial, even in the absence of its family, suggests that her opinion was jointly based upon commentary provided by Jackson, as well as the performance of certain social and domestic rituals, in which an 'objectscape' of housewifery figured prominently. Consequently, the journals do more than simply provide an account of contemporary sociability, instead describing a culture of visiting that, through material culture, was equally possible to enact with house and owner, even in the absence of the latter.

Sociability

At Holkham, Lybbe Powys's experiences as a country house tourist were both facilitated and shaped by her status as a guest at Weasenham Hall. Accordingly, her 1756 tour is particularly significant as an example of how Lybbe Powys and

her family organized their domestic tourism and attendant schedule of visits. Typically, these tours employed the home of a family friend or relative as a base from which they could visit properties in the surrounding area, in this case going from Weasenham Hall to visit nearby homes. This was also true of Lybbe Powys's 1778 visit to Mrs Annesley of Bletchingdon House, Oxford, during which the party of fourteen guests went to see 'places everyday we were there', starting with the nearest, Blenheim Palace.[81] As she noted to her father in her account of her 1756 tour, the Jacksons received 'a vast deal of company', although she conceded that this was 'not half they used to have in Mrs. Jackson's lifetime, when the Orford, Leicester, and Townsend families and theirs, used to meet almost every week at each other's houses'.[82] While Lord Townsend was not 'now down at Rainham', 'nor [...] the Leicester's at Holkham' during the time of the family's visit, Jackson nevertheless entertained the current Lord Orford (George Walpole, 3rd Earl of Orford, resident at Houghton between 1751 and 1791), 'Mr. and Mrs. Lee Warner of Walsingham' (Henry and Mary Lee Warner of Walsingham Abbey, 1688–1760), 'Mr. Spilman', 'Captain Hambleton', 'Mr. Host', 'Mr. and Mrs. Carr and family', 'the clergyman and his wife', and, in keeping with Lybbe Powys's description of Jackson as a benevolent landlord, on Sundays his tenants also dined at the house.[83] As Lybbe Powys wrote to her father 'since my last letter we have had company every day to dinner'.[84]

Beyond this quotidian round of company, while staying at Weasenham Lybbe Powys and her mother were also exposed to those visitors who were likewise based at the house. These included Sir William Harbord, Baron Suffield (c. 1697–1770), who had been at Weasenham 'for some days', and like 'all of the families I've mentioned as visiting here', 'most obligingly insisted on seeing us at each of their houses'.[85] Though these requests ultimately went unreturned on this trip, her account nevertheless presents Jackson's home as a nexus of sociability, in which guests would be introduced to each other and potential future relationships formed.[86] Despite their polite refusal of several invitations, Lybbe Powys and her mother did manage to visit a number of nearby properties owned by those whom the pair had met during dinners at Weasenham, including Houghton Hall and the home of Mr Spilman, whose eccentric personality, was, in Lybbe Powys's eyes, only matched by the decoration of his home.[87]

Such accounts of sociability between households recall when in 1753, Hannah Mary Reynolds, daughter of the philanthropist Richard Reynolds, had described how homeowners 'generally look'd cheerful, and seem'd pleas'd with [...]

company, having been accostom'd to have publice friends viset them'.[88] This idea of the 'public friend' is an evocative concept, providing a neat metaphor for visiting properties, with whose owners tourists may not have been previously acquainted, but whose social connections formed 'on the road', might engender visits to their home. Accordingly, the 'fruits of the estate' enjoyed by the visitor comprised not merely the material or gastronomic produce grown or reared on the property, but also the social fruits fostered by intra-domestic interaction, in which guests and visitors alike functioned as 'public friends' within their host's own network of sociability.

Having previously met around the dinner table at Weasenham Hall, relations between their hosts for this trip, the Jacksons, and the current Lord Orford had been crucial in both the Girle's reception in and invitation to Houghton Hall, built at the behest of Sir Robert Walpole (1676–1745) between 1722–38. Writing to her father, of the 'strikingly fine [...] gallery of paintings' at Houghton, Lybbe Powys promised that she would bring him 'home a catalogue, as I've taken the pains to copy a written one the late Lord gave to Mr. Jackson'.[89] As already established, Lybbe Powys's journals exemplify the confluence between forms of travel and its attendant body of literature, in this instance highlighting the relationship between the catalogue given to Jackson, and her own writings, the descriptive tendencies of which hints towards their relationship with forms of literary production consumed by tourists during their travels. The production of both manuscript and published catalogues of homes grew analogously with the rise of domestic tourism, heralding a canon of British architectural gems to be sought out by the traveller, including country houses such as Holkham, Castle Howard and Blenheim Palace.[90] In 1794, for example, the young traveller Mary Anne Keene wrote an account of Warwick Castle, which she described as 'quite perfect [...] fitted up in the most magnificent stile [with] a very fine collection of pictures', which she then proceeded to list under the title of 'some of the principal Pictures in Warwick Castle', producing a formulaic catalogue typical of contemporary travel writing.[91] Within Lybbe Powys's journals, the formal characteristics of such literature were likewise emulated and reproduced, a process that echoes Wall's argument regarding the increasingly strong relationship between the diurnal and the descriptive during this period. As Wall suggests, the 'textual articulation of detail' exemplified by descriptions of homes, found its 'critical vocabulary' from the supplementary guidebooks provided to tourists during their visits to these great houses, a 'sort of cultural interweaving' or 'mutual influencing between visitors and guidebooks', which can be seen in Lybbe Powys's own collection and reading of catalogues such as that of Houghton's picture collection.[92]

Walpole's presentation of a guidebook to his home to his friend Jackson is also significant here, as it suggests an affective, as well as informative, use for such texts, something explored at length in Chapter 5.[93] In the interim, it is crucial to note the familial dynamics of this transaction, rendered particularly significant by Horace Walpole's production of a similar catalogue of his father's paintings at Houghton, published in 1747, his *Ædes Walpolianae; or, a Description of the Collection of Pictures at Houghton Hall in Norfolk*.[94] In fitting emulation of his father's exchange of books, eighty-three of the one hundred printed copies of the *Ædes Walpolianae* were distributed as gifts amongst Walpole's friends.[95] Though Sir Robert died in 1745, well before the volume's eventual publication, Walpole's effusive dedication to his father dates from 1743. This suggests that it may have existed in near complete but manuscript format before his father's death, and that his father might conceivably have owned a copy (or several) of the work in manuscript, one of which may have been subsequently given to Jackson and later passed on to Lybbe Powys herself.[96] Alternatively, the catalogue of paintings may be derived from Walpole's 1742 *Sermon on Painting*, 'which referred to individual paintings at Houghton and which was delivered before Lord Orford by his chaplain'.[97]

This familial documentation of Houghton's collections is appropriate for a conglomeration of objects whose owner relied heavily on contributions from friends and family. Having never travelled to Italy himself, much of Robert Walpole's collections were gifts from those who had. His bronze copy of the Borghese gladiator, for example, was given to him by Thomas Herbert, the eighth Earl of Pembroke (1656–1708); while Horace Walpole's first tour of Italy in 1739 had initially been undertaken for the purpose of enriching Houghton's collection.[98] It is unclear from Lybbe Powys's 1756 journal whether the written catalogue given to Mr Jackson formed either the basis for Walpole's own text, or vice versa. It is quite possible however, that Lybbe Powys read Walpole's own guide to the collections before, or even while compiling her own. Indeed, there are chronological and formal confluences that occur throughout her journals and correspondence that suggest that Lybbe Powys had been given access to guidebooks from those properties she visited. When she travelled to Horace Walpole's own home Strawberry Hill in 1785 for example, she retrospectively recorded this visit in a diary entry dating from June 1786, whose content provocatively echoes Walpole's own guidebook to his home, his 1784 *Description of the Villa of Mr. Horace Walpole*, a text discussed in greater detail in Chapter 5 of this book. While Clarke has argued that this text was emphatically not produced for the captive audience of tourists who frequented Walpole's home,

he concedes that versions of this text may have been circulated amongst Walpole's friends and acquaintances, of which, we know Lybbe Powys was one.[99] Certainly, by 1785, when Lybbe Powys visited the property, the expanded 1784 edition had been recently produced.[100] Furthermore, several of Lybbe Powys's own notes from the property are directly comparable with the text of the 1774 edition, copies of which Walpole himself admitted were intended as gifts.[101] Taking the form of a list, Lybbe Powys records the following list of paintings in her description of Strawberry Hill:

> Madame de Maintenon.
> Madame de la Vallière.
> Comtesse de Grammont (Miss Hamilton).
> Madame de Sevigné, when young; very beautiful.
> Ditto, small, with that of Madame de Grignan, her daughter.
> An original and only picture of Ninon de l'Enclos.
> Original of Henry VIII, by Hans Holbein.
> Cowley, when a boy, by Sir Peter Lely.
> Numbers of fine miniatures, and other curiosities.[102]

Unlike many of her journal entries, that detailing the contents of Strawberry Hill reflects the perfunctory character of its inclusion; written way after the fact and, accordingly, lacking the anecdotal flair which accompanies many of the descriptions of homes as discussed above. Nevertheless, her descriptions of the portrait of Madame de Maintenon, the Countess de Grammont, and Madame de Grignan each have corresponding entries in the *Description*.[103] Furthermore, several of the listings even employ language seemingly directly lifted from the *Description* itself, as in Lybbe Powys's mention of 'An original and only picture of Ninon de l'Enclos', described in the 1774 text as 'Ninon de l'Enclos, the only original picture of her'.[104] Similarly, Lybbe Powys's inclusion of the portrait of 'Madame de Sevigne, when young', echoes the *Description*'s 'Madame de Sevigne, when a young widow'.[105] While there are many omissions from Lybbe Powys's short description of Walpole's property, the coincidental instances in the wording and familiarity of expression between the two documents is suggestive, laying credence to the idea that certain visitors may have had access to either or both of the copies of the *Description* published by the time of Lybbe Powys's visit in 1785. However, even if, as Clarke strongly argues, very few copies of the *Description* intentionally met public hands before Walpole's death in 1797, Lybbe Powys's own attempt at cataloguing the property may be seen as an endeavour on her part to fill a void, potentially left by the lack of access to Strawberry Hill's

catalogue in an age in which they were so routinely available. Moreover, given her propensity for travel and for recording her journeys, it seems likely that Lybbe Powys would have been interested in consuming travel literature and tourist guides to the homes she visited, which by the late century, were ubiquitous.

Recalling the idea that country house visiting was simultaneously an intellectual, material and familial experience, the description of a hand-written catalogue of Houghton's paintings, perhaps written by Horace Walpole, given by the late Lord Orford to Mr Jackson, which was then transcribed by Lybbe Powys and subsequently gifted to her father, presents a complex metaphorical social interaction, one in which both absent and present participants meet through an exchange of descriptive information. From Lybbe Powys, her father and Jackson, to both Robert and Horace Walpole, each was in some way involved in the generous gift of the catalogue, an act of material and literary sociability that more broadly mirrors the social nature of contemporary (epistolary) writing at this time.

Epistolarity

On 30 December 1785, Lybbe Powys wrote a letter to an anonymous friend, endeavouring 'to entertain, as you say I always do, by my anecdotes of this social neighbourhood'.[106] Typical of these anecdotes is a letter completed in the January of the following year, in which she wrote to a friend detailing an 'amusing account of a party of distinguished foreigners visiting unexpectedly her friends and neighbours, General Conway and his wife, Lady Ailesbury, at Park Place'. Describing hastily prepared meals and beds, the account stresses the social fluidity that was typical of late eighteenth-century social interaction, and the status-related anxieties that an unexpected visit might prompt. Like much of Lybbe Powys's journals and correspondence, this narrative of frantically arranged hospitality reiterates the intimate relationship between the provision of material comforts – from dinner to a warm bed – and the forms of sociability enacted within the space of the home. More significant, however, were the various incarnations of the anecdote, from Caroline Campbell, Countess of Ailesbury's retelling, to Lybbe Powys's own detailed recollection. Such epistolary exchanges suggest that visiting culture was sociable exchange not only in the first physical and experiential instance, but also in its descriptive and epistolary afterlives. Viewed as such, Lybbe Powys's journals present the experience of sociable travel as something that operates on more than one temporal moment. Like her

account of her visit to Houghton's picture collection, such encounters embody the sensorial, social and material involvement of the visitor, which when captured in various forms of epistolary or diurnal reflection, could be relived multiple times by absent participants.

Indeed, Lybbe Powys's correspondence itself demonstrates an awareness that description functioned in this way. When in 1756, she included a full description of Weasenham Hall in the letters addressed to her father, despite his familiarity with the property, she justified its presence by voicing her concern that 'tho' you are not unacquainted with it, my journals would be deficient if without this description'.[107] This concern with the potential deficiency of her journal is also echoed within its opening, in which, when explaining its translation from an epistolary correspondence between father and daughter into journalistic form, Lybbe Powys anticipates the text's future consumption by readers beyond this intimate pair. Prefacing the journal with a disclaimer, she writes that 'if any one chuses to peruse it, I've only to call their friendship to my aid, which, like affection in a parent, ever draws a veil over errors unintended'.[108] Taken together, Lybbe Powys's desire to present a complete account of her tour through Norfolk, alongside this highly reflexive preface, is suggestive of the open nature of epistolary and diurnal writing during this time, in which letters functioned as 'cultural artefacts that revealed the interplay of public and private, political and personal'.[109]

Inherently, Lybbe Powys's physical transcription of her letters into journalistic dossiers confirms her own particular sensitivity to the public character of epistolary writings, functioning as a material process that anticipated the journals' future handling, reading and enjoyment by others. Letters and journals were often read aloud during this period, and resultantly, many correspondents 'stage managed the character [...] displayed to descendants, by selecting, rephrasing, and correcting [their] store of manuscript letters'.[110] The poet Anna Seward, for example, began transcribing her letters for publication from 1784.[111] In a letter dated 17 July 1807 to a Mr Constable, she wrote that in her will, she had left him 'the exclusive copy-right of Twelve Volumes (vi) quarto, half-bound. They contain copies of letters, that, after I had written them, appeared to me worth the attention of the public [...] I wish you to publish two volumes annually'.[112] Highly aware of their potential public appeal, many writers either retrospectively edited their correspondence or burned that which they did not want to survive.[113]

In her own nod towards literary posterity, Lybbe Powys was highly concerned that her journals comprised complete and accurate records, at times returning

to, and subsequently correcting, her text. Her description of Strawberry Hill, for example, was inserted into her diaries a year after the fact, diligently translated from a 'memorandum of many curious pictures I had seen there', which fastidiously recorded the 'pictures I set down', alongside a description of the many other 'valuable rarities', in Walpole's possession.[114] Often adding addendums to her journal entries, Lybbe Powys would return to include notes such as 'N.B. Since the above, Mr. Freeman has erected an elegant building in his island, planned and executed by Wyatt, and the room is ornamented in a very expensive manner', or 'Since I was at Belvedere, I hear Sir Sampson has rebuilt the house in a most magnificent taste, and immensely large'.[115] These revisions demonstrate an existence for her journals well beyond their initial writing, after which point they were modified, reviewed and shared. Like the material culture that she recorded, her journals were themselves social objects, read by friends and family alike, and perhaps even by the owners of those homes that they described.

Like epistolary writing, the travel journal was also subject to intimate publication amongst friends and family. As Mark Elstob described in the preface to his 1779 *A trip to Kilkenny, from Durham*, 'the letters which gave birth to this little book, were principally intended to amuse a near relation: But those letters not being confined to one hand, nor even to a few hands, they in a little time became almost a public manuscript. – Some requested, and all approved of, their publication'.[116] In being read by family members and friends, the significance of the journals shifts from their status as Lybbe Powys's own literary observations, to their becoming public, consumable and material objects, which could be handled, passed around, shared and discussed with family and visitors alike. Though not initially intended for publication, the journals themselves confirm that these manuscripts were accessible for friends and relatives to read at Lybbe Powys's seat at Hardwick House, as the opening to her 1771 *Shropshire Journal* asserts. Taken from three letters to her cousin, Margaretta Wheatley, Lybbe Powys dedicated the account of her latest tour to her relative, noting Wheatley's 'kind partiality to your friend when last at Hardwick [. . .] in professing yourself entertain'd by journals of my former excursions'.[117] Continuing, she confessed how she 'vainly imagine[d]' that she could give her cousin 'pleasure by a concise account of our present journey into Shropshire'.[118]

Stuart Sherman has highlighted the public function of such 'journey packets' of what he calls 'letter-journals', which he discusses in relation to the epistolary conduct of Frances Burney.[119] Recounting an anecdote contained within Burney's early journals (in which her father had found and subsequently kept one of her diary pages), Sherman highlights the difference between private journals, the

reading of which had caused Burney both embarrassment and distress, and what he calls 'journal-letters', literary transactions of the kind also written by Lybbe Powys to her father and her cousin.[120] The reception of Lybbe Powys's own packets of 'journal-letters' was characterized by a number of eager participants, including the author herself, who actively anticipated an interest in her journals on behalf of readers such as her cousin and her father, and wrote accordingly to cater to their literary tastes.

As texts which were constantly and consistently *subjected* to the gaze of those other than the author, the diary form was inherently a public one.[121] The fashioning of an author's identity through such a text, was therefore, as a much an act of self-fashioning through the process of writing, as a fashioning of the subject enacted by the readers of those texts, in which familiar literary devices, such as narrative description and formulaic diurnal writing formed central and shared mechanisms. As Sherman has argued, the eighteenth century represented a 'culturally crucial encounter' between 'chronometry and a prose structure', a convergence that manifests itself most prominently in the diurnal form.[122] Emphasizing the significance of this form of writing, Sherman suggests that 'genres deployed the diurnal form as a means of enabling authors to recognize, interpret and inhabit the temporality by which the whole culture was learning to live and work'.[123] Accordingly, diurnal literature articulated subjective quotidian experience in such a way that had real significance for contemporaries, for whom this new literary form was particularly germane. While the exchange of such letters and journals clearly bolstered and cemented congenial relationships through an enjoyment of shared experience, in the case of Lybbe Powys, this literary sociability was facilitated by the culmination between the anecdotal and the diurnal, through the medium of thick description.

Conclusions

Just as Geertz has called cultural analysis 'our own constructions of other people's constructions', it is essential to remember that Lybbe Powys's journals are highly mediated constructions of eighteenth-century culture.[124] Exemplifying their orchestrated nature, the opening of her 1760 Plymouth Journal discusses her desire to become a better writer: 'if the rusticity of a dull pen, like a piece of rough marble, may be polish'd by exercise, then (as I've scribbled o'er much paper), may I in time, perhaps, have the honorary title of an expert journalist. Here am I now commencing my fourth essay on our summer's rambles'.[125] As is

typical of her writings, here Lybbe Powys employs a material object – the 'piece of rough marble' – to conjure an evocative image, constituting a particularly suggestive marriage between the form and function of the texts. Just like the ritualized performances of material politeness that she so consistently returns to throughout their course, the journals themselves constitute highly eloquent and orchestrated observations; an apt culmination of the journal's formal features and narrative content.

Beyond their detailed transcriptions of eighteenth-century interior space, much of the journals' significance hinges upon their oscillation between the states of consumption and production that they variously assumed throughout their intellectual gestation, initial writing, transcription and subsequent reading. From the physical production and writing of the journals by Lybbe Powys, to their eventual publication for a new public audience in the late-nineteenth century, the journals' fluid material states are closely mirrored by their concordantly fluid relationships with their maker-owners. On the one hand, this constant mutability is reminiscent of the vacillation between forms of physical and intellectual production and consumption that all objects embody, but on the other, it prompts us to consider the provocative simultaneity of the owner-reader-maker's relationships within the journals themselves more actively. This stimulating coalescence between the form and function of the journals is particularly clear in their treatment of both material culture and sociability, wherein the journals' lengthy descriptions of each are paralleled by the fact that they themselves functioned as both material and sociable objects. Conceived of in this way, the journals were physical, consumable objects that told narratives of consumption; sociable objects that detailed sociability while simultaneously enabling the same between Lybbe Powys and members of her family; and objects that described the creation of comfort, while providing absent members of the family with feelings of consolation and intimacy.

Written twenty-six years after Lybbe Powys's first tour to Norfolk, the opening to Richard Beatniffe's *The Norfolk Tour or, Traveller's Pocket Companion*, published in 1773, expounds its author's ability to 'offer a more satisfactory account of [Norfolk] than has been given in any former tract'.[126] Describing the many stately collections afforded by a visit to the county, Beatniffe's tour includes a catalogue of the treasures of Holkham, Narford and Houghton. Beatniffe's is a travel guide for the gentleman connoisseur, providing the reader with both ready-formed judgements and detailed descriptions of interiors.[127] Offering buildings' exact dimensions, descriptions of innovative spatial layouts, and the order in which their paintings were displayed, Beatniffe provides a highly

accurate descriptive account of Norfolk's many fine collections of art and antiquities.

Unlike Lybbe Powys's 1756 tour of Norfolk however, Beatniffe's account lacks a sense of the interaction and sociability enacted between the visitor to, and owner of, a house, instead presenting them as gorgeously attired, but inherently empty spaces, bereft of life. While Lybbe Powys's description of Holkham Hall includes the same meditations upon its broad vistas, elegant grounds and impressive architectural features, it is her relation of these aspects to their socio-cultural present that renders her description thick. More than providing a sheer abundance of detail, Lybbe Powys's descriptions are characterized by their interpretive context, descriptions which make houses into homes. The descriptions employed within Lybbe Powys's 'anecdotes of [her] social neighbourhood', constitute thickly interpretative accounts of hospitality, sociability, and materiality, which in turn may be implicated within a thick interpretation of eighteenth-century culture, from which the historian may 'draw large conclusions from small, but very densely textured facts'.[128]

Notes

1 Emily J. Climenson (ed.), *Passages from the Diaries of Mrs. Philip Lybbe Powys of Hardwick House, Oxon. A.D. 1756 to 1808* (London: Longmans, Green, and Co. 1899), 186. For a biography of Lybbe Powys, see Ann Pimlott Baker, 'Powys, Caroline (1738–1817)', Oxford Dictionary of National Biography (Online Edition) (Oxford University Press, 2004). Written between 1756 and 1808, and now housed between the British Library (Caroline Lybbe Powys Diaries, Add MSS 42610–42173) and Lybbe Powys's familial home of Hardwick House, Oxfordshire, her correspondence was edited by Emily Climenson in the 1890s, and published in 1899.
2 Climenson, *Passages*, 178.
3 Ibid., 179.
4 Ibid., 185.
5 Ibid., 185–7.
6 Ibid., 187.
7 See for example: Linda Levy Peck, *Consuming Splendor: Society and Culture in Seventeenth-Century England* (Cambridge: Cambridge University Press, 2005).
8 On the emergence of comfort as a discourse see: John E. Crowley, *The Invention of Comfort: Sensibilities and Design in Early Modern Britain and North America* (Baltimore & London: John Hopkins University Press, 2001).
9 Pimlott Baker, 'Powys, Caroline (1738–1817)'.

10 For example, in *Fabricating the Antique*, Coltman cites Lybbe Powys's description of Sambrooke Freeman's residence at Fawley Court within her discussion of the Etruscan style of interior decoration that was much in vogue in the latter half of the eighteenth century. However, Coltman's citation of Lybbe Powys fails to take into account the close social relationship shared between the family and the Freemans, which both strongly coloured and formed Lybbe Powys's description of their home. Coltman, *Fabricating the Antique*, 93.

11 George Haggerty, 'Horace Walpole's Epistolary Friendships', *Journal for Eighteenth-Century Studies*, 29 (2006): 217.

12 Ibid. See also Viccy Coltman, 'Paper trails of imperial trav(a)ils: Janet Schaw's Journal of a journey from Scotland to the West Indies, North Carolina and Portugal, 1774–1776', in Kate Smith and Rosie Dias (eds), *British Women and Cultural Practices of Empire, 1770–1940* (New York & London: Bloomsbury Visual Arts, 2018), 51–71.

13 Anderson, *Touring and Publicizing*, 32. Zoë Kinsley, *Women Writing the Home Tour, 1682–1812* (Aldershot & Burlington: Ashgate, 2012), 8–9.

14 Jo Dahn, 'Mrs Delany and Ceramics in the Objectscape', *Interpreting Ceramics*, 1 (2000), http://www.interpretingceramics.com/issue001/delany/delany.htm

15 Coltman, *Fabricating the Antique*, 65–96.

16 George M. Woodward, *Eccentric Excursions: or, Literary & Pictorial Sketches of Countenance* (London: Allen & Co. 1796), iv.

17 For the sensory turn in art history, see: Jenni Lauwrens, 'Welcome to the revolution: The sensory turn and art history', *Journal of Art Historiography*, 7 (2012): 1–17; Patrizia di Bello and Gabriel Koureas (eds), *Art, History and the Senses: 1830 to the Present* (Farnham & Burlington: Ashgate, 2010); Francis Halsall, 'One sense is never enough', *Journal of Visual Arts Practice*, 3, no. 2 (2004): 103–22.

18 Mimi Hellman, 'Furniture, Sociability and the Work of Leisure in Eighteenth-Century France', *Eighteenth-Century Studies*, 32, no. 4 (1999): 416.

19 Brian M. Norton, '*The Spectator* and Everyday Aesthetics', *Lumen: Selected Proceedings from the Canadian Society for Eighteenth-Century Studies/Lumen: travaux choisis de la Société canadienne d'étude du dix-huitième siècle*, 34 (2015): 123.

20 Elizabeth Bohls, *Women Travel Writers and the Language of Aesthetics 1716–1818* (Cambridge: Cambridge University Press, 1995), 5.

21 Norton, '*The Spectator* and Everyday Aesthetics', 125.

22 Michel Foucault, *The Order of Things* (London & New York: Routledge, 2005), 149. See also Ursula Klein and Wolfgang Lefèvre, *Materials in Eighteenth-Century Science: A Historical Ontology* (Cambridge, MA: MIT Press, 2007), 297–8, for a discussion of these concepts in an eighteenth-century context.

23 Wall, *The Prose of Things*, 2.

24 Clarke, 'A Fine House Richly Furnished', 205.

25 Climenson, *Passages*, 1. 'Mr. Jackson', was Richard Jackson, Esq. a merchant and a director of the South Sea Company. See W.P. Courtney, 'Jackson, Richard (1721/2–1787)', Rev. J.M. Alter, *Oxford Dictionary of National Biography* (Online Edition), Oxford University Press (2004).
26 Sir Edward Lyttleton, Journal, MS 369, 1755, Cadbury Research Library, University of Birmingham, Birmingham.
27 Montagu Pennington (ed.), *Letters from Mrs. Elizabeth Carter to Mrs. Montagu, between the years 1755 and 1800*, 3 vols. (London: C. & J. Rivington, 1817), 1:161–2.
28 Oswald G. Knapp (ed.), *The Intimate Letters of Piozzi and Pennington* (Stroud: Nonsuch Publishing Limited, 2005), 55.
29 Ibid.
30 Francis Douglas, *A general description of the east coast of Scotland, from Edinburgh to Cullen* (Paisley: Alexander Weir, 1782), 1.
31 Richard Joseph Sulivan, *Observations made during a Tour through Parts of England, Scotland, and Wales: In a Series of Letters* (London: T. Becket, 1780), 1.
32 Edward Daniel Clarke, *A Tour through the South of England, Wales, and Part of Ireland, made during the Summer of 1791* (London: Minerva Press, 1793), ix.
33 Geertz, 'Thick Description', 19.
34 Norman K. Denzin, *Interpretive Interactionism* (Newbury Park, CA: SAGE, 1989), 3.
35 Robert Darnton, *The Great Cat Massacre and Other Episodes in French Cultural History* (New York: Basic Books, 1984), 3–4. Natalie Zemon Davies, *The Return of Martin Guerre* (Cambridge, MA: Harvard University Press, 1982).
36 Geertz, 'Thick Description', 21.
37 Adam Budd, 'Anthropological description and objects of history', in Adam Budd (ed.), *The Modern Historiography Reader: Western Sources* (Abingdon & New York: Routledge, 2009), 421.
38 Climenson, *Passages*, vii.
39 Malcolm Baker, '"For Pembroke Statues, Dirty Gods and Coins": The Collecting, Display and Uses of Sculpture at Wilton House', in Nicholas Penny and Eike D. Schmidt (eds), *Collecting Sculpture in Early Modern Europe* (New Haven & London: Yale University Press, 2008), 379.
40 Climenson, *Passages*, 3.
41 Ibid.
42 Ibid.
43 Ibid., 3–4.
44 Ibid., 7.
45 Charles Hughes (ed.), *Mrs. Piozzi's Thraliana* (London: Simpkin, Marshall, Hamilton, Kent & Co. Ltd, 1913), 33–4.

46 Freya Gowrley, 'Taste *à-la-Mode*: Consuming Foreignness, Picturing Gender', in H. Strobel and J. Germann (eds), *Materializing Gender in Eighteenth-Century Europe* (London: Routledge, 2016), 35–50.
47 Climenson, *Passages*, 4.
48 Ibid., 4. For 'camblet gowns' see *The Leeds Intelligencer* (Leeds), 7 November 1769.
49 Climenson, *Passages*, 4.
50 Wall, *The Prose of Things*, 2.
51 Climenson, *Passages*, 5–6.
52 Ibid., 6.
53 Ibid., 180.
54 Caroline Lybbe Powys, Journals and Recipe Book, Add MSS 42610–42173, 1756–1808 (1773), 4: 68.
55 Ibid.
56 Ibid.
57 Ibid.
58 Stacey Sloboda, 'Displaying Materials: Porcelain and Natural History in the Duchess of Portland's Museum', *Eighteenth-Century Studies*, 43, no. 4 (2010): 457.
59 Elizabeth Kowaleski-Wallace, 'Women, China and Consumer Culture in Eighteenth-Century England', *Eighteenth-Century Studies*, 29, no. 2 (1996): 153–67. See also her *Consuming Subjects: Women, Shopping, and Business in the Eighteenth Century* (New York: Colombia University Press, 1997), particularly, 52–70.
60 On it-narratives see Blackwell, *The Secret Life of Things*.
61 The role of material objects in framing and staging relationships between women has recently been explored at length in the work of Madeleine Pelling. See Pelling, 'Collecting the World'.
62 Climenson, *Passages*, 123.
63 Ibid., 114.
64 Margot Finn, 'Men's things: masculine possession in the consumer revolution', *Social History*, 25, no. 2 (2002): 134.
65 Karen Harvey, *The Little Republic: Masculinity and Domestic Authority in Eighteenth-Century Britain* (Oxford: Oxford University Press, 2012), 22.
66 Susan E. Whyman, *Sociability and Power in Late-Stuart England: The Culture World of the Verneys, 1660–1720* (Oxford and New York: Oxford University Press, 2002), 16.
67 Letter from George Chamberlayne to Richard Bedingfield, London, 29 December 1798. Jerningham Letters, JER, 1776–1833 23, Cadbury Research Library, University of Birmingham, Birmingham, 117.
68 Whyman, *Sociability and Power*, 16, 29.
69 On the eighteenth-century dairy, see: Meredith Martin, *Dairy Queens: The Politics of Pastoral Architecture from Catherine de' Medici to Marie-Antoinette* (Cambridge, MA:

Harvard University Press, 2011), and Emma Newport, 'The Fictility of Porcelain: Making and Shaping Meaning in Lady Dorothea Banks's "Dairy Book"', *Eighteenth-Century Fiction*, 31, no. 1 (2018): 117–42.

70 Climenson, *Passages*, 10.
71 Ibid.
72 Ibid.
73 John E. Crowley, 'From Luxury to Comfort and Back Again: Landscape Architecture and the Cottage in Britain and America', in M. Berg and E. Eger (eds), *Luxury in the Eighteenth-Century: Debates, Desires and Delectable Goods* (Basingstoke: Palgrave Macmillan, 2002), 137.
74 Climenson, *Passages*, 148.
75 Mr Marshall, *The Review and Abstract of the County Report to the Board of Agriculture from the Several Agricultural Departments of England*, 5 vols. (York: Thomas Wilson & Sons, 1818), 4: 546.
76 Ibid.
77 See Martin, *Dairy Queens*, 2–3, which draws distinctions between the 'pleasure dairy' and the 'preparation dairy'.
78 Climenson, *Passages*, 11.
79 Ibid.
80 See: James Walvin, *Fruits of Empire: Exotic Produce and the British Taste, 1600–1800* (New York: New York University Press, 1997); Elizabeth Kowaleski-Wallace, 'Tea, Gender, and Domesticity in Eighteenth-Century England', *Eighteenth-Century Culture*, 23 (1994): 131–45; Sidney Mintz, *Sweetness and Power: The Place of Sugar in Modern History* (London: Penguin Books, 1986).
81 Climenson, *Passages*, 196.
82 Ibid., 4–5.
83 Ibid., 5.
84 Ibid., 7.
85 Ibid., 9.
86 Ibid.
87 Ibid., 7.
88 Eustace Greg (ed.), *Reynolds-Rathbone Diaries and Letters, 1753–1839* (printed for private circulation, 1905), 180.
89 Climenson, *Passages*, 6.
90 For a discussion of such publications see: Carol Fabricant, 'The Literature of Domestic Tourism and the Public Consumption of Private Property', in Felicity Nussbaum and Laura Brown (eds), *The New Eighteenth Century: Theory, Politics and English Literature* (New York: Meuthen, 1987), 254–75; Jocelyn Anderson, 'Remaking the Space: the Plan and the Route in Country House Guidebooks from 1770 to 1815', *Architectural History*, 54 (2011): 195–212.

91 M.A. Keene, Diary, MS225, 1794. Cadbury Research Library, University of Birmingham, Birmingham, 35–7.
92 Wall, *The Prose of Things*, 193.
93 Climenson, *Passages*, 4–5.
94 Horace Walpole, *Ædes Walpolianae; or, a Description of the Collection of Pictures at Houghton Hall in Norfolk* (London, 1747). According to Peter Sabor, *Ædes Walpolianae* was privately printed in an edition of 100 copies, with subsequent enlarged editions published in 1752 and 1767. Peter Sabor (ed.), *Horace Walpole: The Critical Heritage* (London & New York: Routledge, 1995), 3.
95 Emma J. Clery, 'Horace Walpole, the Strawberry Hill Printing Press and the Emergence of the Gothic Genre', *Ars & Humanitas*, 20, no. 12 (2010): 102.
96 Andrew Moore, *Norfolk and the Grand Tour* (Norwich: Norfolk Museums Service, 1985), 49.
97 Ibid.
98 Ibid., 22–3, 55.
99 While Clarke argues that the *Description* was 'never handed out to the visitors that came to see Walpole's house and collections: indeed it was not published, or even circulated until after his death', he later notes that 'a few copies of the updated and extended 1784 edition were given to particularly favoured friends'. Stephen Clarke, '"Lord God! Jesus! What a House!": Describing and Visiting Strawberry Hill', *Journal for Eighteenth-Century Studies*, 33, no. 3 (2010): 358 and 360. In the journal of her 1776 visit to Stourhead, Lybbe Powys recalls her acquaintance with Walpole. Climenson, *Passages*, 174.
100 Clarke notes that 200 copies of the 1784 edition were published. '"Lord God! Jesus! What a House!"': 358.
101 Ibid., 359.
102 Climenson, *Passages*, 228.
103 Horace Walpole, *A Description of the Villa of Horace Walpole, Youngest Son of Sir Robert Walpole, Earl of Orford, at Strawberry-Hill, near Twickenham* (London: Strawberry Hill, 1774), 105, 104 and 100.
104 Climenson, *Passages*, 228 and Walpole, *A Description*, 104.
105 Climenson, *Passages*, 228 and Walpole, *A Description*, 100.
106 Climenson, *Passages*, 217.
107 Ibid., 3.
108 Ibid., 1.
109 Nicole Pohl, 'The Plausible Selves of Sarah Scott (1721–95)', *Eighteenth-Century Life*, 35, no. 1 (2011): 134.
110 Abigail Williams, '"I Hope to Write as Bad as Ever": Swift's Journal to Stella and the Intimacy of Correspondence', *Eighteenth-Century Life*, 35, no. 1, (2011): 116.

111 Norma Clarke, *The Rise and Fall of the Woman of Letters* (London: Random House, 2004), 13.
112 Anna Seward, *Letters of Anna Seward: Written between the Years 1784 and 1807*, 6 vols. (Edinburgh: George Ramsay & Company, 1811), 1: 5.
113 For example, on 5 January 1798, Hannah Mary Rathbone records that she 'passed a quiet day burning letters, etc., and walking in the garden'. Greg, *Reynolds-Rathbone Diaries*, 74.
114 Climenson, *Passages*, 228.
115 Ibid., 145 and 151.
116 Mark Elstob, *A trip to Kilkenny, from Durham* (Dublin, 1779), i.
117 Climenson, *Passages*, 124.
118 Ibid.
119 Stuart Sherman, *Telling Time: Clocks, Diaries and the English Diurnal Form, 1660–1785* (Chicago & London: Chicago University Press, 1996), 257.
120 Ibid.
121 On this see Felicity A. Nussbaum, *The Autobiographical Subject: Gender and Ideology in Eighteenth-Century England* (Baltimore & London: The John Hopkins University Press, 1989).
122 Sherman, *Telling Time*, x.
123 Ibid., xi.
124 Geertz, 'Thick Description', 9.
125 Climenson, *Passages*, 59.
126 Richard Beatniffe, *The Norfolk Tour or, Traveller's Pocket Companion* (Norwich, 1773), iv.
127 Ibid., 17.
128 Geertz, 'Thick Description', 28.

2

Publishing John Wilkes's 'Villakin': Reception and Reputation at Sandham Cottage

In 1792, Lybbe Powys wrote an account of her visit to the Isle of Wight, prompted by her desire to get a 'change of air'. Travelling from Fawley Rectory in Buckinghamshire, by then her home, the party went via Basingstoke, Winchester and Southampton, before landing at Cowes, where they took refreshments and prepared their carriage for travel. Over the next few days, the party would visit Newport, which Powys noted for its uniform and well-paved streets, remarkable neatness, civility and its bustling social life, before moving on to Ryde, which she described as consisting almost entirely of cottages. Perhaps one of the most interesting of Powys's elaborately drawn vignettes from this trip is her account of an excursion to Sandown, which would eventually become a seaside resort town in the Victorian period, but was then notable for its castle, its military fort and Sandham Cottage, the famous seaside home of one of the area's temporary residents, the radical politician John Wilkes.[1]

Wilkes first visited the Isle of Wight when he was Colonel of the Buckinghamshire militia during the course of the Seven Years' War (1756–63). The proximity of his residence (the now-demolished Longwood House in Winchester) to the Isle of Wight meant that he was able to occasionally visit the nearby island.[2] A contemporary biographer noted that even then 'he attracted more notice than is generally bestowed upon the mass of summer visitors, who either take lodgings, or run over the island observing or unobserved'.[3] Following his return to Britain after his self-imposed French exile (1763–8), Wilkes continued to visit the Isle of Wight, and eventually purchased the house he would call his 'Villakin', from Colonel (afterwards General) James Barker, of Stickworth Hall on the Isle of Wight, in May 1788.[4] As his biographer Horace Bleackley described it, the Cottage was a 'tiny two-storied house', which stood 'alone on the gorse-covered downs above the sea in the midst of Sandown Bay, half a mile nearer to Shanklin than the fort, with an open view of the expansive shore as far as the cliffs on either side. There were only a few rooms in the little

dwelling, but it had a picturesque exterior with its latticed windows and creeper-clad walls'.[5] Apparently, Wilkes 'fell in love with it at first sight' thanks to the picturesque beauty of the house's surrounds.[6]

Publishing Wilkes's Villakin

On Wednesday 15 June 1932, *The Times* newspaper published a piece of news in brief that read: 'A memorial plaque to John Wilkes is being unveiled to-day at Sandown, Isle of Wight, where Wilkes had a villa in his declining years'.[7] Placed at the former site of Wilkes's cottage, the plaque now occupies a wall of a building on one of the town's streets. Reading 'SITE OF "VILLAKIN", OCCUPIED 1788–1797 BY JOHN WILKES, M.P., LORD MAYOR OF LONDON, 1774–75', the plaque not only commemorates the area's once-famous resident, but also draws attention to the material absence of the Cottage, which had fallen into ruin following Wilkes's death in 1797, and which accordingly no longer survives. Contrasting with this immaterial culture, however, is the large number of published accounts describing the house and a handful of visual representations of the property. Thanks to its notable inhabitant, Sandham Cottage received significant attention from contemporary writers, who often made note of the property in publications on Wilkes or the Isle of Wight. Indeed, Sandham Cottage featured in almost every account of the island dating from the late-eighteenth or early-nineteenth century, from histories of the region such as John Albin's *A new, correct, and much-improved history of the Isle of Wight* of 1795, and Thomas Brettell's *A topographical and historical guide to the Isle of Wight*, published in 1840, to tourist accounts as found in John Hassell's *Tour of the Isle of Wight* of 1790, or John Bullar's *A companion in a tour round Southampton* of 1799. Such texts aimed to furnish the 'tourist and general Reader with a brief, yet comprehensive account of every thing worthy of attention in "*The Isle of Wight*"', and included information about the sights, entertainments, accommodation and history of the island.[8]

Further to these texts, the house also featured within the periodical press of the time. For example, in 1832, the Saturday 13 October edition of *The Mirror of Literature, Amusement, and Instruction* included the article 'Notes from a Pedestrian Excursion in the Island'.[9] Headed by an illustration of Wilkes's Cottage, the piece provides a two-page account of the author's time on the Isle of Wight, including a short and fairly typical description of Sandham Cottage. The accompanying image (fig. 2.1) is more unusual: being one of only a few surviving

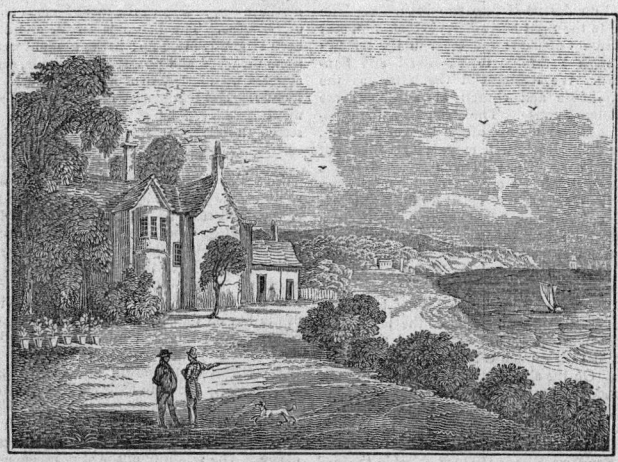

Figure 2.1 'Wilkes's Cottage', *The Mirror of Literature, Amusement, and Instruction*, 13 October 1832. Wood engraving. Royal Collection Trust/© Her Majesty Queen Elizabeth II 2021.

illustrations of the house, and notably showing it in relation to its gardens and broader surroundings, it highlights its proximity to the shoreline, and illustrates some of the planting done in its grounds. Such representations of the house are accordingly crucial to understanding the once-extant space of the Cottage, which, given the significant changes to Sandham between Wilkes's death and the present day, reinforce just how much has been lost to the historical record in terms of the house and its locale.

The house also appeared prominently in the January 1804 edition of *The Gentleman's Magazine*, which featured two contributions from readers on the topic of the property, as well as a visual representation of the house and a related poetic inclusion, both apparently sketched by a friend of the letter's author (pl. 2).[10] The first letter, dated 10 January, noted that the house had 'uniformly attracted the notice of travellers passing through that Island', recalling both the large number of visitors to the property and the swathes of travel literature mentioning it, before describing how life on the island represented a truer version of Wilkes than that enjoyed in the capital, a recurring trope in such texts, and an idea to which we shall return later in this chapter.[11] The second letter, dating from 28 October the previous year, and addressed from the nearby Sandown Barracks, writes to inform readers of a single feature of the house, a monument 'raised by the Patriot to the memory of his friend Churchill the Poet', and which took the form of a fluted, broken column. Accompanying the letters are two images associated with their authors; labelled 'Father Paul del.' and 'T.S. del.', respectively.[12] 'Father Paul's' drawing presents a familiar image of the Cottage, showing it to be a relatively modest residence, while 'T.S.' provided an illustration of Wilkes's monument to the poet Charles Churchill (1731–64). These small vignettes of the Cottage contrast tellingly with earlier accounts of Wilkes-related activities as published in the *Magazine*. For example, in 1768 they reported on riotous Wilkite mobs as follows:

> the mob which has constantly surrounded the King's Bench prison in St. George's-field, ever since the imprisonment of Mr. Wilkes; grew outrageous; the riot act was read, and the soldiers ordered to fire. Several persons who were passing along the road at a distance were unfortunately killed; and one youth about 17, son to a stable-keeper in the Borough, was singled out, followed, and shot dead, in an outhouse where he had fled for shelter.[13]

This account of state-inflicted violence against Wilkes's supporters contrasts sharply with the tone and content of these later pieces, which are couched instead in the language of tasteful sociability and affection, and as such, are a clear

indication of the changing esteem in which Wilkes was held as the century progressed.

Within the broader body of literature discussing the Cottage, each text employs the thickly material language of description outlined in the previous chapter. As Cynthia Wall has compellingly argued, description was one of the key technologies of eighteenth-century culture, wherein the perception and representation of space became unprecedentedly textually visible in both eighteenth-century novels and prose narratives.[14] The latter of these categories included country house guidebooks and travel narratives, which, as Jocelyn Anderson has recently demonstrated, are characterized by the period's descriptive impulse, particularly when it came to documenting the interiors of the homes that they discussed.[15] Indeed, the proliferation of descriptive texts has made such sources figure amongst the central documents that this book employs, with its chapters on Strawberry Hill, Lybbe Powys and Plas Newydd all making consistent use of written descriptions of domestic spaces in order to understand not only what contemporaries thought of houses, but also the mechanisms through which these thoughts were expressed. As such, these accounts of Wilkes's property are not inherently remarkable, but accord instead with this broader impulse to describe, often in great detail, the domestic spaces which tourists found themselves in.

However, such writing becomes extraordinary when read as an overlapping, interreferential body of literature on Wilkes's home. Taking an October 1794 edition of the *St James's Chronicle, or the British Evening Post* as an example, we can see how such texts were interrelated through the processes of exception and recycling.[16] This was common practice in both the eighteenth and the nineteenth centuries, periods that saw the development of a rampant culture of circulation that has been termed 'viral textuality'.[17] Like the correspondence from the *Gentleman's Magazine* discussed above, the issue features a letter praising Wilkes's Cottage, with the correspondent here writing in to correct an omission that they perceived in Henry Penruddocke Wyndham's text *A picture of the Isle of Wight, delineated upon the spot, in the year 1793* (1794). The correspondent notes that certain spaces of the house, omitted from Wyndham's discussion, should 'have found some indulgence'; with this complaint demonstrating how different forms of literature on the house intersected to create a space woven from tropes and images into an architectural tapestry.[18] In his account of the house, Bullar likewise quotes extensively from a biography of Wilkes published in the *Annual Hampshire Repository*, which was itself an excerpt from an anonymously published biography of Wilkes, quoted at such length as to lead the

magazine to transgress their 'usual limits' of word length.[19] The biography, as published in the *Annual Hampshire Repository* was, in turn, excerpted in issues 15 to 18 of the *Anti-Jacobin Review and Magazine* (1803–4), arguably an interesting repository for such a positive account of Wilkes's life. Both this complex intertextual sampling, and the consistent employment of specific tropes across the body of writing on Wilkes's island Cottage, highlights how this corpus should be read as an ensemble, that is, as a series of published accounts, which not only provide detail about this lost domestic space, but also about how Wilkes, as a key eighteenth-century figure was, and should, be understood.

Wilkes undoubtedly represents one of the most compellingly complex characters of the eighteenth century. At once radical politician, writer and journalist, he was elected Member of Parliament in 1757, yet his time in politics would be marred in scandal. Wilkes was a member of the infamous Hellfire Club, a group known for the rakish behaviour of its members; he was involved in numerous duels; he co-wrote the pornographic poem *An Essay on Woman in three Epistles*; and he was eventually outlawed on the charge of seditious libel following his criticism of the King's Speech in his paper *The North Briton*, resulting in massive public outcry and backlash. Yet by the 1770s Wilkes would come to hold down two highly respectable positions, acting firstly as London's Alderman (1770) and then as its Lord Mayor (1772). After 1780, his popularity declined sharply: viewed as distinctively less radical than he once was, he lost much of his support. This was compounded by his actions in the Gordon Riots of 1780, in which he commanded the troops that protected the Bank of England to fire on the rioters, an action that transformed him from man of the people into a changed hypocrite.

Accordingly, no shortage of ink has been spilled attempting to grapple with the uniquely multifaceted character of Wilkes. There have been several monographic biographies, including early examples written by Bleackley and Percy Hetherington Fitzgerald, which have been followed more recently by those of John Sainsbury, Peter D.G. Thomas and Arthur Cash.[20] Political histories of the eighteenth century, such as Christopher Tilley's *Popular Contention in Great Britain, 1758–1834* (1995), John Brewer's *Party Ideology and Popular Politics at the Accession of George III* (1976) and Kathleen Wilson's *The Sense of the People: Politics, Culture and Imperialism in England, 1715–1785* (1998), have highlighted Wilkes's vital role in the popular politics of the time.[21] Attention has also been given to his relationships with other important public figures of the period, such as the Chevalier d'Éon, as well as his role in constructing contemporary (and often highly sexualized) masculinities.[22] Each of these texts has tried to grapple

with the multifaceted, multivalent life of this complicated figure, discussing everything from his familial background and early life, and his political popularity, to his more infamous 'scandalous' behaviour.

Against these episodes, Wilkes's time at Sandham has perhaps unsurprisingly been judged to hold less interest for potential readers. Although Lindsay Boynton has discussed Sandham in the context of several Georgian 'Marine Villas' on the Isle of Wight – a particularly apt location for such retreats given the area's association with the picturesque – most texts on the politician mention Sandham Cottage only briefly, if at all.[23] Wilkes described himself as an 'exhausted volcano' during this period of his life, and his biographers have followed suit in privileging narratives of his meteoric rise and salacious controversies as opposed to his later political decline, the period that directly intersects with his time at Sandham.[24] Wilkes's stint on the Isle of Wight accordingly often occupies only fleeting moments within published biographies. Indeed, it is mentioned on only a single page of Thomas's *John Wilkes: A Friend to Liberty* (1996), and is relegated to the epilogue of Cash's *John Wilkes: The Scandalous Father of Civil Liberty* (2006), with such authorial decisions echoing the nineteenth-century view that 'Wilkes retired into the obscurity of private life' around this time.[25] Only Robin Eagles, the editor of Wilkes's diaries, has sought to give this episode in Wilkes's life any real attention, writing that as Wilkes was a man 'who was supremely successful in reinventing himself throughout his career, we must accordingly view this final phase [as] just as important, if less obnoxious, than the earlier ones'.[26]

A deeper understanding of the house is perhaps also difficult to access due to its seemingly contradictory position within Wilkes's own life history. Sandham, where Wilkes enacted the role of hospitable and tasteful gentleman, seems at odds with a life characterized by radical incitement, libel, treason and accordant political infamy. Indeed, a nineteenth-century commentator highlighted the strange juxtaposition between house and man, describing a 'quiet little cottage', that had once been the residence of the 'radical and restless John Wilkes […] the contrast between the nature of the secluded spot and the character of the man' being 'rather interesting'.[27] Yet Wilkes, as a 'gentleman politician outlawed', has long been viewed in terms of these sharp contrasts, which at their most extreme are couched in language of good versus evil.[28] In the second half of the nineteenth century, for example, Wilkes was tellingly profiled in a lecture dualistically titled 'John Wilkes, demagogue or patriot?', later published as a pamphlet.[29]

As Sainsbury has noted, one of the ways of dealing with the contradictory and 'problematic issues of Wilkes's personality and conduct has been to steer clear of them, treating them as irrelevant to the supposedly larger questions of those

movements conducted in his name or in response to his persecution'. This was despite the fact that, 'the nature of the movements that swirled around him was influenced by the idiosyncracies of his character and behavior', meaning that 'a fuller understanding of the Wilkes phenomenon surely requires exploration of the rich dynamic between Wilkes and his supporters'.[30] Indeed, as we shall see, questions of Wilkes's character and how these affected perceptions of both him and his cause are clearly central to published accounts of Sandham Cottage, which not only tacitly acknowledge, but often also explicitly address the complexities of Wilkes as an individual. Although obituaries published close to Wilkes's death have often been viewed as unforgiving – with Thomas noting that 'immediate posterity gave Wilkes a bad press' – accounts of his time on the Isle of Wight suggest a more complex posthumous reputation for him as a figure.[31] Such texts display an active attempt to grapple with these two conflicting accounts of Wilkes, based on the one hand, on his positive impact on the island, and on his earlier and wilder reputation, on the other.

Following both Sainsbury's call to more deeply consider the idiosyncracies of Wilkes's character, and Declan Kavanagh's critique of the narrative of the 'archetypal divide between Wilkite libertinism and Wilkite respectability', this chapter seeks to show how notions of polite masculine self-fashioning could be constantly in flux and repeatedly redefined around a single character both during his life and following his death.[32] The chapter will accordingly examine 'one typically paradoxical component of Wilkes's career' by attempting to position publications about Wilkes's cottage as a reflection of how writers – both contemporaneously and posthumously – were grappling with the difficulties presented by a figure like Wilkes. In so doing, the chapter unpacks a difficult episode in the relationship between domestic materiality, literature and identity formation in late eighteenth-century Britain. Considering how Wilkes's home was characterized within contemporary literary and visual representation, it contends that such texts and images provide an unprecedented opportunity to consider the aesthetic programme of Wilkes's country home. Focusing on published accounts of Sandham Cottage, it situates descriptions of Wilkes's home within the contexts of taste, sociability and domestic tourism, highlighting the centrality of visual and material culture within these texts. Outside of their focus on the objectscape of Wilkes's home and garden however, these texts and images were also part of a representational objectscape that surrounded Wilkes's celebrity, which included satirical prints, portraits, ceramic figurines and politicized material culture, many examples of which survive in collections today. Finally, the chapter demonstrates how such writings allow for a better

understanding of the house's role in constructing and reflecting its owner's multifarious identities during this late stage of his career and life. Providing an account of Wilkes as a consummately refined host and tasteful art collector that exists not in opposition to, but deliberately alongside, his radical politics and rakish self-presentation, it carefully unpacks what Sainsbury calls 'the curious spectacle of the domestic libertine'.[33]

Novelty and taste

Following her initial description of her time on the Isle of Wight, Lybbe Powys provided a typically richly inscribed account of Sandham Cottage. Written in the highly illustrative manner established in the previous chapter, she described a visit to Sandown Fort, praising the nobility of its sea views and the bay's roaring waves, and recording her party's walk along the beach, which lasted for around half a mile, before they came to Sandham Cottage, 'a summer cottage of the famous Mr Wilkes', which commanded 'an uncommon view of the sea and surrounding cliffs', and which had 'a very fine garden', complete with a menagerie. She continued by noting that the cottage itself 'had only a very few small rooms', but as 'Mr. Wilkes often entertains many families', he had erected in the gardens of the property 'many of the fashionable canvas ones, fitted up in different manners and of large dimensions'. Lybbe Powys then went on to describe the decoration of these impermanent spaces in some detail, mentioning their prints and fine china, concluding that altogether, Wilkes's cottage was indeed 'well worth seeing'.[34]

In its focus on both the interior and exterior material culture of Wilkes's house, as well as its natural surroundings, Lybbe Powys's account of Sandham Cottage is typical of a number of published descriptions of the property. Indeed, her discussion of the Cottage's interiors can be expanded upon by reference to the work of a number of other travel writers and enthusiasts of the Isle of Wight, all of whom mobilized descriptive language in order to convert the Cottage into literary form. In so doing, these ekphrastic transformations of house into text all presented the space as small but tasteful, focused on its gardens and marine landscape views, and stressed the novelty of the design and decoration of the canvas rooms used to provide more space for residents and guests, aspects of the Cottage that will be explored further below.

As noted above, Sandham Cottage, sometimes known as Sandown Cottage, was a relatively small home. The house's describers repeatedly note that the Cottage was 'low', and 'not large', although all comment on the notable improvements made

to the house by Wilkes. Remarkably consistent amongst these descriptions was an emphasis on the novelty of Wilkes's improvements to the Cottage, a focus that particularly emerged through descriptions of the house's canvas 'rooms'. Albin, for example, detailed the 'marquee on the west of the house', which was 'designed to be occasionally used as a Summer house; on the sides of which are suspended some very curious antique engravings'.[35] Wilkes had several canvas spaces set up in the gardens of the Cottage, which stood independently from both its structure and from each other. Almost every commentator on the house made note of these structures. Wyndham identifies them as having been purchased from a floorcloth manufactory in Knightsbridge.[36] As Ann Robey has argued, floorcloth produced at this time was both practical and beautiful, with some surviving examples even painted in imitation of discoveries from archaeological digs.[37] Of Wilkes's structures, Robey notes that they were furnished by Nathan Smith, who visited Sandham in 1788 to design and plan the canvas rooms.[38]

Several commentators made note of the rooms' relationship to the landscapes around Sandham.[39] As Bullar observed, the canvas rooms were positioned 'in the most advantageous points of view' for the property, thereby exploiting the beauty of the Cottage's surroundings and gardens.[40] According to contemporaries, the Cottage stood at the precipice of Sandown Heath, commanding impressive views of 'the whole extent of Sandown bay, from Chine head and Dunnose on the south-west, to the Culver cliffs on the east'.[41] This impressive vista was captured in a view of the house's gardens made by Wilkes's younger daughter Harriet, who engraved the print and drew the image upon which it was based (fig. 2.2). From the Cottage's 'North-east View', we see the house's shrubbery in the foreground, with the view unfurling into fields employed for agriculture, and Sandham Fort with its St George's Cross flag, with the expansive bay and scenic cliffs occupying the right-hand side of the print. As we can just see in the image, the house and the beach that it overlooked were linked by a sloping cliff, ornamented with a series of neat gardens. Despite the barren soil and harsh winds characteristic of the Isle of Wight, Wilkes grew 'ornamental shrubberies of the dwarf kinds' in the house's grounds, and the gardens bloomed with roses, honeysuckle and cowslips, although, as was unsurprising for such a self-confessed English patriot, he reputedly 'disclaimed the introduction of exotic plants of difficult culture'.[42] The grounds also boasted a large pond, full of fish, a 'prolific kitchen garden' stocked with strawberries, asparagus and broccoli, and a grove of fruit trees bearing apples, pears, peaches, apricots and nectarines.[43]

Wilkes was himself a keen gardener. In his biography, Cash describes how the politician would don old clothes and spread manure, and even includes an

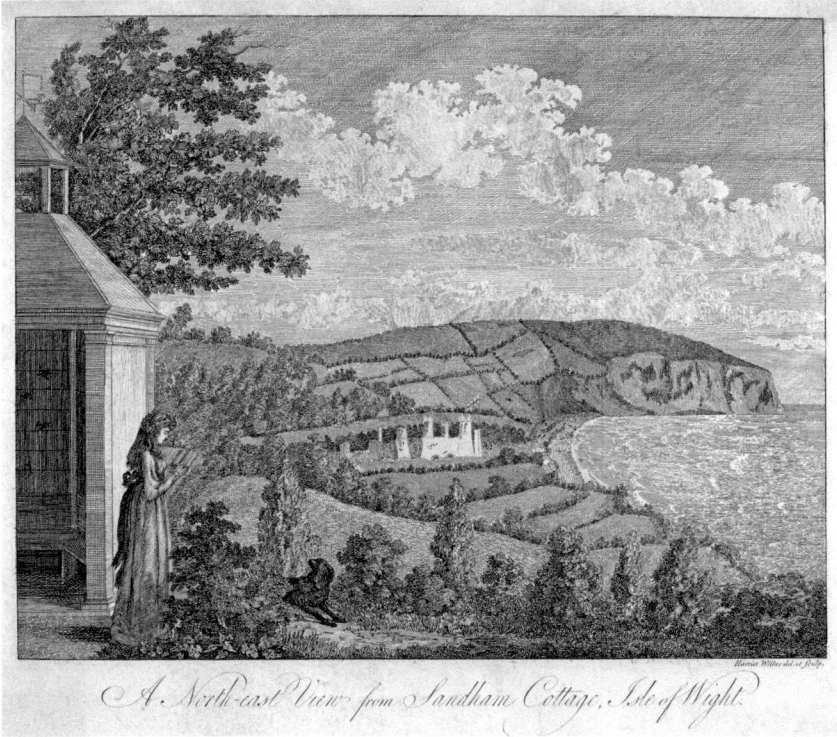

Figure 2.2 Harriet Wilkes, *A North-East View from Sandham Cottage, Isle of Wight*. Etching. Courtesy of the National Gallery of Art, Washington.

anecdote in which Frederick Reynolds found Wilkes hoe in hand 'raking up weeds and destroying vipers'.[44] Wilkes's letters to Polly reflect his direct interest in the garden, including poeticizing accounts of the 'the humble flowers of the vale, the primrose and cowslips', which 'just begin to lift their beauteous heads from the dull mould which surrounds them and to perfume the air'.[45] His correspondence with his daughter is filled with such floral reports from his gardens at the Cottage, and sometimes even reference gifts of seeds from its grounds, which, as we will see in Chapter 4, was a commonly employed affective gesture that connected donor and recipient, bringing to mind shared spaces even when correspondents were physically distant.[46]

Observers also made note of the garden's less typical features, namely its animal residents. Referred to by Lybbe Powys as a 'menagerie', Albin describes how the Cottage's grounds boasted an impressive aviary, 'consisting of a great collection of various species of birds, immediately behind the house [...] the subject of much curiosity, and highly deserving of attention'.[47] Another

commentator described how Wilkes 'raised numerous fanciful structures, for the purpose of rearing poultry, and keeping various kinds of birds, of which he was exceedingly fond'.[48] Bullar even proclaimed that Wilkes's 'kindness to the feathered tribe' was unmatched, describing the 'numerous fanciful structures, for the purpose of rearing poultry, and keeping various kinds of birds', and the 'open boxes, filled with corn, upon the stems of trees, to feed the sparrows and other small birds', that he had established at his home.[49] We see a slither of this famous enclosure in Harriet Wilkes's engraving of the view from Sandham's gardens. Although not hugely detailed, the left-hand side of the image shows an open-fronted building executed in a simple yet elegant classicizing style, in which several flitting birds can just be made out.

This aviary presentation within Wilkes's garden at Sandham reinforces our sense of this space as one of carefully stage-managed and refined display. Christopher Plumb has noted that birds and animals were particularly valued during this period for their role in creating an 'animated garden', in which the viewing of birds from windows and other architectural features transformed them into evocative garden furniture, to be viewed against the garden's other decorative and architectural features, such as a follies.[50] Although Wilkes's garden lacked follies in the traditional sense, when read against the ephemeral quasi-interior spaces of the canvas rooms, whose openings looked on to stunning coastal vistas on the one hand, and the rest of the garden and menagerie on the other, one can envision how these elements might have interacted in a contrived narrative designed to direct the visitor-viewer's gaze around the property's grounds.

Such active attempts to shape the visiting experience were also reinforced by Wyndham, who described the space between the various canvas rooms as comprising a 'little polished orchard', and a 'close grove of short stunted trees, that resemble, both in their size and number, a pastoral scene on the stage of a play-house', before noting that one of the marquees opened out onto a view of 'the ocean, and takes in the whole of Sandown Bay; a grand and noble object!'[51] The location of the canvas spaces therefore directed the attention towards the picturesque and explicitly Romanticized views for which the Isle of Wight was famed during this period. For example, the frontispiece to Brettell's *A topographical and historical guide to the Isle of Wight* of 1840, tellingly featured quotations from the Romantic poet Sir Walter Scott, which described the island as 'that lovely spot'.[52] Harriet Wilkes's engraving from the house's grounds exemplifies this relationship between house, garden and landscape, with its bird-filled menagerie on the left bordering the expansive views to the right. More specifically, Sandham was well known for its 'situation on an eminence', from

which it commanded 'the whole prospect of Sandown Bay'.[53] Interestingly, Wyndham's account highlights Wilkes's deliberate use of framing and staging at his property, a clear attempt to shape the viewer's experience of the space of his home. Through clear allusions to stage sets, the various spaces of house, marquee, menagerie and gardens function almost like proscenium devices which alert the viewer (and subsequently the historian) to the performative nature of Wilkes's hospitality; in which material objects *play* clear roles, and where spaces dictate behaviour and which objects one's attention should be drawn to. As such, these accounts highlight that the Cottage's overarching aesthetic programme was equally characterized by both interior and exterior spaces, both house and garden, and both permanent and transient structures, all of which contributed to Wilkes's self-presentation as the tasteful decorator of his home.

The taste demonstrated by Wilkes in the presentation of the interiors of his home is likewise stressed by nearly all commentators on the property. Hassell, for example, described the house as plain but 'elegantly fitted up, and abounding with every convenience that can tend to the accommodation of a family'.[54] These conveniences included the 'very capital prints and very fine china' described by Lybbe Powys, alongside garden furniture, purchased from the large London-based furniture maker, George Seddon, and a broad array of silver-handled cutlery for entertaining, both of which were brought to the Isle of Wight from London by Wilkes's daughter Polly.[55] The elegance demonstrated by Wilkes in the decoration of his home is a particularly notable feature in accounts of the house. Lybbe Powys, for example, noted that canvas spaces were 'all very elegantly furnish'd', while another wrote that the house had 'every convenience and accommodation, which such a spot can boast of; and for that purpose, the house has been fitted up with much simplicity, but with every regard and attention to elegance', here articulating Wilkes's home through the language of taste.[56]

Within these texts, taste was explicitly linked to Wilkes's innate character and broader practices of self-fashioning, with Albin writing that the house had 'been improved with all the characteristic neatness for which its owner has been at all times distinguished', and which 'must always command the stranger's attention, whether its situation or elegance be considered', noting that the house had 'received vast improvements from the present chamberlain of London, whose refined taste and strong judgement have been so signally manifested in various scenes of life, within the last thirty years'.[57] Hassell similarly described how the house had 'had many improvements made to it by its present proprietor, whose judgement and taste in all the elegancies of life are well known'.[58] Assertions such as those made by Charles Tomkins in his *A tour to the Isle of Wight* (1791) that

Wilkes had 'shewn the excellence of his taste', or John Sturch, who wrote in his *A view of the Isle of Wight* (1794) that the house was 'disposed of with a frugality and taste which do honour to the celebrated proprietor', highlight yet another contradiction surrounding Wilkes: despite his repute for ugliness in both his face and his behaviour, he was also consistently deemed to be refined and tasteful in his dress, deportment and, here, in the decoration of his home.[59] Functioning as examples of praise for both house and owner, these examples thereby show an adherence to Karen Lipsedge's assertion that 'an individual's material acquisitions, including their house and its furnishings, were believed to be equally resplendent indicators of their politeness', an approach to the connection between house and owner that we have also seen in Lybbe Powys's writings.[60]

Although his biographer Fitzgerald describes Wilkes as a collector of '"curios" of all kinds, of books, Wedgwood, cameos, china, prints, paintings, and furniture', little critical attention has been given to his relationship with contemporary visual and material culture, undoubtedly due to the lack of a distinct surviving collection.[61] Jonathan G.W. Conlin is one of the few to address Wilkes's relationship with art that doesn't focus on his commodification in prints or other commodities.[62] Seeking to correct this oversight, Conlin offers a compelling account of Wilkes as aesthete, discussing his Continental travels and friendships with Diderot and Winckelmann, the latter of whom had served as Wilkes's *cicerone*, before turning to Wilkes's parliamentary defence of the arts, which included his support of a motion from the trustees of the British Museum for an increase in their parliamentary grant, and his arguments for the preservation of Sir Robert Walpole's collection of paintings at Houghton, which, as will be discussed at length in a later chapter, would eventually be sold and dispersed.[63] Such activities thereby provide a compelling background against which to read the decoration of his home at Sandham Cottage, showing Wilkes not merely to be a radical agitator, but a politician concerned with creating a national art collection. These interests thereby accord with Jason M. Kelly's assessment that societies like the Dilettanti arose in parallel with, as opposed to in distinction to, libertinism, highlighting, once again, that there could be no clear division between gentlemanly knowledge and libertine private conduct during this period.[64] An analysis of the decoration of Sandham Cottage accordingly builds on Conlin's work, allowing us to consider Wilkes's relationship with the fine arts not on the public stage of politics, but the semi-private space of his home.

Wilkes seems to have been a prodigious print collector. His biographer Fitzgerald noted that he found 'among his papers a bill from a dealer, in which the famous 'Hundred-Guilder' etching [after Rembrandt] is charged three guineas!'.[65]

Wilkes was also actively involved in the display of his print collection across his homes, describing the process of the setting up and naming of his 'Etruscan' room in a letter to his daughter: 'I have now disposed of all my Tuscan vases, with several prints from Sir Richard Worsley, in a room, which I call the Tuscan room, and I hope my dear daughter will approve as much as Sir Richard says he does'.[66] Worsley, a politician and noted antiquarian, also owned a cottage on the Isle of Wight, later designated his 'Marine Villa'. Its garden featured a temple folly called the 'Seat of Virgil', which, according to Boynton, was based on the Temple of Minerva in Athens, and was heavily inspired by the classical improvements Wilkes had made to his own cottage by the sea.[67] Wilkes also asked Polly to send him leftover prints from his London home in Grosvenor Square, specifying their ideal dimensions and how they should be packaged for transport.[68] Aside from these practical instructions, Wilkes also repeatedly sought his daughter's judgement in the arrangement of his collections, a fact that underlines the extremely close bond between the pair. From Sandham in 1790, Wilkes wrote to his daughter to tell her that he had 'examined with particular care and attention the plan, which you enclosed, of the arrangements of the prints for the eating-parlour in Grosvenor Square, and I most entirely approve', although he advised her that some of the prints in her lists he had intended for Sandham Cottage.[69] Classicizing prints were also exchanged as gifts between members of the Wilkes family, with Harriet, Wilkes's youngest daughter, sending her sister Polly an engraving of Hygeia copied from an antique gemstone.[70] As we have seen, Harriet used her talents in this area in order to capture a view from the grounds of the Cottage itself. Showing a young woman (likely Harriet or Polly) reading in the house's gardens, the image binds Harriet's creative talents with the importance of print to Wilkes and his family, and with collective time spent at Sandham.

Nowhere was Wilkes's status as taste maker more clearly evidenced than in the classicizing decoration of his canvas rooms. Notwithstanding the overlapping geographical and historical complexities signalled by the use of the term 'Tuscan' and 'Etruscan' in the naming of these rooms, the nomenclature used for the marquee suggests that it housed images from sources comparable to the publication *Collection of Etruscan, Greek, and Roman Antiquities* (1766–7), which documented Sir William Hamilton's collection. Lavishly illustrated, it formed the basis of a number of decorative schemes in contemporary houses. As such, the existence of a 'Tuscan' room at the property suggests an attempt on Wilkes's part to keep up with contemporary aesthetic fashions for the ancient past, thereby showing his adherence to broader trends within interior decoration. The relationship between the acquisition of classical and neoclassical visual and

material culture and the demonstration of elite taste and gentility has been firmly demonstrated by art historians such as Viccy Coltman and Jonathan Scott, who have shown that such collections were part of a foundational 'style of thought' that characterized intellectual and artistic culture at this time.[71]

Several commentators on the Cottage describe the tents as fitted up with engravings after the antique, a reference to the reported 1,300 prints on their walls.[72] William Fordyce Mavor, for example, noted that 'some curious engravings, from the antique, grace its sides, and the tables are covered with several others', while Hassell also detailed its decoration (in notably similar language) with engravings and prints: 'several curious engravings from the antique grace its sides; and we saw several others lying on the tables'.[73] So praised was Wilkes's classical presentation of his retreat that visitors sent correctives to newspapers to amend published accounts of the house that they felt gave inadequate attention to the design of its interiors. For example, the letter from the *St. James's Chronicle or the British Evening Post* cited above, provides more information about the engravings mentioned by Mavor. In the correction, the anonymous contributor wrote to complain that Wyndham's 'Picture of the Isle of Wight', had not given due consideration to the so-called 'Tuscan Room':

> The Tuscan room, which is here alluded to, should methinks, have found some indulgence, if not favour, from the classical taste of so profound an adept in the Fine Arts. The large folios of the *Museum Florentinum*, the *Picturae Etruscorum in Vasculis*, and the *Dactyliotheca Smithiana*, furnished in greater part the engravings in that apartment. Even the backs of the chairs, which are of sattin wood so much admired, are Tuscan vases published by Passerius.[74]

Wilkes's use of prints from these rarefied folios as decoration for his canvas spaces as described here accorded with broader trends in print collection at this time, with the most common type of collection comprising 'furniture prints' that were used as wall decoration in houses.[75] Though portraits generally dominated this genre, published accounts of Wilkes's home refer to the prints as representing classical objects and collections, which were taken from several distinguished antiquarian publications. The letter therefore suggests that the decoration of this space was perhaps reminiscent of somewhere like Mere Hall in Cheshire, which was decorated with full prints taken from Hamilton's volumes.[76]

The calibre of the volumes listed in the *St James's Chronicle* letter is notable. The *Dactyliotheca Smithiana* (1767) was the Florentine antiquarian Antonio Francesco Gori's catalogue of Consul James Smith's gem collection. Featuring page-size engravings by the renowned Italian engraver Giovanni Volpato, copies of the text

were also owned by King George III. The *Museum Florentinum*, also published under the direction of Gori between 1731 and 1766, was a heavily illustrated account of the most notable cameos, gems, coins, sculpture, and paintings in major Florentine collections of classical art and material culture at that time. Particularly concerned with the Medici collections housed in the Uffizi, the volumes functioned as 'the most ambitious visual archive of a museum undertaken at the time'.[77] It was a highly anticipated work, and following its publication copies of its volumes were purchased by figures such as the historian and classicist Edward Gibbon, and the celebrated French traveller Jérôme de Lalande.[78] The work of Gori's associate Giovanni Battista Passeri, is also present in the above description of Wilkes's canvas room, specifically his *Picturae Etruscorum in Vasculis*, published between 1765 and 1775. Well known at the time, it featured 300 illustrations of 249 vases. Maria Emilia Masci has described volumes like Passeri's and d'Hancarville's as crucial texts through which a new typology of antiquarian collecting was codified, a characterization that reflects the deeply scholarly nature of these publications. This was something that many viewers of Wilkes's home would have recognized, like the writer of the above letter, who wrote specifically to ensure that the appearance of these particular volumes, and by extension Wilkes's own antiquarianism, received adequate attention.[79]

Designs from such volumes formed the basis of a number of decorative schemes in contemporary domestic residences, as at Newtimber Place, Sussex and Heaton Hall, near Manchester.[80] In these spaces, texts like the Hamilton volumes became images 'fit to furnish the cabinets of men of "Taste and Letters"'.[81] This was true in two senses. Not only were the volumes themselves collectible pieces of material culture that formed the furnishings of the gentlemanly library, but the designs that they provided functioned as a veritable suite of neoclassical motifs to be used and reconstituted by craftsmen. As Coltman has persuasively argued, the 'inventive fabrications' inspired by texts such as Hamilton's were 'stamped with the prestige of the collector and his collection of artefacts: a prestige that the craftsmen literally subscribed to in their productive craft'.[82] This kind of repurposing and reformulating of the images of antiquity is seen directly in Wilkes's space. Echoing his display of the volumes' prints, even the carved backs of the satin-wood chairs in the described canvas rooms were apparently decorated with designs based on the 'Tuscan vases published by Passerius', that is, according to the author at least, images of Etruscan vases from Passeri's *Picturae Etruscorum in Vasculis*. As such, they may have looked something like the armchairs from the Music Room at Woodhall Park in Hertfordshire, now in the collections of the Victoria and Albert Museum (fig. 2.3). Made sometime between 1780 and 1800,

the elaborately carved chairs feature a central roundel painted in the fashionable Etruscan colouring of black and terracotta, and designs that may well have come from contemporary volumes of vase engravings. Together with the prints themselves, the chairs' inclusion in the Etruscan room gives the impression of the totalizing aesthetic of this space, one whose grandiosity and splendour would

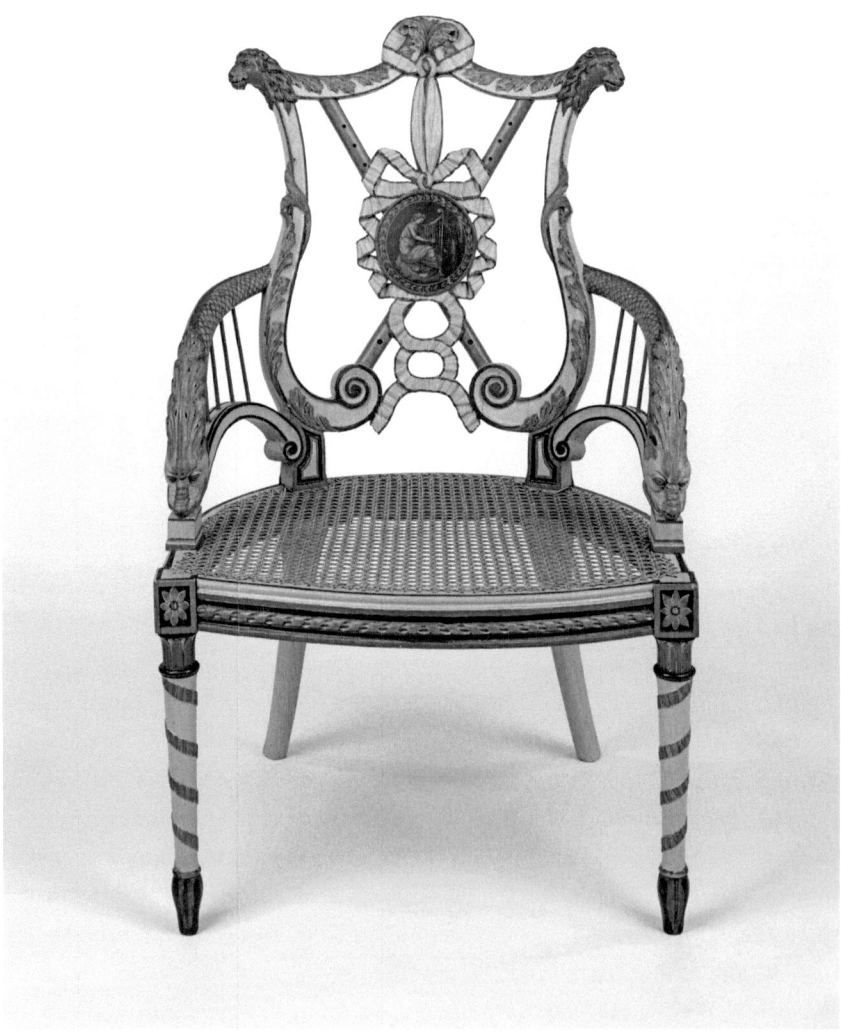

Figure 2.3 Carved beechwood armchair, *c.* 1780–1800. Courtesy of the Victoria and Albert Museum, London.

have contrasted strongly with the impermanency and semi-exterior nature of these tented canvas rooms.

Sociability and affection

Beyond their aesthetic functions, the canvas rooms were, on a practical level, designed to provide extra accommodation for both family and guests, working as a solution to the problematically small size of Sandham Cottage. Lybbe Powys recorded that one of the spaces functioned as a dressing room for Polly Wilkes, while others were fitted up as bedrooms.[83] These spaces may therefore be read as a physical reflection of the sociable interaction in which Wilkes partook during his time on the Isle of Wight; exchanges that saw him mixing with friends and domestic tourists alike. By the late eighteenth century, the island had become a popular leisure destination. Contemporary guidebooks describe not only the vibrant scene of assemblies, theatres and other amusements, but a broader community of gentleman who owned summer properties there, such as 'the marine cottage of John Fleming, Esq., M.P.' and 'the Swiss cottage of Lewis Wyatt, Esq.'.[84] Indeed, Wilkes's own diaries reflect the seemingly constant rounds of visiting, dining and socializing with friends whilst on the island, and the politician certainly adopted the guise of the generous host on more than one occasion, feeding guests at Sandham Cottage on spreads of 'Beef roasted, mutton boiled, and good plum-puddings'.[85]

Sandham Cottage also appears to have been open to those he did not know directly, which as we have already seen, was customary of the practices of domestic tourism at the time. A number of writers recorded that Wilkes received visitors in the 'most hospitable manner; and his acts of benevolence were neither sparing nor ill applied', and that at 'an early hour he was made up for the day, and ready to see company; which he willingly entertained with anecdotes and characters he had met with in his private and political walks through life'.[86] Lybbe Powys highlights how the canvas rooms were specifically dedicated to provide extra space for travellers to Sandham Cottage, confirming Wilkes's commitment to his visitors – whether prior acquaintances or not – by noting that 'strangers have leave to see the place by setting down their names in a book kept on purpose'.[87] As Wyndham wrote, 'Sandham Heath is, perhaps, more visited than any other spot in the island, and some ladies have, most provokingly, preferred it to the romantic cottages of the Undercliff, and to the luxuriant richness of the neighbourhood of Rye', a fact that was no doubt thanks to the celebrity of Wilkes

and his home.[88] Between Wilkes's provision of these external, transient spaces dedicated to the comfort of his many visitors, and the tent which served as a recreation of Miss Wilkes's dressing room – whose presence is suggestive of the ritualized sociable practice of the *levée* – the spaces of Sandham Cottage clearly served highly social purposes.

Indeed, the dedication of the house to some of Wilkes's closest social relationships was made clear through the establishment of two monuments within its grounds. These included a marble tablet dedicated to his daughter Polly, located in one of the tented rooms. It read 'To filial Piety and Mary Wilkes. Erected by John Wilkes, 1789', and was described by a commentator as 'a specimen of conjugal felicity in *basso relievo*'.[89] Wilkes's deep attachment to his daughter Polly is well known. Most famously, their relationship is emblematized in the double portrait of the pair by Johan Zoffany, which depicts Wilkes adoringly looking up at his daughter.[90] Wilkes's diaries record that he was often at the Cottage with Polly, although he would eventually leave Sandham, as well as its plate, pictures, prints and books, to his younger daughter Harriet.[91]

Wilkes's stone dedication to his daughter was not the only monument at Sandham Cottage. As noted above, the house's grounds also contained a memorial to Churchill, Wilkes's close friend and collaborator. Churchill had worked alongside Wilkes on the production of their anti-ministerial periodical *The North Briton* (1762–3), and much of his literary output has been conceived of as emanating from a Wilkesite perspective.[92] Taking the form of a doric pillar that stood around eight feet high and fourteen inches in diameter, the monument was apparently modelled after an aspect of Virgil's tomb at Naples, and seems at some point to have been topped by an urn given to Wilkes by the classical scholar Winckelmann.[93] Functioning as a store for Wilkes's 'choicest wines', a purpose that he apparently felt 'could not make a more grateful oblation' to Churchill, the monument was an assemblage of affective associations and connections, wrapped in an appropriately classical façade.[94] As objects which palpably transformed emotion into material form, monuments represent a key manifestation of the material culture of sentiment, particularly those commissioned posthumously, as in the case of this one for Churchill. Likewise, the placement of a funeral urn at the monument's termination demonstrates that it clearly subscribed to the dominant visual and material language of mourning of the period, in which the urn was firmly associated with both classical antiquity and the material culture of death, as further discussed in the following chapter.

This function was reinforced by the monument's inscription, which read: 'CAROLO CHURCHILL DIVINO POETAE AMICO IVCVNDO' (To Charles Churchill, Divine Poet, Delightful Friend).[95] The use of 'IVCVNDO' is important here. As Lindsay Watson has noted of Horace's *Epodes*, though 'largely avoided in elevated poetry, *iucundus* has a strongly affective or sentimental flavour', making it a particularly apt term 'in contexts of friendship'.[96] Given Wilkes's notable knowledge and enjoyment of Horace, as exemplified by an anecdote in James Boswell's *Life of Johnson* in which Wilkes and Johnson debate a 'contested passage' of the *Ars Poetica*, this seems like a careful and deliberate choice of wording. Designed to firmly reinforce not only Wilkes's classical knowledge, but also his affection for his old friend, the inscription emphasizes the monument's sentimental qualities.[97]

Consideration of both the monuments to Wilkes's relationships with his friends and relatives, and the tents designed to hold extra guests at the Cottage, reveals how Sandham can be conceptualized as an explicitly affective and social space. Serving to 'celebrate all that was dear' to Wilkes, it created the dual impression of welcoming hospitality and considered aesthetic taste for visitor and reader alike.[98] Yet if the sweetly sentimentalizing and dedicatory nature of the Wilkes's monument to Churchill seems at odds with the rambunctiousness of the pair's public reputations, there are hints that this tension was also picked up on by contemporaries, as we see in the poem commemorating the monument included in the *Gentleman's Magazine* (pl. 2).[99] It reads:

> Sweet power of Poesy! thy moving lay
> E'en Discord hears, and list'ning fiends obey;
> Thy Churchill sings; the angry passions cease;
> And Wilkes can sacrifice to thee and Peace.
> T.S.

Although the poem's overall meaning is somewhat ambiguous in nature, 'poesy' here seems to work as a counter to the 'discord' and 'angry passions' mentioned elsewhere in the stanza; a reference to turmoil that perhaps reflects the conflict in which both men had repeatedly found themselves throughout their younger years. As such, the 'poesy' and 'peace' found in the poem might also be read as being in alignment with the trope of peaceful retreat and pastoral retirement; the author thereby figuring the Cottage as a site in which both Wilkes in life, and Churchill in death, turn away from radical dispute.[100] As such, the monument is a material manifestation of some of the contradictions inherent to Wilkes's island retirement that we have seen throughout this chapter, and which shaped the reputation of Wilkes and his home alike.

Reputation and celebrity

As emphasized through both the tasteful decoration of his temporary residence and his renowned sociability while at the Cottage, there is evidently a notable disparity between Wilkes's earlier public persona and his positioning as a refined and highly hospitable host at Sandham Cottage. Accounts of the house and Wilkes's time on the Isle of Wight accordingly suggest a successful reinvention of character on Wilkes's part. This was facilitated by the repetitive nature of the print culture surrounding the house, which reflected the viral textuality enabled by immensely popular review periodicals such as the *Monthly Review* and the *Critical Review*. As Abigail Williams has noted, the cultures of reprinting that characterized these publications ensured that 'numerous books would have had a much wider circulation on the extracted form of review essays than they ever did as entire works'.[101] With the *Monthly Review*'s sales figures at 5,000 for the year 1797, these texts were, as Megan Peiser has demonstrated, instrumental in building 'contemporary reputation and popularity', for presses, authors and subjects alike.[102] In the context of this close connection between reputation and the practices of literary excerption we can accordingly view the proliferation of texts on Sandham Cottage as in line with, if not directly contributing to, Wilkes's distinct popularity by the end of the century.

But was this a deliberate strategy of reshaping public perception adopted by Wilkes himself or merely something that arose around him? Multiple historians have discussed the highly deliberate machinations of Wilkes's political self-fashioning as one that purposely exploited his private life. Brewer, for example, depicts Wilkes as 'a propogandist whose skills fell little short of genius', while Kavanagh argues that Wilkes's unmistakeable heterosexuality was an example of the transformation of the private into a public persona.[103] Kelly, likewise, has highlighted that Wilkes's 'intimate knowledge of his audiences, their common knowledge and their expectations allowed him to adroitly respond to the government's attacks, which increasingly focused on his morality', which, as Clark has established, sought to portray Wilkes 'as a devilish creature who would incite mobs, ruin tradesmen, and ravish their daughters'.[104] Crucially, these active attempts at shaping Wilkes's public persona extended beyond his most politically active years, and also encompassed the period in which he became Alderman of London in 1770. Clark argues that at this time, Wilkes 'presented himself as a reformed rake to gain the support of sober, pious, dissenting London merchants', an analysis that suggests that Wilkes continued to manipulate his reputation even in the period he described himself as an 'extinguished volcano'.[105]

Furthermore, it is clear that Wilkes understood the association between home and gentlemanly self-fashioning, noting, after he had visited Stowe, that 'I have since seen Mr. Hoare's house, which contains many excellent pictures. The views from it are exquisite. The house itself is a good gentleman's house'.[106] Wilkes's activities at Sandham, in which he assumes the guise of the sociable and polite gentleman, who exhibited exquisite taste in the decoration of his home, and who entertained numerous guests, can certainly be read against this complex narrative of shifting self-presentation as enacted by a shrewd propagandist.

Though we cannot know for sure if it was a deliberate and self-conscious strategy by Wilkes to employ his residence at Sandham in this way, it is nevertheless

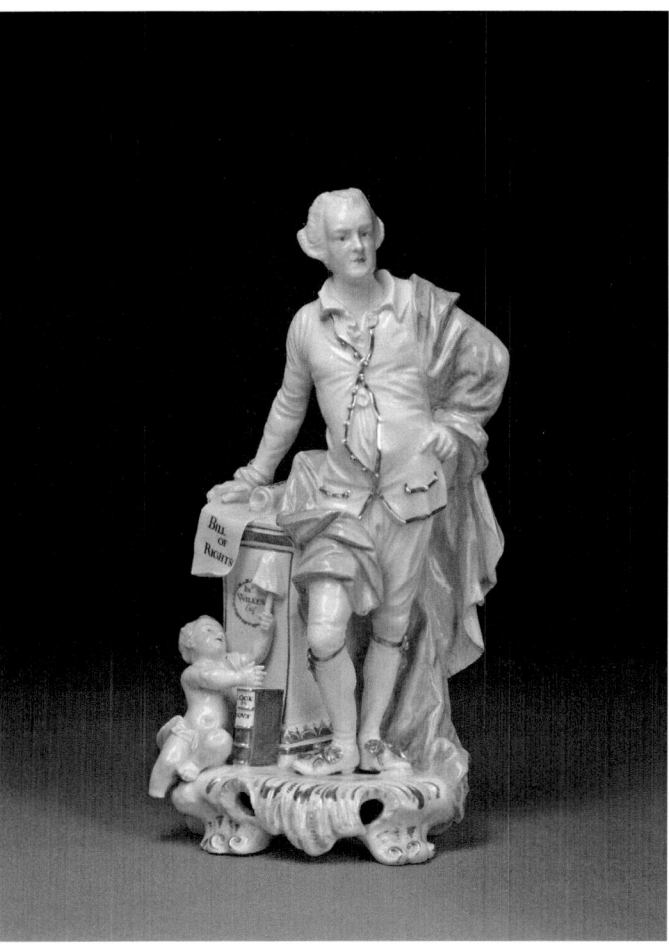

Figure 2.4 Derby Porcelain Factory, figurine of John Wilkes, *c.* 1775. Soft-paste porcelain, painted in enamels and gilded. Courtesy of the Victoria and Albert Museum, London.

true that its presentation in travel writing and other forms of published literature encouraged this view, regardless of any attempts, or lack of same, on Wilkes's part at self-fashioning in this way. Kelly has highlighted Wilkes's knowledge of, and complicity in, the medium of print as a vehicle for communicating with the public, arguing that through the medium 'author, printer, and reader collaboratively created meaning'.[107] Beyond the gossip, rumour and seditious symbolism that surrounded Wilkes in printed texts and images however, Sandham Cottage represents a different episode in the print culture relating to Wilkes. In focusing not on populist symbolism but upon how his home appeared in print, attention to writings on Wilkes's island retreat reveals how the publication of his house could itself shape conceptions of the politician.

Such accounts of Wilkes's Cottage, were, of course, directly invested in the celebrity of Wilkes, rather than the repute of the house itself. As Bullar writes, the house 'from the celebrity of its *owner*, than its *own*, became one of those fancy-places, which the Summer visitors of the Isle of Wight seldom omitted in their excursions'.[108] This celebrity directly corresponded with a remarkable print and material culture that emerged around Wilkes as an individual and political phenomenon.[109] This is made particularly clear through the production of a wide variety of ceramic objects available that employed Wilkes's likenesses and political messages that were available for contemporary consumers to purchase.[110] Alongside Chinese import punchbowls, decorated with Wilkite imagery and symbols, such as the semiotically-dense '45', perhaps the most famous example of a ceramic item referencing Wilkes were the Derby Porcelain Factory statuettes of the politician (fig. 2.4).[111] Made around 1775, the figure shows Wilkes dressed in a philosopher's banyan that falls around his shoulders, while his political allegiances and dedication to liberty are suggested through his carefully positioned leaning on a copy of the Bill of Rights. A piece of classical statuary in miniature, the statuette rendered Wilkes as a consumable in order to suit the tasteful shopper with radical leanings. Here, he was far from the squinting demagogue of William Hogarth's infamous print, and instead, in this classicizing form, he adopts the guise of the patrician democrat, defending both classical democratic models and contemporary liberty in equal measure. Such objects show that Wilkes was not merely a collector and consumer of visual and material culture, but also that he was himself consumable property.

Since the earliest days of his political radicalism, both Wilkes's words and images were equally sought, purchased and exhibited. As Brewer has argued, Wilkes was more than mob orator, instead occupying the role of a 'flag, a badge, or a symbol', which was transposed on a diverse array of visual images and material objects 'used, purchased or displayed as an act of ideological solidarity'.[112]

Tilley likewise describes the Wilkite cause as a 'symbol-drenched pageant of opposition to governmental tyranny'.¹¹³ In many ways, the production of the cause's associated visual and material culture runs parallel with the types of images and objects produced within other political movements from the long eighteenth century, from the Jacobite uprisings of 1715 and 1745, to the American Revolution of 1789.¹¹⁴ In their dense iconographies and use of numeric suggestion, rather than explicit references to the cause, some of the objects associated with Wilkes mirror the symbolic languages employed by Jacobite material culture, which, due to its treacherous nature, made use of a grammar of symbolic allusion and duplicity.¹¹⁵ Portraits of both Charles Edward Stuart and Wilkes were repeatedly used in material propaganda associated with their movements; a parallel iconicity that encouraged a strong identification between leader and cause. Stuart's repetitive portraitive representation has been identified by art historians such as Robin Nicholson as central to the intimacy established between a political ideology's leader and its followers, encouraging the latter to 'look, love and follow', an ocular engagement with the image of the leader that placed visual culture at the heart of such political movements.¹¹⁶

Like the exiled Prince, Wilkes's image occupied its own form of iconographic representation through its repeated use in paint, print and ceramic. Indeed, Wilkes's image was circulated consistently throughout this period by critic and supporter alike, most notably, perhaps, in William Hogarth's infamously unflattering satirical etching of his former friend (fig. 2.5).¹¹⁷ Titled *John Wilkes Esq.* and published in 1763, the image depicts a squinting Wilkes with a copy of the treasonous *North Briton* Number 45 nearby. The print sold 4,000 copies in the first few months after its publication, and it was copied relentlessly, reflecting the intensity of interest in Wilkes at this time.¹¹⁸ Although intended as a blistering attack, the print was co-opted into the radical cause, transformed into an emblematic icon of Wilkite support due to its strong and recognizable symbolism. Shearer West has written how thanks to the print Wilkes's squint 'became a metonym for the man himself', that participated in the 'transformation of Wilkes the private man into Wilkes the public champion of Liberty'.¹¹⁹ This symbolic transformation was particularly reinforced by the repetition of Hogarth's image of Wilkes, which was adapted by numerous copyists who created a legion of what West designates 'squint prints', and which participated in an overlapping inter-visual culture that surrounded Wilkes and once again reinforced his celebrity status. I have written elsewhere about the cultural significance of repeated images and tropes during this period, particularly as they slip, or migrate, between the cultural realms of text, image and object.¹²⁰ Wilkes was no

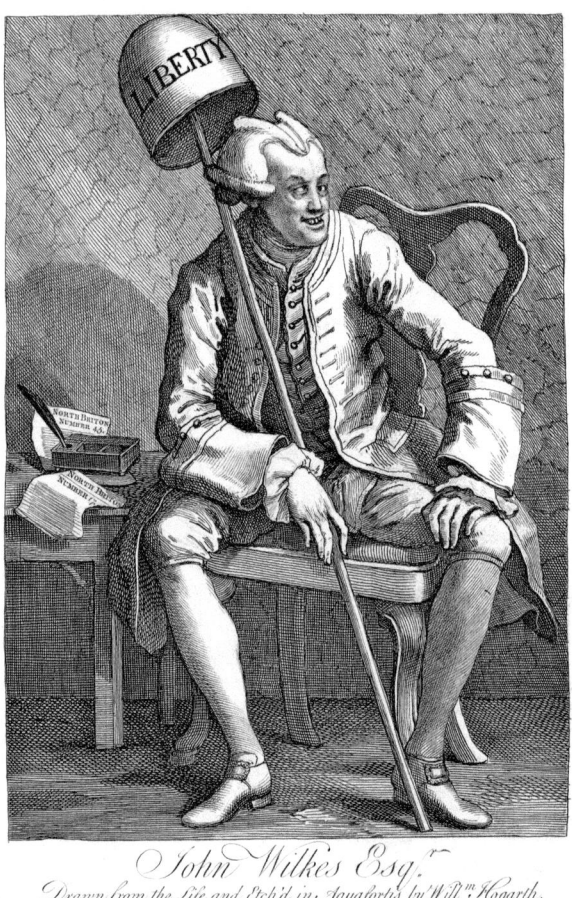

Figure 2.5 William Hogarth, *John Wilkes Esq*. Published by Longman, Hurst, Rees and Orme, 1 July 1807. Engraving, 21.9 x 18.0 cm. Courtesy of The Lewis Walpole Library, Yale University.

different; with his image consistently appearing and reappearing within pamphlets, satirical prints, formal paintings and mass consumable wares, he could dually function as both a general and iconic idea, and as a living and individualized ideologue. Together, these objects demonstrate the importance of visual and material culture to both the commodification of the individual subject and their ensuing codification in the guise of celebrity.

Alongside Hogarth's print, West also unpacks the significance of that other famous image of Wilkes, Zoffany's double portrait of him and his daughter Polly, which she suggests may even have been painted on the Isle of Wight (fig. 2.6). The

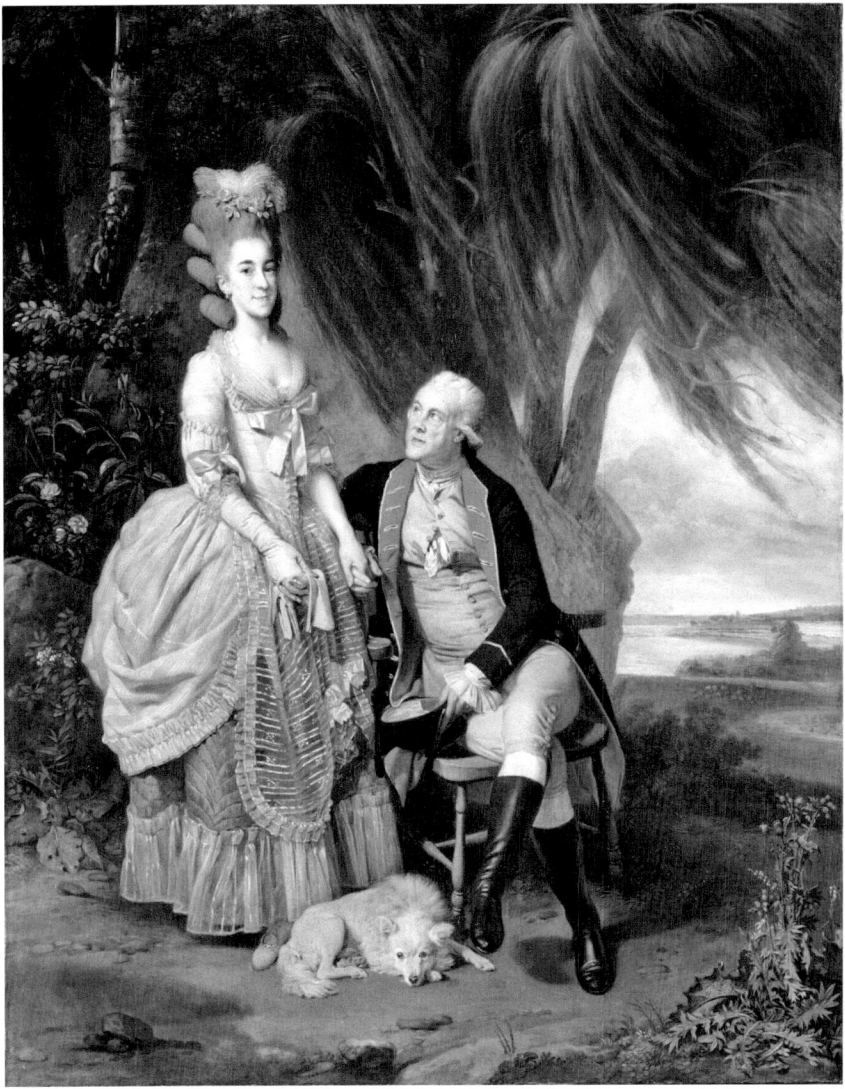

Figure 2.6 Johan Zoffany, *Mary and John Wilkes*. Exh.1782. Oil on canvas, 126.4 cm × 100.3 cm. Courtesy of the National Portrait Gallery, London.

image is notable for showing Wilkes the private figure rather than the public man, a shift in his iconography that West frames as an alteration of 'Wilkes's representational history'.[121] Following this argument, portraitive representation – both positive and negative – played a central role not only in the consolidation of Wilkes's celebrity status, but in the creation of his 'representational history', from formalized and flattering painted portraits rendered relatively accessible through

the democratizing medium of print, to the satirical likenesses that exploited the more unusual features of Wilkes's face. Considered against the swathes of visual, material and literary culture, which variously castigated and celebrated Wilkes, the contemporary interest in Sandham Cottage takes on a different character. Beyond the house portraits typical of this time period, as sketched at length in the previous chapter, depictions of Wilkes's house instead constitute yet one more episode in his representational history, one in which the complexities of his character – at once patriot and demagogue – could be reconsidered.

Just as published descriptions of Wilkes's home were repeatedly characterized by an emphasis on the Cottage's gardens or the decoration of its canvas rooms, so too were such accounts typified by attempts to understand Wilkes's character, and to contextualize his comparatively uncontroversial time on the Isle of Wight. The biography excerpted in the *Annual Hampshire Repository*, for example, describes amusing incidents during Wilkes's earliest adventures on the Island, in which he sought a bed at a farmhouse, only to be confronted by a maid who on 'no consideration upon earth should induce her to trust herself in the same room with so dangerous a man as Mr. Wilkes', and another, in which a property's landlord flew into 'a violent rage that such a lodger as Wilkes should be received into any house that belonged to him'.[122] Far from shying away from Wilkes's poor reputation and private vices, the biography portrayed Wilkes 'in the strong colours of truth', his failings 'lashed with that severity which they deserve'.[123] Likewise, Bullar's account of the house, which drew heavily on citations from the *Repository* biography, was footnoted by the following 'the writer of the above sketch reprobates, with an honest warmth, the obliquity of John Wilkes's politics, and the licentiousness of his private life: and justly observes, that "his progressive profligacy advances in regular gradation of guilt, and rises in an ascending series of shame, from his licentious conversation, through his culpable conduct, to the acme of infamy, his criminal publications. Bad as each in itself, the next is worst [...] till we arrive at *ne plus ultra* of evil, – *the disturber of the public peace, and the corrupter of the public manners*"'.[124] Such inclusions attest to the enduring omnipresence of Wilkes's negative reputation, even long after he adopted a quieter, less controversial life.

Yet neither Wilkes's radical history, nor his later popularity entirely characterize stories of Sandham Cottage. Instead, such accounts embrace the contradictory complexity of Wilkes's contrasting public and private selves by repeatedly emphasizing that on the Isle of Wight, and at Sandham Cottage specifically, Wilkes was his true, *insular* self, a construction that highlights the coexistent duality of Wilkes. As the epistolary contributor to the *Gentleman's Magazine* suggested, at

Sandham Wilkes 'passed many of his pleasantest hours, free from the distraction of parties, or cares of office; and, amid the pleasures of the surrounding scenery, a well-chosen library, and a few intelligent friends, he experienced a more solid delight, than when hailed by the rabble as "Patron of expiring Liberty"'.[125] Brettell, likewise identified Sandham as the place 'where this celebrated politician, free from the turmoil of strife of his public life, spent the evening of his days'.[126] The *Repository* biography also draws attention to the cohabitation of these two Wilkes, noting that 'whatever part he acted in former life, or with whatever vices and immoralities the world, right or wrong, might have branded him, here our retired alderman, at his Villakin, spent his time in as rational, quiet, and blameless a manner, as any of his graver brethren'.[127] Crucially these analyses of Wilkes's character were couched in specifically local terms, with each rooting their accounts against Wilkes's home of Sandham Cottage. An article on Wilkes in the *Isle of Wight Magazine* was typical in this respect, with its author writing that 'Locality gives a turn to the manners of all men, and, that their true characters may be understood, they must be studied not so much in the busy scenes of life, in the paths that lead to wealth and fame, as in retirement and domestic habits', while the *Repository* noted similarly that 'To investigate the true characters of men, we must not so much contemplate their public as their private demeanour'.[128] It is significant that far from being tainted by association with Wilkes, by the time the property was sold in 1798, the advertisement selling the house printed in the *St. James's Chronicle* also explicitly stressed the link between the Cottage and Wilkes's ownership, which appears between assertions that the villa was 'neatly fitted-up', and assurances of its convenience and the fine views it commanded.[129]

This positivity, however, was not to last, as the divergent accounts of Wilkes's property by Bullar in his 1799 publication, *A companion in a tour round Southampton; comprehending various particulars, ancient and modern*, and in his 1817 text, *A Historical and Picturesque Guide to the Isle of Wight*, suggest. The former praises Wilkes as a celebrated character, quoting extensively from the flattering *Annual Hampshire Repository* biography of the politician, which crucially related Wilkes's personality to the presentation of his home, noting that 'the taste shown by him in ornamenting his rooms and ground, bore a great affinity to that displayed in his person'.[130] By 1817, however, Bullar wrote the following of Sandham Cottage, 'a few years ago an object of attraction and of curiosity, but now exhibiting an emblem of the quickly faded popularity of its late owner, the celebrated Mr. Wilkes. It is now in a ruinous state; all its former decorations are fled; and the large canvass dining room is carried to the Sandrock-spring hotel'.[131] Just as his 1799 account stressed the mutability

between Wilkes and his house, highlighting the complementary and becoming qualities of each, so too did the 1817 description directly compare the Cottage's ruinous state to the declining popularity of its former owner. Indeed, as demonstrated throughout the literature cited in this chapter, these contrasting accounts affirm that Wilkes's villa was seen, by contemporaries at least, as a measure of his renown and the esteem in which he was held, wherein Wilkes's radical reputation was underwritten by his status as a fashionable, tasteful and sociable gentleman. Although the *Repository* biographer claimed that 'when the frail ornaments of Sandham shall have mouldered away, and its inscriptions shall have ceased to be legible' visitors would continue to 'muse over the spot, and still hail as at least minor classic ground, *the villakin of John Wilkes*', it was clear that by the early nineteenth century, both the house, and interest in Wilkes, had badly declined.[132]

Beyond the rise and fall of Wilkes's social standing, this episode is also revealing in terms of the relationship between visual and material culture and written texts during this period, in which the two categories of culture object operated in a complementary and even mutually constitutive way. As demonstrated within this chapter, every account of Wilkes's home privileged a description of the objects within this space as a means by which to convey something of its owner's personality, temper and taste. As such, descriptions of the visual and material culture of Wilkes's home function almost narratively, as represented within and functioning as an integral element of, the text. Like Wilkes himself, whose subjectivity was defined in relation to these objects through a collapsible boundary between the two, the relationship between text and object was similarly mutable, allowing for a reading of the eighteenth-century house and its decoration, while highlighting the narrative operations of the very same, with publication the key cultural transaction that allowed the home to function in this way. A consideration of how Sandham Cottage was published not only challenges divisions between the fine and decorative arts, and between interior and exterior spaces, but also between the material object and the written word more broadly.

Notes

1 Climenson, *Passages*, 265.
2 Anon. '*Provincial Life and Anecdotes of John Wilkes*', excerpted in *The Annual Hampshire Repository, or Historical, Economical, and Literary Miscellany. A Provincial Work, of entirely original Materials; comprising all Matters relative to the County,*

including the Isle of Wight, &c. Vol. 1. (London & Winchester: Robbins, White). Excerpted in the *Anti-Jacobin Review and Magazine*, Issues 15–18 (1803–4): 143.
3 Ibid.
4 Thomas Brettell, *A topographical and historical guide to the Isle of Wight, Comprising Authentic Accounts of its Antiquities, Natural Productions, and Romantic Scenery* (London: Leigh & Co. 1840), 188.
5 Horace Bleackley, *Life of John Wilkes* (London & New York: John Lane, 1917), 379.
6 Ibid.
7 *The Times* (London), Wednesday, 15 June 1932, 11.
8 Brettell, *A topographical and historical guide*, iii.
9 C.R.S. 'Notes from a Pedestrian Excursion in the Island', *The Mirror of Literature, Amusement, and Instruction*, 13 October 1832, 225–6.
10 *Gentleman's Magazine*, January 1804, 95: 17–18.
11 Ibid., 18.
12 Ibid.
13 *Gentleman's Magazine*, 1768, 242. Cited in Christopher Tilley, *Popular Contention in Great Britain, 1758–1834* (Cambridge, MA: Harvard University Press, 1995), 156.
14 Wall, *The Prose of Things*.
15 Anderson, *Touring and Publicizing*.
16 *St James's Chronicle, or the British Evening Post* (London, England), 7 October–9 October 1794.
17 See Ryan Cordell and David A. Smith's *Viral Texts* project, viraltexts.org
18 *St James's Chronicle*. Thanks to Matthew Reeve whose elegant phrasing I have borrowed here.
19 John Bullar, *A companion in a tour round Southampton; comprehending various particulars, ancient and modern* (Southampton: T. Baker, 1799). 'Provincial Life and Anecdotes of John Wilkes', 143.
20 Bleackley, *Life of John Wilkes*. Percy Hetherington Fitzgerald, *The life and times of John Wilkes, M.P., Lord Mayor of London, and Chamberlain* (London: Ward & Downey, 1888). John Sainsbury, *John Wilkes: The Lives of a Libertine* (Aldershot & Burlington: Ashgate, 2006). Peter D.G. Thomas, *John Wilkes: A Friend to Liberty* (Oxford: Oxford University Press, 1996). Arthur Cash, *John Wilkes: The Scandalous Father of Civil Liberty* (New Haven & London: Yale University Press, 2008).
21 Tilley, *Popular Contention in Great Britain*. John Brewer, *Party Ideology and Popular Politics at the Accession of George III* (New York: Cambridge University Press, 1976). Kathleen Wilson, *The Sense of the People: Politics, Culture and Imperialism in England, 1715–1785* (Cambridge: Cambridge University Press, 1998).
22 Jonathan Conlin, 'Wilkes, the Chevalier D'Eon and 'The Dregs of Liberty': An Anglo-French Perspective on Ministerial Despotism, 1762–1771', *The English Historical Review*, 120, no. 489 (2005): 1251–88. Declan Kavanagh, 'John Wilkes's

Closet: Hetero Privacy and the Annotation of Desire', in A. De Freitas Boe and A. Coykendall (eds), *Heteronormativity in Eighteenth-Century Literature and Culture* (London and New York: Routledge, 2016), 77–95. Jason M. Kelly, 'Riots, Revelries, and Rumor: Libertinism and Masculine Association in Enlightenment London', *Journal of British Studies*, 45, no. 4 (October 2006): 759–95. Anna Clark, *Scandal: The Sexual Politics of the British Constitution* (Princeton, NJ: Princeton University Press, 2004), 19–52.

23 Lindsay Boynton, 'The Marine Villa', in Dana Arnold (ed.), *The Georgian Villa* (Stroud: The History Press, 2011), 118.
24 Bleackley, *Life of John Wilkes*, 315.
25 Cash, *John Wilkes*, 42. Walter Shirley, 'John Wilkes, demagogue or patriot?: a sketch of the eighteenth century: being a lecture delivered at Leeds, in London and at Doncaster, in the early part of 1879', *Bristol Selected Pamphlets*, 1879, 43.
26 Robin Eagles, 'A patriot in retirement: John Wilkes's pastoral retreat on the Isle of Wight 1788–1797', paper delivered at the British Society for Eighteenth-Century Studies Conference, St Hugh's College, University of Oxford, 2019, 2.
27 Robert Sears, *A New and Popular Pictorial Description of England, Scotland, Ireland, Wales, and the British Islands* (New York: Robert Sears 1847), 66.
28 Linda Colley, 'Eighteenth-Century English Radicalism before Wilkes', *Transactions of the Royal Historical Society*, 31 (1981): 4.
29 Shirley, 'John Wilkes, demagogue or patriot?'
30 Ibid., 165–6.
31 Thomas, *John Wilkes*, 215.
32 Kavanagh, 'John Wilkes's Closet', 78. On the complexities of elite polite masculinity during this period, see: Kelly, 'Riots, Revelries, and Rumor'.
33 Sainsbury, *John Wilkes*, 1.
34 Climenson, *Passages*, 265.
35 John Albin, *A new, correct, and much-improved history of the Isle of Wight* (Newport: J. Albin, 1795), 484.
36 Henry Penruddocke Wyndham, *A picture of the Isle of Wight, delineated on the spot, in the year 1793* (London: C. Roworth, 1794), 54.
37 Ann Robey, 'Floorcloth Manufactory in Knightsbridge', *The Georgian Group Journal*, 7 (1997): 160.
38 Ibid., 165.
39 Bleackley, *Life of John Wilkes* 380.
40 Bullar, *A companion in a tour*, 232.
41 Albin, *A new, correct, and much-improved history of the Isle of Wight*, 483.
42 Bleackley, *Life of John Wilkes*, 151. Bullar, *A companion in a tour*, 232.
43 Bleackley, *Life of John Wilkes*, 151.

44 Cash, *John Wilkes*, 22.
45 John Wilkes, *Letters from the Year 1774 to the Year 1796 of John Wilkes Esq. Addressed to his Daughter, the Late Miss Wilkes* (London: S. Gosnell, 1804), 4: 14.
46 Wilkes, *Letters*, 4: 105.
47 Climenson, *Passages*, 265. Albin, *A new, correct, and much-improved history of the Isle of Wight*, 484.
48 Bullar, *A companion in a tour*, 232.
49 Ibid. Christopher Plumb has discussed the contemporary interest in keeping birds in *The Georgian Menagerie: Exotic Animals in Eighteenth-Century London* (London: I.B. Tauris, 2015), 143–4.
50 Ibid., 146.
51 Wyndham, *A picture of the Isle of Wight*, 54.
52 Brettell, *A topographical and historical guide*, i.
53 Bullar, *A companion in a tour*, 231.
54 John Hassell, *Tour of the Isle of Wight* (London, 1790), 2: 2.
55 Climenson, *Passages*, 265. Wilkes, *Letters*, 4: 94 and 97.
56 Climenson, *Passages*, 265. Albin, *A new, correct, and much-improved history of the Isle of Wight*, 483.
57 Ibid.
58 Hassell, *Tour of the Isle of Wight*, 2:21.
59 Charles Tomkins, *A tour to the Isle of Wight, illustrated with eighty views, drawn and engraved in aquatinta*, 2 vols. (London: G. Kearsley, 1796). Vol. 1: 136. John Sturch, *A view of the Isle of Wight, in four letters to a friend Containing Not only a Description of its Form and principal Productions, but the most authentic and material Articles of its natural, political, and commercial History* (Newport: 1794), 9
60 Lipsedge, *Domestic Space*, 8.
61 Fitzgerald, *The life and times of John Wilkes*, 299.
62 Jonathan G.W. Conlin, 'High Art and Low Politics: A New Perspective on John Wilkes', *Huntington Library Quarterly*, 64, no. 3/4 (2001): 356–81.
63 Ibid., 369, 372.
64 See Kelly, 'Riots, Revelries, and Rumor'.
65 Fitzgerald, *The life and times of John Wilkes*, 299.
66 Wilkes, *Letters*, 4: 46.
67 Boynton, 'The Marine Villa', 124.
68 Wilkes, *Letters*, 4: 94.
69 Ibid., 101.
70 Ibid., 141, 149.
71 Coltman, *Fabricating the Antique*. Jonathan Scott, *The Pleasures of Antiquity: British Collectors of Greece and Rome* (New Haven & London: Yale University Press, 2003).
72 Robey, 'Floorcloth Manufactory in Knightsbridge', 165.

73 William Fordyce Mavor, *The British tourists; or traveller's pocket companion, through England, Wales, Scotland, and Ireland. Comprehending the most celebrated tours in the British Islands*, 6 vols. (London: E. Newbery, 1798–1800), 5: 43. Hassell, *Tour of the Isle of Wight*, 2: 22.
74 *St. James's Chronicle, or the British Evening Post* (London), 7 October–9 October 1794.
75 Stana Nenadic, 'Print Collecting and Popular Culture in Eighteenth-Century Scotland', *History*, 82, no. 226 (1997): 203.
76 Coltman, *Fabricating the Antique*, 78.
77 Paula Findlen, *The First Modern Museums of Art: The Birth of an Institution in 18th- and Early-19th-century Europe* (Los Angeles: J. Paul Getty Museum, 2012), 78.
78 Ibid., 79.
79 Maria Emilia Masci, 'The birth of ancient vase collecting in Naples in the early eighteenth century: Antiquarian studies, excavations and collections,' *Journal of the History of Collections*, 19, no. 2 (2007): 215.
80 Coltman, *Fabricating the Antique*, 80–1.
81 Ibid., 76.
82 Ibid., 77.
83 Climenson, *Passages*, 265.
84 Brettell, *A topographical and historical guide*, 35 and 48.
85 Wilkes, *Letters*, II: 266.
86 Bullar, *A companion in a tour*, 234.
87 Climenson, *Passages*, 265.
88 Wyndham, *A picture of the Isle of Wight*, 55.
89 Hassell, *Tour of the Isle of Wight*, 2: 22.
90 Shearer West has suggested that the background of this portrait might possibly depict the Isle of Wight. Were this to be the case, their relationship would be even more firmly anchored to the affective space of Sandham. See West, 'Wilkes's Squint: Synecdochic Physiognomy and Political Identity in Eighteenth-Century Print Culture', *Eighteenth-Century Studies*, 33, no. 1 (Fall, 1999): 77.
91 For an account of his time on the Isle of Wight, see Robin Eagles, *The Diaries of John Wilkes, 1770–1797* (London: Boydell & Brewer, 2014). William Bowyer, *Literary Anecdotes of the Eighteenth Century: Comprising Biographical Memoirs of William Bowyer, Printer, F.S.A. and many of his Learned Friends* (London: Nichols, Son, and Bentley, 1815), 754.
92 Declan Kavanagh, *Effeminate Years: Literature, Politics, and Aesthetics in Mid Eighteenth-Century Britain* (Bucknell University Press, 2017), 3.
93 Cash, *John Wilkes*, 388.
94 *The Monthly Visitor, and Entertaining Pocket Companion*, 1800, 9: 84.
95 *Gentleman's Magazine*, January 1804, 95: 18.

96 Lindsay C. Watson, *A Commentary on Horace's Epodes* (Oxford: Oxford University Press, 2003), 62.
97 James Boswell, R.W. Chapman (ed.), *Life of Johnson* (Oxford: Oxford University Press, 1980), 771–2.
98 Anon., *The Annual Necrology, for 1797-8: Including, Also, Various Articles of Neglected Biography* (London: R. Phillips, 1800), 1: 545.
99 Kavanagh, *Effeminate Years*, xxxvi.
100 Many thanks to Erin Lafford for sharing her thoughts with me about this poem.
101 Williams, *The Social Life of Books*, 101.
102 Megan Peiser, 'William Lane and the Minerva Press in the Review Periodical, 1780–1820', *Romantic Textualities: Literature and Print Culture, 1780–1840*, 23 (2020): 124–5.
103 Brewer, *Party Ideology and Popular Politics*, 166 and 164. See Kavanagh, 'John Wilkes's Closet'.
104 Kelly, 'Riots, Revelries, and Rumor'. 779. Anna Clark, 'The Chevalier d'Eon and Wilkes: Masculinity and Politics in the Eighteenth Century', *Eighteenth-Century Studies*, 32, no. 1 (1998): 29.
105 Ibid.
106 Wilkes, *Letters*, 2: 98.
107 Kelly, 'Riots, Revelries, and Rumor', 766.
108 Bullar, *A companion in a tour*, 234.
109 Alexandra Macdonald, 'Idle Talk: Portraiture, Visual Culture and Politics in Eighteenth-Century England', unpublished manuscript (2016), 4. My thanks to Alexandra for allowing me to read a copy of this paper.
110 On Wilkes's commodification, see: McKendrick, Brewer and Plumb, *The Birth of a Consumer Society*, 197–264, and Kevin Bourque, 'Cultural Currency: *Chrysal, or the Adventures of a Guinea,* and the Material Shape of Eighteenth-Century Celebrity', in Ileana Baird and Christina Ionescu (eds), *Eighteenth-Century Thing Theory in a Global Context: From Consumerism to Celebrity Culture* (Farnham: Ashgate, 2013), 49–68.
111 Tilley argues that the number 45 became ironically connected to Wilkes, a transformation that turns the number into a 'recognised symbol of opposition to arbitrary rule'. Tilley, *Popular Contention in Great Britain*, 151–2.
112 Brewer, *Party Ideology and Popular Politics*, 184–5.
113 Tilley, *Popular Contention in Great Britain*, 152.
114 Ibid., 157. Indeed, Wilkes's cause and liberty-infused language would be particularly celebrated in revolutionary America, accounting for the large number of pro-John Wilkes images and objects that survive in American museum collections, such as those of the Wintherthur Museum, Garden and Library.

115 On Jacobite material culture, see Murray Pittock, 'Treacherous Objects: Towards a Theory of Jacobite Material Culture', *Journal for Eighteenth-Century Studies*, 34, no. 1 (2011): 39–63.
116 Robin Nicholson, *Bonnie Prince Charlie and the Making of a Myth: A Study in Portraiture, 1720–1892* (Lewisburg: Bucknell University Press, 2002). Paul Kleber Monod, *Jacobitism and the English People, 1688–1788* (Cambridge: Cambridge University Press, 1993), 70–96.
117 See West, 'Wilkes's Squint': 65–84. See also Amelia Rauser, *Caricature Unmasked: Irony, Authenticity, and Individualism in Eighteenth-Century English Prints* (Plainsboro: Associated University Press, 2008), 50–5.
118 Samuel Ireland, *Graphic Illustrations of Hogarth*, 2 vols. (London: R. Faulder and J. Egerton, 1794–9), 1:177.
119 West, 'Wilkes's Squint': 66–7.
120 Gowrley, 'Taste *à-la-Mode*'.
121 West, 'Wilkes's Squint': 77–8.
122 'Provincial Life and Anecdotes of John Wilkes', 146.
123 Ibid., 148.
124 Bullar, *A companion in a tour*, 236–7.
125 *Gentleman's Magazine*, January 1804, 95: 18.
126 Brettell, *A topographical and historical guide*, 188.
127 'Provincial Life and Anecdotes of John Wilkes', 147–8.
128 *The Isle of Wight Magazine, for 1799* (Newport, 1800): 372. 'Provincial Life and Anecdotes of John Wilkes', 143.
129 See the classified ads, *St. James's Chronicle, or the British Evening Post* (London, June 14–16 June 1798): 'Marine Cottage, Isle of Wight; To be Sold by PRIVATE CONTRACT [...] The much-distinguished and neatly fitted-up VILLA, called SANDHAM COTTAGE [...] the Property and late Residence of JOHN WILKES, Esq. deceased. The Villa is very convenient; and suited with proper Offices, Pleasure Grounds, and Kitchen Garden containing altogether about EIGHT ACRES. The whole ornamented and improved with peculiar Taste, commanding about beautiful Sea View and Fine Land Prospects'.
130 Bullar, *A companion in a tour*, 235.
131 John Bullar, *A Historical and Picturesque Guide to the Isle of Wight* (London, 1817), 102.
132 'Provincial Life and Anecdotes of John Wilkes', 148.

Part Two

Movement

3

Material Translations, Biographical Objects: Craft(ing) Narratives at A la Ronde

Within the varied collections of A la Ronde, a domestic residence located near Exmouth in Devon, is a small octagonal worktable, comprising a hollow rosewood base decorated with floral decoupage, surmounted by a collaged plane of 'souvenir' objects and covered with a glass panel. Reminiscent of specimen tables purchased by Grand Tourists throughout the eighteenth century, the table's top is a colourful bricolage of visual and textural contrast, featuring natural materials, purchased *objets d'art* and copies from the antique.[1] More specifically, its specimens include shells collected from the shores of Devon's beaches, polished marble fragments, two circles of lapis lazuli, micromosaics, a selection of casts taken after classical cameos and intaglio gemstones and, centremost, a ceramic plaque depicting a vestal virgin that reads 'LIFE SHALL TRIUMPH OVER DEATH' (fig. 3.1 & pl. 3). Although no documentation for the table survives, a close examination of its vibrant materiality and a contextualization of the table within the lives of A la Ronde and its inhabitants suggests that its constituent objects were variously acquired during its owners' Continental tour, collected from the coastal locality of the house, and purchased to suggest enduring familial bonds. Taken from diverse contexts before being translated into the space of the tabletop, these small and fragmentary things attest to the diverse nature of the souvenir. In this intricate arrangement, it functions as a biographical object, signifying a relationship between material culture and the construction of narrative, one exemplified by the decoration of A la Ronde as a whole.

The table is part of an extensive scheme of interior design at A la Ronde, now a National Trust property, fabricated by its owners, first cousins Jane and Mary Parminter. The house was designed to their specifications following their return from an extensive Continental tour enacted *c.* 1784–91 (fig. 3.2).[2] Originally, the sixteen-sided house was limewashed and thatched, and would

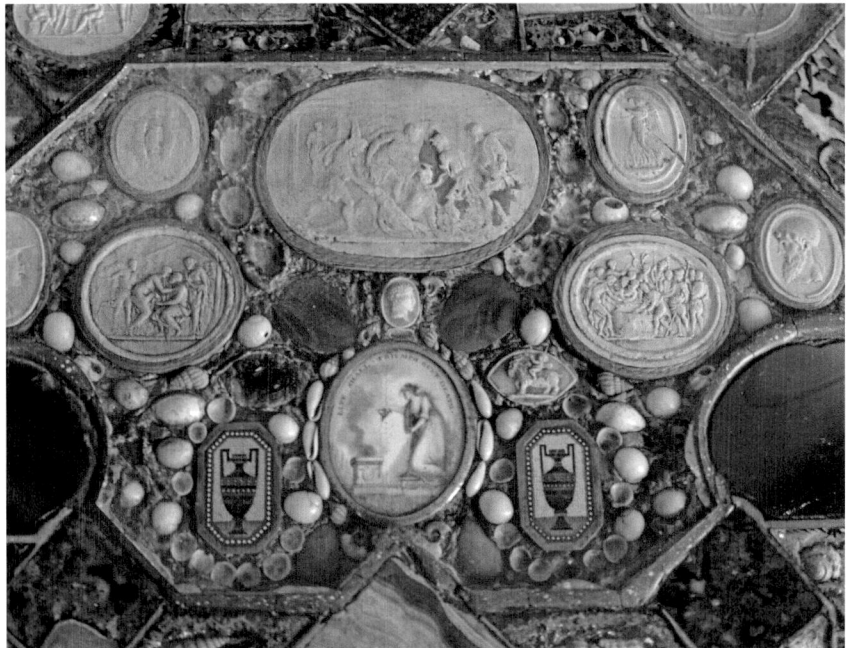

Figure 3.1 Jane and Mary Parminter, specimen table, Exmouth, Devon, 1790s. Glass, mineral, shell, paint, paper and wood. 1312249. National Trust Collections, A la Ronde, Exmouth, Devon. Photograph: author.

have evoked the fashionable rusticity of the *cottage orné*, with its current slated roof one of several major alterations completed at the behest of its only male owner, Oswald Joseph Reichel (1840–1923).³ The daughters of affluent merchant families, Jane and Mary became independently wealthy upon the death of their parents, which facilitated their extensive period of travel and subsequent cohabitation as unmarried women at A la Ronde. The cousins lived together at the house from around 1796 until Jane's death in 1811, after which time Mary lived alone at the property until her own death in 1849.⁴ It was during their period of cohabitation that the women ornamented the property, using an array of souvenir objects to create highly detailed shell- and feather-work interiors and handcrafted furniture, much of which remains in situ today.

Following a definition of the souvenir as 'the material counterpart of travels, events, relationships, and memories of all kinds', this chapter considers both purchased and collected objects, and includes those souvenirs amassed during the Parminters' Continental tour, *objets trouvés* (found objects) that the Parminters sourced from their coastal surroundings, and familial objects

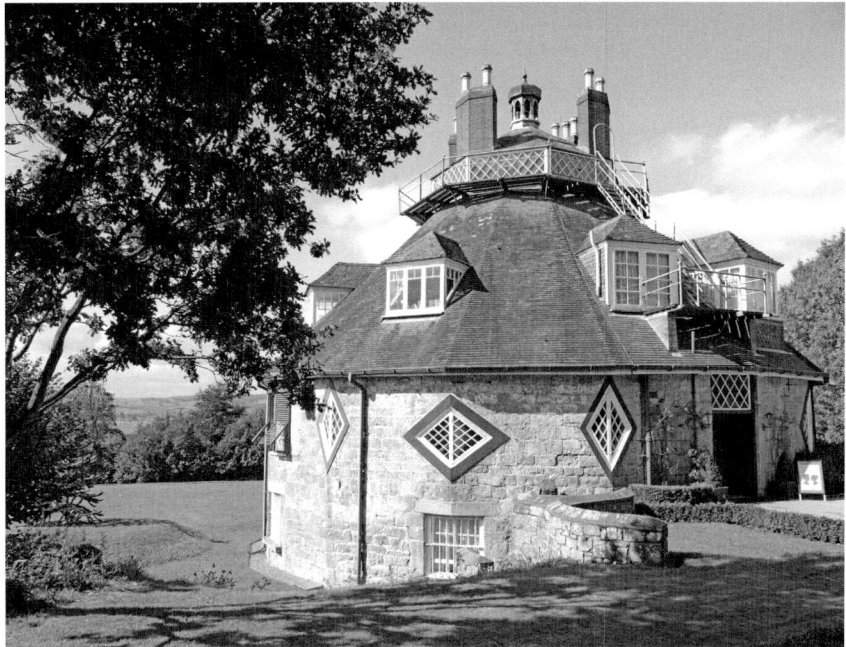

Figure 3.2 A la Ronde, *c.* 1796. National Trust, Exmouth, Devon. Photograph: author.

subsequently procured or inherited by the women.[5] During their travels, the Parminters accumulated a diverse collection of souvenirs including plaster intaglios, fragments of precious minerals, shell-pictures and prints, many of which were subsequently used to embellish their home. Once established at A la Ronde, the cousins combined the souvenirs of their tour with an array of materials taken from their coastal locale, including shells, mineral fragments, sand, locally-sourced textiles, stones, bones, spar, glass and mica, which together fabricated the wide selection of crafts practiced by the cousins. Though removed from their associated cultures of tour and shore, once translated into A la Ronde, such souvenirs were integrated with familial objects to create highly personal decorative pieces and spaces, a transformation that was at once geographical and semantic. As the integrative use of such objects within the Parminters' specimen table shows, souvenirs could collapse geographical, temporal and spatial distances; unifying home and tour, past and present, the generic and the personal. Symptomatic of the analogous construction of craft and narrative at A la Ronde as a whole, the creation of this specimen table demonstrates how the

translative processes by which it was made encapsulated the experiences, recollections and histories of its owners.

In contrast with this surviving material heritage, the textual trace left by the cousins regarding their acquisition and use of their souvenirs is comparatively lacking, with a number of key records destroyed by the bombings that devastated the city of Exeter in the 1940s.[6] Of the surviving documents, two are particularly significant for understanding the material culture of A la Ronde. The first is what survives of Jane Parminter's travel journal, written during their Continental tour, the first six weeks of which are preserved in extracts transcribed and eventually published by Reichel in 1902.[7] The second is Mary Parminter's will (1847), a vital source for understanding how the Parminters themselves viewed their decoration and cultivation of the homosocial space of A la Ronde.[8] The document provides strict instructions for the inheritance of A la Ronde, stipulating that only a female inheritor could claim ownership of the property.[9] Entrance into marriage, making alterations and failure to maintain the house and gardens could all cause disinheritance and revocation of legal title to the estate. These explicit strictures demonstrate that the construction, decoration and projected legacy of A la Ronde was an essential aspect of the Parminters' creation of an explicitly gendered space, providing a home where feminine accomplishment could flourish, sustained and protected throughout the succeeding centuries. The document therefore invites us to consider the complexly delimited inheritance of the house as a form of distinctively female, and in Halberstam's terms, queer, heirlooming, which was constitutive in A la Ronde's construction of a gendered social identity in the eighteenth century, and amongst its subsequent owners.[10]

Following the expressly feminine agenda expounded by Mary Parminter's will, previous interpretations of A la Ronde's comprehensive interior scheme have relied upon the apparent equivalency between its status as a kind of homosocial utopia, and the appropriacy of 'feminine' forms of artistic practices, such as shell-, feather-, and paperwork, as decoration for a space of this kind. The architectural historian Colin Cunningham, for example, cites A la Ronde as 'an important example of what has come to be seen as "feminine taste"', while Amanda Vickery characterizes its decoration as 'a rampant culture of flamboyant ornamentation' suggestive of the 'virtuous consecration to a domestic cloister of curiosities and a luxuriant exfloreation of femininity'.[11] Highlighting the Parminters' knowing cultivation of a specifically feminine space, ratified legally through Mary Parminter's last will and testament, such interpretations gender A

la Ronde's interiors as distinctively female, emphasizing the inherently feminine nature of both the kinds of objects collected at A la Ronde, as well as craft practices more generally. Yet the bricolaged spaces and furnishings of the house and its collections express more than this agenda. Indeed, while Mary Parminter's will stresses her anticipated construction of an explicitly feminine future for A la Ronde, it is crucial to conceptualize the house's ornamentation both in relation to the Parminters' creation of a female space, as well as the experiences of the Parminter family more broadly. Encompassing their continental travel, subsequent life at A la Ronde, and the powerful affective bonds established between the women, these experiences powerfully demonstrate that the Parminters were at once seasoned travellers, residents of Devon, family members *and* women. Sustained attention to the disparate material elements that constitute A la Ronde's decoration reveals these competing narratives and identities, ultimately demonstrating how fragmentary forms of material culture, such as the specimen table, actively allowed the Parminters to construct a highly personal and subjective space.

Souvenir, narrative, translation

Deriving from the French word for a remembrance or memory, in the eighteenth century the term 'souvenir' was conventionally found in French memoirs and their translations.[12] However, a number of individuals identified the incentive for the acquisition of objects that we today would recognize as souvenirs. In 1740, Horace Walpole wrote to his cousin Henry Seymour Conway from Italy, declaring: 'how I like the inanimate part of Rome you will soon perceive at my arrival in England; I am far gone in medals, lamps, idols, prints, &c. and all the small commodities to the purchase of which I can attain; I would buy the Coliseum if I could'.[13] Particularly significant here is Walpole's identification of the souvenir as an 'inanimate part of Rome'. Confirming the close material association between the souvenir, the location of its fabrication and, finally, its subsequent appropriation by the tourist, this notion of the preserved fragment of Rome is particularly salient to our understanding of how the souvenir functioned within eighteenth-century culture: in purchasing such objects, Walpole feels he has acquired a piece of Rome itself.

In her foundational text *On Longing* (1993), Susan Stewart highlights the narrative capacity of the souvenir object, writing that the souvenir does not tell

the 'narrative of the object', but that of the possessor.[14] Understood in this manner, the souvenir is not the final objectification of the journey, but the point of embarkation for subsequent narratives articulated through its successive interactions with its owner(s), a model to which the Parminters' own souvenir objects may be usefully related. In this characterization, souvenirs are rooted in ideas of memory, experience and narrative, functioning as biographical objects, redolent with the personal histories of those who acquired them.

As first conceptualized in the work of cultural anthropologists such as Arjun Appadurai, Igor Kopytoff and Janet Hoskins, the biographical approach to objects is one that encourages increased attention to their materiality as well as their social function throughout history, encompassing the formulations of both the biography of the object and the object as biography.[15] As Hoskins has argued, objects have biographies as 'they go through a series of transformations', while simultaneously 'persons can also be said to invest aspects of their own biographies in things'.[16] This chapter argues that the physical, aesthetic and semantic transformations to which an object is subjected – discussed here in terms of 'translation' – are key to the relationship between its material status and its meaning as biography. Focusing on the souvenir at A la Ronde, it examines how the translation of an object from its place of collection or purchase into the home in late eighteenth-century Britain, was a transformative process that allowed the souvenir to evoke memory, experience, and narrative, and therefore, to function biographically.

Here denoting the process by which souvenirs were resituated within new material, geographical and emotional contexts, translation is a usefully elastic term that embraces many of the biographical transformations that such objects are subjected to. In this context, translation encompasses the various kinds of acquisition, movement and display of objects that characterize the creation and formation of a house's decoration and collections.[17] Whether found, purchased, resituated or discarded, material objects are translated in very literal ways, taken from one context and integrated into another, a physical dislocation that has an attendant transference of meaning. Beyond physical repurposing, translation also signifies the semantic transformation that objects undergo when subjected to such processes, rendering it a useful framework for discussing the cumulative creation of objects that characterize A la Ronde. Conceptualized in this way, translation functions productively beyond the written text, where it can help in understanding the heterogeneous cultural processes of exchange, manipulation and appropriation that characterize the transformations of material culture that

occur at the house. This kind of material translation operated on a number of levels within the Parminters' home. Firstly, there was the literal, physical translation of the souvenir object into the space of the A la Ronde itself: be it from abroad (their continental tour) or from home (their Devonshire surrounds). Secondly, a visual translation occurred through their replication of aesthetic strategies encountered on the tour, which saw them adopt modes of display such as the cabinet of curiosities, the specimen table and the shell grotto. Finally, translation occurred creatively through the embedding of the souvenir into the collaged object, a haptic process characterized by the use of fragmentary souvenirs disassociated from their originating context and narratively reused in another. Creating a dialogue between original and subsequent environments, translation not only allows for the interpretation or appreciation of the original object or text, but is similarly revealing of the social technologies of its new cultural setting. Adopting translation as a dualistic framework that embodies the space between meaning and materiality therefore allows us to conceptualize how objects of disparate origins and associations were reframed within the space of the Parminters' home, and subsequently used to craft highly personal narratives of travel, commemoration, and loss: a process exemplified by the Parminters' specimen tables.

Following Jules Prown's model of speculative readings of material culture, the chapter explores the Parminters' collections in lieu of an extensive familial archive, presenting the souvenirs translated into the interiors of A la Ronde as powerfully communicative fragments of the women's experiences.[18] It argues that through the constituent processes of physical and semantic translation – acquisition, replication and transformation – such objects were subsumed within narratives of the self, a process that allowed for the creation of the cousins' gendered and familial identities while living at A la Ronde. This construction was at once material and narratological, rooted in both the physical fabric of their home, as well as the experiences and reminiscences of the women. As demonstrated throughout this book, material objects were consistently deployed within forms of domestic and foreign travel writing, where they allowed their authors to demonstrate knowledge and taste, provided foci for broader discussions, and framed and staged social relationships. Reciprocally, at A la Ronde the interrelationship between material form and narrative meaning is articulated through object, not text. Where Caroline Lybbe Powys created object-centred travel narratives in which her use of description echoed and emphasized her feelings about a house's owner, the Parminters created narratives *from* objects via the transformative process of translation: the movement and

adaptation of material culture, which, through its transposition from one context into another assumed an almost biographical significance.

Acquisition

On 27 September 1749, Philip Stanhope, 4th Earl of Chesterfield, bestowed the following advice upon his son Philip, who was touring the Italian peninsula at the time:

> You are travelling now in a country once so famous for both arts and arms […] View it, therefore, with care […] Consider it classically and politically, and do not run through it, as too many of your young countrymen do, musically, and (to use a ridiculous word) knick-knackilly. No piping, nor fiddling, I beseech you; no days lost in poring upon almost imperceptible *intaglios* and *cameos*; and do not become a virtuoso of small wares. Form a taste of painting, sculpture, and architecture, if you please; those are liberal arts, and a real taste and knowledge of them become a man of fashion very well. But, beyond certain bounds, the man of taste ends, and the frivolous virtuoso begins.[19]

This letter reinforced the advice furnished upon Chesterfield's son during the previous year, in which he had written at length on the nature of the 'trifling and frivolous mind'.[20] According to Chesterfield, this mind was 'always busied, but to little purpose; it takes little objects for great ones, and throws away upon trifles that time and attention which only important things deserve. Knick-knacks; butterflies; shells, insects, etc., are the subjects of their most serious researches'.[21]

Chesterfield's preference for painting, sculpture and architecture has been echoed by the many studies that have privileged the study of collections of antique sculpture, 'old master' paintings and the Grand Tour portrait as the principle souvenirs of the tourist experience.[22] Focusing on a predominantly male elite of travellers and collectors, these texts have, as a result, overlooked the broader array of souvenirs collected by travellers, although this narrative has been challenged in recent work by scholars such as Emma Gleadhill.[23] In fact, tourist souvenirs not only included relics of Italy's classical and Renaissance past, but also small-scale souvenir objects and other more quotidian forms of material culture, such as books, paper, jewellery and textiles. This variety is echoed by the Parminters' own collection of souvenirs, which variously includes examples of high and decorative arts production, purchased and found objects,

and even examples of contemporary mourning culture, which, through their close presentation with souvenirs of their tour, assume an analogously commemorative function. As such, A la Ronde's collections comprise many kinds of objects that fall outside of the traditional designation of the souvenir, and yet which similarly elicit their owners' memories and experiences, demonstrating the need for fluidity in its definition.

This attempt to redefine 'the souvenir' may be profitably situated in relation to a number of recent revisionist accounts of the Grand Tour itself, such as those by Frank Salmon and Rosemary Sweet, both of whom advocate an encompassing approach to British continental travel in the long eighteenth century.[24] Traditionally, the term 'Grand Tour' has referred to a notably prescriptive framework of travel undertaken during this period, one that is limited in terms of gender, class and even geographical boundaries. Many accounts of Grand Tourism have accordingly encouraged a homogenous and inflexible understanding of contemporary travel, its destinations and participants, and the material relics of their experience. An examination of the wide array of souvenirs procured by female travellers therefore allows for an enrichment of this singular Grand Tour, through which a broader account of the engagement with both the foreign and the antique emerges.

Along with Jane's sister Elizabeth (1756–c. 1790) and another female companion, the Parminter cousins toured Europe from around 1784–91.[25] Given the length of time spent travelling and the kinds of souvenirs collected, it has been suggested that the Parminters toured through Italy, Germany, Switzerland, Spain and Portugal, but this itinerary cannot be precisely confirmed.[26] Although the Parminters' own records of their tour are now lost, women travellers often described the act of shopping, the shops themselves and the goods available for purchase in written accounts of their travels.[27] Mary Berry's diaries of her Continental tours for example, provide a sense of the everyday material experience of travel, with Berry describing 'a street of silversmiths' in Genoa, a 'manufactory of printed linen' at Rome, the coral manufactory at Leghorn, and numerous *brocanteur* or second-hand shops in Paris.[28] A number of other contemporary women writers similarly recollect both visiting and purchasing from shops while travelling. The travel writer and salon hostess Lady Anna Miller (1741–81), for example, described Naples as the 'most charming town […] the shops filled with all sorts of merchandise; the markets stocked with the best provisions in the greatest abundance'; while at Venice, she recalled how the shops that bordered either side of the famous Rialto bridge sold 'nothing but pearls and gold ornaments'.[29] On 14 January 1770, Miller wrote to her mother from Naples

to inform her that she had 'already begun to pick up some curious things', to send home, a package that would eventually include a tortoiseshell comb, inlaid with gold designed 'to imitate an Etruscan border, copied from an antique vase', and, tellingly-worded, a number of 'other trifles'.[30]

The appendices to the travel writer Mariana Starke's (1761/2–1838) *Travels in Italy, Between the Years 1792 and 1798* (1802) provide perhaps the most consummate guide to shopping in late eighteenth-century Italy. Covering towns from Leghorn to Naples, Starke's regionally delineated appendices include information pertaining to rates for local inns, the best drawing and dancing masters, letter couriers, nearby country houses available for rent, as well as comprehensive guides to what goods could be purchased, for what price and where.[31] In her entry on Rome for example, Starke lists the following selection of shops:

> Cameo-workers – MANGEROTTI, *Piazza di Spagna* – LONDINI, *Strada Laurina* – ZUCCERI, *all'Otto Cantoni* – PESTRINI, *nello Studio di Volpato*.
>
> Mosaic-worker – RINALDI, *Sotto La Locanda dell'Acquila Nera*.
>
> Print-seller – VOLPATO. Prints are likewise sold at the *Chalcographie*, much cheaper than by Volpato. Here the prices are printed in the catalogue, and ten or fifteen per cent is deducted when you purchase any quantity. Drawings and coloured prints are sold by MIRRI, *incontro il Palazzo Bernini*.
>
> Sulphurs are to be purchased of the Maker, by name DOLCI, in *Strada Conditti*.[32]

Tellingly, this list includes several categories of objects that are comparable with those acquired by the Parminters during their tour. The cousins' handcrafted specimen table includes a common tour souvenir mentioned by Starke: two examples of micromosaic work, an identical pair of urns made from tiny coloured tesserae. Developed by mosaicists employed by the Vatican Mosaic Workshop, micromosaics became increasingly popular from the late 1750s.[33] When visiting Rome in 1817, the traveller Charlotte Eaton noted the proliferation of micromosaic wares and their producers within the city, describing 'hundreds of artists, or rather artisans, who carry on the manufactory of mosaics on a small scale. Snuff-boxes, rings, necklaces, brooches, earrings, &c. are made in immense quantity'. Confirming that these were specifically designed as tourist wares, she went on to note that 'since the English flocked in such numbers to Rome, all the streets leading to the *Piazza di Spagna*, are lined with the shops of these *Musaicisti*'.[34] Indeed, a number of micromosaics that are close in design to the Parminters' examples survive today, highlighting their status as a 'mass-

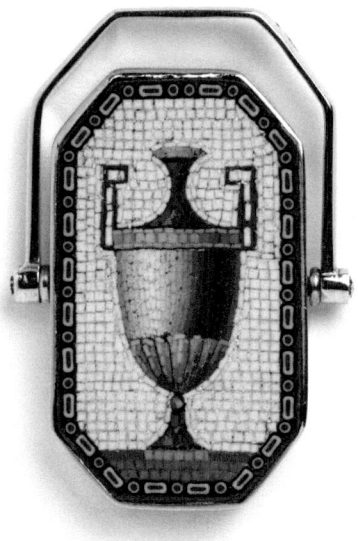

Figure 3.3 Gold bezel mounted with a micromosaic urn, Rome, 1790s. The Rosalinde and Arthur Gilbert Collection. Courtesy of the Victoria and Albert Museum, London.

produced' object. One can be found in the collections of the Victoria and Albert Museum (*c.* 1800, fig. 3.3) where the micromosaic is presented in the form of a mourning ring; while another was recently sold in the form of a 15kt gold pendant brooch (1780s, likely reset in the nineteenth century).

Urns, the motif used in the Parminters' micromosaics, had longstanding classical associations and as such were intimately connected with both the physical and visual experience of the tour. When Berry visited the Mausoleum of Cecilia Metella, she described 'a large Chamber where there was a great Urn of white marble destin'd to hold the ashes of the deceas'd'.[35] In addition to viewing urns, tourists also described acquiring examples for their own collections. In her record of her time staying at Ariccia in the Roman campagna, the traveller Selina Martin noted that there had recently been 'discovered several sepulchral urns deeply imbedded in lava' that her brother-in-law Sir Walter Synnot had wished to purchase.[36] Like Walpole's joking lamentation that if only the Colosseum was smaller, he would acquire it for his collections, the Parminters' micromosaic urns accordingly reinforce the notion that souvenirs replicated the sites encountered during travel, miniaturized to suit the realities of ownership and transportation.[37]

The Parminters' collection of prints purchased abroad is also reminiscent of Starke's comprehensive list of Roman commodities. The cousins bought at least fifteen prints from one of Giovanni Battista Piranesi's famous suites of images, his *Views of Rome* (c. 1750–78) during their travels, a selection that included depictions of a number of iconic Roman monuments, such as the Pantheon, the Arch of Constantine and Trajan's Column (fig. 3.4). Prints by Piranesi were routinely available for tourists to purchase. When in Rome in 1771, Miller confirmed the consummate popularity of the artist's prints, remarking that despite her personal disapproval, they were 'esteemed the best', and that she had accordingly 'made an ample collection of the most valuable of them'.[38] The Parminters' tour collections also include prints after works by Renaissance masters, including Caravaggio's *Lusores,* or *The Cardsharps* (c. 1772–1800), the original of which had been displayed in the Palazzo Barberini, and Raphael's *The Disputation of the Holy Sacrament (La Disputa)* (1509–10), housed in the *Stanza della Segnatura,* in the Vatican, drawn by Stefano Tofanelli.[39] Published in 1735, the latter print was sold by Johan Volpato, whose shop – as noted by Starke – was one of the primary print-sellers in late eighteenth-century Rome. Displayed in several rooms of the house, such inclusions firmly root the Parminters' collections within a more typical model of Grand Tour collecting, complicating the narrative of singular femininity and craft production that has previously been associated with A la Ronde.

Nevertheless, such purchased objects were only one aspect of the broad range of goods collected by the Parminters. Like Starke's carefully detailed list of commodities, the souvenirs acquired by the cousins, both during their Continental

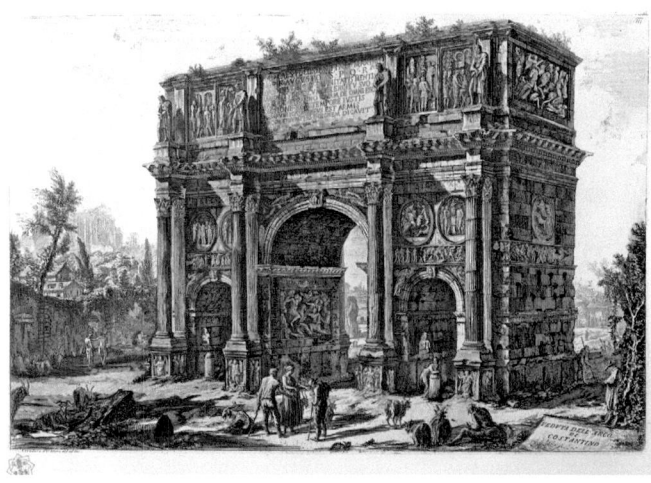

Figure 3.4 Giovanni Battista Piranesi, *Veduta dell' Arco di Costantino,* from *Vedute di Roma, c.* 1750–1778. *Tomo* II, *tav.* 25. Creative Commons CC0.

tour and after their return to Britain, encompassed a highly diverse array of objects, many of which fall outside the confines of the traditional definitions of this category of object. The study of the Grand Tour souvenir has not only been constrained by a close focus on specific kinds of objects, but by the very modes in which they were acquired, accounts of which have often focused on models of 'digging and dealing'.[40] Thanks to this concentration upon the complementary processes of excavation and purchase, acquisitions made by tourists that fall outside of such antiquarian and economic transactions demonstrate that both our conception of the souvenir, and the ways in which contemporaries understood the material and experiential nature of the tour, requires refinement.

Richard Wrigley argues that increased attention must be paid 'to the role played by the physical environment, and indeed the inherent physicality of the experience of Rome' in our discussions of the Grand Tour.[41] Wrigley suggests that we must move beyond traveller's preoccupations with Rome's 'immanent historical identity', to instead focus on how their interactions with the city 'transcended mere empirical inspection and activated a sense of corporeal identification'.[42] While Wrigley restricts his argument to forms of sensory experience that fall outside of the 'possessive commodification' of Grand Tour collecting, his argument in favour of the study of the 'emotive kind of act and experience' of tourism works particularly well for discussing traveller's narrative experiences with material objects, both during and after their tours.[43]

The inherent physicality of travel and its relationship with object-acquisition is a constant theme within late eighteenth- and early nineteenth-century travel writing, as evident in Berry's account of her visit to the Villa Doria Pamphili in Rome in 1820. In her recollection of the outing, Berry wrote of an intimate audience with the surviving collections of its former owner, Olimpia Maidalchini (1591–1657). In Maidalchini's 'cabinet of rarities', Berry describes viewing cases filled with ivory, coral and amber, 'bundles of empty purses', a 'Japan box', a 'coffer contain[ing] a number of artificial flowers, faded, tumbled, and all squeezed together', a 'number of little pasteboard boxes, containing each six small wash balls, in cotton, still much perfumed' and finally, 'another box [...] full of very thin brown and some whitish leather, stamped in all sorts of patterns and for all sorts of purposes'.[44]

Berry's evocative literary transcription of this space culminates in her acquisition of a material remembrance of this collection, as permitted by the property's custodian, who allowed her 'to take a little bit of the pierced leather [...] a border of lace, three of the wash balls, and two bits of the artificial flowers'.[45] Berry's anecdote, in which the material and literary souvenirs of her experience

at the Villa Pamphili operate simultaneously, exemplifies the varied means by which travellers acquired souvenirs during this period. Berry's narrative removes the souvenir from existing exclusively within a commodity status, instead proffering a complementary model in which objects acquired through unconventional modes are of equal importance to those implicated within the economic processes of exchange.[46] Furthermore, her experiences recall Wrigley's emphasis upon the sensory and emotive nature of the tour, from her handling of the objects, to the sense of intimacy and privilege established between Berry, the custodian of the room, and ultimately, its contents.

Berry's anecdote is typical of a number of travel accounts in which the acquisition of souvenirs extended beyond the act of purchase, evocatively comprising found, stolen and gifted objects collected by travellers, and which similarly suggest the experiential and deeply narratological nature of object acquisition during the tour. While staying at Valle d'Aosta in Italy in 1792, Elizabeth Fox, Baroness Holland (1771–1845) described dismounting from her carriage at Montjovet in order to obtain specimens of the 'steatites and garnets imbedded in quartz' from the roadside.[47] When lodging at Montjovet at the Baron d'Aviso's home, Holland recorded in her journal that she had stolen some 'specimens of minerals; my conscience smites me almost for the plunder', anecdotes which firmly situate the material object as centremost within Holland's stories of her travel.[48] Tourists could also receive such mineralogical specimens as gifts. In Pavia on 13 June, Holland was given 'many good specimens' by 'Padre Pini', an 'old Barnabite monk', which included numerous fragments of 'Adularia', a type of felspar he had discovered.[49] Similarly, when having been impeded by difficult terrain, Miller was unable to view the Caduta della Marmora cascade at Terni, she subsequently wrote to her mother that her husband, who had continued alone, had returned with incrustations formed from its spray, 'some of which he brought me in his pocket', and which served to represent the experience in which Miller could not partake in material form.[50]

Tourist's accounts emphasized the sensory, as well as the emotive nature of this kind of acquisition. While visiting Vesuvius on 21 January 1788, Ann Flaxman (wife of the sculptor John), described her contentment at picking 'up a piece of the sulphurous matter which was rather too hot to hold however I manag'd to keep it & with a double satisfaction turn'd my Back on this Curiosity'.[51] Similarly, Hester Thrale Piozzi recalled how the *solfatara* of the volcano burned her fingers as she 'plucked an incrustation off, which allured me by the beauty of its colour', with such examples attesting to the sensory experience of finding, holding, and collecting objects.[52] Tellingly, travellers also recollected finding the

kinds of objects found within the Parminters collections; namely, shells, cameos and intaglios. In her *Narrative of a three years' residence in Italy* (1831), Martin described combing the rocky Neapolitan coast with her young niece Anny, recalling how she had found 'exhaustless amusement in exploring rocky caverns [and] crags to collect shells and coral'.[53] Likewise, Miller recounted finding an 'abundance of antique bits of mosaic, broken agate', and 'one intaglio of jasper', during her visit to the Cumæan Sibyl's cave, located near Puzzoli, where she dug her hands into the earth in order to excavate its treasures.[54]

In each of these accounts, it is the narrative of object-acquisition that is privileged. From gifts to stolen fragments, stones which burnt fingertips, and classical gemstones unearthed from ancient soil, these anecdotes highlight the sensory, experiential and emotional dimensions of acquiring souvenirs. This was particularly true of the found object, whose finding and subsequent keeping crystallized these highly personal narratives into the object itself. The Parminters' own collections heavily comprised such found objects – from both tour and home – which were subsequently incorporated into the interiors and furnishings of their home at A la Ronde. The cousins' bookcase *cum* curiosity cabinet for example, includes mineralogical specimens acquired during their travels (fig. 3.5), while their specimen table is peppered with shells apparently collected by the women.

Like the table, A la Ronde's famous shell gallery also comprises an evocative combination of natural found objects, including shells, feathers, lichen, mica, spar and animal bones, supplemented with mirrored glass, paint, cut paper and pottery sourced from their local environment (fig. 3.6).[55] Shellwork had grown in popularity throughout the course of the century, and was, by its end, synonymous with the creation and decoration of fashionable semi-interior spaces, such as garden follies.[56] Richard Beatniffe's *The Norfolk Tour* of 1773, for example, provides a detailed description of the grotto of a 'Mrs. Styleman', which was 'very prettily contrived out of a boat, by cutting it in halves, and fixing it together with a little addition'.[57] Like the shell gallery of A la Ronde, which itself was decorated to resemble a cave, the grotto was 'stuck full of spar, shells, seaweed, coral, glass, ore, &c. all disposed with taste and elegance'.[58] Reminiscent of a number of contemporary grottoes, the house's shell gallery employed materials derived from the local area, imbuing the space with echoes of the proximate natural environment and, presumably, the memories of collecting such objects. William Bray's *Sketch of a tour into Derbyshire and Yorkshire* (1778), described a grotto made 'with the spars &c. found in the neighbourhood', while Thomas Broderick's *Letters from several parts of Europe, and the East (1753)*

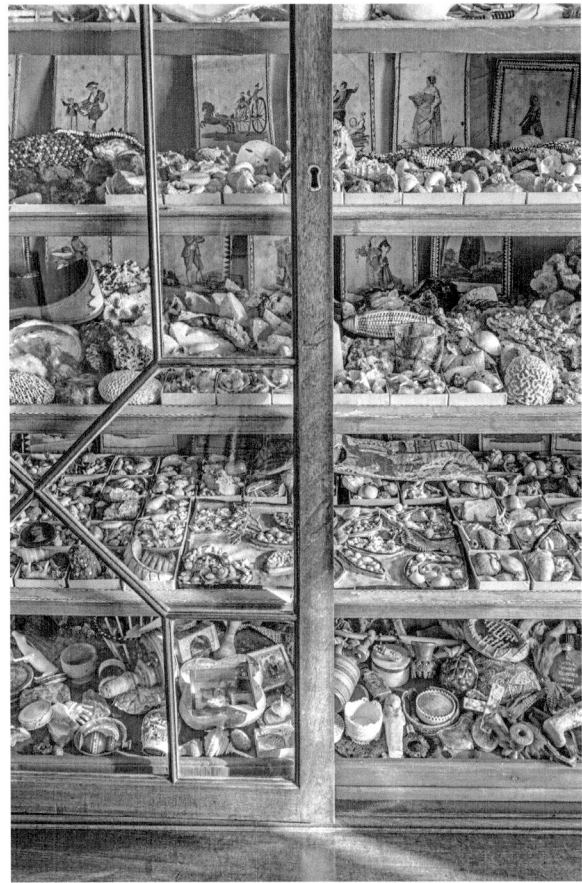

Figure 3.5 Detail, breakfront bookcase, 1795–1800. Glass, brass and mahogany. National Trust Collections, A la Ronde, Exmouth, Devon. © National Trust Images/ Andreas von Einsiedel.

prompted his correspondent to remember how she and her sisters had honoured the moonstones found on their estate with a place in her grotto.[59]

The carefully selected location of A la Ronde, which was strategically positioned to allow vistas of Exmouth, the Devonshire coast and the estuary of the River Exe, affirms the house's intimate connection with its countryside surroundings. Exmouth was famous for the evocative prospects afforded by its coastal walks, as well as the botanical and conchological richness of its beaches, which provided the Parminters with a plethora of shells necessary for both the gallery's fabrication and the materials for a number of other assemblages displayed within their home.[60] The cousins produced painstakingly constructed

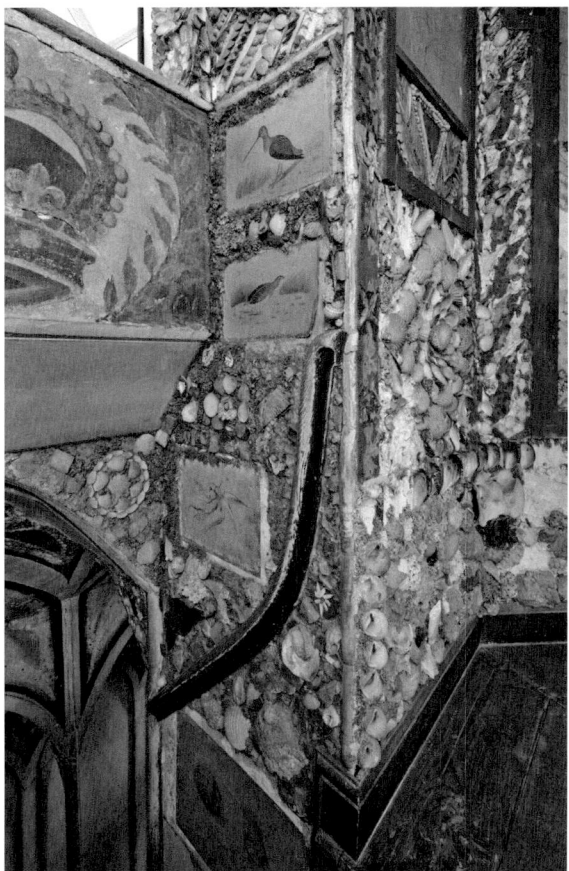

Figure 3.6 Jane and Mary Parminter, shell gallery (detail), c. 1796–1811. Shells, feathers, lichen, mica, spar, animal bones, supplemented with mirrored glass, paint, cut paper and pottery. A la Ronde, Exmouth, Devon. © National Trust Images/John Hammond.

scenes of rustic life from sand and seaweed stuck onto watercolour-washed paper, depicting men hunting quail with dogs, shepherding and arable farming, displayed in frames encrusted with painted sand.[61] Using materials collected from the nature that surrounded them, the Parminters translated and transformed the detritus of the beach and countryside, reformulating it to convey their close relationship with the landscape and locale of Devon.

Read against tourists' descriptions of the historical material objects and geological specimens that they found during the course of their travels, the Parminters' combinative use of found objects from Devonshire landscapes, physically and ideologically connects the spaces of home and tour. Whether

by gathering geological specimens, receiving gifts or even theft, such examples demonstrate that the souvenirs of Continental travel were obtained by a variety of means that fell outside the traditional narrative of Grand Tour collecting, constituting highly personal modes of acquisition, intimately tied to the experience and commemoration of travel, as well as the activities of the traveller once home. Through a focus on the experiential and emotional nature of souvenir collecting, both from home and abroad, A la Ronde emerges as a space that is not defined by objects that reflect an inherent femininity, but by the interconnecting and subjective identities of its inhabitants, in which they are simultaneously women, family members, travellers and residents of Devon. Rather than presenting the relics of a uniquely feminine Continental tour then, the Parminters' collection of souvenirs constitutes an evocative combination of objects – fragments from Devon, Italy and beyond – which through their evocative collection and subsequent movement into the space of A la Ronde, linked the Parminters' experiences past and present.

Replication

It was not only found objects that recalled the Parminters' experience of travel, however. As we shall see, typical, prefabricated tourist wares could also powerfully recall the spaces and places of the tour through a replicative form of translation, wherein the cousins recreated techniques and objects seen during their travels within their new home. Like the Parminters' collection of souvenir objects more broadly, this replication aesthetically united A la Ronde with the spaces of the tour, marrying the shared experience of travel with what we can imagine to be the shared experience of decorating their home.

Though not explicitly articulated in these terms, Wrigley discusses this kind of translation in his book *Roman Fever* (2013).[62] Defining 'influence', as 'transmission and assimilation of artistic knowledge in and from Italy', Wrigley describes a process comparable with the aesthetic translation presented here.[63] Complicating the idea of influence as simply the accumulation and transference of artistic knowledge, Wrigley argues that it should be considered 'in contextual terms, acting through an ambient, immersive dimension as much as being the result of conscious ambition'.[64] This conception of influence, located between aesthetic transference and the physical experience of foreign travel, is compelling. Instead of simple replication, at A la Ronde this form of translation was as rooted in the Parminters' sensuous and emotive experiences of the tour, as it was in its aesthetics.

The desire to replicate the visuality and materiality of the tour was emphasized by the writings of a number of travellers from the late-eighteenth and early-nineteenth centuries. Writing from Montalegre in Portugal on 28 June 1814, Percy Bysshe Shelley described purchasing 'specimens of minerals and plants, and two or three crystal seals, at Mont Blanc, to preserve the remembrance of having approached it'.[65] Continuing, he noted that 'the most interesting of my purchases [was] a large collection of all the seeds of rare alpine plants, with their names written upon the outside of the papers that contain them. These I mean to colonise in my garden in England, and to permit you to make what choice you please from them'.[66] Shelley's planned reproduction of an Alpine plantscape is suggestive of the traveller's compunction to actively replicate the sights and experiences of their journeys.

Jane's own travel journal records a crucial instance that prefigures this kind of transference at A la Ronde. In 1902, Reichel published 'Extracts from a Devonshire Lady's Notes of Travel in France in the Eighteenth Century' in the reports and transactions of the Devonshire Association for the Advancement of Science, Literature and Art.[67] Transcribed from Jane's travel journal, the excerpts detail the first portion of the party's tour, describing at some length their disembarkation from Dover and the details of their journey. Comprising just the first six weeks of travel, only those entries as far as Dijon survive.[68] However, the surviving transcripts are rich with detail, and, like the travel journals of Lybbe Powys, reveal a sophisticated understanding of the landscape, architecture, and social conventions of the foreign cultures through which the party travelled.

Travelling through Montreuil, Abbeville, Picquigny, Amiens, Picardy, Chantilly, Paris and finally, to Dijon, Jane's journals record the party visiting churches, farms, palaces and manufactories.[69] Like many contemporary travellers, she was particularly taken with the palace of Versailles, and provided a detailed description of its decoration, grounds and architecture.[70] The journals are typically concerned with impressing upon the reader the sumptuous materiality of the experience of travel, bringing to mind the confluence between narrative and description that, as the first two chapters of this book have demonstrated, characterized contemporary travel writing. Such descriptions, however, are particularly salient when placed in relation to the aesthetic transference between home and abroad that occurred within the interiors of A la Ronde.

Perhaps the most significant extract of those transcribed from Jane's journals for our purposes provides an evocative description of the *wunderkammer* at the Prince of Condé's palace, the Château de Chantilly. Demonstrating her attention to descriptive detail, Jane's literary sketch of the Prince's 'Cabinet of curiosities' lists 'a fine set of medals, a pair of noble globes a foot round, a set of Birds, Beasts, fish, a

calf with two fore parts, spar, coral, amber, Crystal, Seeds of plants, shells and many other natural Curiosities.'[71] When compared with the kinds of objects collected and displayed at A la Ronde, the varied contents of this glittering *wunderkammer* constitutes a suggestive combination of natural specimens and *objets d'art*. Jane's voracious ocular consumption of the cabinet's treasures, as suggested by her detailed and inventorial description of its contents, forces us to consider a potential aesthetic transference from tour to home, that is, the visual and material replication of sites experienced abroad within a domestic context. Echoing the Prince of Condé's cabinet, the combination of such natural materials as shells, feathers and corals, with cultural objects and curiosities at A la Ronde rendered the house comparable with the types of *wunderkammer* encountered by the Parminters during their tour.

Beyond the cousins' general invocation of the Prince of Condé's cabinet in the combination of natural and aesthetic objects that would eventually constitute their collections, the Parminters' seemingly emulated this space in a much more literal way, forming their own cabinet of curiosities following their return from the Continent and establishment at A la Ronde. Using their tripartite breakfront bookcase, the Parminters employed its central receptacle and raked shelving to display a jumbled array of souvenirs, shells and curios, papering its surfaces with the botanical drawings, fragile Italian gouaches and printed representations of the Swiss peasantry that they had acquired during their European tour.[72] This translation of the Prince of Condé's cabinet constitutes a metaphorical linking of the space and place of the tour with that of the Parminters' home, reiterating the narratives of travel told within Jane's own journal, while materially integrating these experiences within A la Ronde's decorative fabric. Furthermore, we might view the communal act of assembling the objects within the bookcase cabinet, just as in the construction of the Parminters' shell gallery, specimen table and collaged fireplace, discussed further below, as socially linking tour and home, imbuing the creation of such objects and the display of such collections with shared memories of Europe. The display of souvenirs within the bookcase can therefore been seen as constituting a replication of the tour by those who participated within it, connecting the experiences of travel with the creative and productive experiences that occurred in A la Ronde.

In addition to this cabinet of curiosities, A la Ronde is home to several other examples of this replicative practice, which, like Shelley's garden, recalled the tour through an invocation of the spaces, objects and modes of display viewed while travelling. The fireplace of the Parminters' drawing room is a key example of the varieties of material translation enacted within A la Ronde. Surmounted by a densely ornamented mantelpiece, its decoration comprises painted elements, a

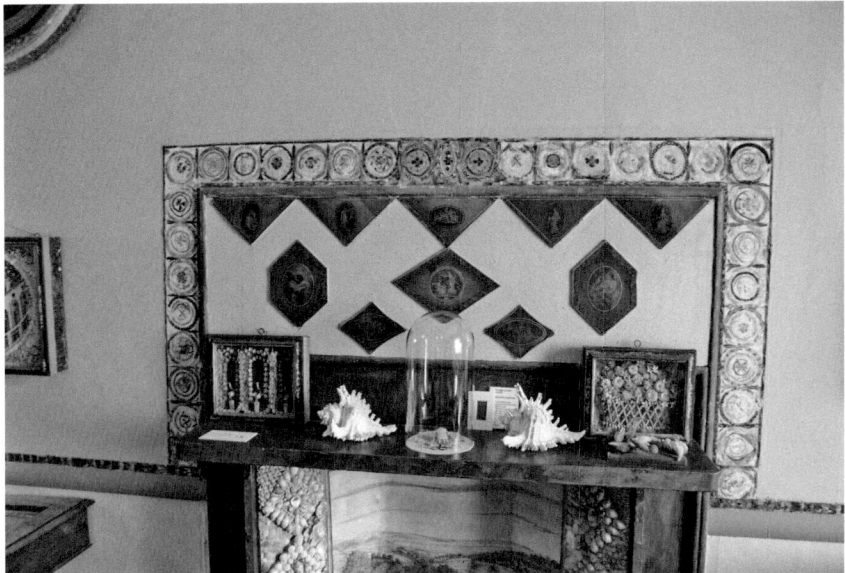

Figure 3.7 Jane and Mary Parminter, drawing room fireplace, *c.* 1796. Feathers, shells, paper, paint and wood. A la Ronde, National Trust, Exmouth, Devon. Photograph: author.

featherwork border, shellwork ornamentation and designs cut from paper and then applied to the wall (fig. 3.7). These designs, featuring classicizing motifs such as lamenting or dancing women, are highly reminiscent of the illustrations in the volume dedicated to Sir William Hamilton's *Collection of Etruscan, Greek and Roman Antiquities* discussed in the previous chapter; indeed, some appear to be directly adapted from the text's accompanying images. The central vignette of the mantel's decoration seems to be a composite image modified from the volume's illustration of a female figure throwing a ball taken from an Apulian lekane, and a seated flute player from an unknown source. Viccy Coltman has discussed this type of translation in relation to the use and reception of Hamilton's volumes as the 'transference and transformation of classical artefacts', in which they are 'transposed from an ancient material culture in Italy into a new (fabricated) material culture in England'.[73] Beyond their original function as a prestige object worthy of collection in their own right, the commercial potential of the volumes was recognized by those such as the entrepreneurial Matthew Bolton (1728–1809) and Josiah Wedgwood (1730–95), both of whom used Hamilton's publication as a kind of pattern book for their respective designs in metal and ceramic. Specific images from the volumes were also selected and reproduced as prints for sale either

individually, or in sets, so that, as the artist Johann Heinrich Wilhelm Tischbein (1751–1829) described, 'each person can then, according to his liking, choose as he wants to decorate a room'.[74] Though we lack documentation for their acquisition of these images, the Parminters may well have seen such prints and purchased them while abroad, or sought to buy similar printed materials upon their return home, imitatively reproducing the objects they had seen while travelling. The display of these images at A la Ronde also echoes the tradition of the print room, in which high-quality prints, often imported from the Continent, were cut and pasted directly onto the surface of the wall.[75] Far from only being 'fit to furnish the cabinets of men of taste and letters' such as Wilkes then, at A la Ronde, similar prints were miniaturized and domesticated via their application to the fireplace; a haptic process likely performed communally by the Parminters themselves.[76]

There is remarkable parity between the processes described by Coltman, specifically that of 'reflexion' – defined as the 'imaginative interpretation and the improvement of the original' – and the use of images seemingly derived from Hamilton's publication at A la Ronde.[77] Coltman describes this manipulation as an example of 'the deferral of antiquarianism to aestheticization, where antiquity can be cropped, shaped, and made to fit according to the specifications of the patron and practices of the manufacturer'.[78] Combining contemporary sentimentalizing images and the illustrations adapted from Hamilton's publication, the display at A la Ronde is testament to the variety of meanings embodied by such antique imagery. Instead of a careful replication of the original illustrations, the designs included in the Parminters' scheme simply allude to their derivation from the volumes. Accordingly, they reflect the easy incorporation of classical imagery into a contemporary programme of interior decoration, transported from their moment of purchase, and enriched, adapted and augmented by other imagery in a diverse series of embellishments, combining prints potentially acquired during the Parminters' tour, with a watercolour painting of Exmouth, and natural materials collected from the local countryside. Produced as testament to the communality of their tour, their home and its decoration, the classicizing decoupage of the fireplace is an integral part of a broader, highly personal, programme of domestic design.

In both its form and decoration, A la Ronde's specimen table also reproduced the kinds of objects seen and acquired by tourists. Named after the specimens of rare marbles and semi-precious stones of which they were comprised, the constituent fragments of specimen tables were reputedly sourced from ruins, archaeological excavations and the destruction of ancient monuments.[79] Examples of specimen tables are mentioned in a number of accounts written by

contemporary travellers. Piozzi, for example, recorded a table 'encrusted with *verd antique*' as part of the furniture of her lodgings during her stay in Rome, while Starke recalled viewing 'a table made of precious marbles' at the Palazzo Barberini.[80] For contemporary tourists, such tables not only formed the physical furniture of the interior spaces that they visited, and the apartments in which they stayed, but also constituted potential pieces of furniture for their own homes, as versions of such tables were routinely available for purchase as souvenirs. At least six specimen tabletop slabs were included in the ill-fated cargo of the *Westmorland*, a British privateer frigate captured in 1778, which contained fifty-seven crates of art objects collected by noble Grand Tourists.[81] Described in the ship's inventory as 'beautiful marble tables inlaid with various fine stones', the *Westmorland*'s decorative tabletops are inlaid with samples of stones arranged in a rigid, geometric format, with each specimen assigned an individual number.[82] An attendant key for the purpose of distinguishing the marbles would often accompany such slabs, allowing for continued analysis and comparison of the individual specimens upon arrival on British soil.

However, instead of rationally-ordered contrasting marbles, the specimens included within A la Ronde's table comprised found shells and fragments of rock, semi-precious minerals and small-scale souvenirs such as the micromosaic urns and plaster casts that encrusted its surface, the inclusion of the latter of which also invoked the aesthetic models seen on tour. In Florence, Starke referred to viewing a 'capital collection of cameos, intaglios, precious vases, small statues, columns &c.' in the 'Royal Gallery of Medicis', noting that 'Sulphurs of the cameo and intaglios belonging to this collection' were shortly to be sold in Florence.[83] Starke's announcement that sulphur casts of this collection were to be sold within the city is of particular significance, confirming both the availability of the types of copies we see in the Parminters' specimen table, as well as tourists' desires to own a literal replication of the material culture that they experienced abroad.

A la Ronde's shell gallery also mirrors the architecture of the tour, namely, grottos such as that found upon Isola Bella, one of two picturesque islands situated on Lake Maggiore. The cousins purchased two pairs of shellwork pictures during their travels, one of which depicts Italianate architectural subjects, elegantly rendered in shell, paper, and painted wood, and labelled 'Isola Bella' on the reverse (pl. 4.1 and 4.2). The island was infamous for its intricately decorated subterranean rooms, which were described as grottos 'adorned with marble and shell-work'.[84] Isola Bella was frequented by a number of contemporary travellers, including William, Mary and Dorothy Wordsworth, who visited during their familial tour of 1820.[85] Many of those who visited the island stressed

its supernatural qualities and its magical nature, including Marianne Baillie (1788–1831), who called the island a 'fairy-green gem', and Holland, who termed it an 'enchanted spot, on which the fairy palace and gardens stand'.[86] Holland explicitly related this supernatural narrative to the compelling qualities of the island's decoration, noting that 'some of the apartments are made like grottos and are brought to the margin of the lake: without exaggeration it is a spot apparently made by magic art'.[87] Like travellers' recollections of finding, stealing and picking up geological specimens, such accounts of Isola Bella are intimately tied to the experience of travel, stressing the evocative nature of the island's forests and grottos, which perhaps provided the impetus for acquiring a souvenir from local vendors. As in Starke's description of the reproduction and sale of sulphurs after those cameos and intaglio gemstones displayed in 'The Royal Gallery of Medicis', the Parminters' shell pictures may be read as potent souvenirs of the shellwork displayed on Isola Bella, carefully replicated in consumable miniature, and subsequently translated into the space of A la Ronde.

Beyond the physical movement of the Continental shellwork pictures into A la Ronde, the Parminters' memories of Isola Bella may have influenced their own use of shellwork to ornament their home. There is an obvious parallel between the grottos of Isola Bella, the Parminters' shell work pictures, and their creation of their own shellwork gallery at the house. Echoing Wrigley's formulation of influence as pertaining to both artistic form and the 'ambient, immersive' nature of travel, such eloquent correlations suggest the Parminters' desire to replicate the island both aesthetically and experientially within their home. Comprising objects that captured the various experiences of travel through the processes of acquisition and recreation that constituted this form of translation, the Parminters' shell gallery attests to the multitudinous nature of the replicated souvenir. Yet this copying of the sights and sites of the tour was about more than reproduction. Instead, the emulation of buildings, objects and forms of cultural production seen while travelling directly related the visual and material experience of travel to its souvenirs. Such practices recalled how, and in what forms, tourists encountered objects whilst abroad, while simultaneously demonstrating their continued significance once home, where travel became a crucial element in the construction of self and space alike. For the Parminters, the communal enactment and reproduction of such practices within the space of A la Ronde was also part of the haptic and collective experience of making that characterizes the house's decoration more broadly. This communal fabrication of objects firmly connected the aesthetic with the emotional, a relationship that will be explored more fully in the final section of this chapter.

Affection

Focusing again on the Parminters' specimen table, the final section of this chapter will go beyond examining the physical and aesthetic dimensions of translation at A la Ronde to ask how this process also enacted a semantic transformation upon the house's visual and material cultures. Recalling both the experience of the tour and the Parminters' lives in Devon, the relocation and adaptation of their souvenirs into the space of A la Ronde entangled these objects within the broader narrative of the Parminter family as a whole, a story that not only predated Jane and Mary's cohabitation, but which continues beyond it in how we as historians understand the house and its contents.

Besides the numerous souvenirs, shells and other objects amassed from both home and abroad, the collections of A la Ronde are characterized by another kind of souvenir: a large number of inherited visual and material objects which refer to, or were produced by, the various members of the Parminter family. An evocative combination of full scale-portraits, painted miniatures, handmade silhouettes, watercolour paintings, pencil drawings and illustrated coats of arms proliferate throughout the space of A la Ronde, acting analogously to the other assemblages of objects we see throughout the rest of the house. Examples include Mary Parminter's silhouette portrait of Mrs and Rev. Walrond (d. 1769), labelled on the reverse in her handwriting 'My dear Grandfather and Grandmother Walrond's profiles', which functions as a touching invocation of her dead grandparents. Similarly, the delicate watercolours of Mary Walrond, later Mrs Richard Parminter (1747–72) provide a familial precedent for Jane and Mary's own creative practices. Relating to the Parminter, Hurlock, Walrond and Frend branches of the family, these genealogical images and objects are associated with multiple generations of members of several intertwined families, and date from the late seventeenth century until the 1790s.

When the construction of the specimen table is read against the history of the Parminter family, its status as a familial object assumes new significance. Shortly after the Parminters' return from their tour, the family was faced with the death of Jane's younger sister, Elizabeth (1756–c. 1790), who died in Malmesbury in around 1790.[88] The tour was often an inherently familial and social undertaking, with the Parminters' travels no exception. Reichel observed that the travellers were a party of four, whom we know to have comprised Jane and her cousin Mary, Elizabeth and a fourth unidentified female participant.[89] Beyond these immediate companions, Jane also described meeting various acquaintances (familial and otherwise) throughout the course of their journey from London

and across the Continent.⁹⁰ Jane's short tour journal accordingly conveys the profoundly social experience of travel. We can surmise that the companionship that Jane, Mary and, to a lesser extent Elizabeth, experienced throughout the course of their own journey would prove highly formative for their future relationships, potentially cementing a bond between cousins and sisters that would become a crucial impetus for their co-habitation at A la Ronde. Accordingly, both the Parminters' collection of souvenirs and their fabrication of decorative furnishings employing them, reflect the emotional, as well as the aesthetic, nature of travel. This relationship between travel, emotion, and experience was compounded by the death of Elizabeth, whose passing transformed their tour souvenirs into objects that commemorated travel and travel companion alike.

Contemporary travel writings confirm that mourning was directly associated with the space and place of tourism. Many tourists died *en route*, having travelled to the Continent to alleviate their illnesses and benefit from the warmer climate.⁹¹ For example Berry, who had lost her father at Genoa in 1817, recalled going to the cemetery with her sister Agnes where they 'gathered flowers and shed tears upon [their] father's tomb'; while Martin had lost both her niece and her brother-in-law during her family's residence in Italy.⁹² Indeed, in her account of the 'painful retrospection' she experienced during her travels, Martin located her reminisces materially, relating them directly with her experiences of collecting souvenirs, namely, specimens of petrified shells, with her young niece.⁹³ Confronted by the death of a relative at the time of a tour, the objects collected throughout its duration would take on new associations of the loved one and partaker. As such, this process extends the function of the souvenir – an object already so intimately connected with the processes of commemoration – to remind viewers of both the act of travel as well as its participants. As Martin's reminiscences of collecting shells with her niece affirm, such objects were often collected in an act of communal sociability, imbuing the materials with the associations of the place in which they were found, as well as the heightened affective significance of mutually enjoyed time spent travelling.

We can presume that both the acquisition of the Parminters' souvenirs and their subsequent translation into the decorative scheme of their home involved communal acts of consumption and production; material gestures that would conjure shared experiences of tourism, collection and making. At home and abroad, souvenir objects were often collected in acts of communal sociability. The travel journal of the young tourist Mary Anne Keene records her family walking 'upon the sands to pick up shells' in Carmarthenshire – an activity she recalled partaking in with her mother, father and aunt.⁹⁴ Writing from Deal, Kent,

on 21 June 1768, Elizabeth Carter wrote to her close friend Elizabeth Montagu describing her visit to Lady Mary Holdernesse, with whom she had 'spent the whole afternoon in wandering along the sea-shore'; correspondingly, in a letter dated 13 July 1800, Deborah Reynolds tellingly complained that she and her companion could 'find plenty of sea weed but few shells' on their beach walk.[95]

In both contemporary literature and interior decoration, the space of the grotto was similarly connected with introspective contemplation and powerful outbursts of emotion. For example, the first volume of Mary Champion de Crespigny's (1749–1812) novel *The Pavilion* (1796), hinges upon a relationship built between the young Ethelinda, and her benefactress, Lady Falkner, the latter of whose death is painfully experienced by Ethelinda.[96] Before leaving Lady Falkner's home of Newton Hall following her death, Ethelinda is described as taking

> a solitary walk round the park and gardens, to bid them an eternal adieu. She stopped in many places, which had been her favourite spots. She went into the grotto, the whole of which had been planned, and parts of the shell-work formed by Lady Falkner. The gothic windows were so shaded by ivy and other foliage, that a gloomy light only appeared. It seemed sacred to contemplation, and calculated to inspire the most serious reflections. She cast her eyes on a chair, and saw a silk handkerchief hanging on the back of it, which she recollected to have been worn by Lady Falkner on the last evening she had been there. Ethelinda flew towards it, and, taking it up, kissing it in an agony of grief, put it into her bosom.[97]

In June 1788, the *Whitehall Evening Post* included a short article featuring 'LINES, *written by, Mrs. CRESPIGNY,' 'placed at the Entrance of her Grotto, which is dedicated to CONTEMPLATION; and within View of the Metropolis*', which read: 'You who are led to this serene retreat / Where Contemplation holds unrivall'd sway / Stop – if Reflection you wou'd dread to meet, And from her rigid mandates shrink away!'[98] Composed several years before *The Pavilion* was written, the dedication of de Crespigny's own grotto suggests that far from merely functioning as a literary device, her location of Ethelinda's aguish within the site of the grotto was based upon her own experiences of both the contemplative and commemorative nature of this space. Such accounts of shell-collecting and grotto-visiting accordingly root the Parminters' interiors in relation to narratives of intimacy and emotion, combining memories of their tour with those of familial closeness.

This reading of the house is confirmed by close analysis of its specimen table, whose central porcelain plaque depicts a vestal virgin and reads 'LIFE SHALL TRIUMPH OVER DEATH'; an inclusion that confirms that the communication of bereavement was central to its function. Subscribing to the contemporary visual language of mourning, the inclusion of this plaque transfigures the meaning of the table, transforming it from an object that replicates the kinds of tables seen and available for purchase in Italy, to one of personal commemoration, encompassing and evoking the interlinked narratives of tour, home and family.

The micromosaic urns included within the specimen table are compelling examples of how generic souvenir objects were implicated within personal narratives of familial association and bereavement. The urn's associations with both classical antiquity and the material culture of death are perhaps most clearly expressed in Sophie von la Roche's famous account of her visit to the British Museum, conducted in 1786. Highlighting how the viewing of urns prompted meditations upon the fragility of life, von la Roche's description captures the overwhelming haptic urge she felt when confronted by these material artefacts:

> Nor could I restrain my desire to touch the ashes of an urn on which a female figure was being mourned. I felt it gently, with great feeling, between my fingers, but found much earth mixed with it. The thought, 'Thou divided, I integral dust am still', moved me greatly, and in the end I thought it must be sympathy which has caused me to pick this one from so many urns to whose ashes a good, sensitive soul had once given life. This idea affected me, and again I pressed the grain of dust between my fingers tenderly, just as her best friend might once have grasped her hand.[99]

Von la Roche's transportive account of her experience at the museum confirms the traditional funereal association of the urn as the vessel of the dead during this period, in which it functioned as part of 'the conventional furniture of the grave through its associations with the burials of the ashes of the dead in Antiquity'.[100] In Von la Roche's account, the urn, as a relic of a past age, was not merely a chance survival from antiquity, evocative of the classical past, but was also more generally representative of lives lived and lost. This symbolic function was reinforced through its consistent use in the language of eighteenth-century mourning, a process Marcia Pointon calls 'repetition', which she identifies as essential in the creation of a material culture of commemoration that linked mourning as concept and as artefact.[101] Urns were a central feature in Richard Cosway's presentation of sisterly mourning in his miniature portrait of

Margaret Cocks (1787), in which Cocks mournfully clutches the ashes of her deceased sister, Mary Russell. Grasping a funeral urn embellished with Russell's initials, the portrait miniature clearly subscribes to the dominant visual and material language of mourning, one shared by the mourning plaque and micromosaic urns included within the Parminters' specimen table.

As the existence of several versions of the micromosaic urns used in the table suggests, these were clearly far from exclusive items, with the varying forms that such micromosaics assumed reflecting the malleability of such objects. This is translation as transformation in action: as jewellery or decoration, the same object was used to adorn body and interior, a symbiotic representation that promulgated either the tour or the emotion of mourning depending on the physical and semantic contexts into which it was inserted following its acquisition. Powerfully demonstrating the complicity of tourist-wares in the creation of personal meaning and narrative, the Parminters' micromosaics are at once proto 'mass-produced' tourist objects, and mourning artefacts suggestive of personal loss.

Like the urns, the painted enamel plaque included within the table also subscribes to Pointon's universalizing visual and material culture of mourning. Depicting a vestal virgin who pours libations onto a burning pyre in a pseudo-sacrificial gesture, in both its subject matter and form the plaque is typical of what Christiane Holm has described as a 'mourning iconography' characterized by a 'small repertoire of elegiac motives: landscape- and garden-scenes, single trees, especially willows and cypresses, graves, especially topped by an urn, female mourners in pseudo-antique capes and floral ornaments'.[102] By the late-eighteenth century, mourning jewellery used a highly sentimental presentation of death, a distinctive and deeply conventional language of mourning, in which widely used visual forms were employed to commemorate private losses.[103] In fact, such imagery had become so routine that pattern books of commemorative imagery were published for the use of engravers, painters, sculptors and jewellers, functioning as a reserve of images for reproduction and adaptation in future designs.[104]

Pointon notes that this 'repetitiousness of motifs and forms' is essential in comprehending the function of such objects, serving to endorse the 'understanding that the lost object is both particular (and lost) as well as universal (and present)'.[105] Such convention in the iconography of mourning can therefore be understood in response to the need for a universally comprehensible vocabulary of mourning; in other words, the translation of mourning into a visual and material language that could be read both by its owner and those

external to the lost relationship.[106] Through its subscription to this common language of bereavement, the Parminters' specimen table visually and materially signalled to the viewer an absence from the tightly bound homosocial culture of A la Ronde, transforming a traditional souvenir item into a biographically and emotionally loaded object.

Far from a simple bricolage of purchased and found objects that imitates the modes of aesthetic display witnessed during the Parminters' tour, A la Ronde's table simultaneously performs an explicitly dedicatory function, serving to commemorate the loss of Elizabeth Parminter. Here then, the souvenir extends its traditional memorial function to enact a commemorative gesture; acting beyond its capacity to objectify the Parminters' tour, and functioning as an associative artefact that also refers to the loss of Jane and Mary's beloved travelling companion Elizabeth. In this context, objects such as the ceramic plaque, which specifically refer to the practices of mourning, can be read against those inclusions in the table that were acquired both at Exmouth and on their tour. Considered as a whole, the table attests to the nature of A la Ronde as not merely a homosocial space, but a distinctively familial one, in which the diverse histories of the Parminters coexist within the objects, surfaces and spaces crafted by the women. Consequently, when situated within the Parminters' home, these historical and familial heirlooms were not merely genealogical relics, but also acted as souvenirs redolent with familial narratives, complementing those told by the souvenirs of Exmouth or the tour. Just like an heirloom, whose function Stewart identifies as weaving 'by means of a narrative, a significance of blood relation', at A la Ronde the souvenir also acts as a kind of narratological, biographical object and consequently, a site of potent familial association.[107] Accordingly, it is crucial not to disentangle the Parminters' souvenirs into categories of home and abroad, of the feminine and the familial. Instead, the evocative combination of objects found at A la Ronde helps us to understand how souvenirs functioned narratively as fragments of subjective experience, memory, and association in the Parminters' creation of a space that was distinctively their own.

Conclusions

The specimen table exemplifies the various levels upon which translation operated in the creation of objects at A la Ronde. Firstly, it comprises objects that were physically translated, through the processes of collection and acquisition,

from the regions of tour and their Devonshire locale into their home, materially connecting the spaces and experiences of tour and home. Secondly, by evoking modes of display and aesthetic creation encountered on their Continental tour in the making of furniture and decoration for A la Ronde, it creatively re-enacts that tour, and the collective experiences that it encompassed. Finally, the table demonstrates how the physical translation of an object from one site to another was echoed by an intellectual and emotional transference of meaning which occurred between object and maker, and subsequently, object and viewer, once the souvenir was reused in its new setting. Commemoration was therefore not a quality integral to the constituent elements of the specimen table, but an associative meaning that came to be imbued into the table through the self-conscious processes of translation and craft, specifically, the Parminters' selection and inclusion of souvenirs, resulting in a semantic transformation of these objects into a mourning device for Elizabeth. It is highly significant therefore, that the Parminters did not purchase a premade specimen slab while visiting the Continent, but instead recreated such items using an assortment of personally meaningful small-scale souvenirs and found objects, impregnating them with the memorial and emotional significance that a prefabricated table would have lacked. In the specimen table, it was the combinative act of translation that was crucial in allowing the 'mass-produced' object to act in this biographical capacity; a transformative act that facilitated the creation of personal narratives within a generic category of souvenir object. By focusing on the wide array of material souvenirs employed by the Parminters' within their home, we can accordingly comprehend the decoration of this space as comprising numerous parallel processes that allowed for the simultaneous construction of the self, the family, and the home, through the physical, aesthetic and semantic translation of material culture.

In traditional accounts of the souvenir, its power to recall a location visited or to impress the act of travel upon its viewers is stressed. At A la Ronde, however, the souvenir was not only transported home, but was physically and semantically transformed by the Parminters, whose craft practices gave these objects a much deeper range of meaning and associations. Susan Pearce has argued that souvenirs 'are intrinsic parts of our past experience' because they 'possess the survival power of materiality not shared by words, actions, sights and the other elements of experience, they alone have the power to carry the past into the present'.[108] In this sense, all material artefacts may be seen to function as some kind of historical souvenir, that, through the process of translation into a particular context, may continue to speak to the historian, even when the textual

source has long since been destroyed. As art historians and scholars of material culture, we take for granted that objects reveal the histories and preoccupations of their owners or makers, but a study of the decorative objects created at A la Ronde demonstrates just how clearly the Parminters' themselves were aware of the potential of visual objects to weave historical, personal and emotional narratives.

Notes

1. For a reading of women's crafts of this period in relation to the concept of bricolage, see Ariane Fennetaux, 'Female Crafts: Women and *Bricolage* in Late Georgian Britain, 1750–1820', in Maureen Daly Goggin and Beth Fowkes Tobin (eds), *Women and Things, 1750–1950: Gendered Material Strategies* (Burlington: Ashgate 2009), 91–108.
2. For biographical information on Jane and Mary Parminter, including the Parminter family tree, see Trevor Adams, *The A la Ronde Story: Its People* (Exmouth: National Trust, 2011).
3. Hugh Meller, *A la Ronde* (Swindon: National Trust Publishing Ltd. 1991), 4. The role that the Parminters played in the design of A la Ronde has been the subject of much debate. It is now common consensus that while the cousins were not the architects of the property per se, they had an active role in the design of the building. See Lynne Walker, 'The Entry of Women into the Architectural Profession in Britain', *Woman's Art Journal*, 7, no. 1 (Spring–Summer, 1986): 13–18.
4. Adams, *The A la Ronde Story*.
5. Nelson H.H. Graburn, 'Foreword', in Michael Hitchcock and Ken Teague (eds), *Souvenirs: The Material Culture of Tourism* (Aldershot & Burlington: Ashgate, 2000), xii.
6. Adams, *The A la Ronde Story*, 6.
7. Oswald Joseph Reichel, 'Extracts from a Devonshire Lady's Notes of Travel in France in the Eighteenth Century', *Report and Transactions: The Devonshire Association for the Advancement of Science, Literature and Art*, 34 (1902): 265–77.
8. Mary Parminter, Will, 1847, Devon Record Office. See also: Adams, *The A la Ronde Story*, 10–11.
9. Adams, *The A la Ronde Story*, 11–12.
10. Halberstam, *In a Queer Time and Place*, 4.
11. Colin Cunningham, '"An Italian house is my lady": some aspects of the definition of women's role in the architecture of Robert Adam', in Michael Rossington and Gill Perry (eds), *Masculinity and Femininity in Eighteenth-Century Art and Culture* (Manchester: Manchester University Press, 1994), 71. Vickery, *Behind Closed Doors*, 248.

12 See for example: M-M. Le Valois de Villette de Murçay Caylus, *Memoirs, Anecdotes and Characters from the Court of Lewis XIV. Translated from Les Souvenirs, or, recollections of Madame de Caylus* (London, 1770).
13 W.S. Lewis (ed.), *The Yale Edition of Horace Walpole's Correspondence* (New Haven & London: Yale University Press, 1983), 37: 57.
14 Susan Stewart, *On Longing: Narratives of the Miniature, the Gigantic, the Souvenir, the Collection* (Durham & London: Duke University Press, 2007), 136.
15 Appadurai, *The Social Life of Things*, 5. Hoskins, *Biographical Objects*.
16 Janet Hoskins, 'Agency, Biography and Objects', in Chris Tilley, Webb Keane, Susan Küchler, Mike Rowlands and Patricia Speyer (eds), *Handbook of Material Culture* (London: SAGE Publications, 2006), 74–84. See also: Kirsten Wehner and Martha Sear, 'Engaging the Material World: Object knowledge and *Australian Journeys*', in Sandra Dudley (ed.), *Museum Materialities: Objects, Engagements and Interpretations* (London & New York: Routledge, 2013), 161. More recently, the idea of 'object itineraries' has provided a fruitful means by which to think through some of these issues, particularly in terms of movement and circulation. See: Rosemary A. Joyce and Susan D. Gillespie (eds), *Things in Motion: Object Itineraries in Anthropological Practice* (Santa Fe: School for Advanced Research Press, 2015).
17 On translation see: Finbarr B. Flood, *Objects of Translation: Material Culture and Medieval 'Muslim-Hindu' Encounter* (Princeton, NJ: Princeton University Press, 2009); Mirella Agorni, *Translating Italy for the Eighteenth Century: British Women, Translation and Travel Writing (1739-1797)* (Manchester: St. Jerome Publishing, 2002); Ruth B. Phillips, '"Dispel all Darkness": Material Translations and Cross-Cultural Communication in Seventeenth-Century North America', *Art in Translation*, 2, no. 2 (2010): 171–200.
18 Jules Prown, 'Mind in Matter: An Introduction to Material Culture Theory and Method', *Winterthur Portfolio*, 17, no. 1 (1982): 9–10.
19 Joseph B. Seabury (ed.), *Lord Chesterfield's Letters to his Son* (New York, Boston & Chicago: Silver, Burdett & Co. 1902), 102.
20 Henry H. Belfield (ed.), *Lord Chesterfield's letters to his son and godson* (London: Maynard, Merrill & Co. 1897), 64.
21 Ibid.
22 For example, Andrew Wilton and Ilaria Bignamini's exhibition catalogue *Grand Tour: The Lure of Italy in the Eighteenth Century* (London: Tate Gallery Publishing, 1996) dedicates only a few of its total pages to smaller souvenirs such as cameos, micromosaics and biscuit-ware.
23 Emma Gleadhill, 'Performing Travel: Lady Holland's Grand Tour Souvenirs and the House of All Europe', *EMAJ: Electronic Melbourne Art Journal*, 9, no. 1 (2017).
24 Frank Salmon, *Building on Ruins: The Rediscovery of Rome and English Architecture* (Aldershot & Burlington: Ashgate Publishing Limited, 2000). Rosemary Sweet,

Cities and the Grand Tour: The British in Italy, c. 1690–1820 (Cambridge: Cambridge University Press, 2012).

25 Adams, *The A la Ronde Story*, 7.

26 Ibid.

27 Sweet, *Cities and the Grand Tour*, 44.

28 Theresa Lewis (ed.), *Extracts of the Journals and Correspondence of Miss Berry*, 3 vols. (London: Longmans, Green and Co. 1865), 1: 39, 111, 120 and 175.

29 Anna Riggs Miller, *Letters from Italy, Describing the Manners, Customs, Antiquities, Paintings, &c. of that Country*, 3 vols. (London: Edward & Charles Dilly, 1776–7), 2: 41 and 47.

30 Ibid., 47.

31 Marianna Starke, *Travels in Italy, Between the Years 1792 and 1798; Containing A View of the Late Revolutions in that Country*, 2 vols. (London: R. Phillips & T. Gillet, 1802), 2: 305–6.

32 Ibid., 2: 322.

33 Wilton and Bignamini, *Grand Tour*, 284.

34 Godfrey Evans, *Souvenirs: from Roman Times to the Present Day* (Edinburgh: National Museum of Scotland Publishing, 1999), 26.

35 Lewis, *Extracts*, 2: 40.

36 Selina Martin, *Narrative of a three years' residence in Italy, 1819–1822* (Dublin: W.F. Wakeman, 1831), 48.

37 Stewart, *On Longing*, 137.

38 Miller, *Letters from Italy*, 2: 157.

39 Other notable prints owned by the Parminters and probably bought during their Continental tour include H.L. Schmitz's *Vue du principalle Borne du Champs de Bataille de Nefelts/View of the Principal Marker Stone of the Battle of Naefels*, 1779 (National Trust Inventory Number 1312122) and a print after Jakob Philipp Hackert, *View of the Ruins of the Bridge of Augustus on the Nera and Narni, c.* 1775–1805 (National Trust Inventory Number 1312121).

40 See for example: Ilaria Bignamini and Clare Hornsby, *Digging and Dealing in Eighteenth-Century Rome*, 2 vols. (New Haven & London: Yale University Press, 2010).

41 Richard Wrigley, 'Making Sense of Rome', *Journal for Eighteenth-Century Studies*, 35, no. 4 (2012): 551–64.

42 Ibid., 552, 554.

43 Ibid., 561.

44 Lewis, *Extracts*, 3: 269–70.

45 Ibid., 3: 271.

46 Appadurai, *The Social Life of Things*, 3.

47 Earl of Ilchester (ed.), *The Journal of Elizabeth, Lady Holland* (London, New York, Bombay & Calcutta: Longmans, Green, and Co. 1908), 1: 63.

48 Ibid.
49 Ibid., 1: 9.
50 Miller, *Letters from Italy*, 2: 292.
51 Ann Flaxman, Journal, Add MS 39787, British Library, London, 1787–8, 70.
52 Hester Lynch Piozzi, *Observations and Reflections made in the Course of a Journey through France, Italy, and Germany*, 2 vols. (London: T. Cadell & A. Strahan, 1789), 2: 68.
53 Martin, *Narrative of a three years' residence in Italy*, 56.
54 Miller, *Letters from Italy*, 2: 130.
55 Meller, *A la Ronde*, 15.
56 On shellwork and shell collecting more broadly, see Beth Fowkes Tobin, *The Duchess's Shells: Natural History Collecting in the Age of Cook's Voyages* (New Haven and London, 2014).
57 Beatniffe, *The Norfolk Tour*, 53.
58 Ibid.
59 William Bray, *Sketch of a tour into Derbyshire and Yorkshire* (London: B. White, 1778), 100. Thomas Broderick, *Letters from several parts of Europe, and the East. Written in the years 1750, &c.* (London, 1753), 51.
60 On Exmouth, see: Martin Dunsford, *Miscellaneous observations, in the course of two tours* (Tiverton, 1800), 84; Edward Donovan, *The natural history of British shells* (London: F.C. & J. Rivington, 1804), 1: 21, 2: 68–9 and 4: 88.
61 See for example: Jane and Mary Parminter, cut out picture, 1770–1820. Paper, sand and wood. National Trust Collections, A la Ronde, Devon.
62 Richard Wrigley, *Roman Fever: Influence, Infection, and the Image of Rome, 1700–1870* (New Haven & London: Yale University Press, 2013), 3.
63 Ibid., 1.
64 Ibid., 2.
65 Mary Shelley (ed.), *Essays: Letters from Abroad, Translations and Fragments*, 2 vols. (London: Edward Moxon, 1840), 2: 94.
66 Ibid.
67 Reichel, 'Extracts': 267.
68 Ibid., 265.
69 Ibid., 267, 270 and 271.
70 Ibid., 69.
71 Ibid., 268.
72 Meller, *A la Ronde*, 11.
73 Viccy Coltman, 'Sir William Hamilton's Vase Publications (1766–1776): A Case Study in the Reproduction and Dissemination of Antiquity,' *Design History*, 14, no. 1 (2001): 1.
74 Cited in Coltman, *Fabricating the Antique*, 78.

75 Arnold, *The Georgian Country House*, 93.
76 Coltman, *Fabricating the Antique*, 76.
77 Coltman, 'Sir William Hamilton's Vase Publications': 2.
78 Ibid.,11.
79 For example, Thomas Martyn and John Lettice described a recent excavation at Portici, whose spoils had included 'a great quantity of African marble, out of which some tables were made'. Thomas Martyn and John Lettice, *The Antiquities of Herculaneum, Translated from the Italian*, 2 vols. (London: J. Taylor, 1773), 1: xi.
80 Piozzi, *Observations*, 2: 119–20. Starke, *Travels in Italy*, 2: 34.
81 Elizabeth Fairman, Cat. 124, 'Inlaid Decorative Stone Tabletop', in María Dolores Sánchez-Jáuregui Alpañés and Scott Wilcox (eds), *The English Prize: The Capture of the Westmorland, An Episode of the Grand Tour* (New Haven & London: Yale University Press, 2012), 292.
82 Ibid.
83 Starke, *Travels in Italy*, 2: 2. Starke also lists sulphurs 'to be purchased of the Maker, by name DOLCI, in *Strada Conditti*' in her catalogue of the best shops at Rome. Ibid., 2: 322.
84 John Payne, *Universal geography formed into a new and entire system; describing Asia, Africa, Europe, and America*, 2 vols. (London: J. Johnson, 1791), 2: 342.
85 Mary Wordsworth, 9 September, 1820. Travel Journal, DCMS 92M. Dove Cottage, Cumbria.
86 Marianne Baillie, *First Impressions on a Tour upon the Continent, in the Summer of 1818* (London: John Murray, 1819), 204; Ilchester (1908), 1: 8.
87 Ibid.
88 Adams, *The A la Ronde Story*, 1.
89 Ibid, 7. Reichel, 'Extracts': 267.
90 For example, when the party set off from London on 22 June 1784, Jane records travelling through Greenwich, Rochester and Canterbury, where she dined at the home of her elder sister Maryanne and her brother-in-law 'Mr. Frend,' before proceeding to Dover. The next day, Jane describes calling 'at Mr. Stringers' before departure. Correspondingly, Reichel notes that a passport was issued at Rome on 16 April 1786 'to Mary's brother, John Parminter, authorising him to travel with his servant to Naples', confirming his presence in Italy at the same time as their tour. Ibid., 266.
91 Jeremy Black, *The British and the Grand Tour* (London: Routledge, 2011), 90.
92 Lewis, *Extracts*, 3: 164; Martin, *Narrative of a three years' residence in Italy*, 351.
93 Ibid.
94 Mary Anne Keene, Diary, MS225 (1794), Cadbury Research Library, Birmingham, 20.
95 Greg, *Reynolds-Rathbone Diaries and Letters*, 89. Montagu Pennington (ed.), *Letters from Mrs. Elizabeth Carter to Mrs. Montagu, between the years 1755 and 1800*, 3 vols. (London: C. & J. Rivington, 1817), 1: 385.

96 Mary Champion de Crespigny, *The pavilion. A novel*, 4 vols. (London: William Lane, 1796), 1: 202.
97 Ibid., 249–51.
98 *Whitehall Evening Post*, 21–24 June 1788.
99 Sophie von la Roche, *Sophie in London, 1786: Being the Diary of Sophie von la Roche*, trans. C. Williams (London, 1933), 107–8.
100 Nigel Llewellyn, *The Art of Death* (London: Reaktion Books, 1991), 99.
101 Pointon, *Brilliant Effects*, 301.
102 Christiane Holm, 'Sentimental Cuts: Eighteenth-Century Mourning Jewelry with Hair', *Eighteenth-Century Studies*, 38, no. 1 (2004): 139.
103 Fennetaux, 'Fashioning Death/Gendering Sentiment', 34.
104 For example, Garnet Terry, a London-based engraver published *A Book of New and Allegorical Devices for Artists in General* in 1795, which presented 'an extensive series of small-scale oval-shaped engravings intermingling a variety of sentimental scenes and mournful subjects'. Ibid.
105 Pointon, *Brilliant Effects*, 301.
106 Ibid.
107 Stewart, *On Longing*, 137.
108 Susan M. Pearce, *Interpreting Objects and Collections* (London: Routledge, 1994), 195.

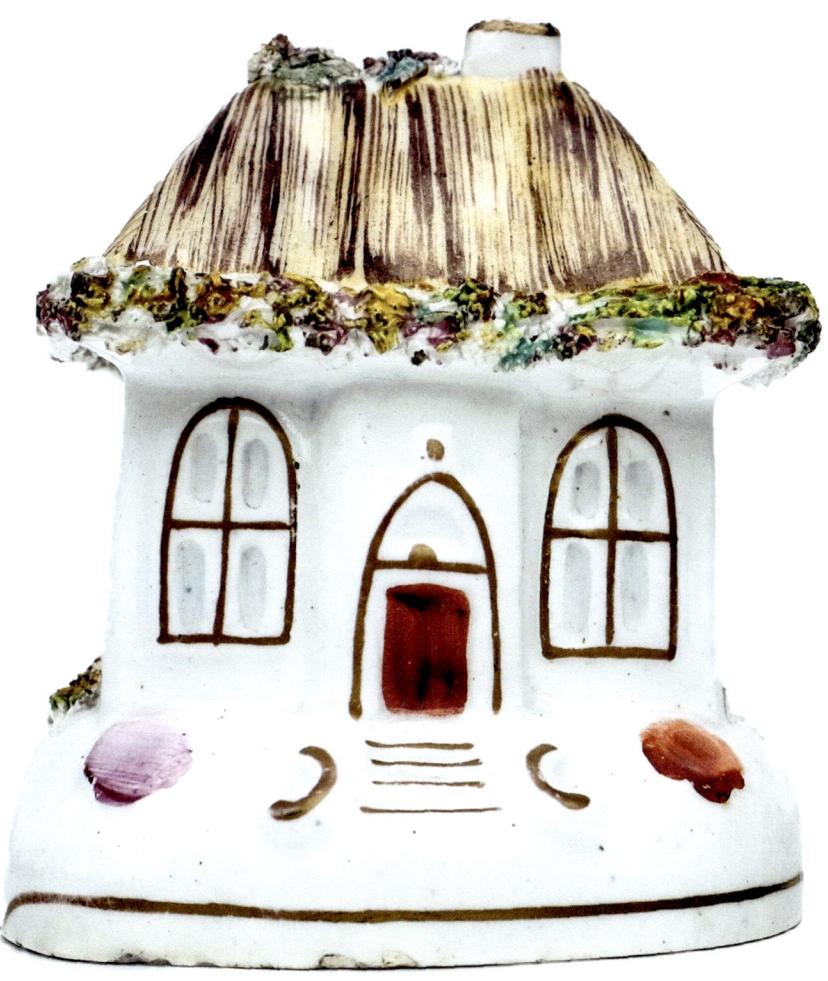

Plate 1 Cottage pastille burner, Staffordshire, mid-nineteenth century. Photograph, author.

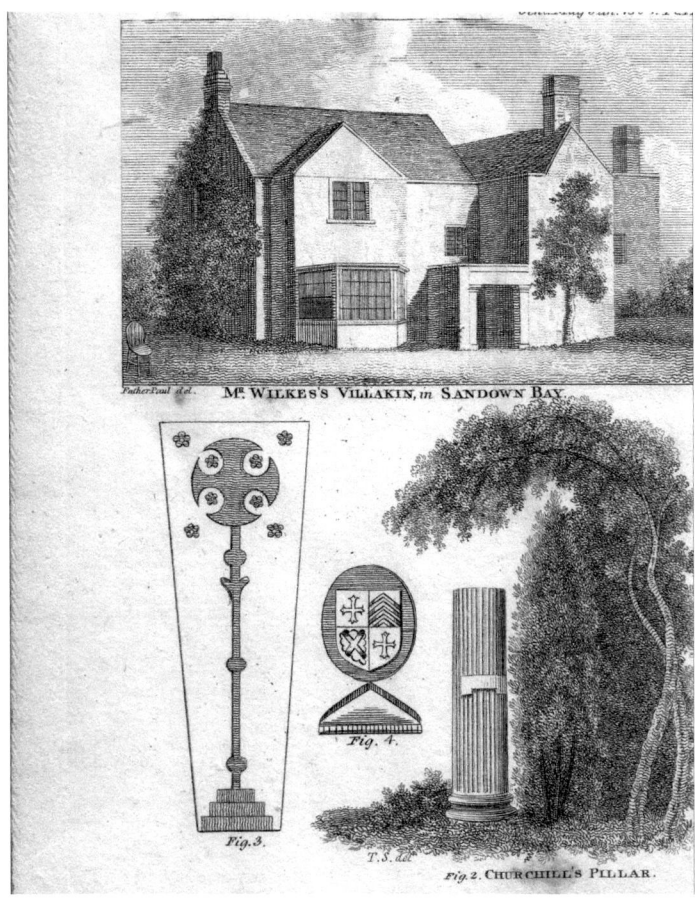

Plate 2 *Mr Wilkes's Villakin, in Sandown Bay*, *Gentleman's Magazine*, January 1804, 95:17. Engraving. Photograph, author.

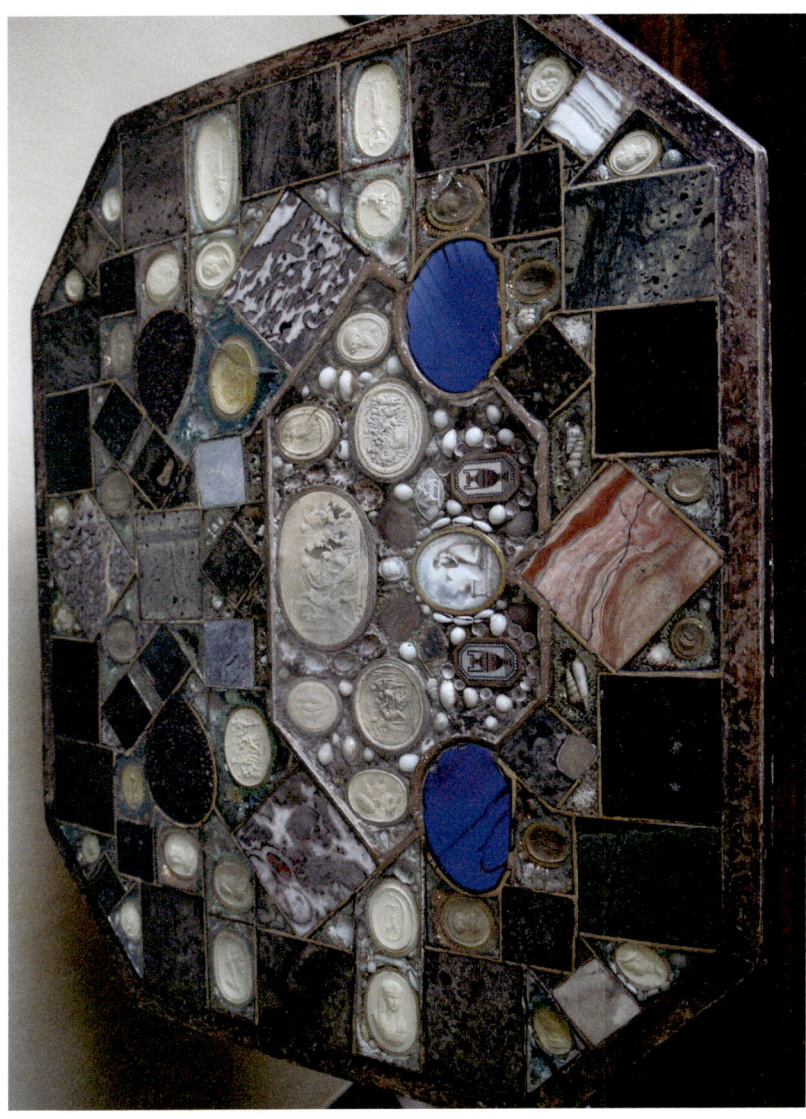

Plate 3 Jane and Mary Parminter, specimen table, Exmouth, Devon, 1790s. Glass, mineral, shell, paint, paper and wood. Photograph, author.

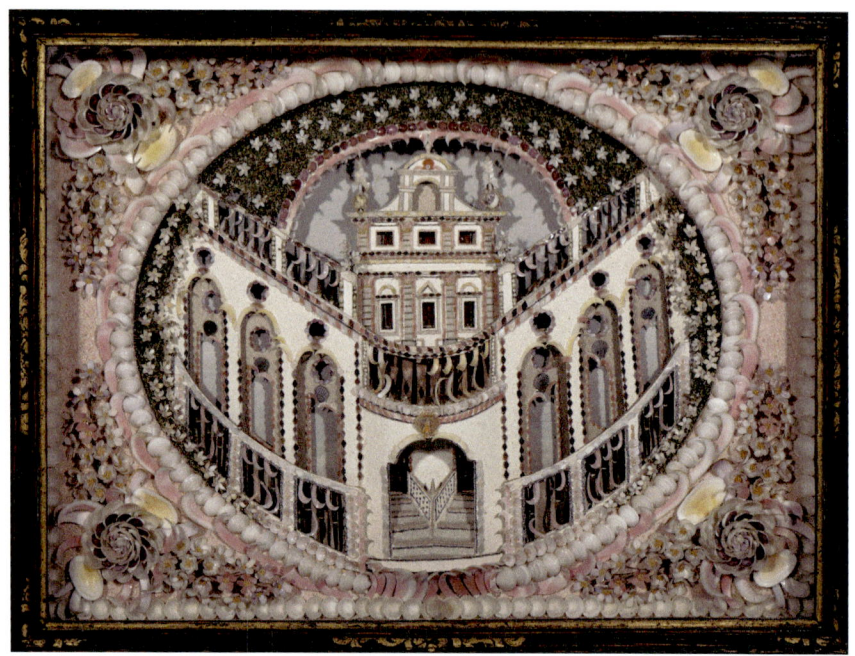

Plate 4.1 Shellwork picture, Isola Bella, Italy, *c.* 1780–90. Paper, shell and wood. National Trust Collections, A la Ronde, Exmouth, Devon. © National Trust Images/Derrick E. Witty.

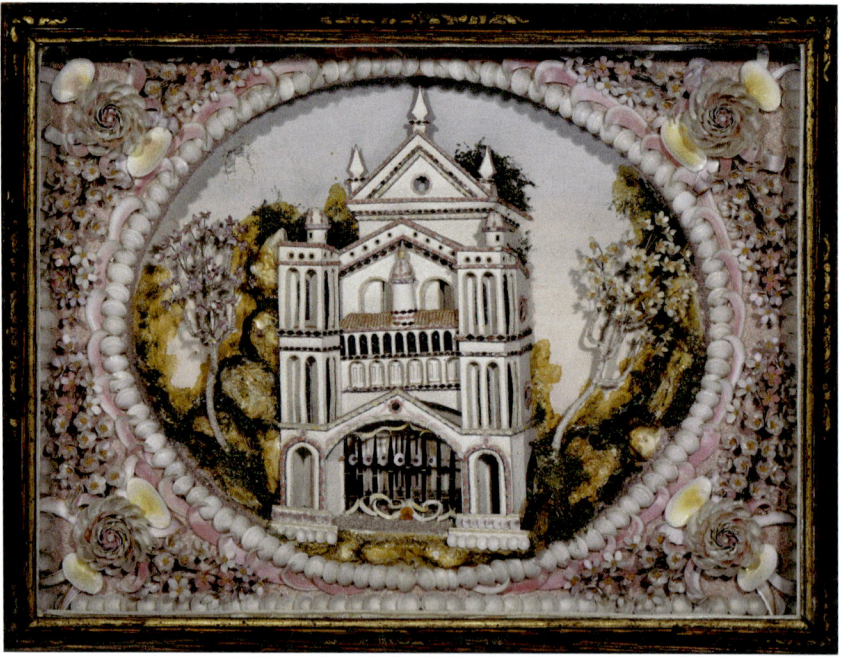

Plate 4.2 Shellwork picture, Isola Bella, Italy, *c.* 1780–90. Paper, shell and wood. National Trust Collections, A la Ronde, Exmouth, Devon. © National Trust Images/Derrick E. Witty.

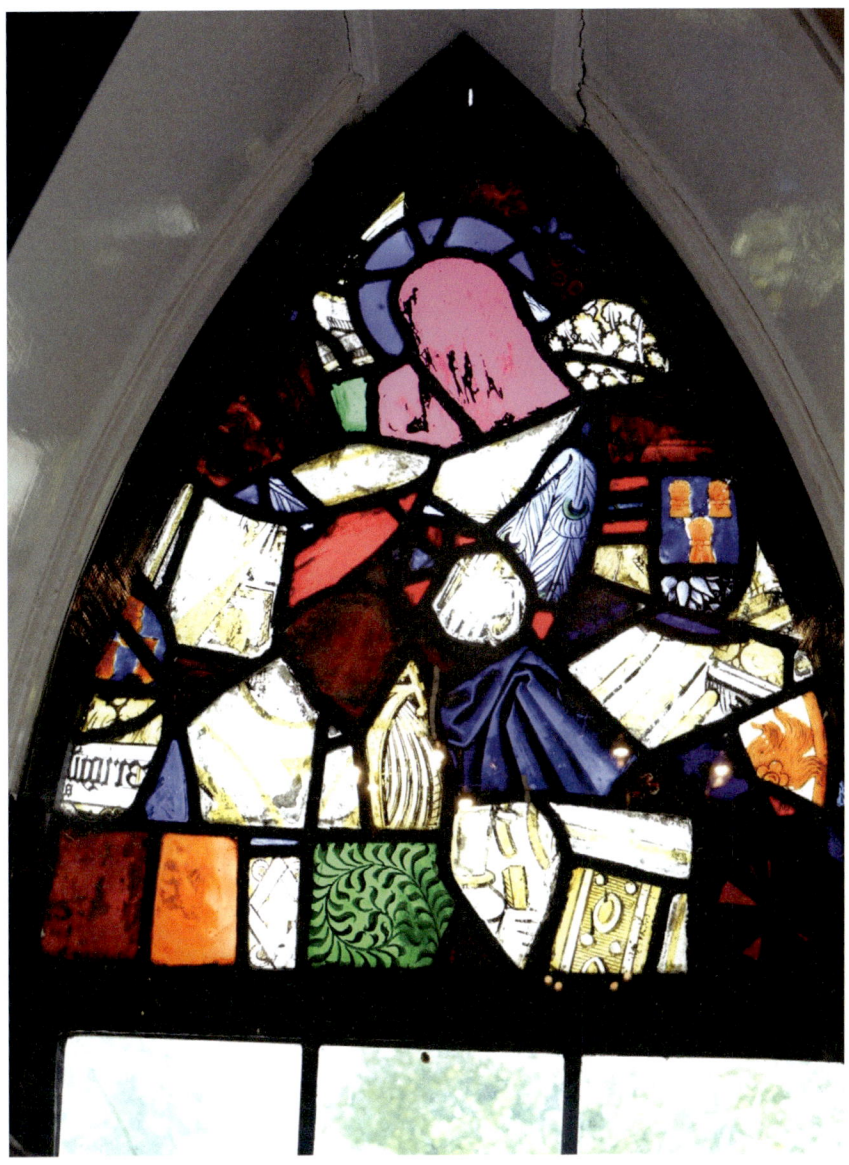

Plate 5 Stained glass windows, Plas Newydd, Llangollen, *c.* 1795. Photograph, author.

Plate 6 Anne Damer, extra-illustrated 1784 edition of *A Description of the villa of Mr. Horace Walpole* (*c.* 1784–1803). Quarto 33 30 Copy 25. Courtesy of The Lewis Walpole Library, Yale University.

Plate 7 Anne Damer, extra-illustrated 1784 edition of *A Description of the villa of Mr. Horace Walpole* (*c.* 1784–1803). Quarto 33 30 Copy 25. Courtesy of The Lewis Walpole Library, Yale University.

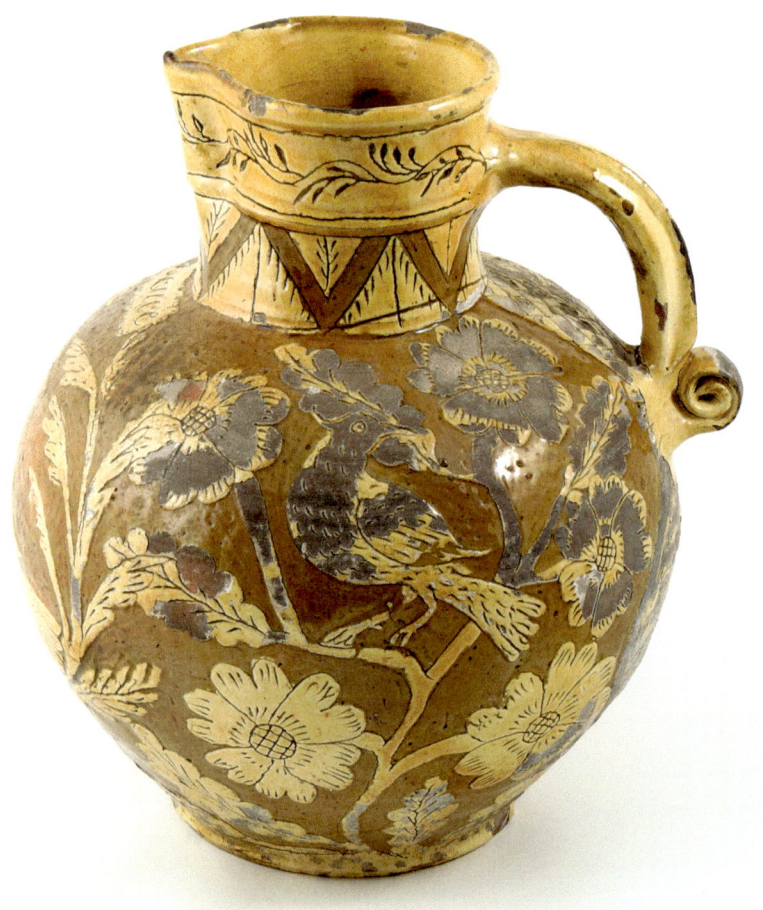

Plate 8 Fremington Pottery, ceramic harvest jug, North Devon, 1828–9. Commissioned by Mary Parminter. Slip coated earthenware. National Trust Collections, A la Ronde, Exmouth, Devon. © National Trust/Simon Harris.

4

'A little temple, consecrate to Friendship and the Muses': Romantic Friendship and Gift-exchange at Plas Newydd, Llangollen

On 17 November 1795, the poet Anna Seward wrote to her friend Mary Powys recounting a recent visit to her new friends, Lady Eleanor Butler and Sarah Ponsonby, the 'celebrated Recluses of Langollen Vale'.[1] In the letter, Seward aptly described the home where they established residence, Plas Newydd, or 'New Place', located in Llangollen, North Wales, as 'a little temple, consecrate to Friendship and the Muses, and adorned by the hands of all the Graces' (fig. 4.1).[2] Seward's identification of the house as a shrine to friendship was typical of contemporary responses to Plas Newydd, many of which directly associated the cottage's material decoration with the intense relationship enjoyed by the two women and their broader circle of friends. In 1795, for example, the Rev. J.H. Michell correspondingly described the house as 'fitted up with every article that can show a dignified taste, a true love of sweet retirement, and the reciprocal charm of improving friendship'.[3]

The longer historiography of the 'Ladies of the Vale' has similarly been preoccupied with Butler and Ponsonby's friendship, and specifically, with determining its exact nature. While in 1986, their biographer Elizabeth Mavor called the suggestion of an explicitly sexual relationship between the women 'a bluntish instrument' with which to discuss their retirement at Plas Newydd, many have hailed Butler and Ponsonby as a paradigm of 'trans-historical Lesbian identity'.[4] However, more recent scholarship examining the women has sought to transcend both the debates of consummated 'genital sexuality' versus 'romantic friendship', and the presentation of Butler and Ponsonby as an 'indissoluble dyad'.[5] As Seward noted in the same 1795 letter to Powys, though 'devoted to each other' Butler and Ponsonby's 'expanded hearts [had] yet room for other warm attachments', attachments that constituted a broad social network that included local landowners and members of the gentry, visiting tourists, the

Figure 4.1 W.L. Walton, after E.W. Jacques, *Plas Newydd*, Chester: T. Catherall, 1847. National Library of Wales, Creative Commons CC0.

villagers of Llangollen, and Seward herself, who visited the women four times throughout their acquaintance.[6]

While historians have questioned the use of the term 'romantic friendship' to describe Butler and Ponsonby's relationship, this chapter subverts the term, expounding instead a notion of 'Romantic friendship'. In this iteration 'Romantic friendship' denotes the cultivation of a creative and productive network between Plas Newydd and its visitors, which included Romantic poets such as William Wordsworth and Robert Southey, and was characterized by the marked closeness and creative activities of its participants.[7] As the literary scholar Fiona Brideoake has asserted, Butler and Ponsonby's contribution to Romantic literary history has long been unacknowledged, reflecting 'the fact that they did not produce canonical Romantic texts'.[8] Nevertheless, the creation of the community of Plas Newydd constitutes a significant contribution to the history of a movement typified by its collective nature and emphasis on the discourses of friendship. Both John Worthen and Jeffrey Cox have stressed the importance of such communities to the history of Romanticism, emphasizing the significance of social and intellectual groupings in the construction of Romantic identities.[9] In so doing, they expound a notion of a broad cultural Romanticism, in which complementary sentimental and literary transactions functioned to construct the movement, and which might therefore be profitably situated alongside the exchange of objects, ideas and sentiments that similarly implicated Butler and Ponsonby within a rich network of correspondents and writers. This chapter follows such developments within Romantic historiography, employing the term Romantic friendship as both the designator of intimate social relations as well as the creative, intellectual and material cultures established between Butler and Ponsonby and their friends, which specifically involved members of the broader Romantic community, including 'big six' poets and others like Seward, and the circulation of their poetry and prose.

This Romantic friendship was most evidently enacted through the exchange of gifts, which, on the one hand, functioned as agents of sentiment and respect, while on the other, generated a dynamic literary and material Romantic culture centred at Plas Newydd. Characterized by the movement of objects from and into their home, these transactions both recalled and replicated the shared social and intellectual experiences of Butler and Ponsonby and their guests. The process of exchange accordingly complicates the notion that the pair were an 'indissoluble dyad', instead presenting lives that comprised multifarious and simultaneous affections.[10] Shifting focus beyond the confines of Butler and Ponsonby's own attachment, a study of their gift-exchange potently demonstrates their cultivation of relationships with a broad array of correspondents, whose exchange of gifts

correspondingly created a material, affective, and ideological dialogue between forms of cultural expression. Plas Newydd's consecration to friendship then, extended far beyond that shared between Butler and Ponsonby themselves.

The culture of the gift

The gift culture surrounding Butler and Ponsonby and their numerous correspondents comprised the exchange of a remarkable variety of material objects, including a lock of Napoleon Bonaparte's hair, a Wedgwood water-bowl for their dogs, pencils, melons, perfume, engravings, poetry and on no fewer than two separate occasions, a cow.[11] In accordance with Lewis Hyde's definition of gift giving as an exchange that establishes 'a relationship between the parties involved', contemporaries clearly perceived the exchange of both letters and objects as conveying sentiment and affection in lieu of their donator's presence.[12] This is demonstrated in a letter written by the Yorkshire gentlewoman Ann Ambler to her cousin Thomasin Ibbetson in 1772, to thank her for an as yet unidentified gift: 'Believe me truly grateful for this, & every other mark of [your] kindness and affection, on which I assure you I set the highest Value'.[13] Two years later, Ambler wrote again to Ibbeston, noting that her correspondent's 'kind attention and remembrance' had been

> so strongly and so elegantly express'd in the present convey'd to me by Lady Ibbetson [which] give me a pleasure and satisfaction which tho I very sensibly feel, I have not power to communicate. They at the same time shew the goodness of your heart & the improvement of your Hand, I shall treasure them up with your other favours as indisputable marks of that affection on such I shall ever set the highest value, and shall be happy to deserve its continuance.[14]

In noting that her cousin's needlework 'express'd' and 'convey'd' her 'attention', 'remembrance' and 'affection', Ambler's letters strongly suggest her understanding of gifts as a physical manifestation of familial intimacy, and more broadly, affirm the potential of gifts to establish and sustain relationships, between donor and recipient, as well as the objects themselves.

The extant literature on Plas Newydd's gift economies has focused on how Butler and Ponsonby used gifted objects in order to consolidate and circulate 'a socially sanctioned narrative of their life together'.[15] Centring primarily on how Butler and Ponsonby 'gifted' the cottage through their circulation of its images in visual and literary forms, such interpretations resist reciprocally placing these gifts in relation

to the broader material exchange that characterized the culture of Plas Newydd. This strongly impacts our understanding of the complex and multi-faceted processes that constituted Butler and Ponsonby's cultural engagement. Focusing on a comparatively narrow array of gifted objects that traded on the women's social capital among their intimates and the wider public, such interpretations miss the creative and affective potential of the act of exchange, wherein the act of giving a gift is only the first in a chain of many reciprocal processes.

Expounding the use of the term 'gift relationships' to discuss such connections, Sarah Haggarty's study *Blake's Gifts: Poetry and the Politics of Exchange* (2010) embraces what she calls the 'dynamic triangulation' of gifts between their 'corporeal' (or material) and 'spiritual' (or intellectual/emotive) manifestations.[16] In lieu of gift-*exchange*, these 'relationships' allow for a conceptualization of the gift beyond its physicality, actively encouraging the consideration of multiple and simultaneous relationships established through the act of giving. Beyond their affective functions, Haggarty's concept of 'relationships' highlights the 'continuous creativity' implicated by gift giving, which encompassed not only the initial act of donation, but also its subsequent responses.[17] This function of the gift, particularly when exchanged between women, has previously been elaborated upon by Elizabeth Eger, who highlights how female 'accomplishments' were implicated within a (material) culture of exchange, transaction and display.[18] Examining an array of Bluestocking objects, including feathers, botanical illustrations, letters and the famous 'Portrait Box' featuring images of several of the most famous Bluestockings, Eger identifies how such objects operated in 'productive parallel with individual scholarship or the shared pleasures of conversation', a dialogue of exchange and correspondence that 'developed through shared pleasures of occupation, reading, and enjoyment'.[19] Eger thereby proffers a model of gift-exchange that emerges from the broader social, intellectual and affective contexts in which it was propagated, which simultaneously highlights the analogous functions of a variety of cultural forms, and recognizes the encompassing manner in which cultural processes operated in the late-eighteenth and early-nineteenth centuries. Employing the models proffered by Haggarty and Eger, the chapter explores how the exchange of objects was an inherently dynamic and fluid process that formed multiple 'Romantic friendships' cultivated within and around Plas Newydd and its gardens, locating these gift relationships within the physical, intellectual and emotional space of Butler and Ponsonby's home.

The first half of the chapter examines the gifts received by Butler and Ponsonby, focusing on how these objects were incorporated within the

decorative programme of their home. Often alluding to Llangollen and the countryside that surrounded Plas Newydd, these objects reflected the house's connection with local monuments such as the castle Dinas Bran, Valle Crucis Abbey and the homes of nearby landowning families, as well as visitors' own encounters in the rooms of Plas Newydd. The second half of the chapter examines the gifted flow of objects from Butler and Ponsonby's home, focusing on how the pair gave 'parts' of Plas Newydd to their friends: gifts that both showcased the productivity and industriousness of the estate of Plas Newydd, and served to remind their guests of the collective experience of visiting the house. Throughout the chapter, exchange emerges as a central social and cultural process within late eighteenth- and early nineteenth-century culture, constituting a creative and productive act that complicated traditional boundaries between material and literary genres, while ideologically and sentimentally unifying its participants.

'Only two rooms are shewn': Plas Newydd's library and drawing room

Many of the descriptions of Plas Newydd written by its visitors include detailed discussions of its library and drawing room, the two rooms 'allotted for the inspection of strangers'.[20] 'Handsomely furnished', the rooms captivated the attention of friends and travellers alike: the drawing room, a light and airy space, was extensively hung with drawings of the surrounding landscape, with compelling picturesque views seen from its windows; while their library was an evocative Gothic chamber, lit by stained glass windows and lanterns, and filled with portraits and books. As at A la Ronde, the decoration of Plas Newydd's interior was one of material multiplicity, featuring a diverse array of objects that at once combined and relayed narratives of highly social acquisition, collection and display. Both library and drawing room were filled with objects that, through their gifted nature, imaginarily recalled the intimate associations of their donor. These gifted inclusions were integral to how Butler and Ponsonby's relationships between themselves and their friends were expressed and perceived, specifically located within a 'Romantic friendship' firmly rooted within Plas Newydd and its surrounding countryside. While the spaces of the library and drawing room have traditionally been designated as 'masculine' and 'feminine' respectively, the rooms at Plas Newydd encourage us to transcend this neatly drawn gendered paradigm, focusing instead on how their use and decoration as fluid and complex spaces expose the intricate social, intellectual and material interactions enacted

between Butler and Ponsonby and their visitors.[21] Consequently, the rooms epitomize how the cottage itself was fashioned by their relationships with their friends, visitors and, more broadly, in relation to its Welsh environment.

The drawing room's pale blue wallpaper was often described by visitors as being 'adorned with charming landscapes, drawn and coloured from nature', with 'the most favourite spots in the vicinity being selected as subjects'.[22] Such images provocatively associated the house with the alluring views seen from its windows, rooting Plas Newydd's decoration to its surrounding landscape, thereby creating a space in which house and locale were closely aligned. Judith W. Page and Elise L. Smith have discussed this oscillation between interior and exterior, identifying the window as a transitional device that allowed 'the membranes of home and the garden to flow together'.[23] Echoing this, visitors' descriptions of Plas Newydd's drawing room consistently emphasize the affiliation between house, garden, and Welsh countryside, a connection mediated by the representation and exhibition of the drawn views of local landscapes that decorated its walls. The published travel accounts of both William Bingley and Henry Skrine commented on Plas Newydd's relation to its picturesque prospect, and other visitors frequently noted the evocative views seen from the drawing room's windows, particularly those of 'Castell Dinas Bran', which was conspicuously positioned at the top of a hill near to the cottage.[24]

This relationship was also a central part of the mythologizing that surrounded Butler and Ponsonby's rural retreat. The anonymous 'Story of Lady Eleanor Butler and Miss Ponsonby', published in 1830, reports that when communicating the history of their first trip to Llangollen, Ponsonby described how the party 'turned round to take a last look at this land of our promise; the setting sun was then shining on the romantic ruins of Dinas Bran, and its sloping beams gave to the wooded sides of the glens so lovely an aspect, that it seemed to invite our return; so we determined to go back and again search for a residence in the shadow of the mountains'.[25] Ponsonby's unpublished Welsh travel journal, written upon arrival from Ireland in 1778, affirms this narrative, describing her attraction to the 'the Beautifullest Country in the World', and its historic monuments such as Vale Crucis Abbey, when the pair were choosing a location for their future residence.[26]

Functioning as material testament to their fascination with the Welsh landscape and its monuments, Butler and Ponsonby gave and received drawings of Plas Newydd and its surroundings. In 1786, the pair sent 'Inscriptions of the Garden [...] and a Plan of our House', at the request of Queen Charlotte, whose own *cottage orné* was under construction at this time.[27] Likewise, Ponsonby sent Seward a drawn vignette of Plas Newydd, nestled within the surrounding

landscape, Dinas Bran visible in the background, for the frontispiece of her collection of poems *Llangollen Vale, with Other Poems*, in advance of its publication in 1796 (fig. 4.2).[28] Though Nicole Reynolds attributes such exchanges to Butler and Ponsonby's desire to accrue cultural and social capital for themselves and Plas Newydd, these transactions can also be profitably situated in relation to those drawings of Llangollen and the Welsh countryside within the house. Considered together, such images emerge as part of a Romantic culture of gifted landscapes that both constituted and reflected the women's relationships with their home, Wales, and their friends.[29]

Visitors' descriptions of the drawing room specifically stressed the gifted nature of these drawings. Katherine Plymley, for example, recorded that Butler and Ponsonby's friends had given the majority of the images to the pair.[30] Visiting

Figure 4.2 Sarah Ponsonby, frontispiece for Anna Seward, *Llangollen Vale, with Other Poems*, published by G. Sael, London, 1796. Author's copy and photograph.

the property in 1816, George Douglas elaborated upon this, noting that the drawings were mainly gifted by Henrietta Maria Bowdler (1750–1830), a view reiterated by Plymley, who herself identified one drawing 'hung over the chimney piece' and representing 'an inside view of Tintern abbey, drawn in crayons, beautifully tinted by Miss Harriet Bowdler', as particularly worthy of visitors' attentions.[31] Known as Harriet, Bowdler had maintained a faithful epistolary relationship with Butler and Ponsonby since meeting in around 1785, characterized by the exchange of drawings, poetry and transparencies, or paper illuminations, the latter of which were also displayed at Plas Newydd, or sent on to other friends such as Seward.[32]

Bowdler's own letters to the women establish the affective nature of these gifts, and their role in the memorialization of happy time spent with Butler and Ponsonby. On 6 April 1793, for example, Bowdler wrote to Ponsonby, describing how she looked 'at the little Drawing in my Day book, I read your precious letter and think of all the happiness I enjoyed with you and my own *Viellard* [Butler] during the most delicious days of my life, but at present I can only enjoy the pleasures of Memory'. She concluded with the following short poetic inclusion, aptly, an extract adapted from the second part of Samuel Rogers' *The Pleasures of Memory*:

> For Joy's bright sun has shed his waning ray,
> And Hope's delusive metre cease to play:
> While Clouds on Clouds the smiling prospect close.[33]

The preface to the 1834 edition of *The Pleasures of Memory* explains that Rogers' poetry was concerned with 'the pleasing melancholy' inspired by revisiting a place 'after a long absence'.[34] As such, Bowdler's quotation from the poem, particularly when read against her invocation of her examination of her drawings from Plas Newydd and her letters from Ponsonby, attests to the transportive nature of drawings and epistolary correspondence, here serving as tangible fragments of the place and the people Bowdler yearned to visit. Beyond their compliance with contemporary aesthetic trends such as the picturesque and the fashion for taking views while travelling, such images were deeply affective, and provoked, as for the antiquarian in his library, an imaginary context.[35] Furthermore, as their friend the writer Stéphanie Félicité, Comtesse de Genlis (1746–1830) identified, many of the remaining drawings that decorated the drawing room were executed by Ponsonby's own hand, which suggests that these gifted objects accorded with a prevailing visual culture that Butler and Ponsonby themselves had established.[36] Such exchanges therefore attest to the importance of drawing within a shared artistic culture enacted between Butler, Ponsonby and their friends: transactions

that embraced their mutual affection for the Welsh landscape and the memories that its image evoked. Representing shared scenes, landscapes and views, drawings of their home and the surrounding countryside symbolized visitors' experience of Plas Newydd, articulated through a collective form of artistic expression.

Beyond such affective provocations, Plas Newydd's surroundings also had a more quotidian significance within Butler and Ponsonby's social lives, one rooted in the communal enjoyment of the Llangollen landscape, and made permanent through the material use of fragments of that landscape and its ruined monuments within the decoration of their home. On 28 January 1788, Butler recorded a visit from her relative, Lady Anne Butler, in her journal: 'the home Circuit then showed her our Cottage. Walked in the Garden. Ordered the Hand Carriage close to the Abbey'.[37] As discussed further below, it was conventional for Butler and Ponsonby to take guests around the so-called 'Home Circuit', an ambulation that took in Plas Newydd's highly productive gardens. Here however, Butler's journal entry extends the route beyond the confines of Plas Newydd's grounds, linking a tour of their grounds with a trip to the local Valle Crucis Abbey, thereby directly relating the space of home and ruin.

By the 1790s, the Abbey was a crumbling edifice of half-standing columns and empty stone tracery.[38] A favoured locale of the women, Ponsonby wrote soon after their arrival in Wales in 1778 that the pair had gone 'on the afternoon to see the remains of an Abbey, call'd Vale de Crucis, two miles from Langollen', expressing her belief that 'There can Scarcely be imagined a more beautiful Situation than this Abbey by the River side & surrounded on all sides by Mountains'.[39] A number of guests toured the grounds of the Abbey with the pair. The Rev. J.H. Michell, for example, climbed Dinas Bran and visited Valle Crucis with the women following a breakfast taken together in 1795; while in 1821, Charles Octavius Morgan visited Valle Crucis with the women after a communal dinner at a neighbouring residence.[40] Images of the ruined Valle Crucis also proliferate throughout the scrapbook made by the young Lady Mary Leighton, the daughter of Butler and Ponsonby's friends, the Parkers of Sweeney Hall, which included a series of watercolour sketches produced as she and the women strolled through the grounds of Plas Newydd and the surrounding area (fig. 4.3). Leighton's sketches show not only how visits to Butler and Ponsonby's home naturally progressed into picturesque ambles amongst the Abbey's remnants, but also how these engagements with the landscape were deeply associated with the artistic cultures of Plas Newydd.[41]

The women also partook in a number of celebrations located between Valle Crucis and their home. On 20 August 1795, Seward described how she and the ladies drank tea and enjoyed 'a rural dinner given by their mutual friend Mrs.

'A little temple, consecrate to Friendship and the Muses' 149

Figure 4.3 Mary Leighton (née Parker), Watercolour on paper. DD/LL, 7. Letters from Sarah Ponsonby to Mrs Parker, Sweeney Hall, Oswestry, 1 vol. Courtesy of Denbighshire Record Office and Archive, Ruthin.

Ormsby, amid the ruins of Valle Crucis, an ancient abbey, distant a mile and a half from their villa'.[42] After dinner, the party returned to Plas Newydd, where, as Seward records in a letter to the Rev. Henry White of Lichfield, the group 'drank tea and coffee in that retreat, which breathes all the witchery of genius, taste, and sentiment', with the movement between these spaces highlighting how the parity between the ruined Abbey and Plas Newydd could be impressed upon participants' minds.[43] These intimate connections between the house and its

surrounding edifices are particularly salient when considering that fragments of stone, wood and glass collected from the ruined Abbey and other local monuments were used in the ornamentation of Butler and Ponsonby's home and gardens. In 1789, Butler described how the pair found and collected stone fragments from the grounds of their local church, where they discovered parts of a 'Mutilated Statue of Saint Cuthlin of which we already had some fragments' 'composed of the finest Alabaster'.[44] Likewise, Simpson's 1827 *Some Account of Llangollen*, noted that a 'carved stone brought from the Abbey Crucis' stood near the entrance of Plas Newydd's gardens.[45] The historic buildings that surrounded Plas Newydd therefore played a tangible role in the physical and emotional construction of Butler and Ponsonby's home. Like the painted and drawn landscapes of its surroundings, the collection and subsequent integration of materials from Plas Newydd's locality within the space of their home would have aroused memories of both the buildings themselves, as well as the social experiences enacted within them, marrying the materiality of the Gothic past with recently acquired memories of communal sociability.

This process of acquisition and integration can also be seen in the construction of the stained-glass windows of the house's library. Employing glass reputed to have been found at Valle Crucis, purchased from the Birmingham glass maker and painter, Francis Eginton, and likely donated by the women's friends, the windows form an intoxicating bricolage of brightly coloured and fragmented

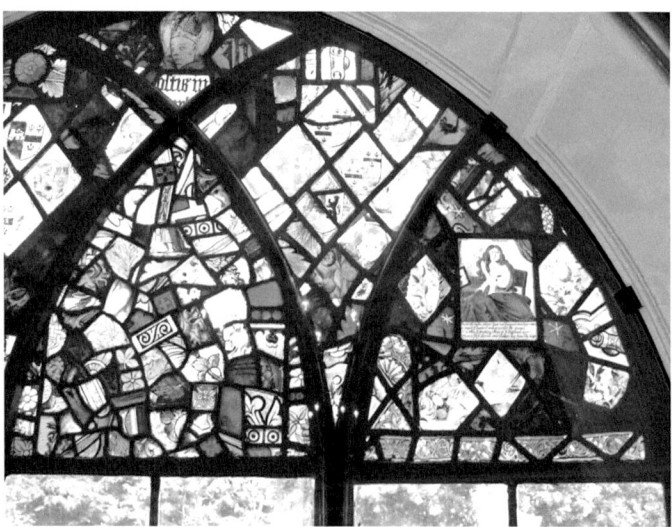

Figure 4.4 Stained glass windows, Plas Newydd, Llangollen, *c*. 1795. Photograph: author.

glass, an arrangement that included representations of biblical scenes, heraldry, foliate designs, abstract patterns, and block colour (fig. 4.4 and pl. 5).[46] In addition to fragments reputedly collected from Valle Crucis and sourced from Eginton, the glass which constituted the library windows also seems to have been gifted to the women by their friend, Mr Owen of Brogyntyn Hall.[47] On 21 November 1789, Butler noted receipt of a letter from a John Jones of Oswestry to inform them that Owen 'had given him directions to take down the Painted Glass' of his home of Brogyntyn Hall and had 'sent it to us with his compliments, which we are very glad of'.[48] By the Thursday of that week, Jones's servant had arrived at Plas Newydd from Oswestry, with 'a casement window of Painted Glass, the arms of Trevor, Owen, the Godolphin Family with their different Quarterings', with Butler recording this as a present from Mr Owen of Porkington.[49] Significantly, this gift was only part of a multifaceted exchange of objects enacted between Owen and the pair. Butler's journals record numerous gifts from the local landowner throughout the subsequent years, including a hare and a present of four sticks of black sealing wax in 1790, the donation of which prompted Butler to exclaim 'what a whimsical pleasant mortal he is!'[50]

While the preservation of this casement of historic glass panes painted with the coats of arms of various local families has obvious antiquarian significance, their relocation into the space of Plas Newydd built on this genealogical function to reinforce the relationship between donor and recipient. As such, the house's stained-glass windows function as a tribute to the thriving gift culture in which Butler and Ponsonby and their friends were implicated, while demonstrating the connectedness between themselves, their acquaintances, and their locale. With Owen's own arms preserved within the windows of Plas Newydd, these fragments of painted glass must have provided a constant reminder of, and intimation towards, their donor, much as the drawings of local landscapes possibly recalled shared experiences in the Welsh countryside, or indeed, how the numerous portraits and books also displayed within the library invoked absent friends and relatives through their visual and material representation.

Numerous visitors to the house also highlighted the gifted nature of Butler and Ponsonby's bibliographic collections. Following her tour of Plas Newydd in 1795, for example, Frances Ann Crewe noted that 'their Gothic Library […] is fitted up with pictures and drawings, painted glass, etc. […] their books are most of them the finest editions, not collected regularly but at different times for them by their Friends who have taken the opportunity of making them such presents of Choice Editions'.[51] Indeed, several of Butler and Ponsonby's correspondents refer to the honour of having a text placed within the pair's library. On 13 March 1796, the poet, Rev.

Leonard Chappelow wrote to Hester Piozzi asking her if she would mind if he gave his copy of *The Florence Miscellany* (1785) – a collection of sentimental poetry associated with the Della Cruscan movement, and featuring a preface by Piozzi – to Butler and Ponsonby, who could not purchase the book anywhere, remarking that 'The Book in their Custody would meet with an Apotheosis'.[52] Joseph Cooper Walker (the Irish antiquary and writer) also wrote to Piozzi, asking if she was 'acquainted with the Lady [Harriet Bowdler] who did me the honour to place my Memoir in Lady Eleanor's library'.[53] Such accounts reflect the fact than the inclusion of one's book within Plas Newydd's library was both a literary and sentimental privilege, a gift that, as Susan Staves has argued of the exchange of books more broadly, helped to 'construct literary and ideological circles'.[54] Within Plas Newydd's library, bibliographic objects such as published books, hand-written manuscripts and transcriptions of poetry were displayed and communally viewed within the same spaces as the portrait miniature, perhaps encouraging the connections between the display of portraits of absent loved ones with the verses that they themselves wrote.[55]

Emphasizing this material and metaphorical association, Seward described Plas Newydd's library as a

> saloon of the Minervas [containing] the finest editions, superbly bound, of the best authors, in prose and verse, which the English, Italian, and French languages boast, contained in neat verse: over them the portraits, in miniature, and some in larger ovals, of the favoured friends of these celebrated votaries.[56]

Here, Seward directly relates the portraits that decorated the library with the books that filled its shelves, revealing a consonant relationship that contributed to contemporaries' perceptions of the space of the library, and thereby, Plas Newydd more broadly, as one dedicated to friendship.

Visitors to the house's library consistently made reference to this collection of portraits, sadly dispersed in the 1832 house sale that followed the women's deaths.[57] The Rev. James Plumptre, for example, succinctly described the library as 'Gothic arches, Gothic painted windows, Aeolian harps, ornamented with pictures and portraits', while Plymley recollected that the library was decorated with a 'gothic chimney piece over which are several pleasing miniature portraits of some of their friends'.[58] An anecdote from Butler on 20 August 1788 records the acquisition of one such portrait: 'Breakfast over, we were agreeably surprised by the appearance of Butler [Eleanor's cousin] who told us his brothers Wandesford and James were coming, as they did while he was speaking, and brought with them his Picture beautifully done by Downman'.[59] Later that day, she described hanging Butler's miniature alongside portraits of Lady Anne Wellesley (the sister of Butler and

Ponsonby's close friend, Arthur Wellesley, the first Duke of Wellington), and another depicting Ponsonby's mother.[60] Presumably executed by the contemporary miniaturist John Downman (1750–1824), both the presentation of the miniature as well as its subsequent display, in a 'large oblong frame over the mantelpiece' with a number of other portraits, help us to understand how such gifted objects were assimilated into the decorative and emotional fabric of the home.[61]

Both Marcia Pointon and Hanneke Grootenboer have written extensively on portrait miniatures, stressing their materiality and sentimental functions.[62] In her article, 'Surrounded with Brilliants": Miniature Portraits in Eighteenth-Century England' (2002), Pointon cites a broad array of examples identifying the portrait miniature as a 'sentimentally invested artefact'.[63] Pointon also highlights that portrait gifts 'not only represent people [but] stand in their stead', a function demonstrated by Esther Milnes Day's poem *On a Father's Miniature* (1796). The poem addresses her father's portrait as follows: 'Come thou, sad substitute of him we mourn / Though gushing tears bedew his sacred urn / Time, precious trust, with guardian care I'll prize / Till I rejoin my father in the skies'.[64] Similarly, when in 1785, Edward Jerningham wrote to his niece Charlotte, he noted that 'my remembrance is too strongly rooted ever to be effaced by your being at a distance from me: your little waxen image, which hangs in full view, reminds me Every day of you'.[65] Accordingly, the placement of Butler's image amongst this sentimental hang of portraits was a symbolic gesture, reinforcing the notion that such images individually and collectively invoked Butler and Ponsonby's dynamic network of acquaintance, with this wall of affective images forming a locus of enacted and represented sociability for the women and their guests. Plas Newydd's collection of portraits constituted a complex web of familial and sentimental representations, including images of Lady Bradford, various members of Butler and Ponsonby's families, Lady Anne Wellesley, Madame de Genlis, and an image that was reminiscent of Seward's deceased stepsister, Honora Sneyd.

The latter image is a key example of how such portraits mediated the multifarious affective and material relations cultivated between Butler and Ponsonby and their friends. Given to the pair by Seward, the print, taken after George Romney's painting *Serena* (*c.* 1780, fig. 4.5), depicts the titular Serena, the heroine of William Hayley's mock-epic poem *The Triumphs of Temper* (1781).[66] Highlighting the mutability between portraiture and generic images, the image powerfully reminded Seward of Sneyd, so much so that the print played an active role in Seward's commemoration of the lost friendship. Beyond owning her own copy of the print, Seward repeatedly discussed its likeness with her friends, even sending a facsimile of the image to Butler and Ponsonby in 1797.[67] On 30 October of that year, Seward wrote excitedly to Ponsonby that she had been

fortunate enough in procuring another copy of Romney's *Serena*, which I mentioned to you as having accidentally formed a perfect similitude of my lost Honora Sneyd's face and figure [...]

The plate is now become so scarce, that fortune has singularly favoured my attempts. It was procured in the country, and will be sent to London to be framed [before] it travels to Langollen. The lively interest which you have each taken in her idea, excites my fervent wish that you should behold her as she was, in a lovely work of art, which recalls her image

'From the dark shadows of o'erwhelming years,
In colours fresh, originally bright.'

Seward continued by expressing her ambition that Sneyd's 'form should be enshrined in the receptacle of grace and beauty' that was Plas Newydd, appearing there as 'distinctly as those of Lady E. Butler and Miss Ponsonby'.[68] In the context of this narrative of lost intimacy, Seward's request that *Serena* might be included within the decorations of Plas Newydd is telling. By donating the image to her friends, Seward attempted to physically and emotionally (re)locate Sneyd within the space of Plas Newydd, an act that reinforces the poet's conception of the house as a literal shrine to friendship. In her discussion of her own version of the print, Seward described how she moved the image so that Sneyd's 'beauteous resemblance' was her 'constant companion'.[69] Identifying the print/portrait as standing in lieu of Sneyd's true presence, Seward wrote how it contributed 'to endear, as the bright reality endeared, in times long past, this pleasant mansion to my affections [...] and thus, whenever I lift my eyes from my pen, my book, or the faces of my companions, they anchor on that countenance, which was the sun of my youthful horizon'. Here, Seward compellingly conflates image and sitter, representation and represented, home and object, to assert the importance of such images in providing comfort to their possessors, highlighting the affective potential of *Serena* and the impetus for its distribution to Butler and Ponsonby.[70]

Importantly, Seward's gift of *Serena* imaginarily and materially conjoined the space of her Lichfield home with that of Plas Newydd. Following their receipt of the print in June 1798, Seward wrote to Butler and Ponsonby to discuss her own use of the image, recalling how, according to her 'annual custom', she moved the print from her sitting-room to her 'little embowered book-room'.[71] Seward's placement of Sneyd's image in her 'book-room', or library, was one of apposite circularity, suggestively connecting the location of her image, with that in which she perhaps envisioned *Serena* residing at Plas Newydd, nestled amongst the room's wall of affective images. As a gift, *Serena* empowered Seward to actively

'A little temple, consecrate to Friendship and the Muses' 155

Figure 4.5 John Raphael Smith, after George Romney, *Serena*, London, 1782. Mezzotint on paper. Courtesy of the Victoria and Albert Museum, London.

ruminate and comment upon her relationships with Sneyd, Butler and Ponsonby, and more broadly, with the space of Plas Newydd, revealing how she conceived of the house as a space dedicated to the preservation of sentiment in material form, and her own desire to harness this commemorative function.

En masse, the gifted objects displayed within the library and drawing-room, reaffirm the narratives of intimacy, friendship and affection that the house as a whole tells – with each referring to a specific experience, idea or emotion, shared between donor and recipient. This integration between house and object emphasizes the crucial role played by the gift in the construction of Butler and Ponsonby's space, and, by extension of this, their utopian ideal of feminine retirement. However, as illustrated below, such exchanges were not only central to Plas Newydd's construction, but its physical and ideological dissemination. Through gifts of food and flowers from its grounds, Butler and Ponsonby played upon this material commemoration of a moment shared at Plas Newydd, directly referencing time spent there through the flow of objects given to their intimates.

'Pledges of an highly-prized friendship'[72]

As well as receiving the multiplicity of gifts discussed above, Butler and Ponsonby reciprocally gifted objects from Plas Newydd's grounds, gardens and interiors to call to mind the social interactions shared between the women and their guests. In a series of complementary transactions that harnessed the visual spectacle of the Home Circuit and exhibited the fecundity of their estate, the women's friends, relatives and visitors, often ate and received gifts of produce made or grown at Plas Newydd. Embedding fleeting temporal moments within a more enduring form of materiality, such gifts might encourage indulgent retrospection of time spent together long after Butler and Ponsonby's guests had left their home.

On 30 April 1788, Butler recorded the activities of a typical day spent at Plas Newydd with Ponsonby:

> Rose at six. Enchanting Morning – My Beloved and I went the Home Circuit. The Morning So heavenly Could not leave the Shrubbery 'till Nine. Breakfast. Half past Nine till Three – again went the home Circuit, how Splendid, how heavenly. Came in for a few Minutes to Write, went out again. Staid till one. Reading, drawing, then Went again to the Shrubbery, brought our Books namely *Gil Blas* and Madame de Sévigné with us [...] Such a heavenly evening, blue sky with patches of Cloud Scattered over it. My beloved and I went to the Shrubbery. Spent the Evening there. Brought our Books, planted out our hundred Carnations

in different parts of the Borders. Heavenly evening. Reading. Writing. Nine till One in the dressing room. Reading. A day of such Exquisite Such enjoyed retirement. So Still. So silent.[73]

Featuring transitions between interior and exterior, house and garden, this account of Butler and Ponsonby's day notes that they 'went the Home Circuit' twice throughout its course.[74] An activity which appears almost daily within Butler's journals, the Home Circuit encompassed a walk around Plas Newydd's garden, fowl yard, drying green, kitchen garden and melon bed, as well as its stable and dairy. The layout of their grounds and the promenade around them accorded with the contemporary designs for shrubberies as advocated in texts like Henry Phillips's *Sylva florifera: the Shrubbery Historically and Botanically Treated* (1823), copies of whose tracts were owned by Butler and Ponsonby.[75] As delineated by Phillips, each route around the garden 'should lead to some particular object; to the orchard, kitchen garden, botanical borders, green-house, dairy, ice-house, mushroom hut, aviary, poultry house or stables', with the overall 'intention of the plantation [...] to be to conduct the walker in the most agreeable manner to each outlet and building of utility or pleasure', thereby resulting in a carefully orchestrated promenade through the grounds.[76]

Functioning as a continuation of the tours of Plas Newydd's public interior spaces, it was customary for guests to accompany the women as they progressed around the Home Circuit. In June 1789, for example, Butler noted that she and Ponsonby had '*ran* the Home Circuit with the Barretts and Miss Wynne' who were obliged to take this compulsory tour of the grounds.[77] Demonstrating Butler and Ponsonby's horticultural and agricultural prowess, the tour of the Home Circuit exhibited both the women's ornamental skills such as in garden design and planting, as well as their accomplished household management – much like that observed by Lybbe Powys while visiting Lady Leicester's dairy at Holkham Hall, discussed in Chapter 1.

As the walk passed through mushroom and melon beds, a kitchen garden verdant with cucumbers, potatoes, onions, endive and celery, and banks laced with blue campanula and strawberries, the tour of the Home Circuit palpably evinced the fertility of their estate. In addition to Butler and Ponsonby's hospitality within the cottage itself, this abundance was ratified materially through gifts exchanged between the women and their visitors, which also included plants and produce grown at the house. In an undated letter to their friend Harriette Piggot, for example, Butler asked

> when will you come and eat with *us*. Ill give you a bill of Fare. For breakfast you will have a Couple of new laid Eggs from our Jersey Hens [...] Your dinner shall

be boil'd chickens from our own Coop. Asparagus out of our garden. Ham of our own Saving and Mutton from our own village. Your Supper Shall consist of Goosberry Fool. Cranberry Tarts roast Fowl and Sallad. don't this Tempt you.[78]

Emphasizing the bounteous 'cottage industry' of Plas Newydd, Butler stressed the home-grown nature of the produce that Piggot could expect to enjoy as a visitor to the house: from freshly laid eggs, to chicken reared in their fowl yard; home-preserved ham; and locally-bred mutton. Such impressive claims were echoed in a letter from Ponsonby to her friend Sarah Tighe written on 20 June 1803, which similarly boasted that 'Our Gardens are overflowing with Green Peas and Strawberries, and Our Dairy with Butter'.[79]

Underscoring the connection between the industrious nature of Plas Newydd and the gifts given to the women's friends, in 1787, Ponsonby wrote to Tighe to alert her to their 'profusion of wonderful fine Goose and Raspberries' and their accordant desire 'to make some giam – or jam' to send to her.[80] As noted in Chapter 1, gifts of food items were common throughout this period; an exchange that relied upon the impressive potential of the fruits of one's estate and other such produce to demonstrate the high regard in which the sender held the recipient. Contemporaries were sent oranges, cheese, strawberries, geese, figs, oysters and ham, with the latter's fine qualities seen as directly conveying 'the Heart of the dear Giver'.[81] Butler and Ponsonby both gave and received a number of gastronomic or botanical presents, many of which used the produce and floral riches of Plas Newydd to provide their acquaintances with a shared reminder of time visiting their home.[82]

A number of recent texts, such as Stephen Bending's *Green Retreats: Women, Gardens and Eighteenth-Century Culture* (2013), have discussed women's engagements with botany and domestic landscape cultivation throughout the eighteenth and early-nineteenth centuries. Focusing on the construction of the garden as a designed whole, the significance of the garden's constituent elements has been comparatively overlooked.[83] However, as the botanical exchanges enacted by Butler and Ponsonby and their contemporaries discussed below attest, the garden also operated on a much smaller scale, on the level of individual plants, which could be dissected and disseminated beyond the physical space of the garden.

Writing to the Rev. H. White of Lichfield following her first visit to Plas Newydd on 30 November 1795, Seward told him that she was 'happy to find, *through floral correspondence*, that my dear friends, on their beauteous mountain, were recently well and cheerful'.[84] The 'floral correspondence' to which she referred was 'a bounteous present of fruit-trees', given to Seward by Butler and Ponsonby, that she would eventually describe as 'the pride of my garden […] the

pledges of an highly-prized friendship'.[85] Such objects had significance beyond their immediate status as gifts. As with Valle Crucis Abbey, Plas Newydd's gardens were often used as the location of their sociable engagements, an association that would inevitably imbue the gifted plants with memories of the house and its owners. On 16 June 1790, Butler recorded dining 'under the shade of the Lime Tree by the door', a situation that was replicated in July 1813, when Butler and Ponsonby provided 'Dinner under the Trees for all our kind neighbours – More than thirty'.[86] Accordingly, the gift of fruit trees was underscored by the social occasions shared between their friends while at Plas Newydd, from the sensory experience of walking the Home Circuit, to enjoying the literal fruits of its production in the company of Butler and Ponsonby themselves.

Like gifts of food, the exchange of plants, flowers and botanical literature was common throughout the period. The sentimental writers Charlotte Smith and Milnes Day both wrote poetical accompaniments to floral presents, while in 1793, Anne Damer sent Mary Berry a 'grove of Lavender plants' unearthed from her familial home, Park Place, a residence discussed further in the final chapter of this book.[87] The implication of plants within the act of exchange left an indelible trace upon them, allowing them to subsequently act as material testament to the affective ties shared between friends. Exemplary of this process is a letter written from Elizabeth Carter to her close friend Elizabeth Montagu in October 1769, in which she told her correspondent that she still had 'the nosegay you gave me at parting, and I contented myself with kissing the roses and myrtles because they had belonged to you, and by this pleasure solaced myself'.[88] As Page and Smith have written of the late eighteenth-century garden, it was often 'constructed by women writers and artists as an idyllic realm, imbued with nostalgia and memory'.[89] Beyond their demonstration of Plas Newydd's fecundity then, the house's gardens were a highly evocative space, ideologically constructed within and around ideas of friendship and intimacy.

Seward herself extolled the virtues of Plas Newydd's kitchen garden in her letter to White, describing it as 'neatness itself', abounding with fruit-trees of 'the rarest and finest sort [...] luxuriant in their produce'.[90] Plas Newydd offered Seward, who has been termed an 'environmental writer' on account of her commitment to natural spaces and their preservation, a space irresistibly presented as a utopia of careful female cultivation, situated within a 'luxuriant Vale', whose inhabitants judiciously cultivated 'Coy Nature's charms', and whose horticultural spoils thereby materialized Butler and Ponsonby's dedication to a landscape that would be otherwise left unprotected against the horrors of modernization.[91]

In addition to Seward, Butler and Ponsonby also maintained a longstanding 'floral correspondence' with their friends Thomas Netherton Parker and his wife Sarah, of Sweeney Hall in Oswestry, a relationship in part facilitated by their shared interests in botanical specimens and horticultural techniques.[92] An invitation to dinner at Plas Newydd dated 19 August 1811, was accompanied with a request to 'let a Cutting of the *Cobbea Scandens* [sic] – rooted or not – occupy a little corner of your Carriage' on their way over to the house, a gift they had received from the couple once before.[93] A gift of 'Seeds of the *Cytisus Nigricans* – One Pod of the *Parrey* – whose proper name I will not pretend to assign – Another of the *Hemerocallis Caerulea* and some seeds of the *Catananche Caerulea*' or Cupid's Dart, was a present to the Parkers in the following October, accompanied by a letter from Ponsonby that expressed their 'Wishes that their progeny may flourish through many Generations'.[94] This gift was itself a response to the Parkers' own offering, a 'Splendid & valuable Collection of Plants', that Ponsonby worried may perish in the forthcoming Winter months. However, as she assured their donators, 'If they die [...] Our Gratitude will not. And we hope you will come long before the cold Weather does'.[95] The women and the Parkers also exchanged lettuce, cabbage, potato and broccoli plants, roses, lilies and cuttings of *Asclepias Carnosa*; transactions which reveal the multifarious technologies of gift culture during this period – functioning variously as the fulfilment of obligations, as bribes, and, perhaps most significantly, as the motivation for future sociability.[96]

In a letter dated 24 November 1818, Ponsonby asked another of their friends, Mrs. Williams, of Gwersyllt Park, to present 'Our particular agenda of compliments to Miss Currie with Our thanks for the *Lupinus Arboreus*', before expressing their desire for Currie to return to their home, in order show 'her how carefully her Gift was attended to'.[97] Seward likewise sought to assure the pair that her husbandry would be just as careful as their own. Writing that she would not 'fail to watch the Brocus Bergamot pear-tree, in [her] garden-wanderings', she expressed doubt in her horticultural capabilities and the poor quality of her soil – a defect that she was no longer happy to endure, now that 'that your and lady Eleanor's bounty have annexed, in my ideas, vegetation and sentiment'.[98] Such assurances of careful maintenance however, did not merely refer to the cultivation of the gifted plants, but functioned more broadly as a metaphor for how the friendship shared between donor and recipient would be similarly nurtured throughout its duration. Evocative of both the sociability enacted at Plas Newydd, and the enduring nature of friendship in the face of estrangement, such objects exploited their associations with both Butler and Ponsonby and the space of their home and gardens, annexing – to employ Seward's phrasing – recipient's sentiments to ensure a lasting bond between them.

The botanical exchange enacted between Butler and Ponsonby and Mr and Mrs Parker also attested to interactions between cultural forms during this period. Cuttings and seeds were frequently accompanied by non-botanical gifts such as an inkstand, a hand embroidered work-box, pincushions, a turkey and literary productions, including poetry composed by Butler and Ponsonby's friend, Mrs Tighe, as well as botanical literature. Furthermore, such complementary gifts could shape recipients' conceptions of the objects they had previously received. On 16 December 1809, Ponsonby wrote to Parker, telling her that they 'now possess[ed] – from Mr Lackington – a Very good set of *Curtis's Botanical Magazine* from its Commencement to this present [...] year'.[99] Described by Theresa M. Kelley as the 'botanical industry of the Romantic period in microcosm', the *Magazine* was begun in 1787 by William Curtis, who employed a series of engravers to produce the botanical illustrations for which the publication was famed.[100] Upon receiving the volumes from Lackington, Ponsonby recalled perusing the '1100 representations' that the publication exhibited, describing to Parker how their gratification was increased, when upon inspection of the texts, they realized what 'a Magnificent Gift' that the couple had 'enriched us with in the *Cobbea Scandens* [*sic*] – whose Flower we were before unacquainted with'.[101]

When, in the following years, Butler and Ponsonby reciprocated with their own 'Magnificent Gifts' to the Parkers, the seeds which comprised their packages accordingly featured plants that had appeared in recent issues of *Curtis's Botanical Magazine*, including the *Cobaea Scandens* (Vol. 22, 1805), *Hemerocallis Caerulea* (Vol. 23, 1805), *Catananche Caerulea* (Vol. 9, 1795) and the *Asclepias Carnosa* (Vol. 21, 1804), demonstrating how gifts from different donors could intersect on both intellectual and emotional levels, with the knowledge gleaned from one gift, deepening the understanding and import of the other.[102] Such transactions highlight the interactions between material culture, written text, visual representation and epistolary correspondence that typified gift-exchange during this period, affirming that Plas Newydd's gift culture comprised a complex web of corresponding gestures.[103]

A key example of these 'gift relationships', was Butler and Ponsonby's cutting of the *Asclepias Carnosa*, gifted to the Parkers on 29 October 1811, which was sent alongside 'a little manuscript extract' of a poem by the poet Robert Southey, composed following his visit to Plas Newydd earlier that year.[104] In Ponsonby's accompanying letter, she stressed that the poem had been composed under the roof of Plas Newydd, where Mrs Parker had apparently met Southey, while he was visiting the pair.[105] Taken together, this gift comprised an evocative combination of objects. Encompassing a fragment of poetry composed at Butler

and Ponsonby's home, and a flower similarly germinated there, it constituted a gifted *part* of Plas Newydd: a physical specimen, cut from its grounds, that, through an accompanying poetical representation of the house, materially reinforced the intimate social interactions that Butler and Ponsonby, the Parkers, and Southey had shared within the space of their home.

Beyond serving as a reminder of mutually enjoyed sociability, such gifts provided Butler and Ponsonby's friends with a chance to emulate, albeit only in part, the material experience of Plas Newydd. Reminiscent of the process of replicative translation discussed in Chapter 3, the fruit trees given to Seward afforded her the opportunity to grow her versions of the trees she had so enjoyed viewing at Plas Newydd within the space of her own garden at Lichfield.[106] Writing to both Ponsonby and Butler in April 1798, Seward transcribed the evocative prospect unfolding before her:

> a summer's sun warmly gilds the fields, the gardens, and the groves, now diffusing fragrance, and bursting into bloom. French and undulating breezes from the east lured me into my drawing-room, having placed in its lifted sash the Æolian harp. It is, at this instant, warbling through all the varieties of the harmonic chords.
>
> [...] Till this spring, it was shrubbery to the edge of the grassy terrace on its summit; but I have lately covered it with a fine turf, sprinkled with cypresses, junipers, and laurels. It is bordered on the right hand by tall laburnums, lilachs, and trees of the Gelder rose.[107]

The letter directly recalls Seward's first description of Plas Newydd, written in 1795, in which she described the 'shrubbery of tall cypress, yews, laurels, and lilachs' of Plas Newydd's garden, viewed against the sound of 'the airy harp loudly rung to the breeze', whose melody 'completed the magic of the scene'.[108] Drawing heavily on this original epistolary invocation of this first visit, Seward's depiction of the sights, scents, and sounds furnished by the grounds of her Lichfield home presents an evocative reconstruction of those at Plas Newydd, from the mirrored planting of her garden, to her harp, built on the model of the famed Æolian harp housed within the women's home, both of which were facilitated by gifts from Butler and Ponsonby.[109]

The pair's harp was afforded a crucial role in Seward's poem *Llangollen Vale*, in which she uses the instrument to establish a mood appropriate to the 'fairy palace' of Plas Newydd:

> What strains Æolian thrill the dusk expanse,
> As rising gales with gentle murmurs play,
> Wake the loud chords, or every sense entrance,
> While in subsiding winds they sink away!

Like distant choirs, "when pealing organs blow,"
 And melting voices blend, majestically slow.

"But ah! what hand can touch the strings so fine,
 "Who up the lofty diapason roll
"Such sweet, such sad, such solemn airs divine,
 "Then let them down again into the soul!"[110]

Played by the wind's breezes passing over its strings, the Æolian harp had become a popular household instrument during the late-eighteenth century, and was eulogized in poems by Samuel Taylor Coleridge and Percy Bysshe Shelley.[111] Originally located in the pantry of Plas Newydd, Butler and Ponsonby had owned an Æolian harp since at least 1789, when they described it as having a 'sublime and delightful effect'.[112] Several writers visiting Plas Newydd extolled its wonders, having been seduced by its haunting music and eventual placement on the library windowsill, where it framed a prospect of the ruins of the nearby Dinas Bran. George Cumberland, for example, described how 'the harp's merry tinkling cheer'd the soul' at 'Matchless Llangollen', while de Genlis described at length an enchanting, if restless, night spent listening to its song while lodging in Plas Newydd's library during her visit to the house.[113]

Like the kitchen garden and its bounteous fruit trees, Seward described the Æolian harp in her letter to White, citing, as she eventually would within *Llangollen Vale* itself, lines from James Thomson's *Castle of Indolence* (1748).[114] Seward's letter affirms the deep impression made upon her by Butler and Ponsonby's harp, an impact ratified materially by her own acquisition of such an instrument in the following year. Writing to a friend in 1796, Seward discussed her Æolian harp, reminding her friend how she had spoken often of her 'purpose to have an Æolian harp, made upon the construction of Miss Ponsonby's, mentioned in my poem, Langollen Vale'.[115] 'Made upon the construction' of Butler and Ponsonby's own harp, Seward's was a literal replication of that she had seen (and heard) at Plas Newydd, made to the specifications provided by 'an exact drawing' gifted to her by Ponsonby, and which she hoped would once again 'awaken those rich harmonies, which so divinely stole upon my ear amid the Vale of Langollen'.[116] Viewed in relation to Seward's declining health, her self-evident and self-conscious reproduction of aspects of Plas Newydd and its gardens, as well as her knowing epistolary communication of this imitation to Butler and Ponsonby, constitutes a particularly poignant act. Her decline into infirmity permitted only one more visit to the house in 1802, taken just a few years before her death in 1809.[117]

As noted above, previous examinations of Plas Newydd's gift culture have generally focused upon Butler and Ponsonby's circulation of likenesses of their home. However, exchanges such as those shared between Butler, Ponsonby, Seward and the Parkers, suggest that it was not merely representations of Plas Newydd that were circulated, but parts of it; relic-like objects that not only conveyed Butler and Ponsonby's high regard for their friends, but also their own affection for the women and their property. Moreover, such exchanges clearly show that Plas Newydd's gift culture was far more than a 'private gift economy' that implicitly promoted and defended their atypical domestic arrangements. Instead, this network of material interactions must instead be identified as a broader cultural project, a network of Romantic friendship that encompassed memorialization, the materialization of affection and literary and poetic exchange.

Conclusions

As demonstrated by the exchange enacted between Butler, Ponsonby and Seward in particular, the flow of objects from and into Plas Newydd was characterized by a number of coactive cultural transactions. Following Seward's first visit to the house in 1795, the relationship between the three women encompassed broad array of material and sentimental exchanges. From the fruit trees identified as 'pledges of an highly prized friendship' to the drawings of Plas Newydd's Æolian harp, Butler and Ponsonby's gifts to Seward commemorated the time they spent together within their home, while facilitating Seward's own replication of this aesthetic and aural experience within a space of her own. Reciprocally, Seward's gift of *Serena*, and her eulogization of Butler and Ponsonby's home in the poem *Llangollen Vale*, constituted affective and intellectual transactions, echoing the modes of display and types of material forms collected and created within Plas Newydd. Each of these exchanges unified the women within a 'Romantic friendship' that transcended geographical, generic, and temporal boundaries, serving to materialize the intimacy enjoyed by the women.

In his 2004 article 'Accumulating Being', Greg Noble identifies collecting as the 'cumulative dimension of subjectivity', 'a complexity of "being in the world" that entails more than discrete statements of identity' but 'embraces the location of subjects in networks of relationships, objects and spaces'.[118] Building on the notion of a 'cumulative self', Noble promotes the idea that

the senses of self [...] function as layers of a more complex being, layers that operate fundamentally as connections to others [...] Our domestic objects, especially those prized possessions we maintain for years, constitute key resources in the ways in which we go about objectifying the complexity and continuity of our selfhood and its relatedness to others, retaining these in the objects and spaces of our everyday environments.[119]

As Noble argues, collections are not merely personal assortments of material culture, but provide a nexus or means by which to engage with wider social or cultural contexts in which the subject resides. Plas Newydd, a locus for social and cultural interaction, was filled with the material traces of these wider contexts in the form of gifts. Forming a crucial part of their encompassing decorative scheme for Plas Newydd, Butler and Ponsonby's collections acted as promoters of the shared intimacy, connectedness, and a communal aesthetic sensibility that was fostered amongst its owners and visitors alike. Crucially though, and as Butler and Ponsonby's gifted fragments of Plas Newydd suggest, this cultural transaction was reciprocated and mirrored within the homes of their friends. Butler and Ponsonby's collection of sentimental gifted objects found its echo in that of Seward and the Parkers, where, in a provocative resonance of Plas Newydd, we can imagine that they too installed objects that could remind them of the sights, sounds, and feelings of Llangollen.

As shown by the gifts of botanical specimens, portraits, books and stained glass discussed above, the exchange of images, texts and objects at Plas Newydd constituted a form of circulation that evoked shared experience. Such gifts related space and place with intimacy and friendship, a relationship suggested by the landscape images displayed within Plas Newydd's drawing room, Seward's replication of Plas Newydd within her own home and garden, and ultimately, contemporaries' view of Butler and Ponsonby's home as 'consecrate[d] to Friendship'. Furthermore, the gift relationships prompted by this exchange of objects also encouraged fluidity between forms of culture themselves. Encompassing quotidian objects such as food, plants, and livestock, as well as cultural objects such as books, portraits, and drawings, the very array of items exchanged between Butler and Ponsonby and their friends encourages a deprivileging of 'high' forms of culture over 'low'.

This chapter has shown the centrality of exchange in creating these relations. With gifting characteristic of the broader materialization of affection during this period, at Plas Newydd, the exchange of material culture produced gift

relationships that used a wide variety of objects to construct relations based on shared memories, experiences and affections. For Butler and Ponsonby, these relationships were central to their conception of both their communally constructed subjectivity, and the very home in which they lived. While several scholars have identified Plas Newydd as creating 'a space for the expression of a sexual identity that might today be called lesbian', Butler and Ponsonby's home was more than just an expression of their socio-sexual difference.[120] Far from the exclusive, homosocial world of intensive one-on-one 'romantic friendship', Plas Newydd was in fact the locus of a thriving aesthetic and cultural community, a space of 'Romantic friendship', whose very decoration referred to the experiences shared between its owners and their guests.

Notes

1 Anna Seward, *Letters of Anna Seward: Written between the Years 1784 and 1807*, 6 vols. (Edinburgh: George Ramsay & Company, 1811), 4: 120. For a full biography, see Elizabeth Mavor, *The Ladies of Llangollen: A Study in Romantic Friendship* (London: Penguin Books, 2001).
2 Seward, *Letters*, 4: 120.
3 Rev. J.H. Michell, *The Tour of the Duke of Somerset, and the Rev. J. H. Michell, through parts of England, Wales, and Scotland, in the year 1795* (London: R. Clay, 1845), 20–1.
4 Mavor, *The Ladies of Llangollen*, xvii. Terry Castle, *The Apparitional Lesbian: Female Homosexuality and Modern Culture* (New York: Columbia University Press, 1993), 93. I follow Judith M. Bennett's useful term 'lesbian-like', which she describes as including 'women whose lives might have particularly offered opportunities for same-sex love; women who resisted the norms of feminine behaviour based on heterosexual marriage; women who lived in circumstances that allowed them to nurture and support other women', and which therefore circumvents the problematic questions of 'genital sexuality' versus 'romantic friendship'. Judith M. Bennett, *History Matters: Patriarchy and the Challenge of Feminism* (Manchester: Manchester University Press, 2006), 110.
5 Fiona Brideoake '"Extraordinary Female Affection": The Ladies of Llangollen and the Endurance of Queer Community', *Romanticism on the Net*, Special Issue: Queer Romanticism, 36–7 (November 2004, February 2005), para 5. For a discussion of the idea of 'romantic friendship', see Lilian Faderman, *Surpassing the Love of Men: Romantic Friendship and Love Between Women from the Renaissance to the Present*, (Virginia: Women's Press, 1981).
6 Seward, *Letters*, 4: 120.

7 For a critique of 'romantic friendship', see Castle, *The Apparitional Lesbian*, 92–5.
8 Brideoake, '"Extraordinary Female Affection"', para 6.
9 John Worthen, *The Gang: Coleridge, Hutchinson and the Wordsworths in 1802* (New Haven & London: Yale University Press, 2001). Jeffrey Cox, *Poetry and Politics in the Cockney School: Keats, Shelley, Hunt and their Circle* (Cambridge: Cambridge University Press, 1998).
10 Brideoake, '"Extraordinary Female Affection"', para 5.
11 Mavor, *A Year*, 179; G.H. Bell (ed.), *The Hamwood Papers of the Ladies of Llangollen and Caroline Hamilton* (London: Macmillan & Co. 1930), 60; Letters from Sarah Ponsonby to Mrs. Parker, Sweeney Hall, Oswestry, DD/LL, 7, 1809–16, 7. Denbighshire Record Office, Ruthin. Mavor, *A Year*, 183. Ibid., 48. Bell, *The Hamwood Papers*, 82. Seward, *Letters*, 4: 107. Mavor, *The Ladies of Llangollen*, 129.
12 Lewis Hyde, *The Gift: Imagination and the Erotic Life of Property* (New York: Vintage Books, 1983), xv.
13 Ann Ambler, Ambler Letters, MS 206, 1760–1788, Cadbury Research Library, University of Birmingham, Birmingham. Likewise in 1777 she wrote again to Ibbetson, 'Your kindness and affection *appear* in every line & give me infinite pleasure. They are I assure you deeply engraved in my Heart where I doubt not but they will ever remain tho not legible to Mortal Eyes'.
14 Ibid., 1774.
15 Nicole Reynolds, *Building Romanticism*, 94, 95 and 96. Castle likewise highlights Butler and Ponsonby's management of their image, referring to it as their 'public relations campaign'. *The Apparitional Lesbian*, 93. In Brideoake's recently published book on Butler and Ponsonby, she mentions their gifting only briefly. Fiona Brideoake, *The Ladies of Llangollen: Desire, Indeterminacy, and the Legacies of Criticism* (Lewisburg: Bucknell University Press, 2017), 103–4.
16 Sarah Haggarty, *Blake's Gifts: Poetry and the Politics of Exchange* (Cambridge: Cambridge University Press, 2010), 3.
17 Ibid., 190.
18 Elizabeth Eger, 'Paper Trails and Eloquent Objects: Bluestocking friendship and material culture,' *Parergon*, 26, no. 2 (2009): 113.
19 Ibid.,110 and 113.
20 *The Cliff of Worcester, The Cambrian directory, or, cursory sketches of the Welsh territories* (Salisbury, 1800), 150. While it is possible that intimates may have been shown more rooms of the property than just the library and drawing room, even Butler and Ponsonby's close friends seem to focus their accounts on these rooms, perhaps indicating that these were the most evocatively furnished.
21 Cunningham, '"An Italian house is my lady"', 67.

22 *La Belle Assemblée*, 1 September 1808. *The Cambrian directory*, 150. The Rev. James Plumptre recorded the following impression: 'Parlour (as well as library) plain blue paper, ornamented with views about Llangollen'. Ian Ousby (ed.), *James Plumptre's Britain, The Journals of a Tourist in the 1790s* (London, 1992), 80–1. Such works corresponded with the contemporary fashion for 'taking views' from landscapes while travelling. For example, Esther Moir notes that hire-boats on the River Wye were equipped with 'a convenient table for drawing or writing'. Moir, *The Discovery of Britain: The English Tourists 1540–1840* (Abingdon & New York: Routledge, 2013), 125.

23 Judith W. Page and Elise L. Smith, *Women, Literature, and the Domesticated Landscape: England's Disciples of Flora, 1780–1870* (Cambridge: Cambridge University Press, 2011), 123.

24 William Bingley, *A tour round North Wales, performed during the summer of 1798: containing not only the description and local history of country, but also, a sketch of the history of the Welsh bards*, 2 vols. (London: J. Smeeton, 1800), 2: 170. Henry Skrine, *Two successive tours throughout the whole of Wales, with several of the adjacent English counties; so as to form a comprehensive view* (London: Elmsley & Bremner, 1798), 241.

25 *Freeman's Journal and Daily Commercial Advertiser*, Dublin, 12 January 1830.

26 Sarah Ponsonby, *A Journey in Wales*, MS 22967C, 1778, 89. National Library of Wales, Aberystwyth.

27 Mavor, *The Ladies of Llangollen*, 109.

28 Seward, *Letters*, 4: 142.

29 On the relationship between gender, Romanticism, and the landscape, see Jacqueline M. Labbe, *Romantic Visualities* (Basingstoke: Macmillan Press Ltd. 1998).

30 Katherine Plymley, Journal, 567/5/5/1/1, 1792, Shropshire Records and Archive Centre. For a discussion of amateur drawing during this period, see: Kim Sloan, *A Noble Art: Amateur Artists and Drawing Masters 1600–1800* (London: British Museum Press, 2000); Ann Bermingham, *Learning to Draw: Studies in the Cultural History of a Polite and Useful Art* (New Haven & London: Yale University Press, 2000).

31 G.L.A. Douglas, 'Observations made during a tour in Wales and different parts of England', 1806, MS 10349, National Library of Scotland, Edinburgh (*c.* 1816). Plymley, Journal.

32 Mavor, *The Ladies of Llangollen*, 89. Ousby, *James Plumptre's Britain*, 5: 392.

33 Mavor, *A Year*, 83.

34 Samuel Rogers, *Poems by Samuel Rogers* (London: T. Cadell, 1834), 17.

35 For the 'imaginary contexts' conjured by the English library during this period, see Viccy Coltman, 'Classicism in the English library: Reading classical culture in the late eighteenth and early nineteenth centuries', *Journal of the History of Collections*, 11, no. 1 (1999): 36.

36 *La Belle Assemblée; or, Bell's Court and Fashionable Magazine*, 1808. On landscape drawing as a cultural practice, see Bermingham, *Learning to Draw*.
37 Eleanor Butler, Journal, MS 22971C, 1788–91. National Library of Wales, Aberystwyth.
38 John Ferrar, *A tour from Dublin to London in 1795* (Dublin, 1796), 19.
39 Ponsonby, *A Journey in Wales*, 89.
40 Michell, *The Tour of the Duke of Somerset*, 20–1. D. Morgan Evans, 'Octavius Morgan: journal of a tour through North Wales in 1821', *Archaeologia Cambrensis*, 160 (2011): 235–63. Even when alone Butler and Ponsonby spent much of their time wandering around the Abbey's ruins. On 19 June 1789 for example, Butler recorded 'the evening being Beautiful we walked to the Abbey' in her journal. Mavor, *A Year*, 116.
41 DD/LL, 7, Sarah Ponsonby to Sarah Parker (1809–16).
42 Seward, *Letters*, 4: 90.
43 Ibid., 4: 153. Similarly, Plumptre recorded sitting down amongst 'a party of 12, to a most elegant and social meal' in a pasture near to Plas Newydd. Ousby, *James Plumptre's Britain*, 162–3.
44 Mavor, *A Year*, 127.
45 W.T. Simpson, *Some Account of Llangollen* (1827), 192. Mavor also notes that a 'a font, purloined from the ruins of Valle Crucis abbey', was placed in Plas Newydd's gardens, where it was 'allowed to develop romantic accretions of fern and moss'. Mavor, *The Ladies of Llangollen*, 107.
46 *Plas Newydd: A brief history* (Denbigh: Denbighshire County Council, 2003), 14.
47 On Friday 8 January 1790, Butler records in their expenses the 'Prices for Stained Glass – Blue, Green, Purple 5/6 per lb. – Yellow 7/6 – Orange 11/7 – Deep Red 13/6 – made by Eginton Soho (Square) Birmingham'. Mavor, *A Year*, 31.
48 Bell (1930), 63.
49 Ibid., 64.
50 Mavor, *A Year*, 26 and 41.
51 Frances A. Crewe, Journal of Lady Crewe in Wales, Add MS 37926, 1795, 18–20. British Library, London.
52 Edward Alan Bloom and Lillian D. Bloom (eds), *The Piozzi letters: correspondence of Hester Lynch Piozzi, 1805–1810* (Delaware: University of Delaware Press, 2002), 4: 70.
53 Ibid., 3: 124.
54 Susan Staves, '"Books Without Which I Cannot Write": How did Eighteenth-Century Women Writers Get The Books They Read?' in J. Batchelor and C. Kaplan (eds), *Women and Material Culture, 1660–1830* (Basingstoke: Palgrave Macmillan, 2007), 203.
55 Hanneke Grootenboer terms such interactions as 'interchangeable signifiers of intimacy', exchanged within the 'late eighteenth-century economy of gift giving'. Grootenboer, *Treasuring the Gaze*, 22 and 23.

56 Seward, *Letters*, 4: 100.
57 DRO NTD/272, copy catalogue of a sale at Plas Newydd, Llangollen, 1832. Denbighshire Record Office and Archive, Ruthin.
58 Ousby, *James Plumptre's Britain*, 80–1. Plymley, Journal. On the portrait miniature as gift, see Katherine Reider, 'Gifting and Fetishization: The Portrait Miniature of Sally Foster Otis as a Maker of Female Memory', in Maureen Daly Goggin and Beth Fowkes Tobin (eds), *Women and Things* (Burlington: Ashgate 2009), 247–63.
59 Mavor, *A Year*, 147.
60 Ibid.
61 Douglas, 'Observations', 75–81.
62 Pointon, '"Surrounded with Brilliants"': 48–71. Grootenboer, *Treasuring the Gaze*.
63 Pointon, '"Surrounded with Brilliants"': 53.
64 Esther Milnes Day, *Poems and Fugitive Pieces, by Eliza* (London: W. Bulmer & Co. 1796), 67–8.
65 Jerningham Letters, JER, 1–79, 23 (1776–1833), Cadbury Research Library, University of Birmingham, Birmingham.
66 Romney painted several versions of *Serena* in the 1780s, several copies of which survive. The Victoria and Albert Museum, National Portrait Gallery, the Harris Museum and Art Gallery and the Dulwich Picture Gallery each hold examples of the image. From Seward's descriptions of the image, we can presume that the print given to Butler and Ponsonby was that produced by John Raphael Smith, published in 1782, and after which the stipple engraving entitled, *Miss Sneyd*, published in 1811 and executed by James Hopwood, and now in the collections of the National Portrait Gallery, was anachronistically taken.
67 For example, in a letter to Powys, she wrote: 'I have shewn you the tinted print from Romney's fine picture of Serena in the Triumphs of Temper, and which bears such perfect, though accidental, resemblance to Honora, when she was in the glory of her virgin graces [...] The luxury of mournful delight with which I continually gaze upon that form, is one of the most precious comforts of my life'. Seward, *Letters*, 4: 258. For Seward's lesbianism, see: Sue Lanser, 'Befriending the Body: Female Intimacies as Class Acts', *Eighteenth-Century Studies*, 32, no. 2 (Winter, 1998–9): 179–98.
68 Seward, *Letters*, 5: 15–17.
69 Ibid.
70 Beyond this physical association, Butler and Ponsonby and Sneyd were related in literary terms within the poet's 1796 collected volume *Llangollen Vale with Other Poems*, whose poems *Llangollen Vale* and *To the Time Past* were each a sentimentalizing series of verses dedicated to Seward's intimate relationships with Butler and Ponsonby, and Sneyd respectively. For a full discussion of the numerous poems, sonnets and elegies Seward dedicated to Sneyd, see: S. Curran, 'Anna Seward

and the Dynamics of Female Friendship', in L.M. Crisafulli and C. Peitropoli (eds), *Romantic Women Poets: Gender and Genre* (Amsterdam & New York: Rodopi, 2007), 11–22. Seward's response to Butler and Ponsonby's happy reception of Sneyd's image was as follows: I am excessively gratified, that you think dear Honora lovely; that you honour her with a situation so distinguished. Every line in that engraving bear her stamp and image, except those which, in a luckless moment, combined to attach the foot of a plough-boy to a form in every other point so beautiful. All the obligation of her establishment in the Lyceum of Langollen Vale is on my side. How could dear Miss Ponsonby speak of it as on yours and her own! I would cheerfully have given treble the cost of this engraving, for the consciousness that the similitude of the fair idol of my affections is thus enshrined. Seward, *Letters*, 5: 106–12.
71 Ibid., 5: 110.
72 Ibid., 4: 131.
73 Mavor, *A Year*, 76.
74 On the idea of the 'circuit' as a crucial ambulatory space in country house gardens, see Anderson, *Touring and Publicizing*, 164–73.
75 See Mavor, *The Ladies of Llangollen*, 103.
76 Henry Phillips, *Sylva florifera: the Shrubbery Historically and Botanically Treated* (London: Longman, Hurst, Rees, Orme & Brown, 1823), 32.
77 Ibid., 115.
78 Harriette Piggot, Letters, MS F. I, 1788. Bodleian Library, University of Oxford, Oxford.
79 Mavor, *A Year*, 124.
80 Ibid., 126.
81 Ambrose Rathborne (ed.), *Letters from Lady Jane Coke to her friend Mrs. Eyre at Derby, 1747-1758* (London: Swan Sonnenschein & Co., 1899), 1, 100, 111, 119 and 140; Mavor, *A Year*, 157. Greg, *Reynolds-Rathbone Diaries and Letters*, 70. Anna Seward Letters, AS MSS 10/iii/9, 1764–1804, Cadbury Research Library, University of Birmingham, Birmingham. Ann Ambler, Ambler Letters, MS 206, 1760–1788, Cadbury Research Library, University of Birmingham, Birmingham.
82 For example, on 25 October 1787, Butler records that 'Lady Dungannon' had sent them 'a fat duck and some Saffron cakes by Mrs Price', while on 4 October 1785, they were sent 'a Cock and some oysters', before a Mr Lloydde's Huntsman [arrived] with a Hare from his master'. Mavor, *A Year*, 184 and 182.
83 Stephen Bending, *Green Retreats: Women, Gardens and Eighteenth-Century Culture* (Cambridge: Cambridge University Press, 2013). See also Page and Smith, *Women, Literature, and the Domesticated Landscape*. On plants, see Sarah Easterby Smith, 'Cross-Channel commerce: the circulation of plants, people and botanical culture between France and Britain, *c.* 1760–*c.* 1789', *Studies on Voltaire and the Eighteenth Century*, 12 (2013): 215–30.

84 Seward, *Letters*, 4: 127.
85 Ibid., 131.
86 Mavor, *A Year*, 118 and 142.
87 See: Charlotte Turner Smith, 'SONNET LXV. To Dr. Parry of Bath, with some botanic drawings which had been made some years', *Elegiac sonnets, and other poems, by Charlotte Smith* (London: 1800), 6. Milnes Day, *Poems and Fugitive Pieces*, 73. Lewis, *Extracts*, 3: 400.
88 Pennington, *Letters*, 2: 39.
89 Page and Smith, *Women, Literature, and the Domesticated Landscape*, 3.
90 Seward, *Letters*, 4: 98.
91 Sylvia Bowerbank, *Speaking for Nature: Women and Ecologies of Early Modern England* (Baltimore: The John Hopkins University Press, 2004), 177. Anna Seward, *Llangollen Vale, with Other Poems* (London: G. Sael, 1796), 6.
92 DD/LL, 7, Ponsonby to Parker (1809–16). Jill Casid has also discussed the women's presentation of flowers to their friends, although she focuses specifically upon Ponsonby's presentation of a rose to Anne Lister, and the metaphorical possibility of queer intimacy indicated by this gift. See Jill H. Casid, *Sowing Empire: Landscape and Colonization* (Minneapolis: University of Minnesota Press, 2004), 174–5.
93 DD/LL, 7, Ponsonby to Parker (1809–16).
94 Ibid.
95 Ibid.
96 Ibid.
97 Letter from the Ladies of Llangollen (written by Sarah Ponsonby) to Mrs. Williams, of Gwersyllt Park, DD/LL, 11, 1818. Denbighshire Record Office and Archive, Ruthin.
98 Seward, *Letters*, 4: 142–3.
99 DD/LL, 7, Ponsonby to Parker (1809–16).
100 Theresa M. Kelley, 'Romantic Interiority and Cultural Objects', Romanticism and Philosophy in an Historical Age, *Romantic Circles* (undated), para 8.
101 DD/LL, 7, Ponsonby to Parker (1809–16).
102 Significantly Miss Currie's gift to Butler and Ponsonby, *Lupinus Arboreus*, was also featured in a recent edition of the *Magazine*, see: Vol. 18, 1803.
103 Eger demonstrates that Delany associated her own botanical illustrations – assuming the form of 'paper mosaicks' – with friendship. Eger, 'Paper Trails', 137.
104 On Southey and Romanticism see: Lynda Pratt, ed. *Robert Southey and the Contexts of English Romanticism* (Aldershot & Burlington: Ashgate, 2006).
105 DD/LL, 7, Ponsonby to Parker (1809–16).
106 Shelley, *Essays*, 2: 94.
107 Seward, *Letters*, 5: 77.
108 Ibid., 4: 98.

109 Ibid., 4: 230–1.
110 Seward, *Llangollen Vale*, 9.
111 See Samuel Taylor Coleridge, *The Eolian Harp* (1796) and Percy Bysshe Shelley, *Ode to the West Wind* (1820).
112 Mavor, *A Year*, 97.
113 George Cumberland, *A poem on the landscapes of Great-Britain, dedicated to James Irvine, Esq.* (London, 1793), 31. *La Belle Assemblée; or, Bell's Court and Fashionable Magazine*, 1 September, 1808.
114 Seward, *Letters*, 4: 100.
115 Ibid., 4: 230.
116 Ibid., 4: 230–1.
117 Her final visit, in 1802, was commemorated in the poem 'A Farewell to the Seat of Lady Eleanor Butler, and Miss Ponsonby, in Llangollen Vale, Denbighshire'. See Walter Scott, ed. *The Poetical Works of Anna Seward*, 3 vols. (Edinburgh: James Ballantyne & Co. 1810), 3: 345–50.
118 Greg Noble, 'Accumulating being', *International Journal of Cultural Studies*, 7, no. 2 (2004): 34.
119 Ibid., 38.
120 Nicole Reynolds, 'Cottage Industry: The Ladies of Llangollen and the Symbolic Capital of the Cottage Ornée', *The Eighteenth Century*, 51, no. 1–2 (2010): 211.

Part Three

Ownership

5

'I love her as my own child': Inheritance, Extra-Illustration and Queer Familial Intimacies at Strawberry Hill

On 26 January 1797, the landscape painter Joseph Farington (1747–1821) wrote in his diary that he had visited Walpole, who would die in March of that year, and whose health was already in decline. Recalling a conversation between Walpole and the visiting party, Farington went on to speculate about Walpole's inheritance, writing that

> he will probably leave something handsome to Miss Berry, but it is not likely, as has been supposed, that he will make the Marquess of Hertford one of his heirs. His Lordship took notice of the newspaper report of his having given £10,000 to Lady Horatia Conway, which he was sorry for, observing on the improbability of his doing it, having fifty nephews and nieces, before noting that he had no 'notion of who he will leave Strawberry Hill to, perhaps Duchess of Gloucester for life.[1]

Here, Farington gestures towards the intense focus on Walpole's potential inheritance that characterized the later years of his life and the period immediately following his death, an interest shared by both his intimates and a wider public audience.

The conjecture that arose regarding Walpole's prospective bequeath before he had even died was echoed by the vociferous criticism of the will itself once it was finally announced. Once again, Farington provided comment, forcefully noting that 'Lord Orford's will is not such as can give general satisfaction. In it are strongly marked vanity and prejudice, and not due sense of the services rendered him'. Having provided an outline of the will, recorded in a level of detail matched by his distaste for its contents, Farington commented that it contained 'no marks of attention to his several friends who were in the habit of seeing him much and who contributed to his amusement', a reference, presumably, to himself.[2] His indignation was not only to continue, but was apparently shared by others. A day later, he recorded that his friend, Daniel Lysons had visited Walpole's close

friends Mary and Agnes Berry (1764–1852) in the company of a number of other guests, all of whom apparently found the will similarly lacking on account of the annuity and reversion given to his sister, Lady Mary Churchill, and the large sum of £10,000 given to the Walpole's niece, Maria Duchess of Gloucester and Edinburgh and Countess Waldegrave. Farington even indicates that he spoke with the sculptor Anne Seymour Damer, Walpole's relative and the executor of the will, to ask her to right these perceived wrongs, noting that 'Mrs Damer does not believe it will be in her power to make up what may be called deficient in Lord Orford's will'.[3]

First drawn up in 1793, with further additions in 1796, Walpole's last will and testament is an extensive and complex document couched in wearyingly repetitive legal language. Indeed, Walpole's will was so long that this aspect of its character was commented upon by the press, with the *True Briton* newspaper reporting that 'The Will of the late Lord Orford extends to the great length of *twenty-five* sheets of paper, besides the addition of *seven* Codicilia'.[4] With the original document totalling over 14,000 words in length, Farington's summary of the will is accordingly a useful shorthand for seeing how Walpole's possessions and fortunes were shared between his friends and relatives:

Table 5.1 From *The Yale Edition of Horace Walpole's Correspondence*, 'Joseph Farington's Anecdotes of Walpole, 1793–1797'. New Haven: Yale University Press, 1937–83, 15: 335. Corrections, Lewis.

To the Duchess of Gloucester	£10,000
To Miss Berrys each 4000	£8,000
To Mrs Damer	£4,000
To ditto for keeping up Strawberry Hill	£2,000
To Lady Aylesbury	£3,500 (*actually £4,000)
To 19 nephews and nieces each	£500
To Mr Bertram his deputy	£2,000
To the clerk who officiated	£1,500
To his Swiss servant	£1,500
To Kirgate	£150 (*actually £100)
To Sir Horace Mann, a bond with interest	£5,000
To Lady Mary Churchill	£2,000
To ditto for life	£200 a year

Like the other unconventionally heteronormative spaces discussed in this book, the inheritance of Walpole's home Strawberry Hill was particularly vexed,

making this perhaps the most interesting part of his bequeath, with the prospective lineage of the house's ownership and protection articulated in careful and specific terms. As at A la Ronde, whose owner Mary Parminter's will insisted that the property could only be inherited by female, unmarried family members, Strawberry Hill's inheritance was fleshed out in some detail. With no direct heir, Walpole's house was to pass to Damer, the daughter of his cousin, the late Henry Seymour Conway and Caroline Campbell, Countess of Ailesbury. This bequest is framed in the will itself as follows:

> I give and devise all my messuages, lands, tenements, and hereditaments with their appurt[enance]s now in my own occupation situated at Strawberry Hill in the parish of Twickenham in the County of Middlesex, part of which being copyhold and held of the Manor of Isleworth Sion in the said County of Middlesex I have surrendered to the use of my will, and all other my messuages, lands, tenements, and hereditaments whatsoever whether freehold or copyhold with their appurtenances in the said Parish of Twickenham, except as hereinafter mentioned, unto and to the use of the said Charles, Duke of Richmond, Lord George Lenox and the Right Honourable Frederick Campbell, commonly called Lord Frederick Campbell, and their heirs during the life of the Honourable Ann Damer [sic], widow, only daughter of my cousin, General Henry Seymour Conway, in trust to permit the said Ann Damer to have, hold and enjoy the same during her life to and for her own sole and separate use independent and exclusive of any husband she may marry to whose power or control, debts or engagements the same shall not be subject or liable, but the receipts and directions touching such premises of the said Ann Damer alone without any such husband shall, notwithstanding her coverture, be sufficient for all such purposes for which the same shall be given as fully and effectually as if she was sole and unmarried.[5]

Alongside the £4,000 given to Damer, she was also awarded a further £2,000 annually for the care and upkeep of the property. Following Damer's death, the house was to pass into the ownership of Lady Waldegrave and her heirs (under whose custodianship the house remained until the mid-nineteenth century), a stipulation that presumes, of course, that Damer would maintain her unmarried status and would not produce heirs of her own throughout the remainder of her life, a potential (but unlikely) eventuality carefully delineated in the wording of the will, and one to which we shall return in the final section of this chapter.[6]

Although Farington's account of the will seems to reflect his own grievances, the comparatively public vehicles that reported on Walpole's death focus more firmly on what would happen to Walpole's famous Gothic Twickenham estate,

Strawberry Hill. For example, on 6 March, 1797, the *True Briton* reported that '*Strawberry Hill* is left by Lord Orford to the Hon. Mrs. DAMER', whilst on 17 March, *The Times* noted that 'The Late Lord Orford has died extremely rich, and has left upwards of 20 considerable legacies [...] Mrs. DAMER 4000l. and the interest of 4000l. more to keep Strawberry Hill in perfect repair, besides all his paintings, which are to be as an heir loom to the house'.[7] In a similar vein, on 14 March the *Whitehall Evening Post* reported that

> Mrs. Damer is left in a situation of some difficulty by the late Lord Orford. She is residuary legatee. Her legacy has been wrongly stated; it is 2000l. net, not 2000l. per annum. *Strawberry Hill* is hers only for life; it then reverts to the Waldegrave Family, from whom it is not alienable until the young Lord is of age. This residence of genius, and repository of science and art, is in a very decayed state, and will demand a considerable sum to render it thoroughly habitable; and certainly much more than the interest of the fair Possessors legacy to maintain it in orderly repair.[8]

As these examples demonstrate, there was palpable concern around who would inherit Walpole's famous house, whether his exemplary collections of art and curiosities would remain intact and preserved as a whole, and, perhaps most transparently, as to whether these would still be shown to the public, as they had been throughout its former owner's tenancy.[9]

This interest in Walpole's bequest as indicated by both published newspaper sources, and the private diurnal writing of his contemporaries, has not been shared by subsequent historians, who have tended to focus either on the ownership and embellishment of Strawberry Hill during Walpole's lifetime, or, conversely, on the infamous sale of 1842, which saw its contents sold and dispersed. Absent from these narratives, however, is Damer's inheritance and ownership of Strawberry Hill, which is often given just a few perfunctory lines of attention.[10] This lack of attention is likely because Damer assiduously burnt her own correspondence before her death, and has, as a result, been treated as a relatively closed book in terms of her historical subjectivity.[11] Nevertheless, by paying closer attention to Damer's inheritance of Strawberry Hill through one of her few surviving personal documents, her extra-illustrated copy of Walpole's published catalogue of his home, *A Description Of The Villa Of Horace Walpole, Youngest Son of Sir Robert Walpole Earl of Orford, At Strawberry-Hill, near Twickenham. With an Inventory of the Furniture, Pictures, Curiosities, &c.*, we can understand both her history and that of the house more clearly.[12] Damer's adapted copy of the text reveals an interesting episode in the history of the late

eighteenth- and early nineteenth-century home, which suggests the centrality of 'inheritance' as both a legal framework for the acquisition of property, and as an evocative and emotive process firmly rooted in the multifarious identities and creative lives of a house's owners.[13]

This chapter will focus on this process through an examination and contextualization of Damer's copy of the *Description*, made sometime after 1784, when the expanded second edition was published. Reading inherited spaces (that of Strawberry Hill) against inherited practices (that of extra-illustration), it argues that both house and creative undertaking were inherited by Damer from Walpole. After establishing Walpole and Damer's close relationship, and asking why the inheritance of his property was such a vexed issue for Walpole, it explores the complex interlinking of Walpole, his home and the enactment of extra-illustration, before focusing in depth on Damer's *Description*. In so doing, the chapter asks how this adapted and embellished copy of a published text allowed Damer to fashion her professional identity as an artist, while reflecting on the role of female creativity within both Strawberry Hill and eighteenth-century society more broadly. At the same time, it suggests that the space of the extra-illustrated text also allowed Damer to position her relationship with members of her family using portraiture and other forms of genealogical visual and material culture in a kind of 'queer family romance', that Matthew M. Reeve, borrowing from Whitney Davis, has suggested that Walpole enacts at the house.[14] Finally, the chapter asks how Damer's inheritance of the property represented an affective gesture relating to Walpole's establishment of an enduring domestically-rooted queer community in and between Strawberry Hill, Damer's inheritance of the property, and Mary and Agnes Berry's inheritance of another of Walpole's properties, known as Little Strawberry Hill. In so doing, the chapter pays unprecedented attention to an overlooked episode in the life of Strawberry Hill, locating Damer's inheritance of the property between the physical and material spaces of book and house, as well as the emotive spaces of familial identity and shared queerness, in order to demonstrate the centrality of this moment in how both Walpole and Damer conceived of his home, and how we as historians continue to consider the complex legacies of one of the eighteenth-century's most compelling domestic spaces.

Inheritance between house, text and emotion

In privileging a specific account of Strawberry Hill that focuses on Walpole's occupation of the space and the eventual breaking up of the house's collections,

scholars have echoed Walpole's own deep concerns regarding the future integrity of his home. This was an anxiety that had haunted him since the death of his father, Sir Robert Walpole in 1745, and the subsequent sale of his great art collection which had been housed at the Walpoles' familial seat of Houghton Hall. Such fears pepper Walpole's correspondence. In 1774, for example, he wrote to his friend William Cole, decrying the recent dismemberment of Richard (Dickie) Bateman's Gothic villa: 'Strawberry is almost the last monastery left, at least in England. Poor Mr. Bateman's is despoiled. Lord Bateman stripped and plundered it; has sequestered the best things, has advertised the site, and is directly selling by auction what he neither would keep, nor can sell for a sum that is worthwhile'.[15] Continuing Walpole notes that he was

> hurt to see half the ornaments of the chapel, and the reliquaries, and in short a thousand trifles exposed to sneers. I am buying a few to keep for the founder's sake. Surely it is very indecent for a favourite relation, who is rich, to show such little remembrance and affection – I suppose Strawberry will have the same fate![16]

Employing notably violent and emotive language, here Walpole emphasizes the betrayal he perceives as inherent to the act of dispersion, as well as the affective potential of the collection shamed and disregarded, relating that directly to his fears around Strawberry Hill's own possible fate.

Walpole's concerns regarding the afterlife of his home make sense in the context of the deep connection between house and owner that coloured his relationship with Strawberry Hill. As Reeve argues, Strawberry Hill was far more than a home, functioning instead as 'a complex, carefully constructed, and very public projection of Walpole himself', closely tied to Walpole's ego, sense of self, and his desire for posthumous repute.[17] This intimate relationship between house and patron can also be viewed in the context of what Stephen Bann describes as occurring through Walpole's historicization of the house more broadly, that is, the enactment of a 'compensatory fantasy', in which Walpole actively used ideas of history, lineage and family in the house's decoration and myth-making in order to ensure its and ergo, his, enduring renown.[18] This fantasy, which is particularly compelling in light of Walpole's contested lineage, was enacted through three distinct strategies that reflect Walpole's desire to fix his house in time, and which echo Luisa Calè's assertion that 'remembering the dispersed collection is a central impulse in Walpole's writing, collecting and book making'.[19] Firstly, this occurred through the house's publication in his descriptive text; secondly, through the house's carefully delineated heirlooming through the will;

and thirdly, through the extra-illustrative practices of Walpole and his circle, a practice also inherited by Damer. Together, this programme of literary posterity, material memorialization and genealogical manoeuvring reinforce the central role played by Strawberry Hill in how Walpole viewed an inheritance that was at once physical, intellectual and social, and which existed between house, text, and emotional gesture.

Walpole's anxieties around the eventual fate of his home manifest perhaps most clearly in the preface to his *Description*, which seeks to justify the potential vanity of publishing a catalogue of a private property by highlighting not only the broader threat to the survival of the Gothic style at the time of writing ('the general disuse of Gothic Architecture, and the decay and alterations made in churches, give prints a charge of being the sole preservatives of that style'), but also more specifically, the threat to his collections and edifice at Strawberry Hill, with Walpole noting that 'the following account of the pictures and rarities is given with a view to their future dispersion'.[20] As argued in the first two chapters of this book, the description of the home and the listing of its associated visual and material culture was a central means by which domestic space was processed and understood during this period, ensuring the literary posterity of a house and its collections against the potential physical destruction and diffusion of its fabric and contents. Beyond this urge to preserve, catalogues such as the *Description* also explicitly linked the collections they documented with other great and historic examples.[21] Again, we see this clearly in the preface, in which Walpole teases out the illustrious lineage of Strawberry Hill's collections by referencing those from which his purchases derived: 'the following collection was made out of the spoils of many renowned cabinets, as Dr. Mead's, Lady Elizabeth Germaine's, Lord Oxford's, the Duchess of Portland's, and of about forty more of celebrity', connections which Walpole described 'as well attested descent', and a 'genealogy of the objects of *Vertu*'.[22] Tellingly, these rarefied assemblages of paintings and *objets d'art* are discussed within the same anecdotal space as a personally significant familial collection for Walpole, that of his father. Combining histories of collections both publicly famed and privately resonant, objects purchased and the ghosts of those lost, Walpole thereby conceives of these collections in explicitly genealogical terms, as formed by lineage, inheritance and acquisition, with objects moving from one great familial seat and into another.[23]

Yet the *Description* was not Walpole's first ekphrastic attempt to transform a collection into prose. His first foray into such a project was his *Ædes Walpolianæ* of 1747, which, as its subtitle informs us, was a '*Description of the Collection of*

Pictures at Houghton-Hall'. With their shared relation to Sir Robert Walpole, the *Ædes Walpolianæ* was the intellectual sibling to Walpole's 1742 *Sermon on Painting*, with the former dedicated to his father, and the latter 'preached before him'. Both texts reflect Walpole's attempt to negotiate his vexed relationship with his father through their shared passion for art, a connection initially formed when he had acquired several pieces for Houghton's collections as a young Grand Tourist.[24] The literary inheritance and familial connection between these works continued on into the *Description*, with the full title of its 1774 edition including a telling reference to Walpole's father, through his prominent self-identification as the '*Youngest Son of Sir Robert Walpole Earl of Orford*'.[25] Demonstrating a deeply rooted need to publicly project a genealogical self that stood in contrast with Walpole's inherently contested parentage, this inclusion sought to underscore the connection between the two men, and therefore, their collections housed in their respective homes. Nevertheless, Walpole contradictorily downplays the relationship between these spaces in the preface to the *Description*:

> Having lived unhappily to see the noblest School of Painting that this kingdom beheld, transported almost out of sight of Europe, it would be a strange fascination, nay a bold insensibility to the pride of Family, and to the moral reflections that wounded pride commonly feels, to expect that a paper fabric, and an assemblage of various trifles made by an insignificant man, should last, or be treated with more veneration and respect than the trophies of a Palace, deposited in it by one of the best and wisest Ministers that this country has enjoyed.[26]

Despite the diminutive language employed here, deployed to honour and flatter the memory of his father's collections through comparison with the ephemeral 'trifles' of Walpole's own home, he was clearly not resigned to the inevitable dispersal of Strawberry Hill's collections, as we see in the carefully sketched and highly detailed inheritance of the house outlined in his will. Indeed Damer's, and later the Waldegraves', inheritance of Strawberry Hill is one of the clearest examples of Walpole taking action to ensure the survival of his home, a gesture that must be read in relation to his concerns regarding its potential dispersion that we see in both the *Description* and his correspondence.

Damer was a logical choice as heir. Walpole had complicated relationships with many of his surviving family members, but that he maintained with the daughter of his first cousin had always been a close one. As Percy Noble asserts in his 1908 biography of Damer, the pair had long enjoyed an intimate affiliation,

with Damer often left with Walpole as a child while her parents were away. Walpole can accordingly be viewed as a 'third parent' of Damer, a characterization that is rendered particularly multifaceted when read against Walpole's love of Conway, possibly transferred to his daughter.[27] With Walpole taking a direct interest in Damer's intellectual development, their friendship grew around her blossoming sculptural talents and keen mind, taking on a distinctly material dimension through her creative practices and their exchange of gifted objects, as well as her intimate knowledge of his home.[28]

Like Damer's inheritance of Strawberry Hill more broadly, her relationship with Walpole is often overlooked in writings on the so-called 'Strawberry Hill set', which tend to focus on his great queer epistolary friendships with his male correspondents, or, when these discussions do extend to women, on his relations with Mary and Agnes Berry. In Haggerty's important work on Walpole and friendship, for example, Damer is mentioned only once, in a footnote, while in the catalogue to the latest exhibition dedicated to reassembling Walpole's collections at Strawberry Hill, her contribution to the biography of the house is limited to a few sentences and the titles of a handful of her works that were displayed there.[29] This critical neglect is, as noted above, inevitably due to Damer's missing personal documents, yet though Walpole and Damer's correspondence doesn't survive, she nevertheless populates his letters to others. To Horace Mann in 1781 he wrote that 'I will say very few words on her, after telling you, that besides being his daughter, I love her as my own child'.[30] In this letter, the intimacy between Damer and Walpole takes on a hereditary quality, with Damer cast in the role of Walpole's progeny, a dynamic that was clearly tied to her eventual inheritance of his home of Strawberry Hill, and which we also see in her daughterly adoption and enactment of one of Walpole's favoured artistic practices, extra-illustration.

Both Walpole's *Description* and Damer's inheritance of Strawberry Hill can therefore be read as anticipatory movements that reflect Walpole's concerns over the eventual dispersion of his collection; a means by which to ensure its existence into the following century, while remembering 'the collection in the form of a paper museum'.[31] Yet this inheritance was also secured through the house's manifestations within the practice of extra-illustration, which saw its legacies enriched and visualized through the creative appropriation of the space. With dispersion identified as a central motivation for both the creation of the *Description* and its extra-illustrated copies then, we can read this profitably in relation to Walpole's highly self-conscious management and projection of his and the house's legacy. This was articulated through its inheritance both as a

physical object, eventually owned by Damer, and its representation within Damer's copy of the *Description*, the latter of which emerges as a crucial space for understanding these competing and emotionally charged narratives of acquisition and loss.

Extra-illustration and the social text

Extra-illustration, or grangerization as it is sometimes known, refers to the practice of adding supplementary materials, often visual images, to 'illustrate' a published text. A central form of composite manuscript production from this period, grangerization takes its name from James Granger (1723–76), whose wildly popular book *Biographical History of England from Egbert the Great to the Revolution* was published without illustrations in 1769, but was subsequently 'grangerized' through the additions of printed portraits and other images relating to the text, which could be pasted, folded and even rebound into the book. Such additions were not just limited to portraiture, however, and included religious and genre prints, gobbets of biographical text, envelopes, images of family trees and even tiny metal chains, designed to show the very literal links between text and image.[32]

The practice became so widespread that many texts were similarly subjected to this kind of customization and embellishment. These included copies of Shakespeare's works, the Bible and the works of Thomas Pennant, as well as several books published by the Strawberry Hill Press, which was located at the house. The importance of extra-illustration to Walpole's intellectual circles has been well documented, particularly around the notable number of extra-illustrated copies of the *Description*, which together constitute an important example of collected and collective bibliographic embellishment and manipulation.[33] For Walpole and his circle, extra-illustration was an inherently social practice. Walpole was at the heart of a vibrant community of print collectors, a position that placed him, and his home of Strawberry Hill, at the centre of extra-illustration practices.[34] Walpole functioned as both correspondent and advisor to Granger, whose *Biographical History* would eventually be dedicated to Walpole, and several of his friends, associates and family members also engaged extensively in extra-illustrative practices. These included Damer, as well as Richard Bull, whose prodigious programme of extra-illustration included the ornamentation of at least sixteen books printed at the Strawberry Hill Press.[35]

As Gabrielle Dean has argued, the practice of extra-illustration results in a book that both 'reflects and facilitates social reading'.[36] Casting it as a transformative process in which the linear text is turned 'into a unique, multi-directional network of "links" to related texts', which transforms 'the reader as the writer's collaborator', Dean highlights the collaboration inherent to extra-illustration as a form, not merely between narratives and forms of culture – so between published text and published print, or between handwritten annotation and hand-painted inclusion – but between those that made, owned and viewed such texts.[37] Likewise Lucy Peltz, in her own work on the emergence of extra-illustration amongst the Strawberry Hill set, has highlighted how the social dimensions of extra-illustration echo the physicality of the practice's enactment by calling it a 'friendly gathering', a term that usefully collapses the gathering of materials and the gathering of peoples that extra-illustration dually encouraged.[38]

This gathering operated on several levels, whether through the giving and receiving of prints, advice exchanged between extra-illustrating correspondents, or as a practice done in emulation of, or learned from, one another. For example, when writing to his friend William Cole, in 1764, Walpole noted that he had included 'the head of Archbishop Hutton, and a new little print of Strawberry' with a copy of his *Anecdotes of Painting*, noting that 'if the volumes, as I understand by your letter, stay in town to be bound, I hope your bookseller will take care not to lose those trifles'.[39] Like his friends then, Walpole also engaged in extra-illustration, as evidenced in his oft-cited proclamation that he had 'invented a new and very harmless way of making books, which diverts me as well, and brings me to no disgrace. I have just made a new book, which costs me only money, which I don't value, and time which I love to employ. It is a volume of etchings by noble authors. They are bound in robes of crimson and gold; the titles are printed at my own press and the pasting is by my own hands'.[40]

There are around ten extant books that Horace Walpole authored and extra-illustrated, including both editions of the *Description*. It has been suggested that it is the *Ædes Walpolianæ* that is the earliest of these.[41] Appearing in the *Description*'s passages on Strawberry Hill's Library, an extra-illustrated version of this text is described by Walpole as '*Ædes Walpolianæ*, the original drawings, with every print that has been engraved from the pictures, and with other prints and drawings of houses and buildings that belonged to Sir Robert Walpole and the family of Walpole'.[42] The text combined the *Ædes* alongside his *Sermon on Painting*, and included numerous annotations and engravings.[43] As noted above, the *Ædes* was a highly resonant text for Walpole, ripe with familial association. Peltz asserts that the production of this object was directly tied to Walpole's

anxieties regarding the fate of his familial collections, suggesting that the practice 'allowed him to rehearse a relationship with works once at Houghton', and giving him 'a way of coming to terms, however partially, with the loss of the collection'.[44] As in Walpole's published writings, and his carefully framed will, the extra-illustration of such volumes was yet another one of the compensatory strategies that allowed Walpole to commemorate his family and fix his home in time.

Walpole also framed these creative practices explicitly in terms of inheritance by including them prominently in his will, which includes a section that reads:

> And it is my will and desire that all the prints, books of prints, and incomplete numbers of prints with whatever else is contained in the large red exchequer trunk in the back room on the ground floor in my house in Berkeley Square, London, should be brought to my house at Strawberry Hill, Twickenham, on my death, as I do not mean that the contents of that trunk should go to the person or persons to whom I have by my said will given, devised or bequeathed my said house in Berkeley Square, but that the said prints, books of prints, and incomplete numbers of prints and all other things contained in the said trunk shall be deposited at my said house at Strawberry Hill aforesaid either in the Round Library of prints in the Round Tower or in the wardrobe in the New Offices there and be enjoyed as heirlooms together with my household goods, furniture, and other particulars therein as mentioned in my said will, so that the persons to whom or in trust for whom I have by my said will given my said last mentioned house may, if she, he or they shall think fit, complete the books of prints in my said Round Library there as successive numbers of such works shall be published.[45]

It was Damer, then, who would acquire not only Strawberry Hill, but Walpole's unfinished 'books of prints', and thereby his extra-illustrative practices, an inheritance that can also be read as an emotively-fuelled gesture. One can only imagine the profound trust and intimacy shared between the two for Walpole to leave such careful curation to Damer. Extra-illustration made during the eighteenth century was deeply related to systems of order, meaning and knowledge production, a kind of material information that allowed participants to research and reflect upon the known world and its histories. As such, extra-illustration is often framed in terms of antiquarian and historical expertise and self-improvement, while its evocative and emotional potential is comparatively overlooked. With several extra-illustrated copies of the *Description* made by Walpole's closest friends, such as Damer, Bull and his printer, Thomas Kirgate, these extra-illustrated texts also highlight how the production of such volumes might uncover the close relationships and affections between their makers and

their subjects. Enacted between friends and transferred amongst family members, the practice of extra-illustration commemorated those relationships in physical form, functioning as material and textual testament to the affective engagements of its makers, owners and viewers. In the case of the *Description*, the emotional nature of such objects was also reinforced and solidified through its association with the space of Strawberry Hill.

Indeed, extra-illustration was inherent to Strawberry Hill and the relations enacted there. Luisa Calè has identified the close relationship between the codex form and the architecture of the house as evident in Walpole's appellation for Strawberry Hill as a 'Paper Fabrick', and a castle 'made of paper'.[46] This reading collapses distinctions between the physical space of Strawberry Hill and its literary and visual representation in the *Description* and its extra-illustrated versions, a provocative realignment between the house and the cultural practices enacted between, in and about it. Strawberry Hill had an accordingly mutable relationship with print, being at once a space literally pasted with print, where print of all kinds was made, kept and used, and which was represented in print in both visual images and literary texts.[47] Exemplifying these connections then, extra-illustrated copies of the *Description* directly connected domestic space with the space of text and image, or as Calè terms it, 'extra-illustrating the *Description* turns the house into a book', and, reciprocally, the book into a house.[48]

As such, Damer inherited not only the house, but an intellectual, creative and emotional approach to the property rooted in personal identity and family history. Thinking about inheritance through the lens of Damer's extra-illustrated copy of the *Description* thereby allows for its consideration as a kind of culturally inscribed process that relates to how homes functioned to express the emotional lives of their owners. Although almost all property that is owned is inherited, the inheritance of Strawberry Hill, as a house always intended and realized as a kind of monument to Walpole's many, multifarious relationships, represents an amplification of the social and affective nature of the inheritance of a property, reinforcing provocatively its status as a key cultural process through which the house was interlinked with emotion and identity. The remainder of this chapter will focus on extra-illustration as an inherited practice, shared by Walpole and Damer, and one which, thanks to their shared reformulation of the *Description*, echoes, mirrors and perhaps even anticipates Damer's eventual inheritance of the house itself. Each of these instances of inheritance was rooted in the shared materialization of identity and affection that centred around domestic space and its ownership, decoration, and representation.

Damer's *Description*

Echoing the relative lack of broader critical attention given to its author, Damer's extra-illustrated copy of the *Description of Strawberry Hill* has yet to be subjected to sustained scholarly analysis. Peltz's discussion of the extra-illustrative practices of Walpole's circle, for example, privileges the work of Bull and Walpole himself; while Calè's analysis of the relationship between house and text is undertaken through an illustrative focus on the writings of Thomas Gray. This inattention is perhaps suggestive of some of the difficulties of working with such documents, as outlined by Peltz, namely, the idea that although extra-illustration had significant cultural cache in the eighteenth and early-nineteenth centuries, now such objects form 'a cumbersome and heterogeneous body of material that resists exegesis'.[49] Often taking the form of highly formulaic reconfigurations of the same text, the analysis of these objects is notably dependent on the survival of related documentation, without which 'we are confronted with objects that are at once bewildering and inscrutable'.[50] Unlike the extensive epistolary correspondence between Bull and Granger, written between 1769 and 1774, which tells us much about the emergence of the genre during this period, Damer's *Description* has few ego-documents to be read against, save for a handful of letters that escaped the burning of her correspondence, and a small number of notebooks and scrapbooks produced by Damer, now in the collections of the Lewis Walpole Library at Yale University.[51] Despite the absence of this supplementary buttressing, Damer's copy of the *Description* nevertheless rewards careful attention. By considering the volume alongside Walpole's writings, his own extra-illustrative engagements and Damer's inheritance of his home as outlined above, a fuller picture of Damer's inheritance of Strawberry Hill emerges, one which intersects with her own artistic identities, emotional and familial lives, and her participation in the queer communities which surrounded and emerged from the house.

Damer extra-illustrated a copy of the 1784 edition of the *Description*, a revised and expanded volume which added twenty-seven engravings, a frontispiece, pull out illustrations and an explanatory preface to the original 1774 text. Although, as the second chapter of this book demonstrated, houses were frequently immortalized in written guidebooks and catalogues designed to accommodate the needs of eager domestic tourists and country house visitors during this period, the *Description* was a rather more private endeavour, primarily printed for and distributed among Walpole's friends.[52] With around 200 copies of this edition produced, Damer was one of a relatively privileged number who owned the text for themselves.

Although the work cannot be dated precisely, it is clear that she began the project sometime after the publication of the 1784 version of the text, and that it endured beyond the death of her mother in 1803, to whose memory, as we shall see, the text is partially dedicated. The additional images which illustrate the text appear in no discernible order: it opens with a printed image of her mother, which is followed by an apparently illogical assembly of prints featuring images of her sculptural works, Strawberry Hill and its collections, and portraits of herself and historical figures, as well as an assortment of bookplates, holographic letters and printed texts relating to her time at the house and the relations she enjoyed there. Unlike Walpole's own extra-illustrated copies of his text then, her inclusions do not follow the logical ordering inspired by the book itself.[53] The standard published version of the *Description* is typical of contemporaneous guidebooks in that it follows a natural, ambulatory procession around the house. Following a short history of the property, the titular description moves from the front gate of the house, to its gardens and finally to its interiors, which are described in notable detail. Extant extra-illustrated copies of the *Description* tend to follow this ordering, directly illustrating the parts of the house, objects or people described on its adjoining pages. As such, these volumes accord with broader notions of extra-illustration as a means by which to understand the world; with its pages akin to a system of organization and knowledge presentation that relates to the emergence of contemporaneous taxonomies that were so prevalent by the late eighteenth century.

Parts of Damer's *Description* do accord with the broader organizational structure provided by the original text, as evidenced by some of the portrait inclusions and images of the house that she added to the text at pertinent moments in the volume. Nevertheless, it is clear that Damer's extra-illustrated *Description* is as much about commemorating and documenting Strawberry Hill as it is a negotiation of her own identity, and particularly her identity as a sculptor and artist, within that space. While featuring the usual images of the house and its owner, her *Description* is actually dominated by images of her close family, her sculptural production, letters and lines of poetry from her friends, and playbills for theatrical displays held at the house in which she and her friends starred. These inclusions reveal Damer's particularized understanding of, and frame of reference for, the house, in which her own identity is illuminatingly foregrounded. Allowing Damer to ruminate on her lost affective relationships and her position amongst various networks of family and community, it is thereby her own identity that is centred in this highly individualized version of Walpole's published text.

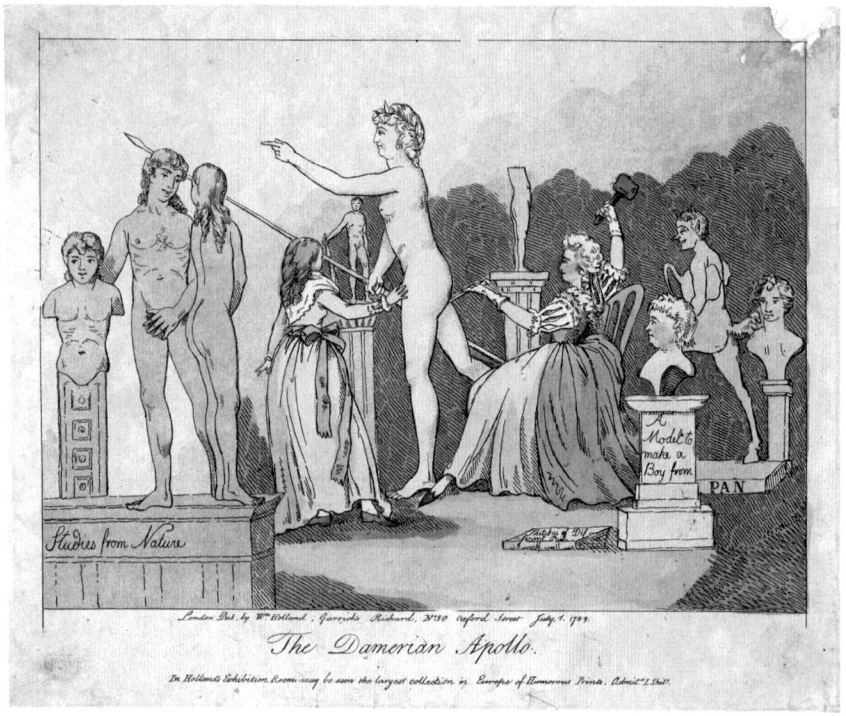

Figure 5.1 *The Damerian Apollo*, 1789. Published by William Holland, London. Etching on laid paper, hand-coloured. Courtesy of The Lewis Walpole Library, Yale University.

Damer's artistic identities

Perhaps most notable amongst the complementary identities that Damer presents in her *Description* is that of her complex and sometimes controversial status as a woman artist. According to Walpole, Damer had been engaged in the making of various forms of sculpture and its related practices since the age of ten.[54] Beginning in wax, she also produced works in both terracotta and marble throughout her career, which were variously housed or exhibited in illustrious spaces such as the Royal Gallery of Florence, the Royal Academy of Arts, and, of course, Strawberry Hill.[55] She specialized in portraiture, completing numerous sculptural representations of friends, relatives and members of the elite class, as well as a number of mythological busts and heads, and works depicting animals, particularly domesticated species, such as cats and dogs. Much of the critical work on Damer has logically focused on her chosen artistic profession and both

her private and public identities as a queer woman, the latter of which, it has been argued, reflected the public nature of her artistic engagements and was commented on through the production of both visual and literary satire.[56] Yet even such apparently clear personal 'attacks' are rendered more complex by examining the practice of extra-illustration. Both Walpole and Damer extra-illustrated examples of the most infamous satirical accusations of sexual debauchery levelled against Damer, with Walpole including a copy of *The Damerian Apollo* – a print depicting Damer chiselling the backside of a young Apollo – in his extra-illustrated copy of his *Reminiscences* (fig. 5.1); and Damer herself including a clipping of some stanzas written in her defence '*on seeing the* BURLESQUE PRINTS *of the* DAMERIAN APOLLO' (fig. 5.2). Such inclusions – far from simply rejecting or resisting the contents of such works – suggest a more circuitous relationship with these suggestive materials than previously acknowledged in histories of Damer, while, more importantly for the

Figure 5.2 Anne Damer, extra-illustrated 1784 edition of *A Description of the villa of Mr. Horace Walpole* (c. 1784–1803). Quarto 33 30 Copy 25. Courtesy of The Lewis Walpole Library, Yale University.

purposes of this chapter, they also highlight the central role played by extra-illustration in documenting Damer's life as sculptor for both herself and for Walpole.

Although many of her sculptural works have been lost, they nevertheless survive in some number when compared with Damer's letters, making those which do endure vital objects of study for any discussion of Damer's self-fashioning and identity construction. Further to the works themselves, several of Damer's extant personal documents contain evidence of her artistic endeavours, inclusions that show how crucial these creative pursuits were for how Damer framed herself and her accomplishments for posterity. Damer's scrapbooks include examples of her watercolour paintings and etching practices, which appear alongside visual representations of significant historical sites from the continent and portrait heads of famous English worthies such as Richard Boyle, 3rd Earl of Burlington.[57] Like Damer's extra-illustrated *Description*, the scrapbooks also contain images of highly personal resonance, including prints of Strawberry Hill and those made by its press, views of her locality, including a Twickenham church and Richmond Bridge, as well as portraits of herself, and the book plate of her friends, Mary and Agnes Berry. Damer's *Description* also contains a mix of evocative private imagery and the comparatively public visual and material culture associated with her sculptural production. Indeed, Damer's *Description* is positively dominated by printed images of sculptures. In total there are eight such prints in the volume, including two marble busts of her mother, of 1789 and *c*. 1803; her marble busts of Bacchus (1787) and Mercury (1787); her marble bust of Elizabeth Farren, Countess of Derby, in the guise of *Thalia*, the Muse of Comedy and Idyllic Poetry (*c*. 1788); and her head of Tamesis (or the Thames), made for Henley Bridge in 1785. The final two images of her works included in the *Description* were owned by Walpole and were on display at Strawberry Hill: her terracotta of an *Osprey, or Fishing Eagle* of 1787 and her terracotta sculpture of two sleeping dogs, mounted on a marble base, made for Walpole in 1782.

It is perhaps these inclusions that suggest most clearly how Damer's creation of her extra-illustrated *Description* was a practice directly inherited from Walpole himself. The appearance of Damer's works within her copy of the *Description* is anticipated by those included in Walpole's own extra-illustrated copy of the text, which features several images of Damer's sculptures that are also included within her grangerized text. Sculptures that appear in both volumes include the terracotta sculpture of two sleeping dogs, the osprey rendered in the act of fishing, and the bust of Elizabeth Farren. Of the dogs (fig. 3), originally displayed

in the Little Parlour, Walpole wrote to the Earl of Strafford in 1784, noting that Damer planned to execute a version of the pair in marble for the Duke of Richmond, and that when a visitor had lately seen them at Strawberry Hill, he had commented that 'he was sure that if the idea was given to the best statuary in Europe, he would not produce so perfect a group'. Concluding this letter, Walpole would go onto say that 'with these dogs and the riches I possess by Lady Di, poor Strawberry may vie with much prouder collections'.[58] While actively showing the links between the two versions of the *Description*, these inclusions are also testament to the high esteem in which Walpole held the pieces of her work that formed part of the fabric of Strawberry Hill. Walpole was a particular exponent of the work of the women artists in his life, such as Lady Diana Beauclerk and Damer, for whose inherent capabilities as a sculptor Walpole was constant advocate.[59]

From as early as 1763, Walpole had been effusive in his praise for what he perceived as Damer's many talents. Writing to Damer's father in that year, Walpole

Figure 5.3 Anne Damer, extra-illustrated 1784 edition of *A Description of the villa of Mr. Horace Walpole* (c. 1784–1803). Quarto 33 30 Copy 25. Courtesy of The Lewis Walpole Library, Yale University.

commented on her 'progress in waxen statuary', which 'advances so fast, that by next winter she may rival Rackstrow's old man', here referencing an infamously life-like plaster of Paris statue, displayed in the 1763 exhibition of the Free Society.[60] To Mann, in 1781, he likewise wrote that 'She has one of the most solid understandings I ever knew, astonishingly improved-but with so much reserve and modesty, that I have often told Mr Conway he does not know the extent of her capacity and the solidarity of her reason. We have by accident discovered that she writes Latin like Pliny, and is learning Greek. In Italy she will be a prodigy; she models like Bernini, has excelled the moderns in the similitudes of her busts, and has lately begun one in marble.'[61] This enthusiasm for Damer's many charms was shared by Mann, whose aesthetic judgement Walpole repeatedly sought and trusted throughout their long friendship. In 1782, Mann wrote to Walpole about Damer, noting that 'No English lady ever acquired so great a reputation in the *belle arti* as she has done. I expect to hear that our best sculptors consult her before they venture to expose their performances to the public'.[62]

Beyond his private correspondence, Walpole's praise for Damer's sculpture was also repeated in published forums, such as his *Anecdotes of Painting in England* of 1762–80, which heralded Damer as a 'female genius', whose sculptural performances were 'not inferior to the antique, and theirs, we are sure, are not more like'.[63] Tellingly, the fullest picture of Damer's prodigious artistic production that we have comes from Walpole in his '*Book of Visitors*', which provides a detailed list of her works and their locations.[64] The text is also couched in the mythos surrounding Damer's talents as a sculptor, something knowingly cultivated by Walpole. In the midst of listing her works, Walpole provides an origin story for Damer's artistic practice: 'Damer gave the first symptom of her talent for statuary, when she was but ten years old. She was reading Spenser, and with bits of wax candle and silk and feathers and tinsel picked out of silks, she made a knight and his esquire, not so long as a finger, in the perfect costumes of the description. A few years after she made a portrait of a shock dog in bas-relief in wax small; and then heads in wax in the manner of Gosset.'[65] We also see this myth-making in the *Anecdotes of Painting*, where Walpole notes that Damer was taught by the 'masterly statuary Mr. Bacon', and that she was trained by the Italian sculptor Ceracchi, while in 1788, he wrote to another correspondent that 'Mrs Damer has finished a bust of an infant Atys or Paris in marble, that not only surpasses any Grecian flesh, but comes up to the softness and delicacy of Correggio'.[66] Establishing a lineage between Damer and both her classical forebears and contemporary and historic greats of sculpture and painting, here Walpole constructs a model of artistic inheritance that connects Damer's talents

to that of her artistic predecessors, and which thereby reinforces the importance of her contribution to his home.

Indeed, his admiration for Damer's sculptures was specifically articulated via the space of Strawberry through their inclusion in extra-illustrated copies of the *Description*, an act which rooted her works within the wider visual and material culture of the house. This relationship between Damer's sculptures and Strawberry Hill's collections more broadly is particularly potent in the case of the connection between Walpole's famous Roman eagle (first century AD, fig. 5.4) and Damer's *Osprey* (pl. 6), the pair of which were illustrated in both Damer's and Walpole's *Descriptions*. Walpole acquired the eagle in 1745, shortly after its 1742 discovery and

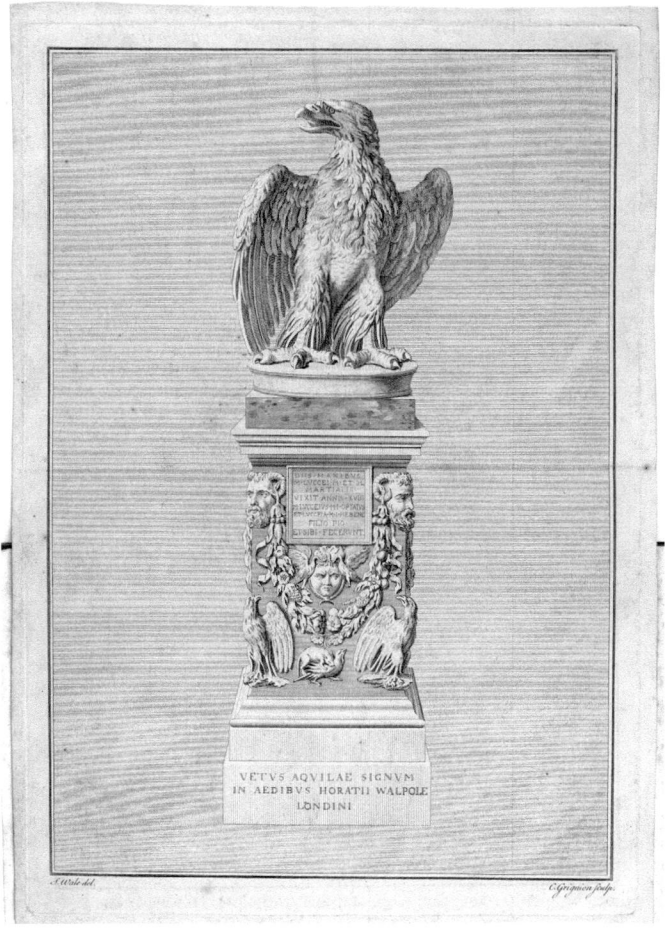

Figure 5.4 Anne Damer, extra-illustrated 1784 edition of *A Description of the villa of Mr. Horace Walpole* (c. 1784–1803). Quarto 33 30 Copy 25. Courtesy of The Lewis Walpole Library, Yale University.

excavation in the gardens of Boccapadugli in Rome.[67] Mounted on a Roman altar decorated with mythological masques, fruit, flowers, and eagle heads, the assemblage finally arrived at Strawberry Hill in 1747, where it occupied pride of place in the house's Gallery. Walpole's esteem for this notable piece is palpable from his description of it in the catalogue of his home, in which he calls it 'One of the finest pieces of Greek sculpture in the world', drawing the viewer's attention to the fact that 'the boldness, and yet great finishing of this statue, are incomparable; the eyes inimitable'.[68] The catalogue of the 1842 sale similarly stressed the high quality of this piece, describing it as 'THE RENOWNED MARBLE EAGLE, matchless as a specimen of sculpture, boldly imagined, and most powerfully carved in the purest statuary marble'.[69] The sculpture even featured in Sir Joshua Reynolds's portrait of Walpole (*c*. 1756–7), where it appears in a printed image that curls down over the lip of the table at which Walpole is working.[70] That it appeared in so public a performance of Walpole's self-fashioning is testament to the centrality of the object in the construction of his identity as a collector, antiquarian, and scholar.

Damer also had a particular affinity for the piece, having repaired its beak with wax.[71] Damer often mended or supplemented Walpole's sculptures with modern additions, for example repairing the curls of his statue of Jupiter Serapis, or creating a bust for the same piece.[72] The Roman eagle was clearly also at least the partial inspiration for Damer's osprey, or 'fishing eagle'. Described in the *Book of Visitors* as 'the fishing eagle in terra-cotta. It was taken in Lord Melbourne's park before Christmas 1786, and one wing almost cut off. Mrs Damer saw it in its rage just taken', the piece depicts a wild-eyed and life-sized osprey, and was housed in Strawberry Hill's Library.[73] Walpole had the following motto added to the piece – 'Non me Praxiteles finxit, at Anna Damer' (not Praxiteles, but Anna Damer made me) – with this witty reference to the infamous ancient sculptor once again locating Damer's work within a mythologizing and legitimizing classical framework.[74]

Walpole called Damer's osprey 'the spoilt child of my antique one', an identification that clearly related the modern sculpture to one of Walpole's most prized classical possessions.[75] Walpole's description of Damer's sculpture as the literal *child* of this antique piece not only places it firmly within the objectscape of Strawberry Hill, but shows how her interventions within the house were cast in terms of explicit lineage. The relationship between the two sculptures is represented visually in both extra-illustrated *Descriptions*. Although Walpole's copy features both images separately, linked via their general proximity alone, Damer's includes the two images together, displayed on opposite, yet overlapping leaves, an arrangement that makes explicit the connection between the two works (fig. 5.5). This is a clear queer family romance of the kind sketched by Davis and Reeve, with

'I love her as my own child'

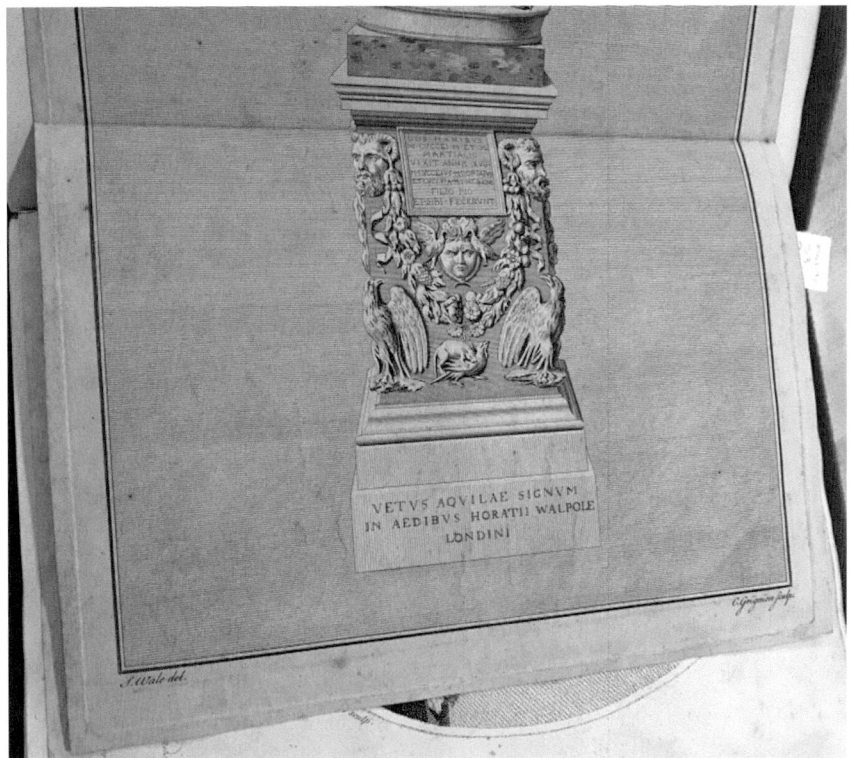

Figure 5.5 Anne Damer, extra-illustrated 1784 edition of *A Description of the villa of Mr. Horace Walpole* (c. 1784–1803). Quarto 33 30 Copy 25. Courtesy of The Lewis Walpole Library, Yale University.

the two birds working in visual dialogue to create a 'family resemblance' among 'objects in a queer collection'.[76] With Damer's osprey evoking a younger, smaller, bird, rendered in a more modern attitude, it is the heir explicit to the first-century sculpture, as echoed by this visual presentation in the text, which deliberately represented Damer's eagle as the modern inheritor of the Roman piece, both aesthetically and in terms of their mutual location within Strawberry Hill.

This celebration of Damer's sculpture was not only reserved for the shared model of extra-illustration that we see in copies of the *Description*. Significantly, Walpole also promoted Damer's talents through this practice beyond his own circle, as Farington tells us in a revealing anecdote. In 1794, he called on Walpole in order to discuss his illustrations for a volume on the Thames, for his and William Combe's opus *A History of the Principal Rivers of Great Britain*, published in 1796. Having informed Walpole that 'some persons thought the skies of the prints of the *Rivers* were too blue', Farington went on to notify him that that 'Mrs

Damer's head of Thames was not introduced on account of its having been very badly executed'.[77] Whether this assertion over quality referred to Damer's sculpture or its printed representation is not clear. By 'Mrs Damer's head of Thames', Farington is referring to Damer's commission to create two sculptural heads, one of Thames and one of Isis, for the purpose of adorning the keystones of the newly built bridge over the Thames at Henley. Writing to Mann in 1785, Walpole described the work's development as follows:

> an extraordinary work: there is just built a new bridge of stone over the Thames at Henley, which is close to Park Place. Mrs Damer offered to make two gigantic masks of the Thame and Isis for the key-stones; and actually modelled them; and *a statuary was to execute them*. I said 'Oh! It will be imagined that you had little hand in them; you must perform them yourself'. She consented. The Thame is an old marine god, is finished, and put up; and they say, has a prodigious effect. She is now at work on the Isis, a most beautiful nymph's face, simple as the antique, but quite a new beauty [...] The key-stones of a county bridge carved by a young lady is an unparalleled curiosity! The originals in terra cotta are now exhibiting at the Royal Academy.[78]

The bridge itself was a familial construction, with its design, according to Walpole, primarily the work of Damer's father, with its form thereby constituting a layering of familial artistic practice that presumably resulted in deepening its place in Walpole's affections, as exemplified by his eventual description of the bridge to Mann as 'the most beautiful one in the world next to the *Ponte di Trinita*'.[79] Usefully, Farington also recorded Walpole's response to his critique of Damer's sculpture (or its printed image), recalling that Walpole 'recommended it – that is the sculpture – to be printed on a sheet to be delivered loose with the second volume, that it might be inserted in the first if people chose it'.[80] Here we see Walpole employing familiar models of prestige and esteem in order to support Damer's sculpture to a broader public, tellingly using the extra-illustrative practices we see in both his and Damer's copies of the *Description*.

Yet despite the prominent inclusion of Damer's sculptural contributions to Strawberry Hill within her own copy of the *Description*, Damer's name actually appears rather infrequently in the two published editions of the text. In the 1774 edition, published before many of Damer's aforementioned works were completed, she is mentioned only a few times, and just once before the Appendix, which begins at page 133.[81] In the Appendix itself, she is listed as a name attached to some gifts given to Walpole and as the creator of some minor works in wax and some small terracotta sculptures, including the sleeping dogs. In the 1784

edition, she appears earlier, but also fairly infrequently. In a text characterized by the densely populated listing of the house's contents, it is accordingly easy to overlook Damer's contributions to the space of Strawberry Hill. Perhaps then, the images of Damer's sculptures that populate her copy of the *Description*, which illustrate her sculptural production both in and beyond those housed at Strawberry Hill, can be viewed as an assertion of Damer's significance to the construction of this space, something that would become increasingly important in the context of Damer's eventual inheritance of the house, which tied her own history intimately with that of the building. Although somewhat absent in the published version of the text, she is undeniably present in her extra-illustrated version, transforming and reorienting the original printed text to function as a background to the exploration of her complex public, private and professionalized identities as a sculptor. As Calè has argued, extra-illustration dismantled and 'destabilized the notions of identity and homogeneity associated with the printed book as a commercial and epistemological object', functioning as a 'radical intervention' in the space of the published text that allowed its (re)makers to reconstitute the book as a 'unique association object', in which personal identity could be foregrounded.[82] Here then, the medium of extra-illustration is particularly significant, reflecting the multiple levels upon which Damer's creative practices were operating: on the one hand commemorating her professional identity as an artist, but on the other, enacting an artistic gesture through the production of the book. Viewed in this way, the extra-illustrated text is as much *about* creativity as it is an *example* of the same. Although women's extra-illustration is often framed in terms of private domestic accomplishment, Damer's copy highlights how it could also be deployed in the service of representing a corpus of high-art production made public through its publication in both printed text and printed image.[83] This reclamation of her public and professional life was particularly important given the vexed status of Damer's career as an artist, which as noted above, was figured by some as an inappropriate intrusion into the public sphere, which opened her up to accusations of various kinds of sexual debauchery.

At the same time, extra-illustration was not only a form of creative production that allowed Damer to reflect on her other artistic practices, but was also one that accorded with the creative models of the 'gift relationship' explored in the previous chapter. With copies of the *Description* gifted from Walpole to his friends, extra-illustration represents a complication of traditional Maussian conceptions of gift exchange that stress the reciprocity necessary to its operation. In the case of the extra-illustrated text, reciprocity did not necessarily mean a

gift in return, but occurred through the creative act of adornment and embellishment through the dedication of time and expense to the project.[84] In this way, the extra-illustrated volume can be viewed as an object that dually reflected and constituted the emotional and social lives of those involved in its production, an association that in this instance mirrors the construction and decoration of Strawberry Hill more broadly.

Genealogical visual and material cultures

Both Damer and Walpole's extra-illustrated copies of the *Description* are dominated by familial references and inclusions, echoing the contents of the printed text. Although the *Description* is generally written from a dispassionate, third-person perspective, the visual and material traces of Walpole's intimate relationships and familial histories appear throughout his account of his home. Despite the rather formal description of portraits of his mother and step-mother in his inventorying of the Great Parlour as follows: 'Catherine, eldest daughter of John Shorter, of Bybrook in Kent, first wife of Sir Robert Walpole; in white: a copy from Sir Godfrey Kneller, by Jarvis. On the other side, Maria Skerret, (in the dress of a shepherdess) second wife of Sir Robert; by Jarvis', the textual density of this genealogical visual and material culture within the depicted space of Walpole's home reinforces its real-life status as a house dedicated to representing these familial lineages and legacies.[85] That Strawberry Hill was a receptacle to both artistic endeavours of, and objects associated with, his close friends and family members has been long established.[86] As highlighted within the *Description*, the house positively teems with objects designed and made by his intimates, with their representations in both paint and print, and with possessions inherited from, and gifted by, his friends and relatives. The affective nature of these collections was also echoed within the decorative programme of the house itself, such as the 'painted glass' windows in the China Room, featuring the crests of the Shorter and Gestinthorpe families, adornments appropriate for a space that was at least partially to house the china collections that had once belonged to Walpole's mother.[87] Likewise, as Reeve has argued, the heraldic decoration of the library enacts a kind of genealogical revenge through which his mother's illustrious lineage is raised above that of his father.[88]

These schemes highlight how the visual and material culture of Strawberry Hill was organized into 'deliberate narrative and thematic trajectories'.[89] These spatial and material narratives connected singular objects of renown within

Walpole's collections with the broader visual and material cultures of his home, emphasizing a number of immediately personal histories.[90] This was typified by the dual nature of Walpole's collections and decorative programme, which included not only portraits of, and objects associated with, those whom he knew and loved, but also those relating to a pantheon of English worthies. Such an approach is demonstrated by his collecting of objects such as the hat of Cardinal Wolsey, or how the China Room was adorned with both Walpole's arms and those of Talbot, Bridges, Sackville families, 'the principal persons who have inhabited Strawberry Hill'.[91] When combined with the gothic nature of the house's architecture and interior design, such inclusions demonstrate powerfully Walpole's attempts to establish his home as an dynastic and ancient seat on the one hand, while serving to express Walpole's emotional relationships in the present on the other. Beyond functioning to materialize relations between Walpole and his close family then, these trajectories served to connect Walpole's efforts towards recording his close family histories with the new interest in documenting, preserving and representing a broader lineage of illustrious persons that emerged during the eighteenth century. Exemplified by the proliferation of published biographies and an emphasis on celebrity that occurred in the second half of the century, such practices complicated boundaries between public and private spheres and identities.

Elizabeth A. Fay has characterized this interest as the 'portrative mode', a term which seeks to understand how the proliferation of a diverse visual, material and literary culture concerned with issues of identity emerged, noting the specific importance of portraiture within this framework.[92] Grand homes increasingly saw ambitious rehangs of their portrait collections during this period, developments which mixed newly commissioned portraits with historic familial examples in order to point to families' long and illustrious histories, thereby tying representations of long dead relatives directly to the affective bonds enjoyed by their surviving members.[93] This combination of intimately personal and broader histories also characterized the collection and display of engraved portrait heads. Beyond their shared focus on Damer's sculptural production, both Walpole's and Damer's extra-illustrated copies are linked by an emphasis on portraiture, inclusions that are typical of extra-illustration as a broader practice. Each volume features a mixture of portraits of those with whom they were personally intimate and portraits of famous people from throughout history. In this, the texts directly follow the model of the *Description* itself, which, in its role as an inventory of Walpole's home, reflected the blended histories of Walpole's own collections. Walpole's extra-illustrated copy of the 1784 edition, for example,

mixes images of his mother and father, and close friends like Gray, with those of infamous figures like Sarah Malcolm (d. 1733) the famous murderer, or Mary Beale the portraitist (1633–99). Likewise, Damer's volume combines portraits of her mother, and her close friends Mary and Agnes Berry, with images of English royalty.

As such, the volumes exemplify the role of personal identity in the reading and writing of histories from this period, in which, as Madeleine Pelling writes, 'the boundaries between historical fact, narrativization, and sentimentality' were notably fluid.[94] The creation of such portrait-dominated extra-illustrated volumes can be attributed to the 'desire for a communal repository of biographical representation' that gave 'visible presence to those invisible bonds that held society together'.[95] Yet this social web of portrait collecting was clearly two-fold, on the one hand, being about social representation at the level of broader society and its interlinking, and on the other, being about experienced or lived sociability on an individual and highly emotional level.

This blurring of personal and national histories is apt for the extra-illustrated text as a genre. Initially it was Granger's desire to use 'personal' rather than 'biographical' as the descriptor in title of his text, a term that has compelling resonances for the current discussion as something that could also mean a 'domestic' or 'private' history during this period.[96] Collapsing public and private, biographical and historical, portraiture therefore had a dual function in such volumes, as differentiated by the varying ideas and expressions of intimacy that appeared through these extra-illustrated texts. Distinct regimes of knowledge operate within these visual, material and literary spaces, at once providing narratives that are historical and intellectual, personal and familial, and even emotional, reflecting at any given moment one's familiarity with British history, the space of Strawberry Hill, and Walpole's friends and family both living and dead.[97] For Walpole they also reflect his identities as a historian, a collector, an antiquarian, a family member and a friend. For Damer, this is more complex again, because they also reflect her professional status as an artist, something that was particularly contested. Such illustrative adaptation and narrative reimagination was therefore particularly appropriate for a text like the *Description*, which almost entirely adopts the form of an inventory-like list. With the text's own narrative emphasis relatively absent, the extra-illustrative process opened up a creative space for Damer and Walpole to mix these histories, and to use this geneological visual and material culture to rewrite and refashion the text into dynamic personal narratives, which in the case of Damer are used to think about female authorship and creativity, and for the expression of a keenly felt loss.

Both Walpole's 1774 extra-illustrated copy of the *Description* and Damer's extra-illustrated copy open with portraits. Although Walpole's volume opens with a classicizing portrait of himself – appropriate here in his dual position as the text's author and later as the text's illustrator – Damer's opens with less immediately logical inclusion, a printed representation of her portrait bust of her mother (pl. 7). Campbell assumes this authorial position by proxy due to her placement in the position where the frontispiece of the text would usually sit, a space often reserved for an author's portrait.[98] As noted above, the extra-illustration of a text was a complimentary gesture; an act which showed one's respect for a book and its author, while providing material testament to their achievements. Mary Berry for example, described how she felt 'flattered by the honour you have done to dear old friend & his darling Strawberry', after viewing Bull's illustrated *Description*, while Horace Walpole himself recounted in a letter to Cole that Bull was 'honouring me, or at least my Anecdotes of Painting', by letting 'every page into a pompous sheet'.[99] The inclusion of a portrait within an extra-illustrated text was not only a flattering gesture, but was also one that could reorient the emphasis of the original published text. Bull for example, prefaced his Strawberry Hill edition of *Mémoires du Comte de Grammont* (1772) not with an image of the author, but with Walpole, thereby displacing the author with a portrait of the text's new editor.[100]

Likewise, Damer's positioning of her mother within this authorial space sets the tone for her book as one inherently about hereditary narratives, familial connection, and women's creativity. Given that so much of Damer's *Description* is about her own artistic creation, placing Campbell (herself an artist whose needleworking was collected and owned by Walpole) in the space of the author wittily identifies Campbell as Damer's author, thereby deliberately playing on the link between bodily creation and artistic creation, or labour (as in birth) and labour (as in work).[101] This connection is only underlined by the fact that Campbell's portrait is in itself an engraved image of a portrait bust of Campbell by Damer, that is, a highly circular image of Damer's maker, made by Damer. Damer's text therefore presents a vision of female creativity that privileges matriarchal inheritance and cultivation, a position that is particularly apt for the description of a place in which the artistic pursuits of each woman had been enshrined in both the physical space of Strawberry Hill, and the textual space of the *Description*'s pages.[102]

Campbell had been a central figure within both Damer and Walpole's lives. Much has been made of Walpole's undeniable affection for Damer's father, whose relationship shared the queer closeness that characterized many of Walpole's close

intimacies with his male friends.[103] Indeed, this was something commented upon by contemporaries, with William Guthrie's pamphlet *Reply to the Counter-address* of 1764 casting their relationship as an '*affaire de coeur*' as part of a notably venomous exchange.[104] This intimacy must have coloured Walpole's relationship with Damer. Yet, it is important to note that Walpole was also particularly fond of Damer's mother, with Lewis writing that Walpole's devotion to her never lessened throughout the course of his life.[105] This affection was reciprocated in material form, through Campbell's creation of needlework firescreens and gifts of delftware for Strawberry Hill.[106] Campbell was also specifically referenced in Walpole's will, in which he bequeathed an annual sum to her on the basis of ensuring that she would be looked after given that her husband had recently 'departed this life'.[107] Correspondingly, Damer's biographer Noble stresses her particular devotion to Campbell, 'upon whom she lavished much care and attention, until death broke the filial link'.[108] This shared commitment to Damer's mother, was itself echoed by their shared closeness with their mothers in general, with Walpole particularly committed to enshrining the memory of Catherine Shorter in the space of Strawberry Hill. Like Campbell, Shorter appears in multiple guises in the house, from her familial arms decorating the roof of the Library, to her appearance in Walpole's collections of portrait miniatures, to the posthumous portrait of her and Sir Robert Walpole painted by John Giles Eccardt around 1754, which was displayed in the house's Blue Bedchamber.[109]

Such displays of filial affection also found articulation in the form of Walpole's extra-illustrated copies of the *Description*. Page 58 of his copy of the 1784 edition of the *Description*, for example, features a double spread of engraved portrait heads of Sir Robert and Catherine Walpole by George Vertue, with this mode of presentation and formal vernacular directly connecting Walpole's parents with the other 'worthies' included in the volume. This form of filial devotion was clearly inherited from Walpole by Damer; indeed, the two *Descriptions* share a specific visual language thanks to Damer's own inclusion of the Vertue prints, which similarly occupy a large space – here a double-page spread of the book. The prominent inclusion of Campbell in place of any frontispiece to the *Description* can therefore be associated within this specific context of representation and inclusion in which motherly identities were celebrated and foregrounded within both house and text. Further to this, was the fact that Damer and her mother would eventually move into Strawberry Hill together following her inheritance of the property, with this adding a layer of resonance to her portrait's inclusion in the extra-illustrated text, in which it becomes an image of potent association, whose appearance in the volume can be read as Damer's physically binding in her mother's story with that of the house itself. This perhaps

represents an attempt on Damer's part to ground her mother's history against a lasting material edifice, something that would have contrasted powerfully with the impermanency of life in a period shortly after her mother's death in 1803.

The loss of her mother was keenly felt by Damer. Writing to Mary Berry in one of her few surviving letters, she recorded that her grief was 'extreme, and, much as I ever thought I should regret this dear mother, I find that regret more painful and deeper than I expected', a pain that gave her the 'feeling of an almost broken heart'.[110] This tragic event is alluded to through several pages pasted into Damer's *Description*. The first is a small watercolour floor plan of the 'The CHANCEL at Sundridge Church, KENT', showing its altar, the graves of Lord and Lady Frederick Campbell (Campbell's parents), the tomb of Lady Campbell

Figure 5.6 Anne Damer, extra-illustrated 1784 edition of *A Description of the villa of Mr. Horace Walpole* (c. 1784–1803). Quarto 33 30 Copy 25. Courtesy of The Lewis Walpole Library, Yale University.

and what had originally been a vacant grave, but which has subsequently been labelled as that of Damer (fig. 5.6). This is followed shortly after by a drawing of the portrait bust of Campbell made by Damer for her mother's monument in the church, which again is amended and identified as such through a later annotation (fig. 5.7). The *Description* also includes lines by the poet Edward Jerningham, written, apparently, about one of Damer's busts of her mother: 'Here Conway in these Features Trace, (which Emulate the living Grace)'. Together with the engraved portrait bust that serves as the volume's frontispiece, these inclusions

Figure 5.7 Anne Damer, extra-illustrated 1784 edition of *A Description of the villa of Mr. Horace Walpole* (c.1784–1803). Quarto 33 30 Copy 25. Courtesy of The Lewis Walpole Library, Yale University.

provide material testament to the role of this extra-illustrated text in commemorating both house and its former resident alike. Indeed, Damer's letter lamenting the death of her mother made explicit the connection between Campbell and the home in which they co-habited: 'All the arrangements, every little improvement at Strawberry Hill, this house, all (sometimes imperceptibly at the moment to myself) tended wholly to procure her amusement and comforts, and all these have lost their value to me'.[111]

Extra-illustrated texts often fulfilled commemorative functions. The infamous Sutherland Clarendon (an extensive multi-volume extra-illustrated edition of Edward Hyde's *History of the Rebellion*, 1702–4), was begun by Hendras Sutherland but completed by his widow Charlotte in a reassuring continuation of her husband's practices that allowed her to manage her grief. Likewise, Bull would accept gifted donations of portraits from family members of their deceased loved ones for his 'Granger'.[112] The physiognomic likeness of portraiture evoked powerful memories, with Walpole himself identifying likeness as calling up 'so many collateral ideas, as to fill an intelligent mind more than any other species'.[113] This associative potential is echoed within Dean's account of extra-illustration, in which she contends that 'the extra-illustrated book is not illustrated in the usual sense; the tipped- and pasted-in additions do not visually re-create actions, things, people, or places represented in the text. Rather, as paper remnants of environments outside the book, they propose to summon those actions, things, people, or places via documentary proxies'.[114] As such, both extra-illustrated texts and the images included within them correspond with the contemporaneous propensity for emotional objects to stand in the stead of those to whom they refer. Read in this way, Damer's extra-illustrated *Description* served to commemorate her mother through its enduring physical presence, a function only reiterated by the portraits that are included in its pages.

Placing Damer's extra-illustrated copy of the *Description* within these contexts, one reveals a fuller picture of its making through which it emerges as a loaded and sentimental object located between narratives of emotion and intellect, taste and sociability, family and legacy. Just as Haggerty has conceptualized Walpole's capacious correspondence in terms of disembodied intimacy, whose presence was negotiated through the large body of letters that Walpole sent and received, here I suggest that Walpole's voluminous correspondence, the decoration and heirlooming of his house *and* the construction of extra-illustrated copies of the *Description* can be reading as functioning analogously to commemorate affection and physicalize these important relationships, of which his familial bond with Damer was an important one.[115]

By refocusing the emphasis of traditional discussions of the *Description* away from anxieties over the house's posterity, and instead concentrating on the explicit emotional narratives that characterize Damer's extra-illustrated copy, a vision of Strawberry Hill that foregrounds the materialization of affection powerfully emerges. Within this context, we can view Walpole's support for Damer as about more than his demonstration of taste, or traditional models of sociable patronage, but as a more overtly emotional process, particularly when combined with the powerful narratives of familial loss that dominate the remainder of Damer's *Description*. Documents such as this thereby offer a compelling reason to read the house and its decoration not merely in terms of Walpole's support and patronage of his myriad friends, but to highlight its potential as a clearly affective space, in which those traditional cultural transactions also work to establish intimacy, to convey affection and to give physical expression to those relationships that were most central for Walpole. In this context then, Damer's inheritance of Strawberry Hill must be read as an unambiguously emotional transaction, an emphasis echoed in his attempts at establishing a queer community around the house.

Queer community and Little Strawberry Hill

Beyond representations of her sculptures and her expression of her love for her mother, Damer's *Description* was characterized by one final type of inclusion: images and documents that relate to the enduring queer community of Strawberry Hill that was to survive Walpole and continue until her own death in 1828. This community reflected the complex and multiple queernesses of Strawberry Hill's inhabitants and neighbours, including Walpole, Damer and Mary Berry. Within the *Description*, the community is represented in ephemeral objects including Walpole's famous lines to Mary and Agnes, printed on Strawberry Hill's press, portraits of the sisters and playbills for private theatricals in which the Berrys and Damer starred, and for others that they wrote. With the plays performed at Strawberry Hill long after Walpole's death, the pasted documents highlight the enduring legacies of his home, revealing a life for the house beyond Walpole himself.[116] As Damer's *Description* suggests, the establishment of this group is an important context for considering the inheritance of the house, one which suggests Walpole's deliberate attempts to create a queer community by not only leaving his house to Damer, but also by leaving another of his properties to Mary and Agnes Berry.

Ideas of queerness are particularly useful for thinking about the varying kinds of identity construction occurring through the heirlooming of Walpole's properties. As Kadiji Amin has argued, queer is 'a singularly mobile and mutable term, capable of adjectivally modifying a range of phenomena – from sex practices, to social formations, temporalities, affects'.[117] At the same time, queer is also explicitly anti-identarian, evoking Haggerty's assertion that Walpole had 'no identity to claim and no label to assume'.[118] As both everything and nothing, it is a fitting appellation for the discussion of a project that crossed multiple kinds of intimacies, relationships, documents and spaces, but all of which ultimately contributed to the establishment of a familially inflected queer community in and around Strawberry Hill. Naomi Tadmor has written compellingly on the complexities of familial groupings in eighteenth-century life, including living groups, circles of kin, lineage families and non-kin circles, which could variously be 'affective' and 'instrumental' or 'sentimental' and 'contractual'.[119] In so doing, Tadmor stresses the flexibility and inclusiveness through which kinship and community models can be understood in relation to more traditional forms of familial construction, such as the lineage family. In many ways Strawberry Hill's communities blend these two conceptions of the family, with Walpole highly concerned with his ancestry, on the one hand, while having no direct heir on the other, and instead choosing to establish a familial network based on emotional intimacy with his friends and the queer potentialities of these relationships.

Having met the Berry sisters in 1788, Walpole was completely enamoured with the pair, playfully calling them his 'sister wives'.[120] Walpole would even go so far as to install them in a nearby property, eventually known as Little Strawberry Hill, which would ultimately be inherited by the women when it was left to them in his will, alongside 4,000l. for each of the sisters.[121] Such an inheritance reveals, as Emily West has described it, Walpole's 'privileging [of] forms of inheritance and affiliation tied to the queer coterie centered at Strawberry Hill'.[122] Little Strawberry Hill is almost entirely absent from discussions of Walpole's home. Yet paying attention to how this house might have formed part of the queer genealogies of Strawberry Hill usefully complicates a notion of queerness that has pervaded scholarship on Walpole and his home, which to date has presented an explicitly masculinized account of the queer relationships and spaces that shaped Walpole's life. Reeve, citing Haggerty, for example, has written about the 'shared sexual subjectivity' of Walpole and his so-called 'committee of taste', reading the very architecture of Strawberry Hill in relation to its owner's queerness.[123] While Reeve has accordingly considered the queerness of Strawberry Hill through an analysis of the complexities of the house's homoerotic potentiality, Damer's *Description* encourages consideration of this queerness in a

quite different way; in terms of the familial world-building enacted between the house and its sister property, emphasizing the queer femininity that was simultaneously central to Strawberry Hill.

The very name of Little Strawberry Hill suggests its own genealogical lineage and physical and emotional relationship with Walpole's home, highlighting the appropriacy of this space for Walpole's establishment of his close friends, the Berrys. The trio's correspondence is highly revealing in terms of Walpole's obsessiveness over the sisters, particularly during the period during which he was seeking a residence nearby Strawberry Hill for them to inhabit. Finding this property was a preoccupation for Walpole. Writing to Mary in 1789, he noted that 'the first object in my thoughts being a house for you, which I cannot find yet'.[124] After a brief stay in Teddington, where Walpole had secured a residence for the sisters, they would eventually take possession of Little Strawberry Hill in 1791. The house in which Walpole sought to install the sisters was that formerly known as Cliveden, once-residence of his friend the actress Kitty Clive until her death in 1785.

In its status as Clive's former home, and thereby a residence previously inhabited by another of Walpole's myriad friends, Little Strawberry Hill was an appropriate choice for the sisters. As at Strawberry Hill, Walpole enshrined his affection for his friends in material form at Cliveden, specifically through the production of an urn dedicated to Clive's memory, which was placed in the garden, and which bore an epitaph written by Walpole.[125]

Like Strawberry Hill, the inheritance of Little Strawberry Hill is delineated in some detail in the body of the will:

> And whereas part of my messuages, lands, tenements and hereditaments at or near Strawberry Hill aforesaid consists of a messuage or tenement and garden with the offices and appurtenances thereunto belonging heretofore in the occupation of Mrs Catherine Clive, deceased, and late of Sir Robert Goodere, Baronet, and of the long meadow before the said messuage between the same and the great road leading to Teddington, now I do hereby (notwithstanding anything hereinbefore contained to the contrary) give, devise and bequeath the said messuage or tenement and garden with the appurtenances late in the occupation of the said Sir Robert Goodere and the said long meadow and also my goods, furniture, and other effects in the same messuage to the uses and purposes following: that is to say, to the use of Mary Berry and Agnes Berry, daughters of Robert Berry of North Audley Street in the County of Middlesex, Esquire.[126]

As for Walpole himself, issues of inheritance were of great concern to the Berry family. Mary and Agnes's father was famously disinherited, with Mary later writing that she had 'suffered in spirits and gaiety from the melancholy difficulties

and little privations of every sort', which this disinherited state had caused for the family.[127] Walpole even described this story in a letter to Lady Ossory recounting his first meeting with the Berrys, in which he provided the story of their disinheritance in full detail, referring to it as a 'precious acquisition'.[128] Beyond Little Strawberry Hill, the Berrys were also entrusted with another important aspect of Walpole's inheritance, that of his literary estate. A wooden box, adorned with an 'O' and containing Walpole's manuscripts, was left to the sisters and their father, Robert Berry, with the instruction that they should produce a new edition of his literary works, with this eventually published in 1798 in a five-volume series titled *The Works of Horatio Walpole, Earl of Orford*.[129] Like Damer's inheritance of Strawberry Hill then, Walpole's bequest to the Berrys can also be understood in terms of the careful propagation of his posthumous reputation. Reading this inheritance as part of the highly deliberate gestures made by Walpole as part of his will makes it clear that it was not only Strawberry Hill, but its surrounding queer community that Walpole was concerned with committing to posterity.

As Noble wrote of Damer's inheritance of Strawberry Hill, 'he had made Mrs Damer his executrix and residuary legatee, on account of her taste in art and her respect for antiquities, to which she added a certain archaeological knowledge acquired during her travels. That Lord Orford should select her as a fitting guardian of the house he loved so well, and of the treasures he collected, was only natural. Many of these cherished objects were of little value to the outside world, but for him each had a meaning and history'.[130] Highlighting the highly personal value, association and emotional meaning inherent to Strawberry Hill, Noble thereby identifies the appropriateness of Damer's inheritance of the house, itself a transaction that represented a material manifestation of those same values and resonances. Not mentioned here, of course, is an unspoken aspect of the appropriateness of Damer's 'fitting guardianship', that of the pair's shared queerness. With each implicated within homosocial relationships characterized by deeply felt intimacy and a lack of adherence to heteronormative models of marriage and family, perhaps this too was part of the impetus for Walpole's bequest. Here then, inheritance works not only as part of an affective, emotional process, but as an attempt at queer familial world building, something in which the objectscape of Strawberry Hill and its multifarious representations and manifestations, was deeply implicated. Although it is important to note that there was no actively articulated sense of shared or common queer subjectivity between men and women at this time, perhaps it is also true to suggest something of a vaguely recognizable yet common alterity between the pair, one certainly intimated at through Walpole's inclusion of *The Damerian Apollo* in his extra-illustrated copy of the *Reminiscences*.

Through their unmarried statuses, both Damer and the Berry sisters lived outside of the marital conventions expected of an eighteenth-century woman. Damer was widowed young after her husband's suicide when she was just twenty-seven, and never remarried, a fact that undoubtedly contributed to the accusations surrounding her. Damer's illicit reputation was also the result of her dangerously public occupation of sculptor, a position that saw her subject to satirical lampooning on account of her apparent lesbianism as early as 1777. Tellingly, the anonymous poem that accuses Damer of lesbianism, the 'Sapphick Epistle' (1771) also mentions Kitty Clive, the former resident of Little Strawberry Hill, a reference that provides a contemporary literary precedent for identifying the queerness of this space.[131] Likewise, neither of the Berry sisters would marry, and the marital statuses of these women, like that of Damer, was notably mentioned in Walpole's will. Beyond their shared rejection of such heteronormative expectations, Damer and Berry's friendship has itself been viewed as queer. Both Emma Donoghue and Andrew Elfenbein have written compellingly on the queerness of Damer and Berry's relationship, emphasizing their passionate intimacy and the excessive sentiment demonstrated by the pair, something that was not only commented on by contemporaries, but which survives in Damer's carefully-made copies of their correspondence, as preserved in her notebooks housed at the Lewis Walpole Library.[132] Although explicit 'evidence' of Damer's lesbianism is absent, Berry and Damer's continuing closeness beyond Walpole's death is made clear in this 1811 letter written by Berry to a mutual friend on the occasion of Damer's leaving Strawberry Hill: 'you cannot conceive how much I regret her giving up Strawberry Hill, for I must ever remember with pleasure the happy rainy days I occasionally passed there; our embarkations, disembarkations, eating Strawberries, the wet grass that adorns the Bay of Biscay, and the terrific adventure of my boat, driven by a gale of wind into Mr. Somebody's garden'.[133] This anecdote reinforces the close relationship enjoyed by the pair, showing how their relationship would centre around the queer spaces of their and their friends' lives.

Berry's and Damer's engagement continued to be focused around the space of Strawberry Hill long after Walpole's death, particularly through their joint production of private amateur theatricals performed at the house. For example, in her diary for the year 1801, Berry records that the play that she had written, 'Fashionable Friends', was performed at the house, with the prologue and epilogue contributed by her friend, the writer Joanna Baillie.[134] The performance was enshrined in literary form through a series of verses anonymously sent to Damer, which praised not only the performance itself, but the specifically female contribution of Damer and Berry in putting on the play. As noted above, the playbill

Figure 5.8 Anne Damer, extra-illustrated 1784 edition of *A Description of the villa of Mr. Horace Walpole* (c. 1784–1803). Quarto 33 30 Copy 25. Courtesy of The Lewis Walpole Library, Yale University.

for the performance is pasted into Damer's extra-illustrated copy of the *Description*, alongside another for a performance of *The Old Maid*, performed by Berry and Damer alongside a number of other friends (fig. 5.8). Placed within the broader context of Damer's *Description*, in which women's productive and creative pursuits are commemorated and praised, the inclusion of these items foregrounds the pair's ongoing creative contribution to the rarefied space of Strawberry Hill. Like the Damer's *Description*, added to over a period of perhaps 15 years, such performances reflect a Strawberry Hill shaped by ongoing and multiple interventions.

Yet these later interventions in the house's history have traditionally occupied a sort of hinterland in the history of Strawberry Hill, falling between the heyday of

Walpole's residence at the house, and the much-discussed sale that saw the dispersal of its contents in 1842. As such, the contribution of Damer (and to a lesser extent, Berry) to this posthumous afterlife of the house can be thought of as a kind of narrative absence that characterizes our understanding of Strawberry Hill more broadly. The space is typified by these kinds of dialogues between absence and presence. While the house survives in something akin to its original form (particularly after the recent restoration of the property), its original visual and material culture is largely absent, brought together only periodically through exhibitions. Likewise, while there is a proliferation of documentary sources relating to Walpole, whose correspondence and literary oeuvre is perhaps one of the richest of all the eighteenth century, we know comparatively little about Damer, a state occasioned by her intentional destruction of her own literary record, and which has resulted in a notable erasure of her presence from the history of the house. Finally, while the house is once again open to the public to tell narratives of the house and its owner, both his, and its broader queerness through figures like Berry and Damer, is relatively absent from these histories. Rethinking the history of the house's inheritance then, is a way to address these absences, to reintroduce overlooked objects, figures and queernesses into the history of Strawberry Hill. Whether through a consideration of Damer's inheritance of the house itself and how this relates to Walpole's broader concerns around the dispersal of his collections, or through an examination of Damer's extra-illustrated copy of the *Description*, such an emphasis allows for an enrichment of Strawberry Hill's diverse histories to encompass accounts of women's artistic practice, familial histories, emotional expression and queer world building, interests shared by both Walpole and Damer, and which was reflected in both the inheritance of house and the inheritance of extra-illustration as a practice, alike.

Notes

1 Lewis, *Correspondence*, 15: 335.
2 Ibid., 337.
3 Ibid.
4 *True Briton* (London, England), 21 March 1797; Issue 1322. Emphasis original.
5 Lewis, *Correspondence*, 30: 349.
6 Ibid., 350.
7 *True Briton*, 6 March 1797. *The Times*, 17 March 1797.
8 *Whitehall Evening Post*, 14 March 1797.

9 On visiting Strawberry Hill, see Clarke, '"Lord God! Jesus! What a House!"'.
10 See for example, Lewis, *Correspondence*, 37: xxvii.
11 Ibid., i.
12 Anne Damer, extra illustrated copy of *A Description of the villa of Mr. Horace Walpole*, Quarto 33 30 Copy 25. Lewis Walpole Library, Yale University.
13 For a detailed discussion of the varying forms taken by the *Description*, see Clarke, '"Lord God! Jesus! What a House!"'.
14 See Chapter 3 of Reeve, *Gothic Architecture*. Reeve borrows the term from the work of Whitney Davis. Davis, 'Queer Family Romance in Collecting Visual Culture', *GLQ*, 17, no. 2–3 (2011): 309–29.
15 On Bateman, see Matthew M. Reeve, 'Dickie Bateman and the Gothicization of Old-Windsor: Gothic Architecture and Sexuality in the Circle of Horace Walpole', *Architectural History*, 56 (2013): 97–131.
16 Lewis, *Correspondence*, 1: 325–6.
17 Matthew M. Reeve, 'Gothic Architecture, Sexuality, and License at Horace Walpole's Strawberry Hill', *The Art Bulletin*, 95, no. 3 (2013): 411.
18 Stephen Bann, 'Historicizing Horace', in Michael Snodin and Cynthia Roman (eds), *Horace Walpole's Strawberry Hill* (New Haven and London: Yale University Press, 2009), 121–2.
19 Luisa Calè, 'Gray's Ode and Walpole's China Tub: The Order of the Book and the Paper Lives of An Object', *Eighteenth-Century Studies*, 45, no. 1 (2011): 113. On the possibility that Walpole was not Robert Walpole's youngest son, see Anne Williams, 'Reading Walpole Reading Shakespeare', in Christy Desmet and Anne Williams (eds), *Shakespearean Gothic* (Cardiff: University of Wales Press, 2009), 13–36.
20 Horace Walpole, *A Description Of The Villa Of Horace Walpole, Youngest Son of Sir Robert Walpole Earl of Orford, At Strawberry-Hill, near Twickenham. With an Inventory of the Furniture, Pictures, Curiosities, &c.* (Strawberry Hill, 1784), ii.
21 Calè, 'Gray's Ode and Walpole's China Tub': 114.
22 Horace Walpole, *A Description Of The Villa Of Horace Walpole, Youngest Son of Sir Robert Walpole Earl of Orford, At Strawberry-Hill, near Twickenham. With an Inventory of the Furniture, Pictures, Curiosities, &c.* (London: Kelly & Co. 1842), 3.
23 As Emily West points out, Mary Berry also noted how Walpole conceived of the collections in these terms 'in describing Strawberry-hill lord Orford must be considered with indulgence as a fond and partial parent dwelling with delight on the merits of a favourite child – of a creation of his own'. Berry, "Preface by the Editor," in *The Works of Horatio Walpole, Earl of Orford* (London: Robinson and Edwards, 1798), 1: viii, cited in West, '"A little play-thing-house": Queer Childishness at Strawberry Hill', draft manuscript (2019).

24 Lucy Peltz, *Facing the Text: Extra-Illustration, Print Culture and Society in Britain, 1769–1840* (Manchester & San Marino, CA: Manchester University Press & The Huntington Library Press, 2017), 201.
25 Stephen Clarke, *The Strawberry Hill Press & its Printing House: An Account & An Iconography* (New Haven & London: Yale University Press, 2011), 26.
26 Walpole, *A Description* (1842), 3.
27 Jonathan David Gross, *The Life of Anne Damer: Portrait of a Regency Artist* (Plymouth: Lexington Books, 2014), 1 and 3.
28 Percy Noble, *Anne Seymour Damer: A Woman of Art & Fashion, 1748–1828* (London: K. Paul, Trench, Trübner & Co. Ltd. 1908), vii and 6. Lewis, *Correspondence*, 35: 544–5.
29 George Haggerty, *Horace Walpole's Letters: Masculinity and Friendship in the Eighteenth Century* (Lewisburg: Bucknell University Press, 2011), 85. Silvia Davoli, *Lost Treasures of Strawberry Hill: Masterpieces from Horace Walpole's Collection* (London: Scala Publishing, 2018).
30 Lewis, *Correspondence*, 20: 317 and 25: 184.
31 Calè, 'Gray's Ode and Walpole's China Tub': 113.
32 For a broad history of extra-illustration, see Peltz, *Facing the Text*.
33 For a more in-depth analysis of the extra-illustrative practices around Strawberry Hill, see Peltz, *Facing the Text*, Chapter 7.
34 Lucy Peltz, 'Engraved Portrait Heads and the Rise of Extra-Illustration: The Eton Correspondence of the Revd James Granger and Richard Bull, 1769–1774', *The Volume of the Walpole Society*, 66 (2004): 5.
35 Clarke, *The Strawberry Hill Press*, 26.
36 Gabrielle Dean, '"Every Man His Own Publisher": Extra-Illustration and the Dream of the Universal Library', *Textual Cultures*, 8, no. 1 (2013): 57.
37 Ibid.
38 Peltz, 'Engraved Portrait Heads'.
39 Lewis, *Correspondence*, 1: 61.
40 Ibid., Vol. 38: 195.
41 Peltz, *Facing the Text*, 201.
42 Horace Walpole, *A Description of the Villa of Horace Walpole, Youngest Son of Sir Robert Walpole, Earl of Orford, at Strawberry Hill, near Twickenham* (Strawberry Hill, 1774), 48.
43 Peltz, *Facing the Text*, 201.
44 Ibid., 201 and 203.
45 Lewis, *Correspondence*, 30: 373.
46 Calè, 'Gray's Ode and Walpole's China Tub': 109.
47 Here I refer to Strawberry Hill's print room, described by Walpole as decorated 'in a new manner invented by Lord Cardigan, that is, hung with black and white borders

printed', as well as its tearoom, 'hung with green paper and prints'. Cited in Kate Heard, 'The Print Room at Queen Charlotte's Cottage', *British Art Journal*, 13, no. 3 (Winter 2012/13): 53–4.

48 Calè, 'Gray's Ode and Walpole's China Tub': 117. Ruth Mack also explores this connection in her essay in Snodin and Roman (eds), *Horace Walpole's Strawberry Hill*, 107.

49 Peltz, *Facing the Text*, 43.

50 Ibid.

51 The correspondence between Bull and Granger is published in its entirety in Peltz, 'Engraved Portrait Heads'. Anne Damer Scrapbooks, Folio 53 D18 828. Lewis Walpole Library, Yale University. Anne Damer Notebooks, LWL Mss Vol. LXIV. Lewis Walpole Library, Yale University.

52 Clarke, '"Lord God! Jesus! What a House"': 358.

53 The extra-illustrated editions of Walpole's text to which this chapter refers are as follows: 49 2523, Horace Walpole, extra-illustrated 1774 edition of *A Description of the villa of Mr. Horace Walpole*. Lewis Walpole Library, Yale University and 49 3582 Horace Walpole, extra-illustrated 1784 edition of *A Description of the villa of Mr. Horace Walpole*. Lewis Walpole Library, Yale University.

54 Lewis, *Correspondence*, 12: 272.

55 Ibid., 15: 576.

56 On Damer's life as a sculptor, see Alison Yarrington, *The Female Pygmalion: Anne Seymour Damer, Allan Cunningham, and the Writing of a Woman Sculptor's Life* (Edinburgh: Public Monuments and Sculpture Association, 1997). On her public reputation and the accusations of lesbianism that accompanied this status, see Andrew Elfenbein, *Romantic Genius: The Prehistory of a Homosexual Role* (New York: Colombia University Press, 1999), and Emma Donoghue, '"Random Shafts of Malice": The Outings of Anne Damer', in Caroline Gonda and John C. Benyon (eds), *Lesbian Dames: Sapphism in the Long Eighteenth Century* (London: Routledge, 2010), 127–46.

57 Damer, Scrapbooks.

58 Lewis, *Correspondence*, 35: 385.

59 See Cynthia Roman, 'The Art of Lady Diana Beauclerk: Horace Walpole and Female Genius', in Snodin and Roman (eds), *Horace Walpole's Strawberry Hill*, 155–60.

60 Lewis, *Correspondence*, 38: 198–9.

61 Ibid., 35: 184.

62 Ibid., 292.

63 Horace Walpole, *Anecdotes of Painting in England; With Some Account of the Principal Artists*, edited by R.N. Wornum (London: Chatto & Windus, 1876), 1: xx–xxi.

64 Lewis, *Correspondence*, 12: 271

65 Ibid., 273.
66 Walpole, *Anecdotes*, 1: xxi and xxii. Lewis, *Correspondence*, 35: 437.
67 'Cat. 138' in Snodin and Roman (eds), *Horace Walpole's Strawberry Hill*, 308.
68 Walpole, *A Description* (1784), 49.
69 *A Catalogue of the Classic content of Strawberry Hill, collected by Horace Walpole sold, by auction, 25th of April, 1842* (London: Smith & Robbins, 1842), 235.
70 See Haggerty, *Horace Walpole's Letters*, 71.
71 'Cat. 138', in Snodin and Roman (eds), *Horace Walpole's Strawberry Hill*, 308.
72 Lewis, *Correspondence*, 39: 442.
73 Ibid., 12: 272.
74 Ibid., 33: 564.
75 Ibid.
76 Davis, 'Queer Family Romance': 310.
77 Lewis, *Correspondence*, 15: 319.
78 Ibid., 25: 576.
79 Ibid., 613.
80 Ibid., 25: 319.
81 Damer appears a total of eight times in the 1774 edition of the Description, and a total of 15 times in the 1784 edition of the text.
82 Calè, 'Gray's Ode and Walpole's China Tub': 105–6.
83 On Bull's daughters, see Peltz, *Facing the Text*, 39.
84 Ibid., 185.
85 Walpole, *A Description* (1774), 6.
86 See, for example, George Haggerty, 'Strawberry Hill: Friendship & Taste', in Snodin and Roman (eds), *Horace Walpole's Strawberry Hill*, 75–85.
87 Walpole, *A Description* (1774), 8. For a more in-depth discussion of genealogical emphases in the decorative scheme of Strawberry Hill, see: Reeve, 'Gothic Architecture, Sexuality, and License'.
88 Reeve, 'Gothic Architecture, Sexuality, and License': 430. Emma J. Clery, *The Rise of Supernatural Fiction* (Cambridge: Cambridge University Press, 1995), 75–6.
89 Reeve, 'Gothic Architecture, Sexuality, and License': 428.
90 See Alicia Weisberg-Roberts, 'Singular Objects & Multiple Meanings', in Snodin and Roman (eds), *Horace Walpole's Strawberry Hill*, 87–97.
91 Walpole, *A Description* (1774), 8.
92 Elizabeth A. Fay, *Fashioning Faces: The Portraitive Mode in British Romanticism* (Lebanon, NH: University of New Hampshire Press, 2010). Both Kate Retford and Marcia Pointon have demonstrated the predominance of these issues within the decoration of familial seats through an examination of country house portrait galleries. See Kate Retford, 'Sensibility and Genealogy in the Eighteenth-Century Family Portrait: The Collection at Kedleston Hall', *The Historical Journal*, 46, no. 3 (2003): 533–60; and

Marcia Pointon, *Hanging the Head: Portraiture and Social Formation in Eighteenth-Century England* (New Haven & London: Yale University Press, 1993), 159–76.
93 Peltz, *Facing the Text*, 112.
94 Madeleine Pelling, 'Reimagining Elizabeth I and Mary Queen of Scots: Female Historiography and Domestic Identities, *c.* 1750–1800', *Women's History Review*, 29, no. 7 (2019): 1086. See also: Mark Salber Phillips, '"If Mrs Mure be not sorry for poor King Charles": History, the Novel and the Sentimental Reader', *History Workshop Journal*, 43 (1997): 110–31.
95 Peltz, *Facing the Text*, 113.
96 Pointon, *Hanging the Head*, 54.
97 On Walpole's conceptions of history, see Marion Harney, *Place-Making for the Imagination: Horace Walpole & Strawberry Hill* (Aldershot: Ashgate, 2014).
98 Marcia Pointon, *Portrayal and the Search for Identity* (London: Reaktion, 2013), 23.
99 Cited in Peltz, *Facing the Text*, 189. Lewis, *Correspondence*, 2: 273.
100 Peltz, *Facing the Text*, 185.
101 As Lewis notes, Walpole 'expressed his admiration of her worsted-work pictures in the fourth volume of his *Anecdotes of Painting*, where he called her 'a very great mistress of the art' of needlework who surpassed several good pictures she copied'. Lewis, *Correspondence*, 37: xvi.
102 For example, Walpole describes 'A fire-screen of admirable needle-work, representing a vase of flowers, by lady Caroline Campbell, daughter of John duke of Argyll, countess of Ailesbury' in the *Description*. Walpole, *A Description* (1784), 5.
103 Haggerty, *Horace Walpole's Letters*, 30–5.
104 Reeve, *Gothic Architecture*, 6.
105 Lewis, *Correspondence*, 37: xvi.
106 Walpole, *A Description* (1774), 16.
107 Lewis, *Correspondence*, 30: 374.
108 Noble, *Anne Seymour Damer*, viii.
109 For more on this portrait, see Davoli, *Lost Treasures*, 65.
110 Lewis, *Extracts*, 2: 218.
111 Ibid.
112 Peltz, *Facing the Text*, 116. For the Sutherland Clarendon, see 'Part III' of this text (273–350).
113 Peltz, 'Engraved Portrait Heads', 18. John Pinkerton (ed.), 'Portraits', *Walpoliana* (London, 1798), 1: 26.
114 Dean, '"Every Man His Own Publisher"': 58.
115 Haggerty, *Horace Walpole's Letters*, 22–3.
116 Stephen Clarke, 'The Strawberry Hill Sale of 1842: The Most Distinguished Gem that has Ever Dorned the Annals of Auctions', in Snodin and Roman (eds), *Horace Walpole's Strawberry Hill*, 261–74.

117 Kadji Amin, 'Haunted by the 1990s: Queer Theory's Affective Histories', *Women's Studies Quarterly*, 44, no. 3/4, Queer Methods (2016): 173.
118 Robert Tobin, *Warm Brothers: Queer Theory in the Age of Goethe* (Philadelphia: University of Pennsylvania Press, 2000), 3. Haggerty, *Horace Walpole's Letters*, 3.
119 See Naomi Tadmor, *Family and Friends in Eighteenth-Century England: Household, Kinship and Patronage* (Cambridge: Cambridge University Press, 2001).
120 Lewis, *Correspondence*, 11: 110.
121 Ibid., 30: 364.
122 West, '"A little play-thing-house"'.
123 Reeve, 'Gothic Architecture, Sexuality, and License': 411. Here Reeve cites Haggerty, 'Strawberry Hill: Friendship & Taste', 75–9.
124 Lewis, *Correspondence*, 30: 176.
125 Ibid., 2: 374.
126 Lewis, *Correspondence*, 30: 363.
127 Lewis, *Extracts*, 1: 4.
128 Ibid., 151.
129 Lewis, *Correspondence*, 2: 21.
130 Noble, *Anne Seymour Damer*, 145.
131 Anon. *A sapphick epistle, from Jack Cavendish to the Honourable and most beautiful Mrs D***** (London, 1771). See Donoghue, '"Random Shafts of Malice"', 131.
132 Ibid., 137–9.
133 Lewis, *Extracts*, 1: 465.
134 Lewis, *Extracts*, 2:116.

Conclusion: Materializing Loss

Lost objects

On 14 December 1795, Caroline Lybbe Powys recalled dining with her husband at Park Place in Berkshire, the residence of her friend, and Anne Seymour Damer's mother, Caroline Campbell, Countess of Ailesbury, following the recent death of Campbell's husband, Henry Seymour Conway.

> Mr Powys and myself dined at Park Place. Lady Ailesbury insisted on our going. It was a visit we much wished to avoid, as her Ladyship was going to quit that sweet place for ever the next day but one, and, of course, everything bore so melancholy an appearance that it was hardly possible to keep one's spirits on the thoughts of losing so kind a neighbour.[1]

Here, in this short anecdote, Lybbe Powys gestures towards the three overarching themes that have characterized this book and its treatment of the late eighteenth- and early nineteenth-century home: materiality, sociability and emotion. Referencing the typical rituals of engagement that included visiting friends in their residences, the excerpt highlights how the home was routinely a space in which sociability was enacted, and in which emotional relations were formed. Yet, as this diurnal fragment attests, the home was more than a passive backdrop for the performance and rehearsal of such connections. Instead, the very materiality of the home was central to how it enacted this affective function, something reinforced here by the predicted absent materiality occasioned by Ailesbury's move, with that material loss identified as a potential cause for future unhappy feelings on the part of Lybbe Powys.

Unlike the remainder of Lybbe Powys's journals, which figuratively brim with described objects, here, it is not the presence of an object that guides its commentator, but the very lack of the same; making for a complexly drawn vignette haunted by the ghosts of an absent material culture, anticipatorily replaced by a new. Yet this absence signals much more than lack. Instead,

the uninhabited Park Place, as well as the descriptions that preserved its transformation, constitute a potent example for thinking through the coactive issues of emotional and material loss and their textual legacies discussed throughout this book. Thinking about the empty space of Park Place accordingly allows us to consider the important role of loss in sociability, emotion, and materiality not only during this period, but for our historical understanding of these ideas. Owned by Damer's parents, Park Place was an important emotional space for the historical actors featured in several of the book's chapters, including Horace Walpole, Lybbe Powys, Damer and her family, and Mary and Agnes Berry, sisters and close confidantes to both Damer and Walpole. With various responses to the empty Park Place recorded by contemporaries, these accounts show how loss was central to how the home's visual and material cultures expressed, reflected and consolidated its social and emotional lives; reinforcing the idea that the empty house by no means represents the end of the story.

Four years later, in 1799, Lybbe Powys revisited Park Place, now under the ownership of James Harris, 1st Earl of Malmesbury (1746–1820) and his wife Harriet (1761–1830), who were giving a ball at the house. In a detailed account, she described the seventy-five guests, dancing, gambling, the refreshments served ('tea, orgeat, lemonade, cakes, &c. brought round every half-hour'), and the 'gilt-plate and glass lustres' of the tableware.[2] In the final part of her description of the 'new' Park Place, Lybbe Powys expressed relief that the newly transformed house did not recall its former owners:

> so intimate had we been with Marshal Conway and Lady Ailesbury, that it was really a painful sensation the idea of visiting again at Park Place; but now the whole house is so totally alter'd, one cannot have an idea of its being the same [...] the whole appearance totally different to those who were before perfectly acquainted with it.[3]

Beyond the loss of its earlier material culture then, Lybbe Powys's memories of Park Place also tell of the processes of improvement, refinement and personalization that the house underwent at the hands of its various owners. Her reluctance to visit Lady Ailesbury when the house was being packed away is highly telling: as we have seen, to her, ownership and personal association were indivisible from a home's interior decoration. The journal entry is therefore typical of Lybbe Powys's writings more broadly, in which, as demonstrated in Chapter 1, descriptions of hospitality and material culture were closely linked with her sense of acquaintance and intimacy with a home's owner.

The changes that characterized Park Place's redecoration can therefore be viewed a process of identity formation, a refashioning and redressing of the house that signalled its new ownership. For example, in fitting up the house with objects such as the 'fine collection of books', housed in its library, including 'a folio edition of all the Greek and Latin classics', and 'very fine copies of all the diplomatic books, dictionaries, foreign topography', its new owner exploited the cachet of the antique to visually and materially demonstrate taste and learning, as we also saw at Wilkes's Cottage. Several chapters of this book seek to establish the importance of domestic space and its material culture as a site of self-fashioning and identity formation. The decoration of Plas Newydd's rooms, as discussed in Chapter 4, recalls the idea of the interior as one's world reconstructed in miniature. The Drawing Room, adorned with gifted drawings depicting the local area, suggests the house's close relationship with the surrounding Welsh countryside, a landscape that had transformed Butler and Ponsonby's lives and had facilitated their comfort following their flight from Ireland. Likewise, the fragments of wood and glass collected from nearby buildings that adorned the house's interior and exterior spaces similarly evoked feelings of the local and the personally significant. When gifted by their friends, drawings, wood and glass alike took on another layer of affective significance, functioning as a synecdoche for their relationships, as well as a microcosmic replication of shared emotions, memories, and experiences.

If, as demonstrated above, Park Place's decoration under both Lady Ailesbury and Lord Malmesbury signalled the close alignment between material culture and identity during this period, it is clear that such furnishings also had a deeply affective function. The connection between house and emotion is exemplified by Mary Berry's own reactions to Park Place following the departure of Damer and her mother from the house. When, in 1811 Berry visited the property, she described it with dismay:

> It is impossible to describe the melancholy I felt at again finding myself at Park Place. We entered it by the kitchen garden, and from thence into the little flower-garden, where several recollections totally overcame me. They needed not the additional melancholy which the forlorn, the neglected, the ruined look of everything gave them. Had I known nothing of the inhabitants I could have sworn, only from seeing the place, that they cared little for the country. Poor Park Place! how changed in every particular! [...] I shall probably never see it again, nor do I wish it; lest the image of it in its present state should derange and confuse my former recollections of its beauties, its comforts, its inhabitants, and my last winter visit there, when I vainly hoped for and looked forward to happiness within my grasp.[4]

Unlike Lybbe Powys, whose concern that Park Place would too closely resemble the form it had taken under the ownership of Lady Ailesbury was met with relief at its differences, for Berry, the very pain of visiting the house lay in its lack of resemblance. The following day, she wrote to Damer, lamenting that 'never did I see a place [...] so perfectly changed, so *triste*, so comfortless'.[5] For Berry, the affective associations of material culture could also render its luxuries cold and joyless. As such, this anecdote suggests how we might not always understand the relationship between domestic space and its objects, and those who owned, inhabited and viewed it, as entirely positive. In the case of Park Place, visitors to the house, like Powys and Berry, had to negotiate the difficult feelings and strong emotions engendered by this lost material culture; while in other houses examined in this book, owners actively anticipated and tried to address the unsettling potential loss of their belongings that would follow their deaths.

Berry's letters from the second half of the 1790s onwards are typified by these kinds of negatively melancholic and materially inclined reminiscences, occasioned, no doubt, by the deaths of some of her close friends such as Walpole, and the movement of others, like Damer and her mother, from the homes she had long known them in. In 1798, for example, Berry wrote to Damer about Park Place from Cheltenham, noting that 'This place and everything about it recalls, in the most lively manner, scenes and recollections to my mind'. Berry then imagines Damer sitting in the library of Park Place, seeing her form 'on a ladder, arranging the new-placed books', as well as herself and Damer in the gardens of the house, thereby recalling the evocative potentiality of places revisited, a process recently discussed by Joanne Begiato.[6] Berry articulated such feelings specifically in relation to the space of the home, writing that 'I know few things more melancholy than to visit the empty house of intimate friends, where one has passed many many days in cheerful company. A thousand recollections immediately rise to one's memory, from which everything tiresome, or dull, or disagreeable, has vanished with the intermediate time, and nothing but what is charming (and consequently the more to be regretted) remains'.[7]

Beyond Park Place, Berry's conception of the empty home also occupied the spaces of Strawberry Hill and her own home of Little Strawberry Hill, the sites of the queer community outlined in Chapter 5. After leaving Little Strawberry Hill in 1807, for example, she returned to the house, expressing her sadness at 'our adieu to Little Strawberry. I took a turn round the enclosure quite alone. The recollections that my walk brought to mind were all melancholy [...] From thence I made a melancholy pilgrimage all round the outside of Little and large Strawberry Hill'.[8] Later she would write that 'Never again will I take such another

walk; all that it recalled to my remembrance, all that it made me think of, all the regrets it suggested, quite overcame me'.⁹ Such reminiscences thereby offer a provocatively oppositional account of emotional materiality to that described in the previous chapter, in which inheritance, or the acquisition of property, was identified as a central process through which Strawberry Hill functioned to express the sentiments and emotions of Walpole and his circle. Here then, in Berry's reminiscences, we find a narrative in which the materiality of these same homes and spaces was not inherited, but lost. As discussed in Chapter 5, Walpole explicitly anticipated the dispersal of his collections and the destruction of his home, something that occurred most palpably through the sale of his belongings of 1842. Around this time, Berry received a letter from a friend, who noted that he had been amusing himself 'lately by looking over the catalogue of the Strawberry Hill collections, and, as you may suppose, have had you often enough in my mind as I went through names and little anecdotes which must be pregnant to you with so many touching recollections'.¹⁰ This note underscores not only that Berry's understanding of domestic material culture in terms of evocation and embodied memory was one shared by her contemporaries, but also that this was a source of affective contemplation that could be textually rooted; an enduring memorial to a collection that sat in direct contrast with a material culture that was, or soon would be, dispersed and lost.

Loss objects

Sometime around 1829, Mary Parminter acquired a slip-coated earthenware harvest jug (pl. 8) from the local pottery at Fremington in Devon. Decorated in yellow, brown and grey glazes, and engraved with a pattern of birds and flowers, the jug's dedication is a meditation upon the relationship between materiality, life and death; testament to the close relationship between individuals and objects that characterized late eighteenth- and early nineteenth-century mourning cultures. Reading 'None with the potter can compare / we make our potts with what we potters are / Our greatest creator formed us of dust / And to the same return we shortly must / Miss Parminter A la Ronde, 1829', the jug's inscription evokes the materials from which it derived – namely, the local clay used by the Pottery – while suggesting its potential commemorative function. Commissioned by Mary almost two decades after her close cousin Jane Parminter's death in 1811, its production can be read as echoing the specific loss of Jane from the tightly bound homosocial space of A la Ronde, the house in

which the two women lived from *c.* 1796 and 1849, as discussed in Chapter 3 of this book. Comparing the clay of the earth with the flesh of the human body ('we make our potts with what we potters are') the author of the inscription draws a compelling line between humans and material culture, one which attests to the centrality played by the creation of objects in the creation of the self.

While recalling the specific broken familial link between Jane and Mary Parminter, the jug also speaks to some of the broader issues at stake in the connection between humans and inanimate objects at this time, such as the duality of material permanency and contrasting physical corruptibility, and the development of aesthetic conventions for the visual and material expression of loss. As we have seen throughout this book, the commemorative association between an individuals' affective relations and material objects is one of the defining characteristics of the late eighteenth- and early nineteenth-century's emotional cultures. In Esther Milnes Day's 1796 poem, *Lines Written on the Anniversary of the Death of a tender Mother,* for example, the writer directly relates her mourning with the material objects left behind by her mother:

> I trace thy active step, thy cheerful looks,
> Hang o'er thy couch, and weep upon thy books;
> These books, I trust, shall be my constant guide,
> Press'd by thine hand in many a folded side!
> O, my full heart! – here breath'd her daily prayer,
> That Providence would make our paths his care!
> Dim's the dear page, by frequent service torn;
> And mark'd the leaf, by her lov'd fingers worn!
> Yes, I will kiss them, fold them to my heart;
> Dear Precious treasures, never shall we part![11]

For the poem's protagonist, her mother's books are her 'constant guide' in two ways – both in their theological content and their material presence – the latter of which reminds her of the consoling aura of her mother. Notably, the narrator's account of the books stresses their materiality; being worn and torn, they show the indelible mark of her mother's interaction, and she herself has a highly material response, 'folding [the pages] to her heart'. Crucially, however, unlike her mother, the 'Dear Precious treasures' will never leave her, fulfilling a longing that the loss of her mother has opened up.

Many of Milnes Day's poems describe associational objects such as these books, including 'little hoarded treasure boxes', a dropped 'posy of wildflowers', and even a miniature portrait 'taken from the lifeless bosom' of the subject's

'unfortunate Lover, when thrown on shore after the shipwreck'.[12] Objects that evoked memory, absence, and loss populate poetry, published novels, and private writing alike at this time. For example, on 17 January 1820, Lady Penelope Pennington wrote to her close friend, Hester Piozzi in a state of dismay brought on by a discussion that had taken place between the two during a recent visit to Bath. Pennington had apparently brazenly asked if, once Piozzi had passed, she might inherit her silver teapot:

> I am on very ill terms with myself respecting the silly speech I made about your pretty *Silver Tea Pot*. Sincerely and fervently do I pray and believe you have many years before you, than I have any right, from constitution and the present state of my feelings, to reckon upon. And it would be worse than absurd to rob you of an article of daily use, to throw it into the hands of other people. All I *can* consent to therefore, is that you continue to use it, dear Friend. Long may you continue to do so, and should the most fateful deprivation I can now ever feel (but one) befall me, desire Betsey to deposit *it* and I will drink my tea from it for the rest of my life, and mingle my tears with the fragrant libation.

In this imagined inheritance, Piozzi's teapot was the material signifier of her ownership, and one that by way of this association would serve to daily remind Pennington of her deceased friend, prompting the viscerally emotional response envisioned above. Despite her perceived indiscretion, Piozzi left the teapot to Pennington in her will, who would describe her grief following Piozzi's death as an irreparable loss.[13]

In her work on the how objects reflect the history of conflict, Elizabeth Crooke suggests that objects such as Piozzi's teapot 'provide a link that builds upon the self and the present – be it a link to the past or a link to significant others [...] artefacts become a reflection of the self in various life phases and, at times of transition and loss, a means to maintain a sense of personal identity. When mourning a death, objects may bring comfort or pain'.[14] Material objects therefore provide a central means by which to negotiate the loss of a significant relationship, presenting at once an inanimate space upon which to project the emotional pain of mourning, and simultaneously, a chance to objectify the memory of that person within a material characterized by its contrasting incorruptible permanency. This complex relationship between absence and presence is crucial to our understanding of eighteenth- and nineteenth-century material culture. Operating on several levels, such 'loss objects' could variously be associational objects which recalled a lost family member, friend or lover, through their opposing continued presence; commercial and 'mass produced'

objects that explicitly engaged with, and were used to express, bereavement; and finally, objects whose own absence and lost status reinforced feelings of longing and grief. Absence and presence therefore provide a framework for understanding contrasts between surviving material durability and fleeting emotional ephemerality; representation and reality; states of materiality and immateriality; and even the relationship between subject and object. Yet this dynamic is as fundamental to how contemporaries used objects to express and develop emotional attachments to material culture, as to how we as historians continue to read material culture in the present.

Mediating loss

This book has been deeply concerned with the relationship between domestic material culture and its visual and literary representations, as exemplified by Lybbe Powys's highly descriptive brand of travel writing. Her ekphrastic reproductions of domestic space offer an interpretative context through which to understand the social and material functions of the eighteenth-century home. Her account of Malmesbury's redecoration of Park Place is typical of the responses to domestic spaces that populate her journals. Describing the permanent decoration of the house, she recalls it as 'furnish'd with every elegance from Italy, France, and, in short, every country – fine pictures, pier-glasses, paintings, of the Vatican Library, some curious tables, &c., that belonged to the unfortunate Louis XVI, and many other curiosities too numerous to name, with the finest collection of books anywhere to be met with'.[15] In these descriptions, Lybbe Powys follows contemporary models of epistolary writing and travel literature, whose undertaking can be profitably situated within broader practices such as visiting, domestic tourism and the physical and ideological consumption and production of domestic space. Her writings were not the only texts in which Park Place was ekphrastically rendered. Indeed, descriptions of the house occupied column inches, space in contemporary journals like the *Gentleman's Magazine* and guides to London and its environs.[16] As we have seen, these texts recorded impressions, informed absent participants and, if published, assured literary posterity for authors and residents alike. As a genre, travel writing was vociferously read, with its prescribed routes emulated and replicated. Accordingly, it significantly shaped contemporaries' impressions of domestic material culture, as readers and writers alike turned to the genre to both guide and record their journeys.

Visual and textual records of domestic material culture serve another immediate, practical purpose for the historian, in that they allow for the reconstruction of spaces and objects long lost to history. During their time at Plas Newydd, Butler and Ponsonby became celebrated as models of rural retirement, a level of fame that resulted in an accordant and enduring consumer culture based on images of their house and their own likenesses, which included printed images, portraits and postcards.[17] Yet despite the thriving visual and material culture that emerged around the women, much of the objectscape of Plas Newydd itself does not survive intact, with the house being significantly remodelled in the Victorian period, and many of their personal effects dispersed in the house sale that followed their deaths, which saw numerous gifted drawings and portraits of friends and relatives lost.[18] As such, the complexities of this now immaterial culture can only be fully reconstructed through close attention to surviving textual records, namely the correspondence between Butler and Ponsonby and their friends, which was notably preoccupied with material objects. Of the many gifts given and received by the women and recorded in their extensive body of journals and epistolary correspondence, each communicates something of how their material interactions and exchanges reflected, fostered and intensified their friendships. Attendance to the (im)materialities of lost things through their record in textual cultures can accordingly be read as a compensatory methodology that does not shy away from disruptive lostness, but instead embraces the lost thing's dissipated materiality by using the very documents through which contemporaries attempted to preserve them. By analysing representational accounts of lost objects, we can accordingly better understand the productive mechanisms through which individuals expressed and recorded their feelings about domestic material cultures throughout this period, while simultaneously recognizing their losses to the historical record.

The detailed reconstruction of a series of objects now lost poses obvious challenges for a discipline like art history, so rooted in the close interrogation of surviving examples of visual and material culture. Yet, as Jaś Elsner has so persuasively argued, art history is inherently concerned with the act of description, with ekphrasis one of its key methodologies.[19] Paying attention to how eighteenth-century correspondents like Butler, Ponsonby and their friends described the objects that they encountered, and how they engaged in their own practices of ekphrasis, is therefore to understand how these women ascribed meaning to these once important objects, and in so doing, wrote their own (art) histories.

Revealing absent, missing and lost material cultures on the one hand, Berry's letters also expose the sorts of intimate relationships lost to history on the other.

While we may never know the specifics of her relationship with Damer, thanks, not least, to Damer's deliberate lack of personal documents, Berry's writings on the house are precious snippets that detail how their intimacy coalesced around and inhabited the domestic spaces where they shared their time. Echoing the 'patchwork of archival remains' through which Serena Dyer argues that one can uncover the lives of eighteenth-century women, this book has used such autobiographical snippets to tell new histories of domestic intimacy, engagement and connection, describing the materialization of lives that often ran counter to hegemonic ideals of family and home.

While documenting and recording material culture, these accounts are also material objects in their own right; at once descriptive, narrative, representational, while having their own distinctive materialities which operate in tandem with that of the objects to which they refer. As Coltman writes, 'all of these textualized objects might be understood in relation to the "vast heap of things" that constitute immaterial culture'.[20] The journals of Lybbe Powys, for example, embodied various states of consumption and production throughout their life cycles. As a consumer, she viewed and experienced material culture within the homes of her contemporaries, while in her role as a producer she recorded and conveyed this experience in the form of textual objects for the enjoyment of her friends and family. Written, handled, shared and read, from their conceptual birth during her tours until their publication as an edited volume in the nineteenth century, the journals highlight the fact that production and consumption were cyclical and reciprocal processes, complementary and fluid states, intimately tied to the biography of an object.[21]

By using broad cultural processes such as loss as its anchoring themes, this book has reoriented accounts of the visual and material culture of the late eighteenth- and early nineteenth-century home away from a focus on grand houses ornamented with the very highest forms of artistic culture, whether collections of sculpture or painting, or work by celebrated architects and designers. Although still examining elite spaces, it has looked beyond the confines of the category of the country house and the work of fine art to interrogate a wide range of domestic objectscapes. The descriptive texts that chronicle the rich materiality of eighteenth- and nineteenth-century life that populate its pages often recall and record small objects like keepsakes, trifles and tokens, objects that might otherwise be considered as rubbish, and the details of decorative arts of all of kinds, which have been considered together here alongside sculptures, paintings and works of architectural renown.

Though belonging outwith the disciplinary confines of the most traditional art histories, the kinds of objects and cultural practices discussed within the context of this book were far from marginal. From the collection of fragments of stained glass, to the enactment of extra-illustration, and from the display of prints on canvas walls, to the use of shells in craft production, these encounters constituted ubiquitous and quotidian aspects of the lives of elite men and women living in the eighteenth and nineteenth centuries, whose employment and conception of material culture shaped their relationships with their families and friends, the homes in which they lived, and ultimately, themselves.

In closing, let us return briefly to Ponsonby's assertion of centrality of things within everyday life in her discussion of her and Butler's pair of wafer tongs, discussed in the Introduction. Such tongs, also known as irons, were employed in the preparation of meals, thereby constituting an integral object within of the rituals of everyday life at Butler and Ponsonby's home of Plas Newydd. Thus, though Ponsonby's declaration that the choosing of a new pair of tongs was as important to the women as the restoration of the Bourbon monarchy seems surprising, it in fact constitutes an entirely logical affirmation of the centrality of material culture within their everyday lives. Throughout, this book has followed Ponsonby's assertion, demonstrating that for men and women in eighteenth- and early nineteenth-century Britain, the dynamic assemblages of domestic space were amongst the central means by which they understood and expressed their world. Its chapters have shown that their production and consumption of material culture allowed them to fashion their identities as public figures and family members, to express emotion, to recall experience, to commemorate travel and to construct their homes, arguing that six key cultural processes – description and publication, translation and exchange, inheritance and loss – were the means by which they were able to do so. Focusing closely on how these cultural processes have shaped the home and the histories that we write about it, we gain a fuller sense of the significance of domestic space and its material culture both to individuals living in the late-eighteenth and early-nineteenth centuries, and to those who seek to understand it today.

Notes

1 Climenson, *Passages*, 287.
2 Ibid., 322–3.

3 Ibid., 323.
4 Lewis, *Extracts*, 2: 481–2.
5 Ibid.
6 Joanne Begiato, 'Selfhood and 'Nostalgia': Sensory and Material Memories of the Childhood Home in Late Georgian Britain', *Journal for Eighteenth-Century Studies*, 42, no. 2 (2019): 229–46.
7 Lewis, *Extracts*, 1: 348.
8 Ibid., 542
9 Ibid., 2: 103.
10 Ibid., 476.
11 Milnes Day, *Poems and Fugitive Pieces*, 5–6.
12 Milnes Day, *Poems and Fugitive Pieces*, 43, 31 and 56.
13 Knapp, *The Intimate Letters*, 285, 358 and 353.
14 Elizabeth Crooke, 'The material culture of conflict: artefacts in the Museum of Free Derry, Northern Ireland', in Sandra H. Dudley, Amy J. Barnes, Jennifer Binnie, Julia Petrov and Jennifer Walklate (eds), *Narrating Objects, Collecting Stories: Essays in Honour of Professor Susan M. Pearce* (London & New York: Routledge, 2012), 27.
15 Climenson, *Passages*, 322–3.
16 See for examples: Anon. 'Verses written in a Cottage belonging to General Conway, at Park-Place, near Henley, in Berkshire', *Gentleman's Magazine*, 1767, 36: 139; *Public Advertiser* (London, England), Wednesday, 4 March 1767; *World and Fashionable Advertiser* (London, England), 23 October 1787; John Ferrar, *A tour from Dublin to London, in 1795* (Dublin: 1796), 58–9.
17 For example, the Glamorgan Pottery, based in Swansea, released a pattern depicting the women between 1813 and 1839. An example survives in the collections of the National Library of Wales (NMW A 34515).
18 Plas Newydd sale catalogue, 1832. NLW MS 9132D, National Library of Wales, Aberystwyth.
19 Jaś Elsner, 'Art History as Ekphrasis,' *Art History* 33, no. 1 (2010): 10–27.
20 Coltman, 'Im-material Culture and History of Art(efacts)', 27. She cites Wall, *The Prose of Things*, 96, here.
21 Maureen Daly Goggin and Beth Fowkes Tobin, 'Introduction: Materializing Women', in Goggin and Tobin (eds), *Women and Things*, 1.

Bibliography

Primary Sources

Manuscripts
Bodleian Library
Harriette Piggot, Letters, MS F. I, 1788.

Birmingham Library
Letters from Matthew Boulton to Francis Eginton, MS 3782/12/25/6, 1780.
Francis Eginton, Memorandum of Painted Glass, Boulton & Fothergill Correspondence, MS 3752/1/30, 1781.
Francis Eginton General Correspondence, MS 3782/12/39/270-297, October 1794.
Francis Eginton to James Watt, n. d. Glass fragments & Letter, MS 3219/4/109.

British Library
Caroline Lybbe Powys, Journals and Recipe Book, Add MSS 42610–42173, 1756–1808.
Ann Flaxman, Journal, Add MS 39787, 1787–8.
Frances Anne Crewe, Journal of Lady Crewe in Wales, Add MS 37926, 1795.

Cadbury Research Library, University of Birmingham, Birmingham
Sir Edward Lyttleton, Journal, MS 369, 1755.
Ann Ambler, Ambler Letters, MS 206, 1760–88.
Anna Seward Letters, AS MSS 10/iii/9, 1764–1804.
Ann Prest, Diaries, MS 52, 1769–76.
Mary Jackson, Commonplace Book, MS696 1775.
Jerningham Letters, JER, 1-79, 1776–1833.
Catherine Hutton, Diary and Scrapbook, MS 15, 1779–twentieth century.
Mary Anne Keene, Diary, MS225, 1794

Cheshire Archives and Local Studies
G.H. Steele, 'A Three Weeks' Tour into Lancashire, Cheshire and North Wales', D 4457/1, 1818.

Denbighshire Record Office, Ruthin
Sarah Ponsonby, Household Account, DD/LL, 1, 1791–1800.

Note from Madam de Genlis accompanying a gift of verses, music and romance 'sur un enfant', DD/LL 6, *c*. 1800.
Letters from Sarah Ponsonby to Mrs. Parker, Sweeney Hall, Oswestry, DD/LL 7, 1809–16.
Letter from the Ladies of Llangollen (written by Sarah Ponsonby) to Mrs Williams, of Gwersyllt Park, DD/LL, 11, 1818.
Note from the Ladies inviting Revd. Jones to tea at Plas Newydd, DD/LL 13, 1821.
Copy catalogue of a sale at Plas Newydd, Llangollen, DRO NTD/272, 1832.
Eleanor Butler and Sarah Ponsonby, Letters to Robert F. Greville, Kings Mews, DD/LL, 3, undated.

Devon Record Office
Mary Parminter, Will, 1847.

Dove Cottage, Cumbria
Mary Wordsworth, Travel Journal, DCMS 92M, 1820.

John Rylands Library, University of Manchester
Hester Piozzi, Inventories of Household Goods, English MS no. 610, 1780s.
Letters from Anna Seward to Hester Piozzi, Eng MS 565, 1787–90.
Hester Piozzi, Journey through the North of England, Scotland and Wales Eng MS 623, 1789.
Letters from the Ladies of Llangollen to Hester Piozzi, Eng MS 581, n.d.

Lewis Walpole Library, Yale University
Anne Damer, extra-illustrated 1784 edition of *A Description of the villa of Mr. Horace Walpole*, Quarto 33 30 Copy 25.
Anne Damer, Scrapbooks, Folio 53 D18 828.
Anne Damer, Notebooks, LWL Mss Vol. LXIV.
Horace Walpole, extra-illustrated 1774 edition of *A Description of the villa of Mr. Horace Walpole*, 49 2523.
Horace Walpole, extra-illustrated 1784 edition of *A Description of the villa of Mr. Horace Walpole*, 49 3582.

National Library of Wales, Aberystwyth
Sarah Ponsonby, 'A Journey in Wales', MS 22967C, 1778.
Eleanor Butler, Journal, MS 22971C, 1788–91.
Sarah Ponsonby, Common Place Book, MS 22969A, 1785–9.
Anon. Sketch of a pedestrian Tour thro' parts of North and South Wales etc. Begun September 3rd, 1798 by GN, DJJ, RP. MS 4419B, f. 8, 1798.

National Library of Scotland, Edinburgh
G.L.A. Douglas, Observations made during a tour in Wales and different parts of England, MS 10349, 1806.

Shropshire Records and Archive Centre
Katherine Plymley, Journal, 567/5/5/1/1, 1792.

University of Edinburgh Library, Special Collections
Adam Matthew Publications, (Wiltshire) *Ladies of Llangollen: Letters and Journals of Lady Eleanor Butler (1739–1829) and Sarah Ponsonby (1755–1831) from the National Library of Wales*, Microfilm, 1997.

Newspapers and periodicals
Anti-Jacobin Review and Magazine
Daily Advertiser
E. Johnson's British Gazette and Sunday Monitor
Freeman's Journal and Daily Commercial Advertiser
Gazetteer and New Daily Advertiser
General Evening Post
Gentleman's Magazine
La Belle Assemblée; or Bell's Court and Fashionable Magazine
Lloyd's Evening Post
London Chronicle
London Daily Post and General Advertiser
Middlesex Journal or Universal Evening Post
Morning Chronicle
Morning Herald
North Wales Chronicle
Parker's General Advertiser and Morning Intelligencer
Public Advertiser
Read's Weekly Journal Or British Gazetteer
St. James' Chronicle or the British Evening Post
The Bee: or, Literary weekly intelligencer
The European magazine, and London Review
The Isle of Wight Magazine
The Lady's Poetical Magazine, or Beauties of British Poetry
The Leeds Intelligencer
The Mirror of Literature, Amusement, and Instruction
The Monthly Visitor, and Entertaining Pocket Companion
The Morning Post
The Times
True Briton
Whitehall Evening Post
World and Fashionable Advertiser

Printed primary literature

Albin, J. *A new, correct, and much-improved history of the Isle of Wight* (Newport, 1795).

Andrew, D. *Notes taken during different journeys, made in the years 1792-3-4-5-6. Into Switzerland, Italy, and Germany* (London, 1798).

Anon. 'Provincial Life and Anecdotes of John Wilkes', excerpted in *The Annual Hampshire Repository, or Historical, Economical, and Literary Miscellany. A Provincial Work, of entirely original Materials; comprising all Matters relative to the County, including the Isle of Wight, &c.* (London & Winchester: Robbins, White). Excerpted in the *Anti-Jacobin Review and Magazine*, Issues 15–18 (1803–1804).

Anon. *A catalogue of shell-work, &c. by Mrs. Dards, consisting of a great variety of beautiful objects, equal to nature, minutely described* (London: H. Fry, 1800).

Anon. *A Catalogue of the Classic content of Strawberry Hill, collected by Horace Walpole sold, by auction, 25th of April, 1842* (London: Smith & Robbins, 1842).

Anon. *A collection of Welch tours, or a display of the beauties of Wales* (London, 1797).

Anon. *A Description of Holkham House in Norfolk; with a Particular of the Pictures, Statues, Bustoes, and other Marbles therein* (Norwich: R. Beatniffe, 1775).

Anon. *A descriptive catalogue (giving a full explanation) of Rackstrow's Museum: Consisting of a large and very valuable collection of most curious anatomical figures* (London: 1794).

Anon. *A sapphick epistle, from Jack Cavendish to the Honourable and most beautiful Mrs D***** (London, 1771).

Anon. *Chambers Encyclopaedia: A Dictionary of Universal Knowledge for the People* (London: W. & R. Chambers, 1865)

Anon. *Essays and letters on the following various and important subjects* (London: Thomas Hope, 1763).

Anon. *The Annual Necrology, for 1797–8: Including, Also, Various Articles of Neglected Biography*, (London: R. Phillips, 1800), Vol. 1.

Anon. *The beauties of the royal palaces: or, a pocket companion to Windsor, Kensington, Kew, and Hampton Court* (London: 1796).

Anon. *The Cliff of Worcester, The Cambrian directory, or, cursory sketches of the Welsh territories* (Salisbury, 1800).

Anon. *The Norfolk Tour: or, Traveller's Pocket Companion* (Norwich, 1795).

Armstrong, J. M. *History and Antiquities of the Country of Norfolk*, 10 vols. (Norwich: J. Crouse, 1781).

Baillie, M. *First Impressions on a Tour upon the Continent, in the Summer of 1818* (London: John Murray, 1819).

Barbauld, A.L., ed. *The Correspondence of Samuel Richardson* (London: Richard Phillips, 1804).

Barlow, P. *The general history of Europe; and entertaining traveller* (London, 1791).

Barrett, C., ed. *The Diaries and Letters of Madame D'Arblay, 1778–1780* (London: Henry Colburn, Publisher, 1843).

Beatniffe, R. *The Norfolk Tour or, Traveller's Pocket Companion* (Norwich, 1773).
Belfield, H.H., ed. *Lord Chesterfield's letters to his son and godson* (London: Maynard, Merrill, & Co. 1897).
Bell, G.H., ed. *The Hamwood Papers of the Ladies of Llangollen and Caroline Hamilton* (London: Macmillan & Co. 1930).
Berry, M. ed. *The Works of Horatio Walpole, Earl of Orford*, 4 Vols. (London: Robinson and Edwards, 1798).
Bingley, W. *A tour round North Wales, performed during the summer of 1798: containing not only the description and local history of country, but also, a sketch of the history of the Welsh bards*, 2 vols. (London: J. Smeeton, 1800).
Bishop, S. The *Poetical Works of the Rev. Samuel Bishop*, 2 Vols. (London, 1796).
Bloom, E.A. and L. Bloom, eds. *The Piozzi letters: correspondence of Hester Lynch Piozzi, 1805–1810* (Delaware: University of Delaware Press, 2002).
Boswell, J. *Life of Johnson*, ed. R.W. Chapman (Oxford: Oxford University Press, 1980).
Boulter, D. *Museum Boulterianum. A catalogue of the curious and valuable collection of natural and artificial curiosities in the extensive museum of Daniel Boulter, Yarmouth* (London: Henry Gardner, 1794).
Bowyer, W. *Literary Anecdotes of the Eighteenth Century: Comprising Biographical Memoirs of William Bowyer, Printer, F.S.A. and many of his Learned Friends* (London: Nichols, Son, and Bentley, 1815).
Bray, W. *Sketch of a tour into Derbyshire and Yorkshire* (London: B. White, 1778).
Brettell, T. *A topographical and historical guide to the Isle of Wight, Comprising Authentic Accounts of its Antiquities, Natural Productions, and Romantic Scenery* (London: Leigh & Co. 1840).
Brightwell, C.L. ed. *Memorials of the Life of Amelia Opie* (Norwich: Fletcher & Alexander, 1854).
Broderick, T. *Letters from several parts of Europe, and the East. Written in the years 1750, &c.* (London, 1753).
Bullar, J. *A companion in a tour round Southampton; comprehending various particulars, ancient and modern,* (Southampton: T. Baker, 1799).
Bullar, J. *A Historical and Picturesque Guide to the Isle of Wight* (London, 1817)
Clarke, E.D. *A Tour through the South of England, Wales, and Part of Ireland, made during the Summer of 1791* (London: Minerva Press, 1793).
Climenson, E.J., ed. *Passages from the Diaries of Mrs. Philip Lybbe Powys of Hardwick House, Oxon. A.D. 1756 to 1808* (London: Longmans, Green, & Co. 1899).
Cock, C. *A catalogue of Mr. Andrew Hay's; Pictures, Brounzes, Marble Bustos, Bass-relievos* (London: Cock, 1739).
Cromwell, T. *Excursions in the County of Norfolk: Comprising a Brief Historical and Topographical Delineation of Every Town and Village; Together with Descriptions of the Residences of the Nobility and Gentry* (London: Longman, Hurst, Rees, Orme, & Brown, 1819).

Cumberland, G. *A poem on the landscapes of Great-Britain, dedicated to James Irvine, Esq.* (London, 1793).

Curtis, W. *The Botanical Magazine; or, The Flower Garden Displayed* (London: Couchman & Fry, 1787).

d'Aulnoy, M.C. *The Earl of Douglas, an English Story*, 3 vols. (Lynn: W. Whittingham, 1774).

de Crespigny, M.C. *The pavilion. A novel*, 4 vols. (London: William Lane, 1796).

de Genlis, S.F. *Adelaide and Theodore; or letters on education*, (London, 1784).

de Genlis, S.F. *Memoirs of the Countess de Genlis: illustrative of the history of the eighteenth and nineteenth centuries* (1825).

d'Hancarville, P.F.H. *Collection of Etruscan, Greek and Roman Antiquities* (Naples, 1767–76).

Donovan, E. *The natural history of British shells* (London: F.C. & J. Rivington, 1804).

Douglas, F. *A general description of the east coast of Scotland, from Edinburgh to Cullen*, (Paisley: Alexander Weir, 1782).

Dunsford, M. *Miscellaneous observations, in the course of two tours* (Tiverton, 1800).

Elstob, M. *A trip to Kilkenny, from Durham* (Dublin, 1779).

Ferrar, J. *A tour from Dublin to London in 1795* (Dublin, 1796).

Fordyce Mavor, W. *The British tourists; or traveller's pocket companion, through England, Wales, Scotland, and Ireland. Comprehending the most celebrated tours in the British Islands*, 6 vols. (London: E. Newbery, 1798-1800).

Graham, M. *Three Months Passed in the Mountains East of Rome, during the Year 1819* (London: A. & R. Spottiswoode, 1820).

Gray, R. *Letters during the course of a Tour through Germany, Switzerland and Italy, in the Years 1791 and 1792, with Reflections on the Manners, Literature, and Religion of those Countries*, cited in *The Critical Review; or Annals of Literature* (London: A. Hamilton, 1796).

Green, S. *Mental improvement for a young lady, on her entrance into the world; addressed to a favourite niece* (London, 1793).

Greg, E., ed. *Reynolds-Rathbone Diaries and Letters, 1753–1839* (printed for private circulation, 1905).

Hassell, J. *Tour of the Isle of Wight*, 2 vols. (London, 1790).

Hicklin, J., ed. *The "Ladies of Llangollen," as Sketched by many Hands* (Chester: Thomas Catherall, 1847).

Holloway, R. *A Letter to John Wilkes, Esq; Sheriff of London and Middlesex; in which the extortion and oppression of sheriffs officers, with many other alarming abuses, are exemplified and detected; and a remedy proposed* (London, 1771).

Horrocks, I., ed. *Letters Written during a short Residence in Sweden, Norway, and Denmark* (Peterborough, Ontario: Broadview Press, 2013).

Hughes, C., ed. *Mrs. Piozzi's Thraliana* (London: Simpkin, Marshall, Hamilton, Kent & Co. Ltd. 1913).

Hutton, C. *The Ladies' Diary: or Woman's Almanack, For the Year of our Lord 1780* (London: The Company of Stationers, 1780).

Ilchester, Earl of., ed. *The Journal of Elizabeth, Lady Holland*, 2 vols. (London, New York, Bombay & Calcutta: Longmans, Green, and Co. 1908).

Ireland, S. *Graphic Illustrations of Hogarth*, 2 vols. (London: R. Faulder & J. Egerton, 1794–9).

Knapp, O.G., ed. *The Intimate Letters of Piozzi and Pennington* (Stroud: Nonsuch Publishing Limited, 2005).

Langley, T. *The history and antiquities of the Hundred of Desborough, and Deanery of Wycombe* (London: Printed for R. Faulder & E. and J. White, 1797).

Lewis, T., ed. *Extracts of the Journals and Correspondence of Miss Berry*, 3 vols. (London: Longmans, Green, and Co. 1865).

Lewis, W. S., ed. *Yale Edition of Horace Walpole's Correspondence* (New Haven & London: Yale University Press, 1937–1983).

Le Valois de Villette de Murçay Caylus, M.-M., *Memoirs, Anecdotes and Characters from the Court of Lewis XIV*. Translated from *Les Souvenirs, or, recollections of Madame de Caylus* (London: 1770).

Marshall, Mr. *The Review and Abstract of the County Report to the Board of Agriculture from the Several Agricultural Departments of England*, 5 vols. (York: Thomas Wilson & Sons, 1818).

Martin, S. *Narrative of a three years' residence in Italy, 1819–1822* (Dublin: W.F. Wakeman, 1831).

Martyn, T. and J. Lettice, *The Antiquities of Herculaneum, Translated from the Italian*, 2 vols. (London: J. Taylor, 1773).

Mavor, E., ed. *A Year with the Ladies of Llangollen* (Harmondsworth: Penguin Books Ltd. 1986).

Michell, Rev. J.H. *The Tour of the Duke of Somerset, and the Rev. J. H. Michell, through parts of England, Wales, and Scotland, in the year 1795* (London: R. Clay, 1845).

Miller, P. *The Gardener's and Botanist's Dictionary* (London: F.C. & J. Rivington, 1807).

Milnes Day, E. *Poems and Fugitive Pieces, by Eliza* (London: W. Bulmer & Co. 1796).

Milnes Day, E. *Select Miscellaneous Productions of Mrs. Day, and Thomas Day, Esq. in Verse and Prose* (London: T. Jones, 1805).

Morgan, S. *Italy*, 2 vols. (London: Henry Colburn & Co. 1821).

Morgan Evans, D. 'Octavius Morgan: journal of a tour through North Wales in 1821', *Archaeologia Cambrensis*, 160 (2011): 235–63.

Ousby, I., ed. *James Plumptre's Britain, The Journals of a Tourist in the 1790s* (London, 1992).

Payne, J. *Universal geography formed into a new and entire system; describing Asia, Africa, Europe, and America*, 2 vols. (London: J. Johnson, 1791).

Pennington, Rev. M., ed. *A Series of Letters between Mrs. Elizabeth Carter and Miss Catherine Talbot from the Year 1741 to 1770*, 4 vols. (London: F.C. & J. Rivington, 1809).

Pennington, Rev. M., ed. *Letters from Mrs. Elizabeth Carter to Mrs. Montagu, between the years 1755 and 1800*, 3 vols. (London: F.C. & J. Rivington, 1817).

Penruddocke Wyndham, H. *A picture of the Isle of Wight, delineated upon the spot, in the year 1793* (London, 1794).

Percy, E. *A Short Tour, Made in the Year One Thousand Seven Hundred and Seventy One* (London, 1775).

Phillips, H. *Sylva florifera: the Shrubbery Historically and Botanically Treated* (London: Longman, Hurst, Rees, Orme & Brown, 1823).

Pinkerton, J., ed. *Walpoliana* (London, 1798).

Piozzi, H.L. *Observations and Reflections made in the Course of a Journey through France, Italy, and Germany*, 2 vols. (London: T. Cadell & A. Strahan, 1789).

Price, C., ed. *The Letters of Richard Brinsley Sheridan*, 3 vols. (Oxford: Clarendon Press, 1966).

Raspe, R.E. *A descriptive catalogue of a general collection of ancient and modern engraved gems, cameos as well as intaglios, taken from the most celebrated cabinets in Europe, and cast in red pastes, white enamel, and sulphur, by James Tassie, modeller; arranged and described by Raspe*, 2 vols. (London: J. Murray, 1791).

Rathborne, A., ed. *Letters from Lady Jane Coke to her friend Mrs. Eyre at Derby, 1747–1758* (London: Swan Sonnenschein & Co. 1899).

Reichel, O.J. 'Extracts from a Devonshire Lady's Notes of Travel in France in the Eighteenth Century', *Report and Transactions: The Devonshire Association for the Advancement of Science, Literature and Art*, 34 (1902): 265–77

Richards, J. and S. Harris, eds. *Selected Letters* (Athens, Georgia: University of Georgia Press, 2009).

Riggs Miller, A. *Letters from Italy, Describing the Manners, Customs, Antiquities, Paintings, &c. of that Country*, 3 vols. (London: Edward & Charles Dilly, 1776–7).

Rogers, S. *Poems by Samuel Rogers* (London: T. Cadell, 1834).

Scott, W., ed. *The Poetical Works of Anna Seward*, 3 vols. (Edinburgh: James Ballantyne & Co. 1810).

Seabury, J.B., ed. *Lord Chesterfield's Letters to his Son* (New York, Boston & Chicago: Silver, Burdett & Co., 1902).

Sears, R. *A New and Popular Pictorial Description of England, Scotland, Ireland, Wales, and the British Islands* (New York: Robert Sears, 1847).

Seward, A. *Letters of Anna Seward: Written between the Years 1784 and 1807*, 6 vols. (Edinburgh: George Ramsay & Company, 1811).

Seward, A. *Llangollen Vale, with Other Poems* (London: G. Sael, 1796).

Shelley, M., ed. *Essays: Letters from Abroad, Translations and Fragments*, 2 vols. (London: Edward Moxon, 1840).

Skrine, H. *Two successive tours throughout the whole of Wales, with several of the adjacent English counties; so as to form a comprehensive view* (London: Elmsley & Bremner, 1798).

Smith, J.E. *A sketch of a tour on the continent, in the years 1786 and 1787, by James Edward Smith* (London, 1793).

Stanhope, Phillip 4th Earl of Chesterfield, *Letters to his Son*, (1774; reprint in 2 vols. New York: M.W. Dunne, 1901).

Starke, M. *Travels in Italy, Between the Years 1792 and 1798; Containing A View of the Late Revolutions in that Country*, 2 vols. (London: R. Phillips & T. Gillet, 1802).

Sturch, J. *A view of the Isle of Wight, in four letters to a friend Containing Not only a Description of its Form and principal Productions, but the most authentic and material Articles of its natural, political, and commercial History* (Newport: 1794).

Sulivan, R.J. *Observations made during a Tour through Parts of England, Scotland, and Wales: In a Series of Letters* (London: T. Becket, 1780).

Tomkins, C. *A tour to the Isle of Wight, illustrated with eighty views, drawn and engraved in aquatinta*, 2 vols. (London: G. Kearsley, 1796).

Turner Smith, C. *Elegiac sonnets, and other poems, by Charlotte Smith* (London: 1800).

Verall Lucas, E., ed. *The Works of Charles and Mary Lamb: Miscellaneous prose, 1798–1834* (London: Methuen, 1903).

Von la Roche, S. *Sophie in London, 1786: Being the Diary of Sophie von la Roche*, trans. C. Williams (London, 1933).

Walpole, H. *A Description of the Villa of Horace Walpole, Youngest Son of Sir Robert Walpole, Earl of Orford, at Strawberry-Hill, near Twickenham* (London: Strawberry Hill, 1774).

Walpole, H. *A Description of the Villa of Horace Walpole, Youngest Son of Sir Robert Walpole, Earl of Orford, at Strawberry-Hill, near Twickenham* (London: Strawberry Hill, 1784).

Walpole, H. *Ædes Walpolianæ; or, a Description of the Collection of Pictures at Houghton Hall in Norfolk* (London, 1747).

Walpole, H. *A Description Of The Villa Of Horace Walpole, Youngest Son of Sir Robert Walpole Earl of Orford, At Strawberry-Hill, near Twickenham. With an Inventory of the Furniture, Pictures, Curiosities, &c.* (London: Kelly & Co. 1842).

Walpole, H. *Anecdotes of Painting in England; With Some Account of the Principal Artists*, edited by R.N. Wornum (London: Chatto & Windus, 1876).

Wilkes, J. *Letters from the Year 1774 to the Year 1796 of John Wilkes Esq. Addressed to his Daughter, the Late Miss Wilkes* (London: S. Gosnell, 1804).

Williams, H.M. *A Tour in Switzerland; or, a View of the Present State of the Governments and Manners of those Cantons: with Comparative Sketches of the Present State of Paris*, 2 vols. (London: G.G. & J. Robinson, 1798).

Woodward, G.M. *Eccentric Excursions: or, Literary & Pictorial Sketches of Countenance* (London: Allen & Co. 1796).

Secondary Sources

Adams, T. *The A la Ronde Story: Its People* (Exmouth, Devon: National Trust, 2011).

Agorni, M. *Translating Italy for the Eighteenth Century: British Women, Translation and Travel Writing (1739–1797)* (Manchester: St. Jerome Publishing, 2002)

Amin, K. 'Haunted by the 1990s: Queer Theory's Affective Histories', *Women's Studies Quarterly*, 44, no. 3/4, QUEER METHODS (2016): 173–89.

Anderson, J. 'Remaking the Space: the Plan and the Route in Country House Guidebooks from 1770 to 1815', *Architectural History*, 54 (2011): 195–212.

Anderson, J. *Touring and Publicizing England's Country Houses in the Long Eighteenth Century* (London: Bloomsbury Academic, 2018).

Appadurai, A., ed. *The social life of things: Commodities in Cultural Perspective* (Cambridge University Press, London & New York, 1986).

Arnold, D., ed. *The Georgian Country House: Architecture, Landscape and Society* (Stroud: Sutton Publishing Limited, 1998).

Avery-Quash, S. and K. Retford, eds. *The Georgian London Town House: Building, Collecting and Display* (New York & London: Bloomsbury Visual Arts, 2019).

Baker, M. '"For Pembroke Statues, Dirty Gods and Coins": The Collecting, Display and Uses of Sculpture at Wilton House', in *Collecting Sculpture in Early Modern Europe*, eds. Nicholas Penny and Eike D. Schmidt (New Haven & London: Yale University Press, 2008), 379–95.

Barrett, C. 'Queering the Home: The domestic labor of lesbian and gay couples in contemporary England', *Home Cultures*, 12, no. 2 (2015): 193–211.

Batchelor, J. *Dress, Distress & Desire: Clothing and the Female Body in Eighteenth-Century Literature* (London: Palgrave Macmillan, 2005).

Batchelor, J. and C. Kaplan, eds. *Women and Material Culture, 1660–1830* (Basingstoke: Palgrave Macmillan, 2007).

Begiato, J. 'Selfhood and "Nostalgia": Sensory and Material Memories of the Childhood Home in Late Georgian Britain', *Journal for Eighteenth-Century Studies*, 42, no. 2 (2019): 229–46.

Bending, S. *Green Retreats: Women, Gardens and Eighteenth-Century Culture* (Cambridge: Cambridge University Press, 2013).

Bennett, J.M. *History Matters: Patriarchy and the Challenge of Feminism* (Manchester: Manchester University Press, 2006).

Berg, M. *Luxury and Pleasure in Eighteenth-Century Britain* (Oxford: Oxford University Press, 2007).

Berg, M. and H. Clifford, eds. *Consumers & Luxury: Consumer culture in Europe 1650–1850* (Manchester: Manchester University Press, 1999).

Berg, M. and E. Eger, eds. *Luxury in the Eighteenth-Century: Debates, Desires and Delectable Goods* (Basingstoke: Palgrave Macmillan, 2002).

Bermingham, A. *Learning to Draw: Studies in the Cultural History of a Polite and Useful Art* (New Haven & London: Yale University Press, 2000).

Bermingham, A. and J. Brewer, eds. *The Consumption of Culture, 1600–1800: Image, Object, Text* (Abingdon & New York: Routledge, 1995).

Bignamini, I. and C. Hornsby. *Digging and Dealing in Eighteenth-Century Rome*, 2 vols. (New Haven & London: Yale University Press, 2010).

Black, J. *The British and the Grand Tour* (London: Routledge, 2011).

Bleackley, H. *Life of John Wilkes* (London & New York: John Lane, 1917).

Bohls, E. *Women Travel Writers and the Language of Aesthetics 1716–1818* (Cambridge: Cambridge University Press, 1995).

Bourque, K. 'Cultural Currency: *Chrysal, or the Adventures of a Guinea*, and the Material Shape of Eighteenth-Century Celebrity', in *Eighteenth-Century Thing Theory in a Global Context: From Consumerism to Celebrity Culture*, eds. Ileana Baird, Christina Ionescu (Farnham: Ashgate, 2013), 49–68.

Boynton, L. 'The Marine Villa', in *The Georgian Villa*, ed. Dana Arnold (Stroud: The History Press, 2011), 118–30.

Bowerbank, S. *Speaking for Nature: Women and Ecologies of Early Modern England* (Baltimore: The John Hopkins University Press, 2004).

Brewer, J. *Party Ideology and Popular Politics at the Accession of George III* (New York: Cambridge University Press, 1976).

Brewer, J. and R. Porter, eds. *Consumption and the World of Goods* (London: Routledge, 1993).

Brideoake, F. '"Extraordinary Female Affection": The Ladies of Llangollen and the Endurance of Queer Community', *Romanticism on the Net*, Special Issue: Queer Romanticism (November 2004, February 2005), 36–7.

Brideoake, F. *The Ladies of Llangollen: Desire, Indeterminacy, and the Legacies of Criticism* (Lewisburg: Bucknell University Press, 2017).

Brown, B. 'Thing Theory', *Critical Inquiry*, 28, no. 1, 'Things' (Autumn, 2001): 1–22.

Budd, A. 'Anthropological description and objects of history', in *The Modern Historiography Reader: Western Sources*, ed. Adam Budd (Abingdon & New York: Routledge, 2009), 421–31.

Calè, L. 'Gray's Ode and Walpole's China Tub: The Order of the Book and the Paper Lives of An Object', *Eighteenth-Century Studies*, 45, no. 1 (2011): 105–25.

Cash, A. *John Wilkes: The Scandalous Father of Civil Liberty* (New Haven & London: Yale University Press, 2008).

Casid, J.H. *Sowing Empire: Landscape and Colonization* (Minneapolis: University of Minnesota Press, 2004).

Castle, T. *The Apparitional Lesbian: Female Homosexuality and Modern Culture* (New York: Columbia University Press, 1993).

Chico, T. *Designing Women: The Dressing Room in Eighteenth-Century English Literature and Culture* (Lewisburg, PA: Bucknell University Press, 2005).

Clark, A. *Scandal: The Sexual Politics of the British Constitution* (Princeton, NJ: Princeton University Press, 2004).

Clark, A. 'The Chevalier d'Eon and Wilkes: Masculinity and Politics in the Eighteenth Century', *Eighteenth-Century Studies*, 32, no. 1, (1998): 19–48.

Clarke, N. *The Rise and Fall of the Woman of Letters* (London: Random House, 2004).

Clarke, S. 'A Fine House Richly Furnished: Pemberley and the Visiting of Country Houses', *Persuasions*, 22 (2000): 199–217.

Clarke, S. '"Lord God! Jesus! What a House!": Describing and Visiting Strawberry Hill', *Journal for Eighteenth-Century Studies*, 33, no. 3 (2010): 357–80.

Clarke, S. *The Strawberry Hill Press & its Printing House: An Account & An Iconography* (New Haven & London: Yale University Press, 2011).

Clery, E.J. *The Rise of Supernatural Fiction* (Cambridge: Cambridge University Press, 1995), 75–6.

Clery, E.J. 'Horace Walpole, the Strawberry Hill Printing Press and the Emergence of the Gothic Genre', *Ars & Humanitas*, 20, no. 12 (2010): 93–110.

Cohen, D. *Household Gods: The British and their Possessions* (New Haven & London: Yale University Press, 2006).

Colley, L. 'Eighteenth-Century English Radicalism before Wilkes', *Transactions of the Royal Historical Society*, 31 (1981): 1–19.

Coltman, V. 'Classicism in the English library: Reading classical culture in the late eighteenth and early nineteenth centuries', *Journal of the History of Collections*, 11, no. 1 (1999): 35–50.

Coltman, V. 'Sir William Hamilton's Vase Publications (1766–1776): A Case Study in the Reproduction and Dissemination of Antiquity', *Design History*, 14, no. 1 (2001): 1–16.

Coltman, V. *Fabricating the Antique: Neoclassicism in Britain 1760–1800* (Chicago: University of Chicago Press, 2006).

Coltman, V. 'Im-material Culture and History of Art(efacts)', in *Writing Material Culture History*, eds. Anne Gerritsen and Giorgio Riello (London: Bloomsbury Academic, 2014), 17–32.

Coltman, V. 'Sojourning Scots and the Portrait Miniature in Colonial India, 1770s–1780s', *Journal for Eighteenth-Century Studies*, 40, no. 3 (2017): 421–41.

Coltman, V. 'Paper trails of imperial trav(a)ils: Janet Schaw's Journal of a journey from Scotland to the West Indies, North Carolina and Portugal, 1774–1776', in *British Women and Cultural Practices of Empire, 1770–1940*, eds. Kate Smith and Rosie Dias (New York & London: Bloomsbury Visual Arts, 2018), 51–71.

Cook, M. *Queer Domesticities: Homosexuality and Home Life in Twentieth-Century London* (London: Palgrave Macmillan, 2014).

Conlin, J. 'High Art and Low Politics: A New Perspective on John Wilkes', *Huntington Library Quarterly*, 64, no. 3/4 (2001): 356–81.

Conlin, J. 'Wilkes, the Chevalier D'Eon and "The Dregs of Liberty": An Anglo-French Perspective on Ministerial Despotism, 1762–1771', *The English Historical Review*, 120, no. 489 (2005): 1251–88.

Cordell R. and D.A. Smith. viraltexts.org

Cornforth, J. *Early Georgian Interiors* (New Haven & London: Yale University Press, 2004).

Courtney, W.P. 'Jackson, Richard (1721/2–1787)', Rev. J.M. Alter, *Oxford Dictionary of National Biography* (Online Edition), Oxford University Press (2004).

Cox, J. *Poetry and Politics in the Cockney School: Keats, Shelley, Hunt and their Circle* (Cambridge: Cambridge University Press, 1998).

Crisafulli, L.M. and C. Peitropoli, eds. *Romantic Women Poets: Gender and Genre* (Amsterdam & New York: Rodopi, 2007).

Crooke, E. 'The material culture of conflict: artefacts in the Museum of Free Derry, Northern Ireland', in *Narrating Objects, Collecting Stories: Essays in Honour of Professor Susan M. Pearce*, eds. Sandra H. Dudley, Amy J. Barnes, Jennifer Binnie, Julia Petrov and Jennifer Walklate (London & New York: Routledge, 2012), 25–35.

Crowley, J.E. *The Invention of Comfort: Sensibilities & Design in Early Modern Britain & North America* (Baltimore & London: John Hopkins University Press, 2001).

Cunningham, C. '"An Italian house is my lady": some aspects of the definition of women's role in the architecture of Robert Adam', in *Masculinity and Femininity in Eighteenth-Century Art and Culture*, eds. Michael Rossington and Gill Perry (Manchester: Manchester University Press, 1994), 63–77.

Dahn, J. 'Mrs Delany and Ceramics in the Objectscape', *Interpreting Ceramics*, 1, (2000), http://www.interpretingceramics.com/issue001/delany/delany.htm

Daly Goggin, M. and B. Fowkes Tobin, eds. *Material Women, 1750–1950: Consuming Desires and Collecting Practices* (Burlington: Ashgate 2009).

Daly Goggin, M. and B. Fowkes Tobin, eds. *Women and Things, 1750–1950: Gendered Material Strategies* (Burlington: Ashgate 2009).

Daly Goggin, M. and B. Fowkes Tobin, eds. *Women and the Material Culture of Needlework and Textiles* (Burlington: Ashgate 2009).

Daly Goggin, M. and B. Fowkes Tobin, eds. *Women and the Material Culture of Death* (Burlington: Ashgate, 2013).

Darnton, R. *The Great Cat Massacre and Other Episodes in French History* (New York: Basic Books, 1984).

Davis, W. 'Queer Family Romance in Collecting Visual Culture', *GLQ*, 17, no. 2–3 (2011): 309–29.

Davoli, S. *Lost Treasures of Strawberry Hill: Masterpieces from Horace Walpole's Collection* (London: Scala Publishing, 2018).

Dean, G. '"Every Man His Own Publisher": Extra-Illustration and the Dream of the Universal Library', *Textual Cultures*, 8, no. 1 (2013), 57–71.

Deetz, J. *In Small Things Forgotten: An Archaeology of Early American Life* (New York: Anchor Books, 2010).

Denzin, N.K. *Interpretive Interactionism* (Newbury Park, CA: SAGE, 1989).

di Bello, P. and G. Koureas, eds. *Art, History and the Senses: 1830 to the Present* (Farnham & Burlington: Ashgate Publishing, 2010).

Donoghue, E. '"Random Shafts of Malice": The Outings of Anne Damer', in *Lesbian Dames: Sapphism in the Long Eighteenth Century*, eds. Caroline Gonda and John C. Benyon (London: Routledge, 2010), 127–46.

Dyer, S. *Material Lives: Women Makers and Consumer Culture in the 18th Century* (London: Bloomsbury Visual Arts, 2021).

Eagles, R. 'A patriot in retirement: John Wilkes's pastoral retreat on the Isle of Wight 1788–1797', paper delivered at the British Society for Eighteenth-Century Studies Conference, St. Hugh's College, University of Oxford, 2019.

Eagles, R. *The Diaries of John Wilkes, 1770–1797* (London: Boydell & Brewer, 2014).

Easterby Smith, S. 'Cross-Channel commerce: the circulation of plants, people and botanical culture between France and Britain, *c.* 1760–*c.* 1789', *Studies on Voltaire and the Eighteenth Century*, 12 (2013): 215–30.

Eger, E. 'Paper Trails and Eloquent Objects: Bluestocking friendship and material culture,' *Parergon* 26, no. 2 (2009): 109–38.

Eger, E., C. Grant, C. Ó Gallchoir and P. Warburton, eds. *Women, Writing and the Public Sphere, 1700–1830* (Cambridge: Cambridge University Press, 2001).

Elfenbein, A. *Romantic Genius: The Prehistory of a Homosexual Role* (New York: Colombia University Press, 1999).

Elsner, J. 'Art History as Ekphrasis,' *Art History* 33, no. 1 (2010): 10–27.

Evans, G. *Souvenirs: from Roman Times to the Present Day* (Edinburgh: National Museum of Scotland Publishing, 1999).

Fabricant, C. 'The Literature of Domestic Tourism and the Public Consumption of Private Property', in *The New Eighteenth Century: Theory, Politics and English Literature*, eds. Felicity Nussbaum and Laura Brown (New York: Meuthen, 1987), 254–75.

Faderman, L. *Surpassing the Love of Men: Romantic Friendship and Love Between Women from the Renaissance to the Present* (Virginia: Women's Press, 1981).

Fay, E.A. *Fashioning Faces: The Portraitive Mode in British Romanticism* (Lebanon, NH: University of New Hampshire Press, 2010).

Findlen, P. *The First Modern Museums of Art: The Birth of an Institution in 18th- and Early-19th-Century Europe* (J. Paul Getty Museum, 2012).

Finn, M. 'Men's things: masculine possession in the consumer revolution', *Social History*, 25, no. 2 (2002): 133–55.

Flood, F.B. *Objects of Translation: Material Culture and Medieval 'Muslim-Hindu' Encounter* (Princeton, NJ: Princeton University Press, 2009).

Freeman, E. *Time Binds: Queer Temporalities, Queer Histories* (Durham: Duke University Press, 2010).

Foucault, M. *The Order of Things* (London & New York: Routledge, 2005).

Fowkes Tobin, B. *The Duchess's Shells: Natural History Collecting in the Age of Cook's Voyages* (Yale University Press: New Haven and London, 2014).

Geertz, C. *The Interpretation of Cultures* (London: Hutchinson & Co. Ltd, 1973).

Girouard, M. *Life in the English Country House* (New Haven & London: Yale University Press, 1978).

Gleadhill, E. 'Performing Travel: Lady Holland's Grand Tour Souvenirs and the House of All Europe', *EMAJ: Electronic Melbourne Art Journal*, 9, no. 1 (2017).

Gowrley, F. 'Taste *à-la-Mode*: Consuming Foreignness, Picturing Gender', in *Materializing Gender in Eighteenth-Century Europe*, eds. H. Strobel and J. Germann (London: Routledge, 2016), 35–50.

Graburn, N.H.H. 'Foreword', in *Souvenirs: The Material Culture of Tourism*, eds. Michael Hitchcock and Ken. Teague (Aldershot & Burlington: Ashgate, 2000), n.p.

Gregory, B.S. 'Is small beautiful? Microhistory and the history of everyday life', *History and Theory*, 38, no. 1 (1999): 100–10.

Greig, H. and G. Riello. 'Eighteenth-Century Interiors – Redesigning the Georgian: Introduction', *Journal of Design History*, 20, no. 4 (2007): 273–89.

Grootenboer, H. *Treasuring the Gaze: Intimate Vision in Late Eighteenth-Century Eye Miniatures* (Chicago: University of Chicago Press, 2012).

Gross, J.D. *The Life of Anne Damer: Portrait of a Regency Artist* (Plymouth: Lexington Books, 2014).

Haggarty, S. *Blake's Gifts: Poetry and the Politics of Exchange* (Cambridge: Cambridge University Press, 2010).

Haggerty, G. 'Horace Walpole's Epistolary Friendships', *Journal for Eighteenth-Century Studies*, 29, no. 2 (2006): 201–18.

Haggerty, G. *Horace Walpole's Letters: Masculinity and Friendship in the Eighteenth Century* (Lewisburg, PA: Bucknell University Press, 2011).

Haggerty, G. 'Horace Walpole: 'Queernesses' in the Epistolary Mode', keynote paper, *Text Artefact Identity: Horace Walpole and the Queer Eighteenth Century*, Strawberry Hill, 15 February 2019.

Halberstam, J. *In a Queer Time and Place: Transgender Bodies, Subcultural Lives* (New York & London: New York University Press, 2005).

Hall, C. and S.O. Rose, eds. *At Home with the Empire: Metropolitan Culture and the Imperial World* (Cambridge: Cambridge University Press, 2011).

Halsall, F. 'One sense is never enough', *Journal of Visual Arts Practice*, 3, no. 2 (2004): 103–22.

Hamlett, J. *Material Relations: Domestic Interiors and Middle-Class Families in England, 1850–1910* (Manchester: Manchester University Press, 2016).

Harney, M. *Place-Making for the Imagination: Horace Walpole & Strawberry Hill* (Aldershot: Ashgate, 2014).

Harvey, K. *The Little Republic: Masculinity and Domestic Authority in Eighteenth-Century Britain* (Oxford: Oxford University Press, 2012).

Hatt, M. 'Space, Surface, Self: Homosexuality and the Aesthetic Interior', *Visual Culture in Britain*, 8, no. 1 (2007): 105–28.

Heard, K. 'The Print Room at Queen Charlotte's Cottage', *British Art Journal*, 13, no. 3 (Winter 2012/13): 53–60.

Hellman, M. 'Furniture, Sociability and the Work of Leisure in Eighteenth-Century France', *Eighteenth-Century Studies*, 32, no. 4 (1999): 415–45.

Hetherington Fitzgerald, P. *The life and times of John Wilkes, M.P., Lord Mayor of London, and Chamberlain* (London: Ward & Downey, 1888).

Holloway, S. *The Game of Love in Georgian England: Courtship, Emotion and Material Culture* (Oxford: Oxford University Press, 2019).

Holm, C. 'Sentimental Cuts: Eighteenth-Century Mourning Jewelry with Hair', *Eighteenth-Century Studies*, 38, no. 1 (2004): 139–43.

Hornsby, C., ed. *The Impact of Italy: The Grand Tour and Beyond* (London: The British School at Rome, 2000).

Hoskins, J. 'Agency, Biography and Objects', in *Handbook of Material Culture*, eds. Chris Tilley, Webb Keane, Susan Küchler, Mike Rowlands and Patricia Speyer (London: Sage Publications, 2006), 74–84.

Hoskins, J. *Biographical Objects: How things tell the stories of people's lives* (Abingdon: Routledge, 2010).

Hyde, L. *The Gift: Imagination and the Erotic Life of Property* (New York: Vintage Books, 1983)

Joyce, R.J. and S.D. Gillespie, eds. *Things in Motion: Object Itineraries in Anthropological Practice* (Santa Fe: School for Advanced Research Press, 2015).

Joyner, C. W. *Shared Traditions: Southern History and Folk Culture* (Urbana & Chicago: University of Illinois Press, 1999).

Kavanagh, D. 'John Wilkes's Closet: Hetero Privacy and the Annotation of Desire', in *Heteronormativity in Eighteenth-Century Literature and Culture*, eds. A. De Freitas Boe and A. Coykendall (London and New York: Routledge, 2016), 77–95.

Kavanagh, D. *Effeminate Years: Literature, Politics, and Aesthetics in Mid Eighteenth-Century Britain* (Lewisburg, PA: Bucknell University Press, 2017).

Kelley, T.M. 'Romantic Interiority and Cultural Objects', Romanticism and Philosophy in an Historical Age, *Romantic Circles* (undated).

Kelly, J.M. 'Riots, Revelries, and Rumor: Libertinism and Masculine Association in Enlightenment London', *Journal of British Studies*, 45, no. 4 (October 2006): 759–95.

Kinsley, Z. *Women Writing the Home Tour, 1682–1812* (Aldershot & Burlington: Ashgate Publishing Limited, 2012).

Klein, L.E. 'Gender and the Public/Private Distinction in the Eighteenth Century: Some Questions about Evidence and Analytic Procedure', *Eighteenth-Century Studies*, 29, no. 1 (1995): 93–4.

Klein, U. and W. Lefèvre. *Materials in Eighteenth-Century Science: A Historical Ontology* (Cambridge, MA: MIT Press, 2007).

Kowaleski-Wallace, E. 'Tea, Gender, and Domesticity in Eighteenth-Century England', *Eighteenth-Century Culture*, 23 (1994): 131–45.

Kowaleski-Wallace, E. 'Women, China and Consumer Culture in Eighteenth-Century England', *Eighteenth-Century Studies*, 29, no. 2 (1996): 153–67.

Kowaleski-Wallace, E. *Consuming Subjects: Women, Shopping, and Business in the Eighteenth Century* (New York: Colombia University Press, 1997).

Labbe, J.M. *Romantic Visualities* (Basingstoke: Macmillan Press Ltd. 1998).

Landreth, S. 'The Vehicle of the Soul: Motion and Emotion in Vehicular It-Narratives', *Eighteenth-Century Fiction*, 26, no. 1 (2013): 93–120.

Lanser, S. 'Befriending the Body: Female Intimacies as Class Acts', *Eighteenth-Century Studies*, 32, no. 2 (Winter, 1998–9): 179–98.

Lauwrens, J. 'Welcome to the revolution: The sensory turn and art history', *Journal of Art Historiography*, 7 (2012): 1–17.

Lepore, J. 'Historians Who Love Too Much: Reflections on Microhistory and Biography', *The Journal of American History*, 88, no. 1 (2001): 129–44.

Levy Peck, L. *Consuming Splendor: Society and Culture in Seventeenth-Century England* (Cambridge: Cambridge University Press, 2005).

Lipsedge, K. *Domestic Space in Eighteenth-Century British Novels* (Basingstoke & New York: Palgrave Macmillan, 2012).

Llewellyn, N. *The Art of Death* (London: Reaktion Books, 1991)

Lynch, D.S. 'Personal Effects and Sentimental Fictions', in *The Secret Life of Things: Animals, Objects, and It-Narratives in Eighteenth-Century England*, ed. Mark Blackwell (Lewisburg, PA: Bucknell University Press, 2007), 63–91.

Macdonald, A. 'Idle Talk: Portraiture, Visual Culture and Politics in Eighteenth-Century England', unpublished manuscript (2016).

Martin, M. *Dairy Queens: The Politics of Pastoral Architecture from Catherine de' Medici to Marie-Antoinette* (Cambridge, MA & London: Harvard University Press, 2011).

Masci, M.E. 'The birth of ancient vase collecting in Naples in the early eighteenth century: Antiquarian studies, excavations and collections', *Journal of the History of Collections*, 19, no. 2 (2007): 215–24.

Maudlin, D. *The Idea of the Cottage in English Architecture, 1760–1860* (Abingdon, Oxon: Routledge, 2017).

Mavor, E. *The Ladies of Llangollen: A Study in Romantic Friendship* (London: Penguin Books, 2001).

McKendrick, N., J. Brewer and J.H. Plumb, *The Birth of a Consumer Society: the Commercialization of Eighteenth-century England* (Bloomington, IN: Indiana University Press, 1982).

Meller, H. *A la Ronde* (Swindon: National Trust Publishing Ltd. 1991).

Mintz, S. *Sweetness and Power: The Place of Sugar in Modern History* (London: Penguin Books, 1986).

Moir, E. *The Discovery of Britain: The English Tourists 1540–1840* (Abingdon & New York: Routledge, 2013).

Moore, A. *Norfolk and the Grand Tour* (Norwich: Norfolk Museums Service, 1985).

Monod, P.K. *Jacobitism and the English People, 1688–1788* (Cambridge: Cambridge University Press, 1993).

Muir, E. 'Introduction: Observing Trifles', in *Microhistory and the Lost Peoples of Europe: Selections from Quaderni Storici*, eds. Edward Muir and Guido Ruggiero, translated by E. Branch (Baltimore & London: John Hopkins University Press, 1991).

Nenadic, S. 'Print Collecting and Popular Culture in Eighteenth-Century Scotland', *History*, 82, no. 226 (1997): 203–22.

Newport, E. 'The Fictility of Porcelain: Making and Shaping Meaning in Lady Dorothea Banks's "Dairy Book"', *Eighteenth-Century Fiction*, 31, no. 1 (2018): 117–42.

Nicholson, R. *Bonnie Prince Charlie and the Making of a Myth: A Study in Portraiture, 1720–1892* (Lewisburg, PA: Bucknell University Press, 2002).

Noble, G. 'Accumulating being', *International Journal of Cultural Studies*, 7, no. 2 (2004): 233–56.

Noble, P. *Anne Seymour Damer: A Woman of Art & Fashion, 1748–1828* (London: K. Paul, Trench, Trübner & Co., Ltd. 1908).

Norton, B.M. 'The *Spectator* and Everyday Aesthetics', *Lumen: Selected Proceedings from the Canadian Society for Eighteenth-Century Studies/Lumen: travaux choisis de la Société canadienne d'étude du dix-huitième siècle*, 34 (2015): 123–36.

Nussbaum, F.A. *The Autobiographical Subject: Gender and Ideology in Eighteenth-Century England* (Baltimore & London: The John Hopkins University Press, 1989).

Orchard, J. *Reading and Sociability in the Correspondence Networks of Elizabeth Montagu and Friends* (unpublished PhD thesis, Swansea University, 2019).

Page, J.W. and E.L. Smith, *Women, Literature, and the Domesticated Landscape: England's Disciples of Flora, 1780–1870* (Cambridge: Cambridge University Press, 2011).

Park, J. *The Self and It: Novel Objects and Mimetic Subjects in Eighteenth-Century England* (Redwood City, CA: Stanford University Press, 2009).

Pearce, S.M. *Interpreting Objects and Collections* (London: Routledge, 1994).

Peiser, M. 'William Lane and the Minerva Press in the Review Periodical, 1780–1820', *Romantic Textualities: Literature and Print Culture, 1780–1840*, 23 (2020): 124–48.

Pelling, M. 'Collecting the World: Female Friendship and Domestic Craft at Bulstrode Park', *Journal for Eighteenth-Century Studies*, 41, no. 1 (2018): 101–20.

Pelling, M. 'Reimagining Elizabeth I and Mary Queen of Scots: Female Historiography and Domestic Identities, *c.* 1750–1800', *Women's History Review*, 29, no. 7 (2019): 1085–113.

Peltz, L. 'Engraved Portrait Heads and the Rise of Extra-Illustration: The Eton Correspondence of the Revd James Granger and Richard Bull, 1769–1774', *The Volume of the Walpole Society*, 66 (2004): 1–161.

Peltz, L. *Facing the Text: Extra-Illustration, Print Culture and Society in Britain, 1769–1840* (Manchester & San Marino, CA: Manchester University Press & The Huntington Library Press, 2017).

Phillips, R.B. '"Dispel all Darkness": Material Translations and Cross-Cultural Communication in Seventeenth-Century North America', *Art in Translation*, 2, no. 2 (2010): 171–200.

Pimlott Baker, A. 'Powys, Caroline (1738–1817)', Oxford Dictionary of National Biography (Online Edition) (Oxford University Press, 2004).

Pittock, M. 'Treacherous Objects: Towards a Theory of Jacobite Material Culture', *Journal for Eighteenth-Century Studies*, 34, no. 1 (2011): 39–63.

Plumb, C. *The Georgian Menagerie: Exotic Animals in Eighteenth-Century London* (London: I.B. Tauris, 2015).
Pohl, N. 'The Plausible Selves of Sarah Scott (1721–95)', *Eighteenth-Century Life*, 35, no. 1 (2011): 133–48.
Pointon, M. *Hanging the Head: Portraiture and Social Formation in Eighteenth-Century England* (New Haven & London: Yale University Press, 1993).
Pointon, M. *Strategies for Showing: Women, Possession, and Representation in English Visual Culture 1665–1800* (Oxford: Oxford University Press, 1997).
Pointon, M. '"Surrounded with Brilliants": Miniature Portraits in Eighteenth-Century England', *The Art Bulletin*, 83, no. 1 (2001): 48–71.
Pointon, M. *Brilliant Effects: A Cultural History of Gem Stones & Jewellery* (New Haven & London: Yale University Press, 2009).
Pointon, M. *Portrayal and the Search for Identity* (London: Reaktion Books, 2013).
Potvin, J. *Bachelors of a Different Sort: Queer Aesthetics, Material Culture and the Modern Interior in Britain* (Manchester: Manchester University Press, 2014).
Pratt, L., ed. *Robert Southey and the Contexts of English Romanticism* (Aldershot & Burlington: Ashgate Publishing Limited, 2006).
Prown, J. 'Mind in Matter: An Introduction to Material Culture Theory and Method', *Winterthur Portfolio*, 17, no. 1, (1982): 1–19.
Reeve, M.M. 'Dickie Bateman and the Gothicization of Old-Windsor: Gothic Architecture and Sexuality in the Circle of Horace Walpole', *Architectural History*, 56 (2013): 97–131.
Reeve, M.M. 'Gothic Architecture, Sexuality, and License at Horace Walpole's Strawberry Hill', *The Art Bulletin*, 95, no. 3 (2013): 411–39.
Reeve, M.M. *Gothic Architecture and Sexuality in the Circle of Horace Walpole* (Philadelphia: Penn State University Press, 2020).
Retford, K. 'Sensibility and Genealogy in the Eighteenth-Century Family Portrait: The Collection at Kedleston Hall', *The Historical Journal*, 46, no. 3 (2003): 533–60.
Retford, K. *The Conversation Piece: Making Modern Art in Eighteenth-Century Britain* (New Haven & London: Yale University Press, 2017).
Rauser, A. *Caricature Unmasked: Irony, Authenticity, and Individualism in Eighteenth-Century English Prints* (Plainsboro, NJ: Associated University Press, 2008).
Reynolds, N. *Building Romanticism: Literature and Architecture in Nineteenth-Century Britain* (Michigan: The University of Michigan Press, 2010).
Reynolds, N. 'Cottage Industry: The Ladies of Llangollen and the Symbolic Capital of the Cottage Ornée', *The Eighteenth Century*, 51, no. 1–2 (2010): 211–27.
Robey, A. 'Floorcloth Manufactory in Knightsbridge', *The Georgian Group Journal*, 7 (1997): 160–7.
Rose, S. 'Close Looking and Conviction', *Art History*, 40, no. 1 (2017): 156–77.
Sabor, P., ed. *Horace Walpole: The Critical Heritage* (London & New York: Routledge, 1995).
Salber Phillips, M. '"If Mrs Mure be not sorry for poor King Charles": History, the Novel and the Sentimental Reader', *History Workshop Journal*, 43, no. 1 (1997): 110–31.

Sainsbury, J. 'John Wilkes, Debt, and Patriotism', *Journal of British Studies*, 34, no. 2 (1995): 165–95.

Sainsbury, J. *John Wilkes: The Lives of a Libertine* (Aldershot & Burlington: Ashgate, 2006).

Salmon, F. *Building on Ruins: The Rediscovery of Rome and English Architecture* (Aldershot & Burlington: Ashgate, 2000).

Sánchez-Jáuregui, M.D. and S. Wilcox *The English Prize: The Capture of the Westmorland, An Episode of the Grand Tour* (New Haven & London: Yale University Press, 2012).

Saumarez Smith, C. *Eighteenth-Century Decoration: Design and the Domestic Interior in England* (London: Weidenfeld and Nicolson, 1993).

Scott, J. *The Pleasures of Antiquity: British Collectors of Greece and Rome* (New Haven & London: Yale University Press, 2003).

Scott, R.J. 'Small-scale Dynamics of Large-Scale Processes', *The American Historical Review*, 105, no. 2 (2000): 472–9.

Sherman, S. *Telling Time: Clocks, Diaries and the English Diurnal Form, 1660–1785* (Chicago & London: Chicago University Press, 1996).

Sloan, K. *A Noble Art: Amateur Artists and Drawing Masters 1600–1800* (London: British Museum Press, 2000).

Sloboda, S. 'Displaying Materials: Porcelain and Natural History in the Duchess of Portland's Museum', *Eighteenth-Century Studies*, 43, no. 4 (2010): 455–72.

Sloboda, S. *Chinoiserie: Commerce and critical ornament in eighteenth-century Britain* (Manchester: Manchester University Press, 2014).

Smith, K. *Material Goods, Moving Hands: Perceiving Production in England, 1700–1830* (Manchester: Manchester University Press, 2014).

Smith, W.D. *Consumption and the Making of Respectability, 1600–1800* (New York & London: Routledge, 2002).

Snodin, M. and C. Roman. *Horace Walpole's Strawberry Hill* (New Haven and London: Yale University Press, 2009).

Stabile, S.M. *Memory's Daughters: The Material Culture of Remembrance in Eighteenth-Century America* (Ithaca: Cornell University Press, 2004).

Staves, S. and J. Brewer, eds. *Early Modern Conceptions of Property* (Abingdon & New York: Routledge, 1995).

Stewart, R. *The Town House in Georgian London* (New Haven & London: Yale University Press, 2009).

Stewart, S. *On Longing: Narratives of the Miniature, the Gigantic, the Souvenir, the Collection* (Durham & London: Duke University Press, 2007).

Stobart, J. 'Status, gender and life cycle in the consumption practices of the English elite. The case of Mary Leigh, 1736–1806', *Social History*, 40, no. 1 (2015): 82–103.

Styles, J. *Threads of Feeling: The London Foundling Hospital's Textile Tokens, 1740–1770* (London: The Foundling Museum, 2010).

Sweet, R. *Cities and the Grand Tour: The British in Italy, c. 1690–1820* (Cambridge: Cambridge University Press, 2012).

Tadmor, N. *Family and Friends in Eighteenth-Century England: Household, Kinship and Patronage* (Cambridge: Cambridge University Press, 2001).

Tilley, C. *Popular Contention in Great Britain, 1758–1834* (Cambridge, MA: Harvard University Press, 1995).

Tobin, R. *Warm Brothers: Queer Theory in the Age of Goethe* (Philadelphia: University of Pennsylvania Press, 2000).

Thomas, P.D.G. *John Wilkes: A Friend to Liberty* (Oxford: Oxford University Press, 1996).

Tosh, J. *A Man's Place: Masculinity and the Middle-Class Home in Victorian England* (New Haven & London: Yale University Press, 2007), 51.

Wall, C. *The Prose of Things: Transformations of Description in the Eighteenth Century* (Chicago & London: Chicago University Press, 2006).

Walker, L. 'The Entry of Women into the Architectural Profession in Britain', *Woman's Art Journal*, 7, no. 1 (Spring-Summer, 1986): 13–18.

Walvin, J. *Fruits of Empire: Exotic Produce and the British Taste, 1600–1800* (New York: New York University Press, 1997).

Watson, L.C. *A Commentary on Horace's Epodes* (Oxford: Oxford University Press, 2003).

Wehner, K. and M. Sear. 'Engaging the Material World: object knowledge and *Australian Journeys*', in *Museum Materialities: Objects, Engagements and Interpretations*, ed. Sandra Dudley (London & New York: Routledge, 2013), 143–61.

West, E. '"A little play-thing-house": Queer Childishness at Strawberry Hill', draft manuscript (2019).

West, S. 'Wilkes's Squint: Synecdochic Physiognomy and Political Identity in Eighteenth-Century Print Culture', *Eighteenth-Century Studies*, 33, no. 1 (Fall, 1999): 65–84.

White, H. *Tropics of Discourse: Essays in Cultural Criticism* (Baltimore: John Hopkins University Press, 1978).

Whyman, S.E. *Sociability and Power in Late-Stuart England: The Cultural World of the Verneys, 1660–1720* (Oxford & New York: Oxford University Press, 2002).

Wigston Smith, C. *Women, Work, and Clothes in the Eighteenth-Century Novel* (Cambridge: Cambridge University Press, 2013).

Williams, A. 'Reading Walpole Reading Shakespeare', in *Shakespearean Gothic*, ed. Christy Desmet and Anne Williams (Cardiff: University of Wales Press, 2009), 13–36.

Williams, A. '"I Hope to Write as Bad as Ever": Swift's Journal to Stella and the Intimacy of Correspondence', *Eighteenth-Century Life*, 35, no. 1, (2011): 102–18.

Williams, A. *The Social Life of Books: Reading Together in the Eighteenth-Century Home* (New Haven & London: Yale University Press, 2017).

Wilson, K. *The Sense of the People: Politics, Culture and Imperialism in England, 1715–1785* (Cambridge: Cambridge University Press, 1998).

Wilton, A. and I. Bignamini. *Grand Tour: The Lure of Italy in the Eighteenth Century* (London: Tate Gallery Publishing, 1996).

Worthen, J. *The Gang: Coleridge, Hutchinson and the Wordsworths in 1802* (New Haven & London: Yale University Press, 2001).

Wrigley, R. 'Making Sense of Rome', *Journal for Eighteenth-Century Studies*, 35, no. 4 (2012): 551–64.

Wrigley, R. *Roman Fever: Influence, Infection, and the Image of Rome, 1700–1870* (New Haven & London: Yale University Press, 2013).

Vickery, A. 'Golden Age to Separate Spheres? A Review of the Categories and Chronology of English Women's History', *The Historical Journal*, 36, no. 2 (1993): 383–414.

Vickery, A. *The Gentleman's Daughter: Women's Lives in Georgian England* (New Haven & London: Yale University Press, 1998).

Vickery, A. *Behind Closed Doors: At Home in Georgian England* (New Haven & London: Yale University Press, 2009).

Yarrington, A. *The Female Pygmalion: Anne Seymour Damer, Allan Cunningham, and the Writing of a Woman Sculptor's Life* (Edinburgh: Public Monuments and Sculpture Association, 1997).

Yonan, M. 'Toward a Fusion of Art History and Material Culture Studies', *West 86th: A Journal of Decorative Arts, Design History, and Material Culture*, 18, no. 2 (2011): 232–48.

Zemon Davies, N. *The Return of Martin Guerre* (Cambridge, MA: Harvard University Press, 1982).

Index

The letter *f* following an entry indicates a page that includes a figure.

A la Ronde 12, 16, 103*f*, 130, 132
 bookcase/curiosity cabinet 115, 116*f*, 120
 femininity 104–5
 fireplace 120–2
 inheritance 104, 179
 interior decoration 101–2, 104–5
 location 116
 shell gallery 115, 116–117*f*, 123, 124
 souvenirs 105, 106–7, 108–9, 118, 125, 131
 specimen table 101, 102*f*, 103–4, 110, 115, 122, 123, 125, 128, 129–31
 translation 106–7
Ædes Walpolianæ; or, a Description of the Collection of Pictures at Houghton Hall in Norfolk (Walpole, Horace) 48, 50, 183–4, 187–8
Æolian harp 162–3
aesthetics 31–2
affection 5
Ailesbury, Countess of (Caroline Campbell). *See* Campbell, Caroline
Albin, John 72, 73, 75
Anecdotes of Painting in England (Walpole, Horace) 187, 196
 Houghton Hall 47–8, 50, 76, 182
 Plas Newydd 144, 145, 146*f*–8, 152–6, 165
 portrait miniatures 6, 152–3
 portraits 203–5, 206, 208–9
art history 9, 11–12, 13

Baillie, Joanna 214
Baillie, Marianne 12
Bateman, Richard (Dickie) 182
Beatniffe, Richard 54–5, 115
Beauclerk, Diana 15
Berry, Agnes 178, 181, 194, 204
 Damer, Anne Seymour 214
 inheritance 212–13
 Little Strawberry Hill 211, 212
 Park Place 224
 queerness 210, 214
 Walpole, Horace 211, 212–13
Berry, Mary 178, 194, 205, 207, 231–2
 amateur dramatics 214–15
 Damer, Anne Seymour 13, 159, 214, 232
 emotion 225–7
 empty houses 225–7
 'Fashionable Friends' 214–15
 Grand Tour 109, 111, 113–14
 inheritance 212–13
 Little Strawberry Hill 181, 211, 212, 226–7
 mourning 126
 Park Place 224, 225–6
 portrait 204
 queerness 210, 214
 Strawberry Hill 215–16, 226–7
 Walpole, Horace 211, 212–13
Berry, Robert 212, 213
biography 106
Bowdler, Henrietta Maria (Harriet) 147, 152
Broderick, Thomas
 Letters from several parts of Europe, and the East 115–16
Brown, Bill 10
Bull, Richard 186, 188, 190, 205, 209
 Mémoires du Comte de Grammont 205
Bullar, John 67, 72, 74, 86, 90
 companion in a tour round Southampton; comprehending various particulars, ancient and modern, A 64, 91–2
 Historical and Picturesque Guide to the Isle of Wight, A 91–2
Burke, Edmund 37–8

Burney, Frances 52–3
Butler, Eleanor 12, 16–17, 225, 231 *see also* Plas Newydd
 Æolian harp 162–3
 floral correspondence 160
 found objects 150
 gift exchange 141–4, 145–8, 151, 152–4, 157–9, 160–1, 164, 165–6, 231
 trifles 18–19
 politics 18–19
 Ponsonby, Sarah, relationship with 139–41
 Romantic friendship 141–2, 146, 164
 Seward, Anna 139
 Valle Crucis Abbey 148

cabinets of curiosity 115, 116*f*, 119–20
Campbell, Caroline 18, 50, 179, 205, 206–9
 Park Place 223, 224, 225
Carter, Elizabeth 33, 127, 159
celebrity 203
ceramic houses 1–2*f*
Chesterfield, Earl of (Philip Stanhope) 108
chinoiserie 40–1
Churchill, Charles 66, 82–3
Churchill, Mary 178
classicism 77–9, 122
Climenson, Emily 35–6
Clive, Catherine (Kitty) 212, 214
Cliveden 212
close reading 11
Cocks, Margaret 129
Coke, Margaret. *See* Leicester, Countess of
Cole, William 182, 187, 205
Coleridge, Samuel Taylor 163
collecting/collections 164–5
 dispersal 182–3, 184, 227
 portraits 203–4
 Strawberry Hill 202–3
Collection of Etruscan, Greek, and Roman Antiquities (d'Hancarville, P.F.H.) 77, 79, 121–2
commemoration 82, 207–9, 211, 227–9
 see also mourning *and* urns
consumer behaviour 2
 male 41
 emotional objects 5–6
contemplation 127

Conway, Henry Seymour 18, 50, 105, 179, 195, 223
 Henley Bridge 200
 Park Place 224
 Walpole, Horace 205–6
Cosway, Richard 128–9
cottage orné 1, 102, 145
cottages 1
country houses 4
Crespigny, Mary Champion de 127
 Pavilion, The 127
Crewe, Frances Ann 151
culture objects 37–8, 92
Cumberland, George 163
Curtis's Botanical Magazine 161

Dactyliotheca Smithiana (Gori, Antonio Francesco) 78–9
dairies 42–4
Damer, Anne Seymour 18, 159, 213–14, 216
 amateur dramatics 214–15
 artistic identities 192–202, 204
 Berry, Agnes 214
 Berry, Mary 13, 159, 214, 231–2
 Description of the Villa of Horace Walpole, A (Walpole, Horace) 17, 180–1, 186, 189, 190–2, 193*f*, 194–5*f*, 197, 198–9*f*, 200–1, 203, 204–5, 206–10, 211–12, 215*f*
 extra-illustration 180–1, 186, 188, 190–2, 193–5*f*, 198–9*f*, 201, 203, 204–5, 206–10, 215*f*
 family/genealogy 205–9
 Henley Bridge sculptures (head of Thames) 200
 identities 191–202
 mourning 207–8
 Osprey, or Fishing Eagle 194, 197, 198–9*f*
 Park Place 224, 226
 queerness 210, 213–14
 reputation 214
 scrapbooks 194
 sculpture 194–5, 196–7, 198–201, 214
 Strawberry Hill 13, 17, 178, 179, 180–1, 185–6, 191, 197, 200–1, 215–16
 Walpole, Horace 184–5, 188, 195–7, 198, 199–200, 205–6, 210, 213

Damerian Apollo, The 192f, 193, 213
Dashwood, Elizabeth 40
Dashwood, James 40
Derby, Countess of (Elizabeth Farren) 194
description 10, 15, 32–6, 67
Description of the Villa of Horace Walpole, A (Walpole, Horace) 17, 48–9, 183, 184, 185, 187, 202
 Damer, Anne Seymour 17, 180–1, 186, 189, 190–2, 193f, 194–5f, 198–9f, 200–1, 203, 204–5, 206–10, 211–12, 215f
 extra-illustration 180–1, 186, 188–92, 193f, 194–5f, 197f, 198, 201, 203–5, 206–10, 215f
 portraits 203–5, 206
diaries 53 *see also* diurnal literature
diurnal literature 39, 47, 51, 53
domestic tourism 46, 47, 81
 Norfolk 29–30, 32–3, 36–7, 38–40, 41, 42–5, 45–7
domesticity 1–2
Downman, John 152–3
drawings 147–8

Eaton, Charlotte 110
Eginton, Francis 150, 151
emotion 7, 127, 128, 223–4, 225–7 *see also* mourning
emotional objects 5–7
epistolarity 29, 32–4, 50–3
 Bowdler, Henrietta Maria (Harriet) 147
excavation 114–15
exceptional typical 11
exchange 10, 16–17
extra-illustration 181, 185, 186–95, 197, 298, 201–2, 203–5
 commemoration 207–9
 Dean, Gabrielle 209

family
 Damer, Anne Seymour 205–9
 history 203
 Parminter 125
 portraits 203–5
 queerness 181, 198, 211
 relationships 125–6, 130
 souvenirs 124–30

Tadmor, Naomi 211
 Walpole, Horace 182–4, 202–10, 211
Farington, Joseph 177–8, 199–200
Farren, Elizabeth 194
'Fashionable Friends' (Berry, Mary) 214–15
Fawley Court 27, 30, 43–4
Félicité, Stéphanie. *See* Genlis, Countess de
femininity 104–5
flowers 159–60
follies 74, 77, 115
found objects 102, 114, 115, 117–18, 150
Foundling Museum 6
Fox, Elizabeth (Baroness Holland) 114, 124
Freeman, Sambrooke 27, 28, 43
Freeman, Sarah 27, 28, 43–4
Fremington jug 227–8
friendship 83
 Plas Newydd 139–42, 143, 144, 146, 154, 160, 165
 Romantic 141–2, 143, 144, 146, 165
 Seward, Anna 139–41, 159, 160, 164

gardens 158
 gift exchange 157–62
 Page, Judith W. and Smith, Elise L. 159
 Plas Newydd 157–9, 161–2
 Sandham Cottage 72–4
gathering (of materials) 187
Geertz, Clifford 4, 34, 53
gendered spaces 104
Genlis, Countess de (Stéphanie Félicité) 147, 153, 163
Gentleman's Magazine, The 66
Gibbon, Edward 79
gift exchange 16–17, 41–2, 142 *see also* gift relationships
 Butler, Eleanor 141–4, 145–8, 151, 152–4, 157–9, 160–1, 164, 165–6, 231
 Eger, Elizabeth 143
 food 42, 158–9
 gathering materials 187
 Haggarty, Sarah 143
 Houghton Hall 48
 plants, flowers, botanical literature 159–62, 165

Plas Newydd 142–4, 145–7, 157–8, 161–2, 164, 165–6, 225, 231
Ponsonby, Sarah 141–4, 145–8, 151, 152, 153–4, 158–9, 160–2, 164, 165–6, 231
Romantic friendship 141
souvenirs 113
Wilkes family 77
gift relationships 16, 143, 201–2
Girle, Barbara 37
Girle, John 32
Gloucester and Edinburgh, Duchess of (Maria Walpole, Countess Waldegrave) 178, 179
Gori, Antonio Francesco
 Dactyliotheca Smithiana 78–9
 Museum Florentinum 78, 79
Grand Tour 108, 109–15, 118–19, 123–4, 125
 Berry, Mary 109, 111, 113–14
 Parminter, Elizabeth 109, 125–6
 Parminter, Jane 101, 102, 103, 104, 107, 119–20, 125–6
 Parminter, Mary 101, 102, 103, 104, 107, 119–20, 125–6
 Piozzi, Hester Thrale 114
Grandison, Countess of (Elizabeth Mason-Villiers) 39–40
Grandison, Earl of (George Mason-Villiers) 27
Granger, James 186, 190, 204
grangerization 186
Gray, Thomas 190
grottoes 115–16, 123–4, 127

Hamilton, William 30, 77, 79, 121–2
d'Hancarville, P.F.H.
 Collection of Etruscan, Greek, and Roman Antiquities 77, 79, 121–2
Hardwick House 52
Hayley, William
 Triumphs of Temper, The 153
Heaton Hall 79
heirlooms 130
Henley Bridge 200
Herbert, Thomas 48
Hoare, Henry 85
Hogarth, William 86
 John Wilkes Esq. 87, 88f

Holdernesse, Mary 127
Holkham Hall 37, 42–3, 44–5, 55
Holland, Baroness (Elizabeth Fox) 114, 124
home catalogues 47–50, 67, 76, 182 see also *Description of the Villa of Horace Walpole, A*
 Ædes Walpolianæ; or, a Description of the Collection of Pictures at Houghton Hall in Norfolk 48, 50, 183–4, 187–8
homes/houses 3, 4, 7, 11, 14
 aesthetic experiences in 30–1
 emotion 223–4, 225–6
 empty 18, 225–7
 feminine spaces 44
 identity 225
 masculine authority 41–2
 materiality 223–4
 owners' character and 37–9, 69–71, 75–6, 85–6, 91–2, 182, 225, 233
 portraits 203
 queer 12–13
 representations of 3
 sociability 223–4
homosexuality 12–13 see also lesbianism
hospitality 36–45, 50
 performative 75
hot drinks 45
Houghton Hall 46, 47–8, 50
 catalogue 48, 50, 183–4, 187–8
 paintings 47–8, 50, 76, 182

Ibbetson, Thomasin 142
identity 107, 203, 204, 211, 229 see also owners' character *under* homes
 collecting 164–5
 extra-illustration 201
 homes/houses 182, 225, 233
influence 118
inheritance 10, 17, 181, 189 see also heirlooms
 A la Ronde 104, 179
 Berry sisters 212–13
 extra-illustration 188
 Little Strawberry Hill 211, 212, 213
 loss 229
 Parminter, Mary 104–5, 179

Strawberry Hill 179–80, 182–3, 184, 185–6, 189, 210–11, 213, 227
Walpole, Horace 177–9, 188, 213
Isle of Wight 63–4, 74, 81 see also Sandham Cottage
Marine Villa 77
Isola Bella 123–4
it-centred narratives 40–1
it-narratives 6, 40
Italy 105, 109–15, 118, 123

Jackson, Richard 32, 36, 38, 39, 41–3, 46, 47, 50
Jacobites 87
Jerningham, Edward 153, 208

Kirtlington Park 40–1

larders 39–40
Leicester, Countess of (Margaret Coke) 37, 42–3
Leighton, Mary 148
 Valle Crucis Abbey 149f
Lepore, Jill 11
lesbianism 139, 166, 214
letters. See epistolarity
literature 7–10, 229 see also texts and travel literature
 diurnal 39, 47, 51, 53
 epistolarity 29, 32–4, 50–3
Little Strawberry Hill 181, 211, 212, 214, 226–7
Llangollen Vale, with Other Poems (Seward, Anna) 146f, 162–3, 164
loss 10, 17, 223–30
 mediating 230–3
Lybbe Powys, Caroline 14–15, 29, 30, 107
 'Account of a Gala Week in the Neighbourhood of Henley-upon-Thames, Oxfordshire' 27–9, 39–40
 Bletchingdon House 46
 chinoiserie 40–1
 Fawley Court 43
 Hardwick House 52
 Holkham Hall 37, 42–3, 44–5, 55
 Houghton Hall 46, 47, 48, 50
 Isle of Wight 63, 71
 Kirtlington Park 40–1
 letters 50–2

Norfolk tour 29–30, 32–3, 36–7, 38–40, 41, 42–5, 45–7
Park Place 50, 223, 224, 226, 230
Plymouth Journal 53–4
porcelain 40–1
Rose Hill 41
Sandham Cottage 71, 75, 81
Shropshire Journal 52
Shrub's Hill 41
Strawberry Hill 48–50, 52
tourism 45–6
Weasenham Hall 36–7, 38–40, 41, 46, 51
writings 29–30, 32, 35–7, 38–9, 47, 49–54, 230, 232

Madame de Sevigne (portrait) 49
Maidalchini, Olimpia 113
Malmesbury, Earl of (James Harris) 224, 225, 230
Mann, Horace 185, 196, 200
Marine Villa 77
Marshall, Mr. 43–4
Martin, Selina 111, 126
 Narrative of a three years' residence in Italy 115
Mary and John Wilkes Zoffany, Johan 88–9f
masculine authority 41–2
material culture 11–12, 30–2
 significance 7–8
 texts 7–10
 emotion 5, 6, 7
 homes 3–4, 5, 7
 temporal experience 8, 9
 art history 9, 11–12
materiality 30–2, 223–4, 227–8, 231
Mavor, William Fordyce 78
memory 147–8, 150, 165, 225–7 see also commemoration
microhistory 10–11, 12, 18
micromosaics 110–11f, 129
Miller, Anna 109–10, 112, 114
Milnes Day, Esther 159, 228–9
 Lines Written on the Anniversary of the Death of a tender Mother 228
 On a Father's Miniature 153
Montagu, Elizabeth 33, 127, 159
monuments 82

morality 37–8
mosaics 110–11*f*, 129
mourning 82, 126, 128–30, 207–9, 227–9
Museum Florentinum (Gori, Antonio Francesco) 78, 79

neoclassicism 77–9
Noble, Percy 184, 206, 213
non-canonical design 13
North Briton, The 68, 82
North-East View from Sandham Cottage, Isle of Wight, A (Wilkes, Harriet) 72, 73*f*, 74

objects 5–18, 232–3 *see also* gift exchange *and* souvenirs
 acquisition 105,113–15
 biographical 101, 106
 collecting 164–50
 culture objects 37–8, 92
 Dahn, Jo 30
 found 102, 114, 115, 117–18, 150
 journals 52, 54
 loss 227–30
 lost 223–7, 231
 selfhood 164–5
 stolen 115
 superadded 6, 7
objectscapes 30–2, 44, 45, 70
Orford, 3rd Earl of (George Walpole). *See* Walpole, George
Orford, 4th Earl of (Horace Walpole). *See* Walpole, Horace
overcloseness 11, 12
Owen, Mr (of Brogyntyn Hall) 151

Park Place 13, 18, 50, 159, 223–6, 230
 library 225, 226
Parker, Sarah 18, 148, 160, 161–2, 165
Parker, Thomas Netherton 148, 160, 161–2, 165
Parminter, Elizabeth 16, 125, 130
 Grand Tour 109, 125–6
Parminter, Jane 12–13, 16, 101–5, 107–8, 227 *see also* A la Ronde
 found objects 115, 117–18
 Grand Tour 101, 102, 103, 104, 107, 119–20, 125–6
 prints 112, 121, 122
 replication 119–24
 shell gallery 115, 116–117*f*, 123, 124
 souvenirs 105, 106–7, 108–9, 110, 112–13, 118, 130–1
 specimen table 101, 102*f*, 103–4, 110, 115, 122, 123, 125, 128, 129–31
 travel journal 104, 119–20, 126
Parminter, Mary 12–13, 16, 101–5, 107–8 *see also* A la Ronde
 found objects 115, 117–18
 Fremington jug 227–8
 Grand Tour 101, 102, 103, 104, 107, 119–20, 125–6
 loss objects 227
 'My dear Grandfather and Grandmother Walrond's profiles' 125
 prints 112, 121, 122
 replication 119–24
 shell gallery 115, 116–117*f*, 123, 124
 souvenirs 105, 106–7, 108–9, 110, 112–13, 118, 130–1
 specimen table 101, 102*f*, 103–4, 110, 115, 122, 123, 125, 128, 129–31
 will of 104–5, 179
Parminter, Richard 125
Passeri, Giovanni Battista
 Picturae Etruscorum in Vasculis 78, 79
Pavilion, The (Crespigny, Mary Champion de) 127
Pennington, Penelope 33–4, 229
Phillips, Henry
 Sylva florifera: the Shrubbery Historically and Botanically Treated 157
Piggot, Harriette 157–8
Piozzi, Hester Thrale 33–4, 37–8, 152, 229
 Grand Tour souvenirs 114
 preface to *The Florence Miscellany* 152
 specimen tables 123
 Thraliana 37
Piranesi, Giovanni Battista 112
 Veduta dell' Arco di Costantino 112*f*
 Views of Rome 112
plants 159
Plas Newydd 12, 13, 16–17, 140*f*, 146*f*, 231
 acquisition and integration of local materials 150–1

Æolian harp 162–3
art 144, 145, 146*f*–8, 152–6, 165
collections 165
drawing room 144–5, 146–7, 156, 165, 225
garden/grounds 157–9, 161–2
gift exchange 142–4, 145–7, 157–8, 161–2, 164, 165–6, 225, 231
Home Circuit 148, 156–7
library 144–5, 150*f*–6
locality 144–5, 148–51, 225
Romantic friendship 141–2, 143, 144, 146, 165
Seward, Anna 139, 145–6, 149, 152, 154–6, 159, 162–4, 165
visitors 139–45, 148, 151–2, 157
windows 145, 150*f*–1
Plumptre, James 152
Plymley, Katherine 146, 147, 152
politics 87
Ponsonby, Sarah 12, 16–17, 225, 231
see also Plas Newydd
Æolian harp 162–3
Butler, Eleanor, relationship with 139–41
floral correspondence 160
gift exchange 141–4, 145–8, 151, 152, 153–4, 158–9, 160–2, 164, 165–6, 231
importance of trifles 18–19
landscape drawings 147
Llangollen 145
politics 18–19
Romantic friendship 141–2, 146, 164
Seward, Anna 139
Valle Crucis Abbey 148
wafer tongs 18–19, 233
porcelain 40–1
ceramic houses 1–2*f*
portrait miniatures 6, 152–3
portraits 203–5, 206, 208–9
Powys, Mary 139
print culture 76–80, 84, 86, 87–8*f*, 121–2
extra-illustration 186–9
privacy 3
publication 10, 15

queerness 181, 198–9, 205–6, 210–16

Reichel, Oswald Joseph 102, 125
'Extracts from a Devonshire Lady's Notes of Travel in France in the Eighteenth Century' 119
relationships 143
repetition 129
replication 118–24
representations 8, 14–15
reputation 84
review periodicals 84
Reynolds, Deborah 127
Reynolds, Frederick 73
Reynolds, Hannah Mary 46–7
Reynolds, Joshua 198
Rogers, Samuel
Pleasures of Memory, The 147
Romantic friendship 141–2, 146, 164, 165
romantic love 5
Romanticism 141
Romney, George
Serena 153–6

Sandham Cottage 15, 63–6, 67, 69–71
aspect 72, 74–5
chairs 79–80
decline 91–2
Domestic tourism
garden 72–4
interiors 75, 76–81
marquees 71–2, 74–5, 77–82
monuments 66, 82–3
novelty and taste 71–81
reputation and celebrity 84–92
sociability and affection 81–3
Tuscan Room 77–8
Sandown 63
'Sapphick Epistle' 214
Scott, Walter 74
selfhood 164–5
sentimentalism 2
Serena (Romney, George) 153–6
Serena (Smith, John Raphael [after George Romney]) 155*f*, 164
Sermon on Painting (Walpole, Horace) 48, 184, 187
servants 38
Seward, Anna 51
Æolian harp 162–3
collection 165

friendship 139–41, 159, 160, 164
gardens/natural spaces 158–9, 160, 162
gift exchange 145–6, 147, 153–4, 158–9, 162, 164
Llangollen Vale, with Other Poems 146f, 162–3, 164
Plas Newydd 139, 145–6, 149, 152, 154–6, 159, 162–4, 165
Sneyd, Honora 153–6
Valle Crucis Abbey 148–9
Shelley, Percy Bysshe 119, 163
shellwork 115, 116–17f, 123
shopping 109–11
Shorter, Catherine 202, 206
Shrub's Hill 41
slavery 37–8
Sleeping Dogs 195f
Smith, Charlotte 159
Smith, John Raphael (after George Romney) *Serena* 155f, 164
Sneyd, Honora 153–6
sociability 45–50, 81–3, 223–4
social texts 186–9
Southey, Robert 141, 161–2
souvenirs 101, 102–4, 105–8, 131
 acquisition 108–18, 123
 family affection 124–30
 mourning 126, 130
 replication 118–24
 specimen tables 123, 130–1
specimen tables 101, 102f, 103–4, 110, 115, 122–3, 128, 129–31
Starke, Marina 112, 123, 124
 Travels in Italy, Between the Years 1792 and 1798 110
Strawberry Hill 13, 17, 48, 195, 215–16 see also *Description of the Villa of Horace Walpole, A*
 Berry, Mary 215–16, 266–7
 catalogue 49–50
 China Room 202, 203
 Damer, Anne Seymour 13, 17, 178, 179, 180–1, 185–6, 191, 197, 200–1, 215–16
 emotion 226–7
 extra-illustration 189
 family/friends 202–10
 inheritance 179–81, 182–3, 184, 185–6, 189, 210–11, 213, 227

library 202
Lybbe Powys, Caroline 48–50, 52
plays 214–15f
prints 189
queerness 210–12, 214
sculpture 197f–8
visual and material culture 202–10
Strawberry Hill Press 186
Stuart, Charles Edward 87
superadded objects 6, 7
Sutherland, Charlotte 209
Sutherland, Hendras 209
Sutherland Clarendon (Sutherland, Hendras and Sutherland, Charlotte) 209

taste 75–81
 feminine 104
 souvenirs 108
tea services 37–8
texts 7–10, 232 see also extra-illustration *and* literature
 diaries 53
 review periodicals 84
 social texts 186–9
theft 114
thick description 34–6
thing theory 10
Thraliana (Piozzi, Hester) 37
Tighe, Sarah 158, 161
Tischbein, Johann Heinrich Wilhelm 121
Tofanelli, Stefano 112
tokens 6
tourism 29–30, 47 see also domestic tourism *and* Grand Tour *and* souvenirs
translation 10, 16, 106–7, 118, 121, 131
travel literature 29–30, 31–4, 51–2, 230 see also tourism
 aesthetics 31–2
 description 32–3
 epistolary 32–4
 Grand Tour 113–15, 119
 home catalogues 47–8
 Isle of Wight 64–6, 67, 71, 75–6, 91
 mourning 126
 object-acquisition 113–15
 Parminter, Jane 119–20
 Sandham Cottage 64–6, 67

urns 82, 111f, 128–9, 212

Valle Crucis Abbey 148–50, 151
Villa Doria Pamphili 113–14
Villiers, Elizabeth Mason- 27, 39–40
Villiers, George Mason- 27
Volpato, Giovanni 78
von la Roche, Sophie 128

wafer tongs 18–19, 233
Waldegrave, Countess of (Maria Waldegrave née Walpole) 178, 179
Walpole, George 46, 47
Walpole, Horace 13, 17, 29, 216, 227 *see also* Strawberry Hill
 Aedes Walpolianae; or, a Description of the Collection of Pictures at Houghton Hall in Norfolk 48, 50, 183–4, 187–8
 Anecdotes of Painting in England 187, 196
 Beauclerk, Diana 15
 Berry sisters 211, 212–13
 Book of Visitors 196, 198
 Campbell, Caroline 205, 206
 Conway, Henry Seymour 205–6
 correspondence 209, 212
 Damer, Anne Seymour 184–5, 188, 195–7, 198, 199–200, 205–6, 210
 Description of the Villa of Horace Walpole, Youngest Son of Sir Robert Walpole Earl of Orford, At Strawberry-Hill, near Twickenham. With an Inventory of the Furniture, Pictures, Curiosities, &c., A. See *Description of the Villa of Horace Walpole, A*
 extra-illustration 187–8, 190, 193, 194–5, 197, 198, 203–5, 206, 213
 genealogy 182–4, 202–10, 211
 Granger, James 186
 Henley Bridge 200
 Italian tour 48
 literary estate 213
 Little Strawberry Hill 181, 212–13
 Park Place 224
 queerness 205–6, 210–11, 213, 216
 Reminiscences 193
 reputation 182, 213
 Reynolds portrait 198
 Roman eagle 197f–9
 Sermon on Painting 48, 184, 187
 souvenirs 105
 Strawberry Hill 181–3, 184, 195
 will of 177–80, 181, 183, 184, 188, 205, 210–11, 212–13
 Works of Horatio Walpole, Earl of Orford, The 213
Walpole, Maria (later Waldegrave) 178, 179
Walpole, Robert 47, 48, 50, 76, 182, 184, 206
Walrond, Mary (later Parminter) 125
Walrond, Mrs (Elizabeth Rebecca) 125
Walrond, Rev. (Richard) 125
Weasenham Hall 36–7, 38–40, 41, 46, 51
Wedgwood, Josiah 121
Wellesley, Anne 152–3
Wellesley, Arthur 153
Wellington, Duke of (Arthur Wellesley) 153
Westmorland (frigate) 123
Wilkes, Harriet 72, 77, 82
 North-East View from Sandham Cottage, Isle of Wight, A 72, 73f, 74
Wilkes, John 15, 63–4, 66–71 *see also* Sandham Cottage
 art 76–81
 aviary 73–4
 biographies 67–70, 90
 ceramic objects of 85f, 86
 character/reputation 69–71, 75–6, 84–6, 90–2
 Essay on Woman in three Epistles, An 68
 gardening 72–4
 as host 81–3
 images of 70, 86, 87
 portraits/prints of 86, 87–90
 prints, collecting 76–80
 relationships 82–3
 as symbol 86–7
Wilkes, Polly (Mary) 73, 75, 77, 81, 82, 88–9f
Winckelmann, Johann Joachim 76, 82
windows 145, 150f–1
women, creativity 205, 214–15

Woodhall Park 79
 carved chairs 79–80*f*
Wordsworth, Dorothy 123
Wordsworth, Mary 123
Wordsworth, William 123, 141

wunderkammers 119–20 *see also* cabinets of curiosity

Zoffany, Johan 82
 Mary and John Wilkes 88–9*f*